WOMEN LEGISLATORS IN CENTRAL AMERICA

WOMEN LEGISLATORS IN CENTRAL AMERICA
POLITICS, DEMOCRACY, AND POLICY

MICHELLE A. SAINT-GERMAIN
& CYNTHIA CHAVEZ METOYER

UNIVERSITY OF TEXAS PRESS
AUSTIN

Copyright © 2008 by the University of Texas Press
All rights reserved
Printed in the United States of America
First edition, 2008

Requests for permission to reproduce material from this work should be sent to:
 Permissions
 University of Texas Press
 P.O. Box 7819
 Austin, TX 78713-7819
 www.utexas.edu/utpress/about/bpermission.html

♾ The paper used in this book meets the minimum requirements of ANSI/NISO Z39.48-1992 (R1997) (Permanence of Paper).

LIBRARY OF CONGRESS CATALOGING-IN-PUBLICATION DATA
Saint-Germain, Michelle A.
 Women legislators in Central America : politics, democracy, and policy / Michelle A. Saint-Germain and Cynthia Chavez Metoyer. — 1st ed.
 p. cm.
 Includes bibliographical references and index.
 ISBN 978-0-292-71716-9 (cloth : alk. paper) —
 ISBN 978-0-292-71717-6 (pbk. : alk. paper)
 1. Women legislators—Central America.
2. Women politicians—Central America. I. Metoyer, Cynthia Chavez, 1965– II. Title.
 HQ1236.5.C35S24 2007
 328.7280082—dc22
 2007030600

CONTENTS

Acknowledgments **vii**

CHAPTER 1	Introduction	**1**
CHAPTER 2	What Gets Women Elected	**72**
CHAPTER 3	Elected Women's Paths to Power	**119**
CHAPTER 4	Elected Women as Legislators and Representatives	**151**
CHAPTER 5	Women and Democratization in Central America	**197**
CHAPTER 6	Public Policy	**251**
APPENDIX A	Methodology	**285**
APPENDIX B	Interview Schedule for Elected Women Legislators	**291**

Notes **295**

Glossary **301**

References **307**

Index **329**

ACKNOWLEDGMENTS

The idea for this book first arose in the mid-1980s; fieldwork was carried out over the ensuing ten years; writing engulfed another six years. Needless to say, this book could not have been completed without substantial support from institutions as well as individuals.

Michelle Saint-Germain received grants from the Tinker Foundation, the Fulbright program, the National Endowment for the Humanities, the University of Texas–El Paso, and the University of Arizona and its Women's Studies Advisory Council. Cynthia Chavez Metoyer received support from California State University–San Marcos.

To the many individuals who helped over the nearly twenty-year span, the authors give their heartfelt thanks. A number of graduate students were directly involved with the project at the University of Arizona, University of Texas–El Paso, California State University–Long Beach, California State University–San Marcos, and the University of California–San Diego. Other students were indirectly involved by commenting about the project in lectures and seminars taught by the authors.

Finally, this work would not have been possible without the generous contributions of the women elected to the national legislatures of Costa Rica, El Salvador, Guatemala, Honduras, and Nicaragua, and of the other Central Americans interviewed for this book. To them, we say, *"¡Gracias!"*

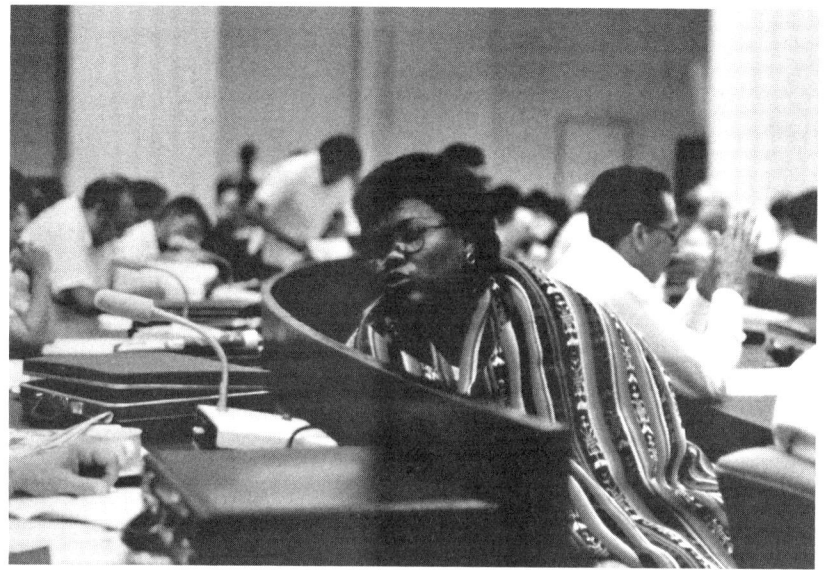

Dorotea Wilson Thatum (Nicaragua)

Ana Ísabel Prera Flores (Guatemala)

Nury Vargas Aguilar (Costa Rica)

Hazel Law Blanco (Nicaragua)

Dolores Eduviges Henríques (El Salvador)

María Eugenia Castillo Fernández
(Guatemala)

Sonia Rodríguez Quesada (Costa Rica)

Gladys Báez Alvarez (Nicaragua)

Ana Chávez Petit (Honduras)

Thelma Iris de Pérez (Honduras)

Mercedes Gloria Salguero Gross
(El Salvador)

Milagro del Rosario Azcúnaga
de Meléndez (Costa Rica)

Sara Ivonne Mishaan Rosell (Guatemala)

Mimi Prado (Costa Rica)

Mireya Guevara Fallas (Costa Rica)

Soad Salamón de Facussé (Honduras)

Hilda González Ramírez (Costa Rica)

Leticia Herrera (Nicaragua)

Auxiliadora Martínez (Nicaragua)

Santos Buitrago Salazar (Nicaragua)

Macla Judith Romero de Torres
(El Salvador)

Flory Soto Valerio (Costa Rica)

Gladys Rojas Prado (Costa Rica) Yadira Centeno (Nicaragua)

WOMEN LEGISLATORS IN CENTRAL AMERICA

CHAPTER 1 INTRODUCTION

> When one woman gets involved in politics, it changes her; but when many women get involved, they change politics.
>
> Central America, 1990s

Political slogans in Central America in the 1990s reflected the belief that qualitative political changes accompany quantitative increases in the number of women in decision-making positions. Other slogans of that era emphasized that a nation's level of democratization could be judged both by the presence of women as representatives and by the extent to which the interests of women were represented. Did these slogans reflect a new political reality for women in Central America? This book considers that question by focusing on women elected to national legislatures in Central America in the 1980s and 1990s. This brief period, the most recent attempt at democratization in the region, was pivotal for women in all of Central America and also witnessed a dramatic rise in the numbers and percentages of women elected to the national legislatures of five Central American republics.

Upon first winning the vote and the right to be elected in the 1940s and 1950s, the percentages of women in the national legislatures of Costa Rica, El Salvador, Guatemala, Honduras, and Nicaragua were rather low but were consistent

TABLE 1.1. WOMEN IN CENTRAL AMERICAN LEGISLATURES

Country	First Year Women Elected	Percent Women Elected	Percent Women Elected in 1980	Percent Women Elected in 1995
Costa Rica	1953	6.7	7.0	15.8
El Salvador	1961	3.7	7.4*	10.7
Guatemala	1954	1.5	3.2	12.5
Honduras	1957	5.2	5.6	7.8
Nicaragua	1972	9.0	21.6**	16.3
Average	–	5.2	9.0	12.6

*Data from 1979; legislature suspended in 1980.
**Data from unelected Council of State after 1979 revolution.
Source: IPU 1995.

with those of most other countries in Latin America, which historically often lagged far behind the worldwide average. However, women's presence in the national legislatures of Central America began increasing after 1980 (Table 1.1). In Costa Rica, women's presence fluctuated around 7 percent until 1980, but then doubled to 15.8 percent by 1995. In El Salvador, women legislators nearly tripled, from 3.7 percent in 1961 to 10.7 percent in 1995.[1] Guatemalan women achieved only a small increase, from 1.5 percent in their first election in 1954 to 3.2 percent in 1980, but then realized a much larger increase to 12.5 percent in 1995. Honduras hovered around 5 to 6 percent until 1980, and then increased slightly to 7.8 percent in 1995. For Nicaragua, there is agreement on the date of women's suffrage (1955), but there are varying reports on when women were first elected to the national legislature and how many were elected. In addition, data for Nicaragua for 1980 were not strictly comparable to those of the other countries in the region because they reflected the composition of an unelected advisory body, not an elected legislature. Nevertheless, in 1995 Nicaragua achieved the highest percentage of elected women in the region (16.3 percent).

These gains were impressive, but how did they compare with those of other countries in the Latin American region or throughout the world? In 1980, the percentage of women legislators in the Central American region climbed above the average for the Latin American

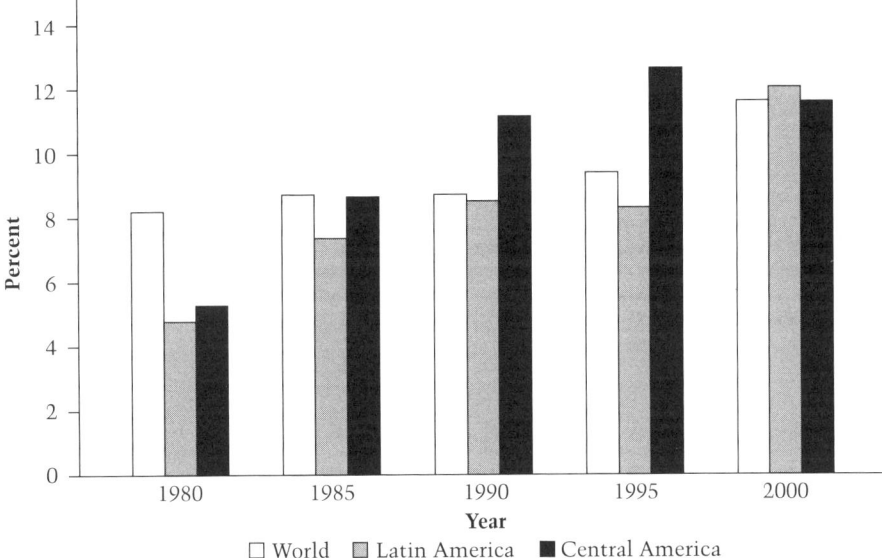

Figure 1.1 **Women in National Legislatures 1980–2000; World, Latin American, and Central American Averages.** Sources: IPU 1995 and 2005.

region (Figure 1.1). In 1985, the Central American percentage grew to equal the world average, which included fully developed economies and democracies as well as those in transition. In 1990, the percentage of women in the national legislatures of four Central American countries (Nicaragua at 16.3 percent, Costa Rica at 12.3 percent, Honduras at 10.3 percent, and El Salvador at 8.3 percent) surpassed the average (6 percent) for a sample of fifty developing democracies (Rule 1994b); the Central American regional average exceeded both the world and Latin American averages. In 1995, the Central American average reached its highest point, at 12.6 percent, again higher than world and Latin American averages. In 2000, the regional average fell slightly, to 11.6 percent, and was overtaken by both the Latin American regional and the world averages.[2] It appeared that women were making exceptional headway in Central American national legislatures between 1980 and 1995.

The changes over this period prompt a number of important questions: Why did these increases occur at that time? Was it due to something about these five Central American countries, either their history of conquest and colonialism, or the more current events surrounding democratization? Was it due to their method of election, or

to cultural norms or political traditions that favored the election of women? What were women's political roles during this period? Were organized groups pressuring for the election of women? Which women were elected, and why? Was it due to the talents of this particular cohort of elected women? What were elected women's goals and interests, and what constituencies did they represent? Finally, did politics change elected women, or did elected women change politics?

This book explores these and other related questions by focusing on women elected to the national legislatures of Central American nations in the 1980s and 1990s. We use this focus to investigate whether explanations about the election of women to national legislatures in general can also be applied to the Central American experience in particular and, conversely, whether the particular Central American phenomenon can contribute to our understanding of the election of women in general. The issues, concerns, and developments covered in our study are not only important to the understanding of women and politics in Central America; they also contribute to a broader understanding of the complex theoretical and practical issues of women, representation, and democratization in the developing world and point to the types of developments in the status of women that can be expected in the future.

One of the important conditions for the rise in the representation of women was the state of affairs in Central America. To set the stage, we first briefly review the histories of Costa Rica, El Salvador, Guatemala, Honduras, and Nicaragua, comparing their economic and political cultures. We examine the major events of the 1980s and 1990s, which coincided with the winding down of the Cold War and the settlement of armed conflicts in three of the five Central American countries.

A second important condition for the election of women to national legislatures in this region was the presence of politically experienced women. We present stories from elected women themselves about their backgrounds that demonstrate not only an early interest but also an early active participation in politics. Their stories reveal many similarities, such as the accomplishment of historic firsts, from the first woman elected to a town council to the first woman to preside over a national legislature. However, there was also extensive diversity among Central American women legislators, with backgrounds as farm workers, international diplomats, university students, artists, and career politicians. They ranged in age from early twenties to late seventies, having from zero to nine children. Some came from urban,

Spanish-speaking elites, and others from rural, indigenous minority groups; some came from the right, and others from the left. Nevertheless, they were all able to overcome barriers to election.

We then explore the interplay among all these conditions that promoted women's election and explore women's participation in the movements for democratization in the region. Finally, we ask what difference it makes if more women are elected, in terms of public policy. Here we find the adoption of a gender consciousness that constitutes the third condition for the increase in women's representation in Central America.

ROAD MAP FOR THE REST OF THE BOOK
Immediately following this introduction is an overview of the major themes in the history of the Central American region in general, and then how these themes developed in specific ways in each of the individual countries (Costa Rica, El Salvador, Guatemala, Honduras, and Nicaragua). The purpose of the historical overview is to provide a context for the discussions that follow in the remaining chapters, which make reference to important developments in Central America during the 1980–1995 time period. It also documents the presence of one of the key factors for the election of women: the presence of a crisis. The overview also addresses some basic concepts about Central American states that may be unfamiliar to the reader (such as corporatism) and explains some of the major events (such as the Esquipulas peace process) that influenced the transition from revolution, war, and crisis to peace agreements and post-conflict elections. The remainder of this book is divided into chapters that focus on one of the initial sets of questions stated at the beginning of this introduction.

CHAPTER 2: WHAT GETS WOMEN ELECTED
Chapter 2 offers a snapshot of the presence of women in national legislatures worldwide during this time period. It introduces one of the central tasks of this book, which is to discover whether the forces that have been previously identified as having helped or hindered the election of women to national legislatures in other countries can also explain the Central American situation in particular. This chapter addresses questions that could be posed by scholars in political science, women's studies, international development, Latin American studies, and legislative studies, among other fields. How many women are in national legislatures worldwide? What helps women

get elected? What are the effects on women's election of differences among nations in economic wealth and urbanization? What hinders women's election? Do some types of electoral systems help women's election more than other types? Our analysis in Chapter 2 relies on secondary data about Central American economies, societies, and electoral systems, as well as primary data obtained through personal interviews with elected women in Central American national legislatures during this time period.

Inquiry into differences in the representation of women in national legislatures began to blossom around 1980 with comparative data from industrialized democracies, mostly in Western Europe (Kohn 1980; Lovenduski and Hills 1981; Christy 1987); the United States is generally excluded from comparative research because it does not use the proportional representation form of democracy adopted by most other Western nations.

The literature quickly grew and branched into three areas of inquiry into what hinders or helps women to get elected: first, the electoral system, especially proportional representation, multi-party districts, and party lists. There have been numerous quantitative studies of women in national legislatures (e.g., Beckwith 1992; Maitland 1991; Rule 1987) concerned with how structural differences in electoral systems affect the proportion of the legislature that is female. All five Central American countries have electoral systems which have been found to favor the election of women, including proportional representation, multi-member districts, and party lists (e.g., Norris 2004).

Notwithstanding, there is tremendous variation among these five countries both in terms of their electoral structures and in terms of results for women. Chapter 2 examines some additional factors suggested as having an effect on women's election, such as the size of the legislature, incumbency, the ideological orientation (left-right) of political parties, the number of parties vying for seats, and the number of seats won per party (e.g., Darcy and Beckwith 1991; Saint-Germain 1994). The analysis shows that generally in Central America more women are elected from districts with larger numbers of candidates than from districts with smaller numbers of candidates, and more women are elected from political parties that win large blocks of seats than from parties that win few seats in the national legislature, although there are some exceptions; there is also some support for the role of leftist parties in electing women.

The second type of explanation looks at indicators of the level of national development, such as the Gross National Product (GNP) or the percent of the population living in urban versus rural locations. Forces that encourage women to move to urban areas, usually to obtain an education and/or enter the paid labor force, especially into professional occupations, also encourage the election of women to national legislatures (Christy 1987; Norris and Lovenduski 1995). Central American nations do not rank highly on such measures of national development, nor is there much variety among these nations, and the sample ($n = 5$) is so small that these factors have little explanatory power in this situation. However, some trends are evident that support the link between better conditions for women and their greater representation in national legislatures.

The third type of explanation examines the social, cultural, and political orientation of the country, for example, by measuring levels of Catholicism or support for a women's movement. Countries with traditional cultures and high levels of religious adherence have lower proportions of women in their national legislatures (Rule 1984). Central America's political culture is heavily shaped by the traditionalistic gender system of *machismo* and by Catholicism, both of which constrain women's activities.

Given the disadvantageous level of economic development in Central America and the pervasive culture that equates political activity with male activity, it is perhaps not surprising that fewer numbers of women than men are in positions of national leadership in the region, although the majority of both women and men have traditionally been excluded from formal power throughout the Central American region. But the acknowledged presence of these structural and cultural barriers does not help us to fully understand the quite varied record of success in the election of women legislators across a region that shares many similarities. This chapter helps to fill in some of the gaps by discussing how other developments, such as a state of crisis, a ready pool of women candidates, and the adoption of gender consciousness, can offset the effects of underdevelopment and *machismo*, especially in countries where women participated visibly in prolonged armed conflict (i.e., Nicaragua and El Salvador). Moreover, it discusses differences among these countries in cultural forces that can positively affect the election of women to national legislatures, for example, the strong commitment to egalitarianism in Costa Rica.

The chapter concludes with some possible strategies that women can use to increase their numbers as elected representatives.

CHAPTER 3: ELECTED WOMEN'S PATHS TO POWER

Chapter 3 brings into focus the specific women who have succeeded in being elected to a national legislature. Some previous individual-level research includes studies of women national leaders, prominent women in politics, and women indigenous leaders (Chaney 1979; Dolan and Ford 1998; Furlong and Riggs 1996; Genovese 1993; Prindeville and Gomez 1999; Richter 1990–1991). However, there are very few studies that are comprehensive, either over time or over place, and very few that focus at the same time on structural indicators and electoral systems as well as the individual-level factors that make women successful in getting elected. This chapter addresses another set of questions, perhaps posed by scholars in psychology, sociology, anthropology, ethnography, and other fields, that concerns which women get elected. What are these women like? Are they extraordinary in some way, compared with other women in their country? What motivates them? Were there unusual circumstances that propelled them toward politics during early socialization, perhaps some type of economic, political, or social crisis? What are their life stories? What paths did they take to power? What are the variations for women from different backgrounds within the same country, and what are the similarities among women from different countries?

Our analysis in Chapter 3 of individual women who are national legislators in Central America demonstrates that they are more likely to have come from more urbanized areas, to have achieved higher levels of education, and to have practiced a profession. However, there are substantial differences among women in national legislatures within and between countries in the region, especially in the poorest countries, Nicaragua and Honduras.

This chapter also documents the second important factor for the election of women: the presence of a pool of politically experienced women from which candidates for the national legislature could be drawn. It identifies the early age at which elected women become interested in politics; the crucial role played by mothers who were involved in politics and/or worked outside the home; and the depth and breadth of their political experience as exemplified by the different paths they take to reach the national legislature. Women in Central America become cognizant of, interested in, and active in politics at

an early age, averaging 16 years old. The most common reasons reported for developing a political consciousness include growing up in a political family; participating in student politics; being drafted into electoral politics; developing an awareness of social problems; and experiencing a crisis or traumatic event. There are also at least six distinct patterns that elected women in Central America have followed to get to the national legislature. These include the traditional route of capitalizing on a connection to a political man, commonly a deceased relative; taking up a political career late in life after completing a professional career; becoming a career party activist from an early age; moving up through the women's section of a political party; transitioning from a nonpartisan community activist into partisan politics; and distinguishing oneself in a revolutionary, military, or police organization (this last path became possible only during the 1980s and 1990s). These paths support our finding that despite the seemingly "sudden" appearance of women in national legislatures, most have put in a lifetime of hard work to get there. Chapter 3 concludes with a discussion of the variation in the paths followed by elected women, both among the countries in the region and within each country over time, and offers considerations for women contemplating a political career.

CHAPTER 4: ELECTED WOMEN AS LEGISLATORS AND REPRESENTATIVES

Once elected, women express themselves in a variety of ways to fulfill the internal and external functions of the national legislature. This chapter addresses questions of interest to those who study role theory, work and family relations, theories of representation, and feminist theory, among other subjects, and examines how women elected in a transitioning democracy define their representational role. How do elected women define the functions of a national legislature, in relation to other government institutions and in relation to the governed? Do elected women perceive themselves to have multiple roles, and how do they balance competing and conflicting role demands? What or whom do elected women represent, and how do they represent them? Chapter 4 discusses another important factor in the election of women: the adoption of a gender perspective or gender consciousness (*concienciación*). It explores the phenomenon of *concienciación* through two normative questions: should women legislators represent women and, if so, how? What is their philosophy of representation, especially with respect to representing women?

Internally, there are various kinds of tasks that legislators perform, including taking leadership posts, serving on committees, and the day-to-day business of the legislature. Despite their relatively small numbers, Central American women legislators are serving in the highest possible leadership positions, and they are well represented on a wide variety of committees, not just on those concerned with "women's issues." Occupying leadership positions is important because "to produce change, women must not only be present: women must be powerful" (Htun 2000). Perhaps their success is due to their incredible commitments of time and energy to their work, a function of the fact that they have always had to work many times harder than men to obtain the barest recognition or rewards.

Within the legislature, a representative may play many roles, depending on the focus of representation (Jewell 1970; Skard and Haavio-Mannila 1985). Central American women legislators feel they represent many constituencies, including political party, geographic region, socioeconomic class, and other groups. Nearly nine out of ten say they also represent women. Some women legislators take a passive role in representing women, while others take a much more active role. Some women legislators see themselves as delegates from women's groups, faithfully executing the group's wishes, while others act as trustees, watching out for women's interests. Trustees predominate in Costa Rica and El Salvador, while both styles are equally present in Guatemala, Honduras, and Nicaragua.

Externally, a legislature establishes relationships with other governmental agencies, as well as with the electorate. Legislators can perform numerous tasks for the electorate, including symbolic, service, policy, and resource distribution tasks (Jewell 1983). In relation to its external functions, many Central American women legislators define the goal of the legislature as an activist one, to pursue broad social goals.

Performing the internal and external functions of a national legislature requires a number of personal qualities. Central American women legislators identified a list of ideal qualities necessary to be successful in general, including educational, professional, leadership, interpersonal, and moral qualities. Professional qualities are most important in Costa Rica; moral qualities dominate in El Salvador; leadership rises to the top in Guatemala; interpersonal qualities are the most desired in Honduras; and Nicaragua prizes both interpersonal and leadership qualities equally. To be successful as a woman,

however, additional qualities are needed, including more personal development in Costa Rica; overcoming *machismo* in El Salvador; a mix of these two strategies in Guatemala and Honduras; and adopting pro-women strategies in Nicaragua. Chapter 4 concludes that, in general, actively representing women is seen as a source of strength by Central American women legislators.

CHAPTER 5: WOMEN AND DEMOCRATIZATION IN CENTRAL AMERICA
The turmoil in Central America during and since the Cold War could be seen as a contest to impose one particular definition of democracy over others. Chapter 5 explores the roles of Central American women in struggles toward democratization. This chapter addresses explicit and implicit questions about democracy, elected women, and democratization, which are of interest to many of the types of scholars mentioned above, as well as to political theorists, students of social movement theory, and students of democratization in comparative perspective. Which theory of democracy have the elected women in Central America adopted? How did elected and activist women contribute to the democratization process of the 1980s and 1990s? What has been the impact of democratization in Central America on women?

A useful framework for democratization developed by scholars such as O'Donnell (1992) and Linz and Stepan (1996) features a sequential process, progressing from a crisis, to a period of transition, and finally into consolidation.[3] This literature often links the achievement of democratic consolidation to the adoption of a liberal, constitutional form of democracy, placing emphasis on formal political arrangements such as competitive party politics from which women are often marginalized (Waylen 1996, 118).

For this process to work, however, there must be widespread agreement on the definition of democracy. The word *democracy* has a long history and has been interpreted in many ways, including liberal, social, and radical versions. Chapter 5 presents comments from personal interviews to understand how democracy has been defined by Central Americans, where they see their countries in terms of democratization, how women have influenced democratization, and what impact democratization has had on women.

During this era, Central Americans drew upon liberal, social, and radical models, but they defined democracy in their own way. Their definition of democracy is multidimensional: it should guarantee public order; pursue social justice; use civil space to determine

goals; and allow for collective influence. The primary rights of the individual are to live in a state free of violence, to have basic needs met, and to organize collectively based on common interests, or status, to influence social decision-making. The civic sphere takes on an enhanced role as the site where consensus is forged among organized sectors, and between sectors and the state, for the realization of the common good, through the process of *concertación* (coming together). Democracy is not only a process, but a process guaranteed to produce a socially desired result.

This conception of democracy is a rather idealized one, but women's commitment to its realization helps to explain why they have been so prominent in the struggle over democratization in Central America: women saw a unique opportunity to shape democracy into a form more responsive to their interests. This chapter examines the specific actions women took to bring about democratization. In the crisis stage, women participated in unprecedented numbers in peaceful marches and hunger strikes as well as in armed combat. To some extent, women were successful in challenging the social norms and political culture that had traditionally been indifferent to women's needs. But women were less successful in the second, transitional stage in their attempts to influence the direction that the new democratization was taking. For example, women were largely excluded from the negotiations that produced the earliest peace agreements, cessation of hostilities, and framework for the process of transition to democracy in Nicaragua, but they were more present in the similar agreements reached six years later in Guatemala, largely through *concertación*. In the third, or consolidation stage, women have had to struggle for visibility under the new electoral processes that are the cornerstones of democratization. Perhaps they should not have been surprised. After all, the experience of Central American women in many ways paralleled that of women in the Eastern European states where democratization resulted in a decrease in the number of elected women, the rollback of programs favoring women, and the adoption of measures increasing the regulation of women by the state (Landolt 1996; Metoyer 1997 and 2000; Nechemias 1994; Rai, Pilkington, and Phizacklea 1992; Regulska 1992). Nevertheless, Central American women contributed importantly to democratization, through their tireless pursuit of peace in the crisis phase, through demands for collective influence to be recognized in the civil sphere (*concertación*) in the transition phase, and through the flourishing of many nonpar-

tisan, non-governmental organizations (NGOs) in the consolidation phase. The chapter concludes with some thoughts about the future of democracy in Central America.

CHAPTER 6: PUBLIC POLICY

Chapter 6 addresses the "so what" questions that are important to policy analysts, activists, legal scholars, and skeptics. What impact—if any—have elected women had on Central American women's lives? Have any new laws, policies, or programs been introduced by elected women? If so, have they been adopted? What can the experiences of women elected to the national legislatures of Central America possibly offer to others?

This chapter contributes to the important debate in the literature over the effects of electing relatively larger numbers of women. Does their election lead to adopting policies that promote the interests of women, such as social justice and an end to violence, through the use of negotiation and compromise (*concertación*) to solve problems? Often women legislators hold more liberal and more feminist views, irrespective of political party affiliation (O'Regan 2000, 23). Nevertheless, we found that some qualitative changes in the political agenda occur when significant numbers of women are elected to decision-making positions in Central America, including:

- More sponsorship of legislation concerning women and more collaboration in promoting such legislation (Craske and Molyneux 2002, 16);
- More introduction and passage of policies addressing social issues, such as peace, child labor, or social justice (Hansen 1995 in O'Regan 2000, 12); and
- A noticeable difference in the priority placed on these issues by women legislators compared to their male counterparts (O'Regan 2000, 19; Saint-Germain 1989).[4]

Most studies addressing whether qualitative changes can occur when larger numbers of women take on decision-making capacities do not consider developing nations, do not compare many nations, or do not track changes over extended periods of time. In contrast, our analysis compares women who were elected to national legislatures in five Central American nations and also traces policy developments among these nations over time during the decades of the 1980s and 1990s. The analysis in Chapter 6 is based on both secondary data on laws and policies in Central America and primary data from field interviews with women legislators.

Chapter 6 explains that having women in the national legislature is important because legislators have significant influence on public policy, and women legislators are more likely to broaden the policy agenda to include new themes.[5] This echoes the findings of other studies of Latin American legislatures (Las Bujias 1996; Nuñez de Escorcia 1996; Reingold 2000; Rivera-Cira 1993; Jones 1997). The number (or proportion) of women elected is also important, since legislatures with higher percentages of women are more likely to enact public policies in areas that affect women (O'Regan 2000; Saint-Germain 1989; Thomas 1994).

Of course, policy does not change overnight, and women have been present in the national legislatures of Central America only a short while, and still in small numbers relative to men. We did find that significant changes have been taking place in laws and policies affecting women in Central American countries. Many factors have combined to produce these changes, including women's participation in struggles for democratization; the mobilization of women's movements and pressure groups; international events such as the U.N. Decade for Women; the increasing presence of women in politics, government, and other influential positions; and the adoption of a gender perspective (*concienciación*) by many women. Whereas most Central American women legislators say they represent women, few label themselves as feminist (by their own definition of the term). Rather, there is a preference to speak in terms of *concienciación*.

The rise of *concienciación* among women in political parties in Central America represents an important development in policymaking by and about women. For example, Alatorre's 1999 study of Mexico revealed that gender-related policies, such as curbing domestic violence, were enacted only when they concurred with party interests. When gender-related policies (e.g., fostering reproductive health or the protection of women in the workplace) contradict party interests, it is less likely that legislation will be enacted (Alatorre in Htun and Jones 2002, 49). Even when gender-related policies have been enacted, the focus has generally been on preventing discrimination against women but without any explicit questioning of why women are structurally marginalized (Craske and Molyneux 2002; Elshtain 1981; Pateman 1988).

Not every country in Central America is equally situated with respect to law and policy on women; nor are women legislators a homogeneous group. They espouse a wide variety of opinions about

existing policy—whether it should be preserved as is; whether it is sufficient and merely needs to be better implemented; or whether revised or new legislation is necessary. And each country presents different challenges and opportunities for transforming public policy concerning women. Still, the problem most commonly mentioned by all women legislators as impacting women is the economic crisis, including lack of development and the size of the foreign debt. Comments from the interviews demonstrate how the imposition of neoliberal economic policies and structural adjustment programs (SAPs) coincident with democratization created new hardships for women. The second most often mentioned problem is discrimination against women in all areas of life (including social, economic, political, and legal) based solely on gender.

The policy remedies proposed by Central American women legislators fall along a broad continuum, from continued traditional treatment of women, to palliative strategies for women's burdens, to strict equality between women and men, to radical or role-changing policies for women. These policies tend also either to treat women as individuals or to treat them as submerged within (or identical with) the family, which are further discussed in Chapter 6.

The discussion of policy in Chapter 6 reveals that while Central American women legislators were grappling with some of the same policy issues as their peers in other countries (e.g., child care), others of their issues were unique (e.g., *machismo*). Some of their ideas about how to address policy issues were comparable to those adopted in other countries (e.g., paid maternity leave), but some of their ideas seemed more radical than anything proposed elsewhere (e.g., laws regarding responsibility for housework). The chapter suggests how Central American women legislators' perspectives on public policy pose important and challenging questions for those interested in public policy on women everywhere. It shows how the seeds of some policies adopted in the new millennium (such as quotas for women in politics) can be traced back to developments during the 1980s and 1990s. It concludes by discussing the questions on the effects of elected women on public policy that remain unanswered and suggesting how they might be approached by future research.

SUMMARY

This book is the first to present an in-depth and comparative study of women elected in the 1980s and 1990s to the national legislatures

of Central American republics. We draw upon a large variety of wide-ranging works, including many Spanish-language sources. We include primary data obtained through personal interviews with women elected during these years as legislators in Costa Rica, El Salvador, Guatemala, Honduras, and Nicaragua, augmented with secondary data on each country. This period is pivotal, since the proportions of women in Central American national legislatures greatly increased after 1980. This book examines the reasons for this increase, the women who formed this new wave, and its impacts. We identify the most salient regional factors as the historical era of democratization that presented a political opening, the presence of politically experienced women who became active during their formative years, and a widespread phenomenon of adoption of a gendered consciousness (*concienciación*).

However, we also examine whether national differences in the level of women's representation in the region are linked to factors identified in previous comparative studies of industrialized democracies as contributing to greater proportions of elected women, such as levels of urbanization, industrialization, and wealth. At the individual level, we look at similarities among elected women across countries in the region as well as differences within each country, especially in terms of early political awareness. We consider whether factors identified in previous studies on successful political women are also present in Central American women legislators. These include ties to politically powerful families, early socialization to politics through a working or politically active mother, and the ability to overcome powerful cultural barriers.

Turning to the women elected during this period, the book analyzes their interpretation of the job of a representative and the personal qualities it requires. Building upon previous comparative studies of national legislators, it looks at the various roles that legislators can play, how legislators balance multiple and conflicting role demands, and how their experience in politics has raised women's gender consciousness. The book then explores not only the impacts of politics on elected women, but also the impacts of elected women on politics, through democratization and public policy.

This book draws on new waves of scholarship on women and representation. Prior studies have tended to focus on one or the other of two main themes: empirical studies on numbers of women holding political office, with particular emphasis on their absence, and/

or studies of individual elected women; or gender-related legislation and public policies on topics such as domestic violence, reproductive health, workplace protection and equality, and their effects on women. Research on women and politics of the first type has generally concentrated on the comparatively smaller numbers of elected women compared to men or the relative absence of women in the political arena, particularly in public office (O'Regan 2000, 13). A shortcoming of the first group of studies is the lack of simultaneous consideration of both national-level and individual-level factors that propitiate the election of women, which we address in Chapter 2 and Chapter 3. A caveat with research of the second type is its legalistic focus, with little exploration of the nuances of public policy for women in different national, cultural, and political environments. Drawing on studies of the impact of increasing numbers of women in decision-making bodies, and of the importance of a gendered perspective, this book reveals in Chapter 4 the great heterogeneity in how elected women perceive their roles.

In Chapter 5, we link both of these types of important studies to the larger theoretical discussion on democratization. What is the impact, if any, of higher numbers of women in elected office on the transition from a pre- or quasi-democratic political system to a more democratic one, and its subsequent consolidation? This is important because as Craske (1999, 86) points out, the struggle for democratization has shown that there is always the potential for change and for power relations to be renegotiated. The book investigates the reciprocal effects of democratization on women as well as the effects of elected and politically active women on democratization. The experiences of women in Central America are also compared and contrasted with those of women in other newly democratizing regimes in Eastern and Central Europe.

Finally, we consider the broad range of policy proposals of elected women in Central America in Chapter 6. In Central America, the interests and demands of women were not well articulated during the transition to democracy in the 1980s and 1990s, and were largely excluded from the agenda for democratic consolidation. This resulted in a profound questioning by women of the connections between peace, rights, development, and gender. Shut out from the new formal institutions, women have begun developing their own informal political practices and creating non-governmental organizations (NGOs) to lobby for their claims on the new democracy. This final chapter offers

examples of how elected and activist women are now drawing upon their political expertise, honed during years of struggle for other causes, to develop gender consciousness and to define and assert their own interests and rights through public policy in the new emerging state. The issues, concerns, and developments covered in our study are not only important to the understanding of women and politics in Central America; they also contribute to a broader understanding of the complex theoretical and practical issues of women, representation, and democratization in the developing world and point to the types of developments in the status of women that can be expected in the future. Finally, the book spells out the implications of the Central American experience for other countries and makes recommendations for the direction of future studies.

OVERVIEW OF CENTRAL AMERICAN HISTORY

The five Central American countries of Costa Rica, El Salvador, Guatemala, Honduras, and Nicaragua have many things in common. Historically, these republics were shaped by their geography as well as by conquest, Catholicism, economics, politics, and gender relations. A brief description of their similarities follows. It should be noted, however, that despite historical similarities, each country also has distinctive geographical, economic, political, social, and gender characteristics that have been well-documented elsewhere. This overview is intended to provide a context for the findings reported in this book, especially for the reader unfamiliar with the region.

GEOGRAPHY

Geographically, these countries form a narrow isthmus of land between Mexico and Panama, connecting the continents of North and South America. The entire area, although rather small, hosts many different micro-climates, from dry and dusty plains, to mountainous cloud forests, to tropical and swampy lowlands. In each country, geography and other forces interacted to shape national history.

CONQUEST

The modern history of Central America began in 1492, when Catholic Spaniards concluded a 700-year campaign to drive Muslims from the Iberian peninsula in Europe. Over this period, Spain developed expertise in armed conquest, territorial administration, and the imposition of Catholicism (Dunkerly 1988). With no more territory to conquer, armed groups that were traditionally exempt from civil law

Map of Central America. Source: St. Catharines [computer file]. (No date.) St. Catharines, Ontario: Brock University Map Library. Available: Brock University Map Library Controlled Access. http://www.brocku.ca/maplibrary/images/stcathv8.jpg. (Accessed Feburary 2007.)

posed a very real problem for the newly unified Spain, which redirected them toward the New World. Settling disputes through violence and granting impunity from the law for armed groups were to become hallmarks of Central American politics.[6]

Central American conquest rewarded the victors with both the land and its native inhabitants as spoils. *Conquistadores* took indigenous women as sexual servants or sold them in Caribbean slave markets while importing Spanish ("white") women to produce legitimate heirs for their property (de Oyuela 1989, 8). Both the conquest and subsequent waves of European diseases wiped out an estimated 90 percent of the original populations of Central America (Weaver 1994). At the same time, African slaves were brought to the eastern shores of Central America for work. The predominant ethnic groups

in the region today are products of these events: people of mixed heritage are variously called *mestizos* (people of mixed ethnicity) or *ladinos* (people who adopt Spanish language and customs). While most Central Americans denied that their societies were racist, social rank and privilege were often correlated with the predominance of European heritage in the family.

The Catholic Church acquired substantial landholdings in the new world of Central America and controlled most schools through various orders of nuns and priests. Its status as the official religion and its control of the educational process resulted in most Central Americans identifying themselves as Catholic. Independence loosened the church's control of education, expropriated some of its lands, and reduced its overall power. After the Vatican reforms of the 1960s, many Central Americans formed *Comunidades Eclesiásticas de Base* (CEBs) [Christian Base Communities], some embracing the more radical liberation theology that fell outside the traditional church hierarchy and its teaching. Nevertheless, the Catholic Church remains the preeminent religious institution in the region today, and it still exerts considerable conservative influence over the lives of women.

ECONOMICS

Land has traditionally been the single most important indicator of wealth, status, and power in Central America. The Spanish colonial administration treated Central America as a great source of natural resources to be exploited. Land was awarded to the elites in the form of *encomiendas,* feudal estates that included their indigenous residents. The few women who owned property required a father or husband to act as agent for them to buy, sell, or trade. The *encomienda* became the basis of society, where a small oligarchy exploited the mass of the population. Indigenous inhabitants or poor *mestizos* were allowed to grow their own food on land within the *encomienda* in exchange for their labor. This system produced economic and social injustices that formed the basis for many of the current Central American problems.

Beginning with the colonial administration, Central American countries were used for producing export crops such as coffee that required large, contiguous parcels of land and a sizeable, mobile labor force. This required taking over and consolidating small plots of communal lands held by indigenous peoples, poor *mestizo* farmers, and otherwise landless peasants (*campesinos*), forcing them to become

migrant laborers to earn money to buy food. After independence, in some countries, valuable resources such as banana plantations were controlled entirely by foreign interests that provided low-wage employment but paid little in taxes and invested little in the host country.

These economic strategies also created vicious circles of social instability. Dedicating more land to export-producing crops meant less land and farm labor were available for producing food for internal consumption. Countries found themselves having to import such staples as corn, rice, and beans, using revenues from export crops. Relying on only a few crops for export left Central American revenues vulnerable to declines in prices on the world market. When prices declined, the government responded by dedicating more land to exports, further reducing the food supply, and so on. After the 1929 stock market crash and worldwide depression, the Nicaraguan nationalist Agusto César Sandino led a rebellion against occupying U.S. forces. Strikes broke out at banana enclaves in Honduras and Guatemala. Over 20,000 *campesinos* were killed in massacres in El Salvador.

As a result of these upheavals, military dictatorships emerged in four of the five countries during the 1930s to provide economic stability; only Costa Rica maintained its civilian and democratically elected government while dealing with workers' strikes. A movement in the 1960s to revive a Central American Common Market prompted these republics to attempt to diversify their economies to include manufacturing. A new strategy of import substitution industrialization (ISI) encouraged developing nations to make goods at home rather than import them. However, Central America had neither the infrastructure nor the labor force: most of the population was still rural, and few women participated in the paid labor force. The prices for export goods fell again on the world market. Finally, spending by the military in the 1980s for internal conflicts outstripped spending on development, frustrating attempts at ISI. The 1990s saw the conclusion of the last of the region's wars and a decrease in military budgets but also the imposition of neoliberal economic policies and structural adjustment programs (SAPs) by international lending agencies.

POLITICS

The colonial era created *criollos*, a new elite made up of Central American–born descendants of the original Europeans. The *criollos* broke with Spanish rule in 1821 and swiftly gained independence. Without a prolonged period of struggle, however, most of these nations

did not develop cohesive national integration, a unifying identify, or plans for self-rule (Dunkerly 1988). For a few years, the countries of Costa Rica, El Salvador, Guatemala, Honduras, and Nicaragua were combined into a single Central American federation, but it soon dissolved over boundary claims and other disputes. Each country declared itself to be an independent republic, although they were barely more than city-states. Many of the political developments that later influenced the revolutions in the United States and France had little impact on the Spanish colonies in Central America. When these colonies did win independence from Spain in the 1820s, they adopted new Constitutions that reflected the language of the new republicanism but did not greatly change the reality of Central American political life.

The configuration of the state known as corporatism has been visible in many Latin American nations (Craske 1999, 28). The political structures that Central American countries inherited from colonial Spain can be described as corporatist: "hierarchical, elitist, authoritarian, bureaucratic, Catholic, and patrimonial" (Wiarda 1981, 97). The corporatist sees society as an organic whole, presided over by the machinery of the state and directed by an authoritative ruler. Society is made up of groups that may have competing interests. These groups are organized on the basis of their principal role in society, such as the military, the church, the university (and students), and the landed aristocracy. The state controls all resources but doles them out in exchange for support from organized groups. The state decides what constitutes an organized group and retains the power to bestow or remove the recognition that empowers a group to have standing before the state. Those so recognized are perceived as legitimate public interests (Wiarda 1981, 132).

From its roots in Roman and Catholic influences on Spain, the purpose of the corporatist state is to address the "moral, cultural and social" as well as the economic needs of society (Wiarda 1981, 131). Society is based on natural groups such as the family, not the individual, and group rights are more important than individual rights (Wiarda 1981, 54). The state takes an active role in managing society and maintaining it as an organic whole. The strong ruler at the top of the corporatist state pyramid should intuitively know how to distribute resources through the bureaucracy to attain state purposes. The bureaucracy tends to be large because it must monitor and maintain the loyalty of the organized groups through the state-sanctioned vertical hierarchies of interest representation (e.g., unions). The state also re-

wards members of groups by offering them employment in the state bureaucracy. The state is often advised by a council made up of representatives from the organized groups. Within each organized group, there is a hierarchy of positions similar to those found in the military, the Catholic Church, a university, or a medieval guild (apprentice, journeyman, master). The state allows each group to draw up its own codes of conduct and does not interfere with the internal functioning of organized groups if they support the state and do not abuse its resources (including land and people). In general, the rights of people in these organized groups are recognized by the state and are respected as long as they do not threaten the organic whole; the idea of a loyal opposition makes little sense. The state is also obligated to "respect the inviolability of the human person" (Wiarda 1981, 151). Arbitrary state repression, torture, or murder of the weakest members of society is not acceptable and may cause the withdrawal of loyalty to the state.

The great mass of society, however, is found either in the lowest ranks of these organized groups or entirely outside them. Over time, those outside the organized groups (e.g., urban laborers, migrant peasants, small businesses) may petition the state for official status and the right to make claims against other groups. The corporatist state's response is to set up vertically structured, state-sponsored organizations such as labor unions, peasant associations, or chambers of commerce so that these groups can have a recognized channel for their demands on the state for a share of resources. Demands made on the state outside of these sanctioned channels are either passively ignored or actively suppressed. For these reasons, the idea of political parties makes little sense, since they do not represent a major functional group in society and do not have a source of legitimacy for claims on the resources of the state. Nor is there room for a meaningful civil society independent of the state. The implications of this political system for the representation of women will be discussed more fully in the following chapters.

The rather abrupt withdrawal of the Spanish colonial administration at independence set the stage for a power struggle that erupted in all the Central American republics. The careful balancing of interests previously enforced by colonial rule dissolved. Two major, competing alliances of elite groups formed and called themselves either Liberals or Conservatives. On the one hand, they represented different sets of elites (new economic interests that favored increasing exports and trade, versus traditional landholders and the Catholic Church). On the

other hand, both wanted uncontested authority to govern the state, and both were determined to utterly defeat the other. Neither was favorable to women. Liberals who lost control of the government in one country would call upon their fellow Liberals in the other Central American countries for support; Conservatives would do the same. Fighting forces were attached to the elites who owned large estates or to the political faction that offered them the most rewards, but there was little that resembled a national army (Holden 2004).

These struggles continued throughout the nineteenth and even into the twentieth century in most of the Central American republics, often organizing around *caudillos,* or strongmen. Following the corporatist tradition, the *caudillo* depended upon the loyalty of his personal fighting force rather than political ideology and would tolerate no dissension. Because of intolerance for opposing points of view, upon gaining power, each party would do its best to tear down whatever the other party had previously set up. When a rival party gained control of the government, it would either ignore the existing Constitution, amend it, or draft a new one.

While party names and allegiances changed over time, the political instability did not. Military service provided one of the few routes to upward social mobility in countries where the land was controlled by hereditary elites. These militaries became considerably more professionalized through their experience in government and rotated a series of their men through the presidencies of El Salvador, Guatemala, Honduras, and Nicaragua. With a monopoly on the use of force, the military state did not have to abide as closely to the corporatist principles either of negotiation between social forces or of traditional respect for the human rights of the weak (Holden 2004). As a result, none of these nations—with the sole exception of Costa Rica—experienced a peaceful transfer of power from one freely elected party in office to another until the 1980s or 1990s.

International powers also played a role in the political instability in the region. The United States considered Central America to be in its "backyard" and limited the influence of other rival powers. In the early 1900s, several countries in the region suffered overt invasion by U.S. troops or their proxies, while others endured covert U.S. involvement in their internal political affairs. After World War II, the national defense forces (armies, national guards, police, and intelligence and counterintelligence units) turned from guarding against invasion by external forces to guarding against perceived internal threats to

national security. In the 1980s, the region experienced the testing of a new U.S. counterinsurgency strategy known as low-intensity conflict. While conventional war seeks to kill or capture an enemy occupying a defined territory, low-intensity war targets a civilian population with a combination of economic, psychological, and physical assaults aimed at weakening both the infrastructure and the social fabric of a region. There is no distinction between combatants and noncombatants in a low-intensity war (Miles 1986, 19). In this case it is the hearts and minds of the population that are the "territory" to be won (Morelli and Ferguson 1984, 9). This strategy allowed the United States to support governments with funds for military buildups in Cold War regions where Communists were suspected of operating but without committing U.S. troops.

The infamous CIA manual "Psychological Operations in Guerrilla Warfare" (Tayacan 1984), issued to the irregular Contra forces fighting the Nicaraguan government, advised the use of terror against those perceived to be leaders of the opposing side (including health workers, educators, technicians, etc.) and the use of rewards for those perceived to be cooperating (Sarkesian 1985, 10). This so-called low-intensity conflict was carried on throughout El Salvador, Nicaragua, and Guatemala during the 1980s and early 1990s. Yet after peace agreements ended hostilities in these countries, Central America was mostly ignored by world powers.

A FRAMEWORK FOR DEMOCRATIZATION

One framework for democratization describes a process of crisis, transition, and consolidation. This framework was developed from analyses of both gradual and rapid democratic transitions in South America, especially in the cases of Brazil and Argentina. Guillermo O'Donnell (1992), theorizing from South American events, described two sequential phases: the first begins with an authoritarian crisis and ends with the installation of democratic government, while the second begins with the consolidation of the democratic regime and ends in a stable democracy. Both transitions rely heavily on pact-making by elites; specific instances of these *pactos* (pacts) in Central America will be addressed in the country-by-country sections that follow.

This crisis-transition-consolidation framework focused on procedures and rules through which elections became possible and repeatable in South America. The first process of change generally began with a military government's response to a stage of crisis. Outgoing

military and incoming civilian elites bargained over extension of political rights to citizens and a framework for elections (when elections would occur, under what conditions, which parties would participate and so on). In Brazil, this process began in the 1980s with intra-elite conflict that generated uncertainty and discontent; the transition phase extended over several years (Stepan 1988). In Argentina, the military's embarrassing defeat in the 1982 Malvinas/Falklands war as well as its economic mismanagement led to a more rapid transition in 1983 (Waisman 1999, 96–97). The collapse of the Pinochet regime in Chile represents a middle ground: growing cohesion among opposition factions allowed the democratization movement to extract some concessions, culminating in a yes/no referendum on military rule in 1988 (Valenzuela 1999, 227–229).

Following the installation of a civilian government through a popular election, the second process of change entailed what Adam Przeworksi (1992) described as "irreversibility," where both military and civilian elites acknowledge democracy as "the only game in town." Democracies finally become consolidated when, according to O'Donnell (1992, 48–49):

- There are positive political rights (to vote, organize, and speak freely) as well as competitive and fair elections;
- There are stable institutions (executives, legislatures, courts);
- Political leaders reach consensus on the country's laws and policies;
- Recognizable channels exist for communication between political leaders and citizens;
- Political leaders respect citizens' rights as well as their freedom from government interference.

O'Donnell's and Przeworski's conceptualizations of democratic consolidation emerged from the definitions of democracy delineated by Western scholars Joseph Schumpeter (1976) and Robert Dahl (1971). In Schumpeter's democracies—and also in Dahl's polyarchies—suffrage and competition result in the election of winners to government offices, and the organization of the losers into a nonviolent opposition. The only sanctioned arena for competition is the political sphere. Competition ensures that government and opposition will continue to represent citizens' voices, as long as citizens hold political rights to choose among the contestants. This model focuses on how elites establish new rules of the game through negotiated understandings or *pactos*. When elites respect these *pactos* that es-

tablish the process for transition as well as the subsequent outcomes of that process (such as election results), then democracy can become a legitimate regime and can be sustained over time (Torres-Rivas 1996; Macías 1996).

The crisis, transition, and consolidation literature from Latin America initially assumed that a liberal, procedural version of democracy would arise and reach a sustainable level. However, there are many possible versions of democracy, and not all transitions achieve a stable, liberal endpoint. Terry Lynn Karl (1995) spoke of the "hybrid regimes" of Central America, defined through "the uneven acquisition of the procedural requisites of democracy" and "the uneven distribution of citizenship [rights] across the national territory." These governments were not called democracies, but rather *democraduras:* quasi-consolidated quasi-democracies subject to military dominance and restrictions on rights (O'Donnell 1992, 19; Karl 1995). If the *democradura* successfully curbed military power and might become a "delegative" rather than a procedural democracy: the winning candidate assumes the presidency with the delegated power of the citizenry, allowed to govern as the traditional oligarchic strongman without institutional constraints (O'Donnell 1994). In delegative democracies, the executive holds the power and regards the legislature and the courts as impediments and nuisances, and both political and civil society abdicate their oppositional roles (O'Donnell 1994).

Another variation described by Zakaria (1997) and Smith (2005) is "illiberal" democracy: the application of executive authority to curb liberal, constitutional freedoms despite the presence of competitive elections. Smith (2005) argues that illiberal democracies are regimes that combine free and fair elections with systematic curtailments of rights and freedoms, as measured by the absence of freedom of the press, citizen protection, rule of law, and public space in which citizens may freely and safely organize for self-interested or political expression. Whether *democraduras* or delegative or illiberal democracies, one theme remains constant: these regimes were not so much stages in a transition to greater democracy but endpoints in themselves. These variants described most governments in Central America during the Cold War era, with the sole exception of Costa Rica.

THE PEACE PROCESS IN CENTRAL AMERICA, 1983–1996

The tsunami of crisis that swept across the region from the 1970s to the 1990s was another attempt to change the existing regimes

to more democratic ones. In all these Central American countries (except Costa Rica), the crisis period lasted for several decades and was marked by both high- and low-intensity conflict, economic collapse, and the widespread violation of human rights. The roots of the conflict stretched back to the semi-feudal conditions in which many people lived. The economies of Central America did not notably improve after the end of World War II, nor did people notice much relaxation of military rule. But the economic and social conditions of the poor, coupled with their lack of effective political participation, finally erupted in violence in Guatemala, Nicaragua, and El Salvador. This time, however, these manifestations were interpreted through the new lens of the Cold War. In the past, each country had often turned to its national armed forces to quell protests that originated among its own (albeit unhappy) citizens. Now, these protests were seen as instigated and supported by outside agitators (i.e., Communists), prompting elite calls for increased aid and assistance from external powers (i.e., the United States). The militaries of Central American countries grew to ever larger dimensions during this period, fueled both by augmented external aid and by their increasing participation as an economic force in society.

The civil wars that broke out in Guatemala, Nicaragua, and El Salvador were different than previous ones. Both government and antigovernment forces were being supplied by powerful interests outside the region and had more sophisticated and deadly weapons than ever before. These conflicts triggered massive population shifts as people fled or were forcibly removed from the most heavily contested territory. For the first time, large numbers of people from one conflict were spilling over into other countries. For example, thousands of rural villagers fleeing the civil war in El Salvador were housed in UN-sponsored refugee camps in Honduras. Funded by the United States, the anti-Sandinista *Contras* established bases in Honduras from which to attack Nicaragua. The involvement of powerful international forces, the addition of low-intensity conflict (LIC) to civil war, and the widespread economic effects of these clashes threatened to greatly destabilize the entire Central American region (including Honduras and Costa Rica).

The most recent attempts at a transition to peace and democratization in Central America did not begin until significant elites acknowledged that "the state of war and the state of hardship had to end" (Domínguez and Lindenberg 1997, 6). By the 1980s, this situation had drawn the attention of both local and international observ-

ers, and a consensus was emerging that something had to be done. One of the first attempts at addressing this situation was initiated by a meeting of the foreign ministers of Mexico, Panama, Colombia, and Venezuela on the island of Contadora in 1983. Various efforts were made by the Contadora group from 1983 to 1987 to address the involvement of external powers in what were seen as conflicts internal to Central American countries. Other Latin American countries as well as international bodies such as the United Nations (UN) and the Organization of American States (OAS) also supported these efforts. A number of tentative agreements were drafted, but none met with the approval of all parties, especially that of the United States (which was funding the *Contras*). Spencer (1997, 8) notes that although the Contadora process did not yield the desired results, it gave rise to a new and more open level of communication among these nations, and it started them thinking about the process of demilitarization.

The next major initiative was also a process, but one that involved the presidents of the five Central American republics (Costa Rica, El Salvador, Guatemala, Honduras, and Nicaragua) taking responsibility for ending decades of conflict, rather than falling back to reliance on foreign powers. After a meeting in Esquipulas, Guatemala, in 1987, the initiative was referred to simply as "Esquipulas" because it was both a process and a series of plans for agreements among these governments. The first plan, Esquipulas I, drew on some of the positive accomplishments of the previous Contadora process, but was intended to be seen as a home-grown, Central American product; for example, it called for the formation of a Central American Parliament. However, its appeal as a regional undertaking was somewhat undermined by its provision for a large oversight committee consisting of the Secretary General of the United Nations, the Secretary General of the Organization of American States, and the foreign ministers of both the Contadora group and the other countries that had supported it (Argentina, Brazil, Peru, and Uruguay) (Child 1992, 45).

Costa Rican President Óscar Arias took the Esquipulas I plan and returned several months later with what would become known as the Arias Plan, or Esquipulas II. This plan was comprehensive in that it called for:

- A process of national reconciliation, which includes national dialogue on justice, liberty, and democracy; amnesty for all who lay down their arms; and the establishment of a Commission of National Reconciliation to guide the process;

- Cessation of all hostilities and a ceasefire in all countries with ongoing internal conflicts;
- Adoption of pluralistic and participatory democratic processes to promote human rights, social justice, sovereignty, and the preferred social and economic model;
- Free elections, which were to take place simultaneously in all countries in 1988;
- Cessation of all [foreign] aid to revolutionary or insurgency [guerrilla] forces;
- Denial of the use of one national territory for groups hostile to another nation;
- Negotiations on security, control, limitation, and verification of weapons;
- Cooperation, democracy, and liberty for peace and development;
- International oversight and verification of compliance with these agreements; and
- An implementation timetable to begin within 90 days. (Acuerdo de Esquipulas II, Guatemala, 7 August 1987 [author's translation])

An International Commission for Verification and Follow-Up was established, but little progress was made. Esquipulas III was finally signed in 1988, calling for each party to take unilateral steps to implement the actions agreed upon, instead of waiting for all the other parties to act, and emphasizing that the major responsibility for oversight and verification lay with the Central American members of the International Commission. Bargaining elites included leaders from government as well as opposition forces, both civil and armed. Nicaragua officially ended its civil war soon afterward, in 1989; El Salvador followed in 1992; and Guatemala in 1996. Honduras was also obligated to begin to downsize its military and reestablish civilian control of both the government and the military.

The cessation of hostilities was no doubt aided by the end of the Cold War, when the interests of many international actors turned to the former Soviet republics and away from Central America. However, the same indifference resulted in a failure to produce the $6 billion promised in development aid for the region by foreign donors. The peace process played out somewhat differently in each country in terms of the number and content of agreements reached between former adversaries, but nearly all political reforms were accompanied by the imposition of strict economic reforms. Many provisions of the peace accords were not implemented in the established time frame,

or still await adoption. This crucial part of Central American history is still developing and has yet to be fully understood. In the short term, most Central Americans suffered a decline in economic conditions and an increase in daily violence in their lives; whether their lives improve in the long term remains to be seen.

GENDER

Every society has created some prescriptions for organizing the behavior of women and men as well as relationships between them. While these prescriptions are not rigidly deterministic, they are often widely accepted as a frame or lens for interpreting and predicting behavior. The system that evolved in Central America has been called *machismo,* an exaggerated maleness (sometimes known as the cult of virility) derived from the idea of the powerful conqueror (as opposed to those who were conquered). *Machismo* encompasses behavior as varied as noble defiance of destiny—or even death—and as such is characterized by "an exaggerated aggressiveness and intransigence in male-to-male interpersonal relationships, and arrogance and sexual aggression in male-to-female relationships" (Stevens 1973, 90). The definition of what makes a man (or a woman) is not fixed and unchanging but evolves over time. Thus we cannot say that all Central Americans must follow certain unbending rules of behavior prescribed by *machismo.* However, a recent study of Nicaraguan men found that the term connotes "a mixture of paternalism, aggression, systematic subordination of women, fetishism of women's bodies, and idolization of their reproductive and nurturing capacities" (Sternberg 2000, 91), and that it still influences the choices men make in their everyday lives.

A female counterpart, *marianismo,* is associated with the worship of the Virgin Mary. *Marianismo* is described as a "cult of feminine spiritual superiority, which teaches that women are semi-divine, morally superior to and spiritually stronger than men" (Stevens 1973, 91). It has also been referred to as *Guadalupismo,* an idealized version of women as virgins or mothers (Baró 1988, quoted in Sternberg 2000, 91). Women are expected to derive their identities through their male relatives—fathers, brothers, husbands, and sons—and to achieve their highest fulfillment as wives and mothers. Even nuns in Catholic orders go through a ceremony where they are symbolically married to Jesus and receive a wedding ring. But women have little control over the men in their lives, so they expect to experience suffering and

sadness in life, manifesting in attitudes of victimization and resignation (Kovel 1988, 93).

Men and women who conform to these expectations enjoy social approval; those who do not may become objects of contempt. As late as 1988, it was assumed that "the proper woman will not leave her house except to run necessary errands or to make family visits" (Levy 1988, 8). Even social activities tend to be spatially segregated by gender, with women found mostly in private spaces (e.g., homes) and men found mostly in public spaces, e.g., at work, sporting events, or bars (Elias 1988). Economic conditions that promote men's migration in search of jobs are compounded by *machismo:* men often have children with different women, leaving the responsibility for the household to fall on the woman as a *de facto* single mother.

Spanish attitudes about the proper place and treatment of women, emphasizing their docility and spirituality, accompanied the *conquistadores* to Central America. One early treatise explained that although the ideal woman was a virgin, a woman's earthly duty was to marry and have children; another recommended that married women devote at least 10 percent of their time to prayer (de Oyuela 1989, 10). These cultural attitudes interacted with the military conquest of Central America and its geographic position as a crossroads to shape how men and women related to one another. Colonial powers enslaved and forcefully relocated people of indigenous and African origin around the region. Later, national elites and international powers, as well as successive civil wars, forced massive internal and external migrations (slavery, indentured labor, seasonal work, military service, or escape from war). With so much movement, power grew to be perceived as arbitrary, authoritarian, and absolute, exercised by men.

Around the time of Central American independence, some new ideas on women emerged. Whereas the traditional view saw women as inferior, unable to learn as much as men, incapable of doing men's work, and needing protection by men, the new view assigned women and men different spheres in which to excel and reach their individual potentials. It described the woman as the jewel of the marriage, the queen of the household who efficiently administers the home, educates the children, manages the servants, and helps her husband through difficult times. This view was espoused by those who believed that women should be educated to perform better in private, not in public (de Oyuela 1989, 22). Of course, these ideas applied only to elite women, and had little relevance for the lives of the majority

of indigenous people, landless *campesinos*, or the *mestizo* working class.

Nearly every country in Central America celebrates at least one woman participant in the era that ended colonial rule. In El Salvador, Manuela Miranda was publicly flogged for participating in an early but failed attempt at independence in 1814 (Moreno 1997, 22). In Honduras, Teresa Mingo, reputed to be the *mestizo* daughter of a Spanish judge, loaned the fledgling republic the funds necessary to raise an army to fight in a border war against Nicaragua (de Oyuela 1989, 25). Francisca ("Pancha") Carrasco Jiménez became the first Costa Rican woman to participate in battle when she picked up a rifle in a fight between Costa Rica and Nicaragua (Moreno 1995, 88). But most women (like the majority of men) played minor roles, if any, in the gaining of independence.

The new Constitutions recognized that men and women could have their separate spheres of the public arena and the private home, respectively, and that women could earn respect within their own sphere, but the two spheres were clearly not equal. In law, women were treated first as wards of their fathers, then of their husbands. Women had few, if any, individual rights and could not enter into contracts without the consent of their male guardian. Women could not compete with men in the political sphere, could not vote or be elected, and were assumed to be, in fact, apolitical. Many of these Constitutions also diminished the power of the Catholic Church, about the only arena of status for women outside the home. *Marianismo* may have led women to believe they would be rewarded in the next life for their efforts in the here and now, but the balance of power in temporal terms clearly lay with the men.

There were a few women's suffrage groups during the 1920s, but most were short-lived; women did not win the right to participate in elections until the 1940s and 1950s. Voting rights were often granted by conservative elites attempting to mobilize support among middle-class women to counter growing activism among the poorer classes. The majority of women were involved outside the home only in social or church organizations. Few women were elected to national legislatures or served in other public decision-making posts until the 1960s. Even when women did win recognition of their individual legal rights, they were still considered socially inferior. Political parties would often create a "women's wing" to mobilize women in electoral campaigns but did little to promote the election of women. Some of

the first women appointed or elected to national-level posts obtained their positions by virtue of their status as the wife or widow of a male politician.

At the dawn of the 1980s, formal politics were still dominated by the values of *machismo.* Only under the Sandinista administration in Nicaragua did women have an extensive role in government, politics, and the national legislature. Until the late twentieth century, women were not perceived to be a group in the corporatist sense. They were among the unorganized masses of the state that belonged to family groups in households assumed to be headed by men. Women involved in helping rural *campesinos* win recognition of the need for land reform and aiding urban workers in their struggle for housing were not seen as having interests apart from those of their male companions. Middle-class women marching with pots and pans to protest increases in the price of electricity were perceived as representing the interests of men in the formally recognized business sector. Religious women activists had protection under the umbrella of the church as one of the pillars of the corporatist state. Women in the landed elites who formed right-wing political parties to protect private property were seen as supporting the interests of their class, not their gender. Even women participating in armed movements for national liberation, to an extent unprecedented in the western hemisphere, especially in Nicaragua and El Salvador, were not perceived as having interests as a group apart from those of the revolution.

The first women to present the possibility of women having group interests were, paradoxically, individual women, mothers, and grandmothers who encountered one another protesting the treatment of relatives who were political prisoners or who had been disappeared. Many of these women were not advocating for gender rights *per se* but rather for the human right to personal inviolability. They were calling on the state to stop using the unacceptable instruments of repression, torture, and murder against the population. And they were demanding that the state live up to its traditional practice of noninterference in family matters, especially in the home. These personal actions evolved into a much wider campaign for democratization throughout the region.

The growing awareness of the gender-based nature of some women's interests was confirmed by many international developments, such as the International Women's Year in 1975; the U.N. Decade for Women and its conferences in Mexico City, Nairobi, and Bejing; and

the growing number of international conventions addressing the status of women. One example is the Convention on the Elimination of All Forms of Discrimination Against Women (CEDAW), which requires signatories to "condemn discrimination against women in all its forms and to pursue by all appropriate means and without delay a policy of eliminating discrimination against women" (Zanotti 1980, 611). The convention calls for equal rights for women in all aspects of life, including participation in public life, to be achieved through affirmative actions such as the adoption of quotas. The shared responsibilities of men for family life should also be recognized. All the Central American nations have ratified CEDAW (the United States has not).[7] In addition, international women's groups and international aid agencies began to support Central American women. Finally, women's studies programs established in universities and Women's Offices opened by governments produced new research on how poorly women's needs in Central America had been met in the past and began to suggest that changes were overdue.

However, movements for peace and democratization in Central America were complicated by the simultaneous imposition of neoliberal economic reforms and SAPs as conditions for international financial support. This two-pronged policy demonstrated the gendered nature of democratization in Central America with the return to party politics on the one hand and to free markets on the other. The reassertion of elections as the hallmark of democracy demobilized many social movements; party politics triumphed over protest politics (Friedman 1998; Waylen 1994). Given middle- and lower-class women's high involvement with grassroots survival and popular organizations during the periods of civil war, the transition and consolidation periods presented multiple, yet contradictory, opportunities for women's groups. Should women's groups remain as autonomous (not affiliated with any political faction) entities within civil society, capable of making demands upon the state while retaining control over their own agendas? Should women's groups or individual female leaders become clients of political parties or state bureaucracies, working to articulate their objectives within political society (Molyneux 1998)? One Guatemalan activist, Nineth Montenegro of the women's Grupo de Apoyo Mutuo (GAM) [Mutual Aid Group], decided to embrace elections and democratic procedures, stating she wanted "to show that in a state of legality things [government] can work" (quoted in McCleary 1997, 138); but other women did not.

On the economic side, the choices that women and women's organizations faced were more dismal. The rollback of the welfare state affected women disproportionately to men (Chant and Craske 2003). Women remained responsible for family well-being; as male unemployment rose and formal sector jobs became scarce, women in Central America began entering the informal sector in greater numbers. As household budgets declined, women neglected their own well-being, removed female children from schools, and assumed greater workloads of household chores (Chant 1991; Craske 1999). Economic hardship forced many civically or politically active women to assume extra productive and reproductive burdens, which ultimately reduced their ability to engage with political society and/or civil society.

Learning from these experiences, women organized across country boundaries to address region-wide issues, such as violence, both on the national level from war as well as on the personal level from domestic assault. They also began to form organizations across class boundaries around their practical and economic needs for health, child care, and food, and across partisan boundaries to make demands to be recognized as a legitimate group by the state. A popular slogan developed during this era stated that women's rights were human rights, i.e., deserving of recognition as legitimate public interests of the state.

COUNTRY DIFFERENCES

Despite historical similarities, each country in Central America also has unique qualities. For example, the varied geographical features of each country and the types and numbers of its original inhabitants interacted with historical events to influence the development of each republic in distinctive ways. The following sections explore some of the differences among the five Central American nations of Costa Rica, El Salvador, Guatemala, Honduras, and Nicaragua that directly affected women's ability to become elected to the national legislature and to formulate and implement public policy.

COSTA RICA

Women have always intervened politically in Costa Rica. But it is only with the Constitution of 1949 that women were given the right to vote and to be elected. Despite the fact that women participated before 1949, they were absolutely ignored [by history]. The participation of women in every area has been so important in this country that I will tell you that the values of democracy, of peace, of dialogue have always been handled by women. In other

words, the history of this country (which is in some ways an exceptional country, compared to the rest of Latin America) owes much to the participation of women. For example, Costa Rica is an exceptional country in terms of literature, and there have been four revolutionary women in this field: Carmen Lyra, Yolanda Oreamundo, Julieta Pinto, and Carmen Naranjo. And just as there are exceptional women in this field, there are many other fields where there are outstanding women. It is women who have contributed the most to [our] culture.

CARMEN NARANJO, Costa Rican writer, 1989

GEOGRAPHY

Costa Rica lies at the southern end of the Central American isthmus, bordered on the south by Panama and on the north by Nicaragua. Two major mountain ranges cross it, one of them volcanic. Most of the population lives on the high central mesa, with its temperate climate and rich agricultural lands, well away from the coastlines. The Pacific coast is semi-arid, and the Atlantic (Caribbean) coast is wet and tropical. Costa Rica has become a pioneer in ecotourism, and it has set aside a substantial portion of its land in ecological reserves.

CONQUEST

The conquest of Costa Rica was slow because its resources were less accessible from the sea and its indigenous tribes resisted enslavement. The few colonizers who settled faced challenges in simply surviving and producing enough to eat. These early conditions gave rise to the cherished icon of the self-reliant farmer. Skirmishes with the native population discouraged overland travel and trade; coastal pirates discouraged seagoing trade. From these origins, Costa Rica developed traditions of internal egalitarianism and external isolationism, rarely participating in regional conflicts that spilled across other countries' boundaries.

ECONOMICS

After independence, rather than allocating large farms to only a few, Costa Rica allocated *minifundios* (small, family-sized plots of land) to many. Few indigenous people remained who could be forced to become migrant laborers. The small size of landholdings and the scarcity of seasonal labor led to relatively better treatment and better pay for agricultural workers than in other Central American republics. There was little foreign involvement in Costa Rica's economy until

the 1890s, when U.S. corporations built railroads and set up large banana plantations. The ups and downs of prices on the world market for export products such as coffee and bananas caused turmoil in Costa Rica but also led to political and social reforms rather than brutal repression. In the 1960s, Costa Rica's economy was more diversified than that of its neighbors, although it was saddled with a large amount of foreign debt.

POLITICS

Costa Rica may have benefited from the limited threats posed by both its neighbors, Panama to the south and Nicaragua to the north, due to their domination by the United States. The Costa Rican elections of 1889 witnessed the first peaceful transfer of government in a Central American republic between a party in power and an opposition party. Democratic elections have been held almost continuously since then, with only two interruptions for a brief dictatorship in 1917 and an even briefer civil war in 1948. Even Costa Rica's relatively few *caudillos* instituted many liberal programs, such as free and compulsory public education (in 1869).

Costa Rica's democratic crisis, transition, and consolidation unfolded earliest and represents the least bloody Central American instance of elite pact-making. By the late 1930s, increasing agitation among the popular sectors for redistributive reforms threatened the Costa Rican oligarchy. The electoral victory of reformist Rafael Ángel Calderón Guardia in 1940 resulted in legislative transformations—social security, welfare guarantees, a labor code, and a workers' Bill of Rights—that angered the traditional oligarchy but won Calderón broad support from other sectors (Rosenberg 1981, 92; Yashar 1997, 73). Calderón and his handpicked successor, Teodoro Picado, spearheaded an unlikely reform coalition of progressive elites, the Catholic Church, and the Communist Party; the urban middle class and the rural landowning classes amassed an opposition united only in its distaste for Calderón (Wilson 1989, 32). Widespread anger over Picado's redistributive tax reform, as well as charges of mismanagement and corruption within his administration, culminated in confrontation following the 1948 elections. A fraudulent vote tally ensured Calderón's victory over opposition oligarch Otilio Ulate, and protests erupted. In response, José Figueres—an opposition leader exiled in Mexico—rallied a small army and prepared to restore order. Figueres and his National Liberation Army marched on Costa Rica's capital

city of San José in 1948, quickly negotiating Calderón's surrender. Figueres and Ulate then faced a standoff: Figueres controlled the arms, but Ulate had won the popular vote. The leaders negotiated a *pacto* wherein Figueres's Partido Social Democrático [Social Democratic Party, or PSD] would rule via junta for 18 months and would then return power to Ulate. This negotiation demonstrated the elites' commitment to "the integrity of elections" and to "the substantive and procedural principles of social democracy" (Booth 1998, 49).

The near bloodless 1948 civil war in Costa Rica replaced oligarchic rule with electoral democracy, a regime based on procedures and social awareness. Elites passed the test of respecting democracy as "the only game in town": Figueres ceded power to Ulate in 1949 as promised, reconstituted the PSD into the Partido Liberación Nacional [National Liberation Party, or PLN], and won the presidency in the competitive and non-fraudulent 1953 elections. The conservative opposition won in 1958, and again Figueres peacefully ceded power. Figueres and the PSD/PLN are largely credited with consolidating democracy in Costa Rica, for several reasons. Figueres's respect for procedures in 1949 and 1958 "gave conservative political parties and elite economic interests sufficient confidence to participate in the new democratic regime" (Booth 1998, 49). The 1948–1949 and 1953–1958 Figueres administrations transformed the Costa Rican state: Figueres diversified the traditional agro-exporting sector and provided the upper classes with tax breaks (to stimulate industrialization), nationalized banks and utilities, implemented public works projects, and extended Calderón's and Picado's social reforms by increasing state spending in health, welfare, and education (Edelman 1999, 56). The 1949 Constitution created the *Tribunal Supremo Electoral* [Supreme Electoral Tribunal] (TSE) as the fourth branch of government, abolished the standing military, and extended women's suffrage (Booth 1998, 48). Rojas Bolaños (1990, 27) interprets the post-1948 pact-making "as a refoundation of the political on the base of a type of national agreement, in which the rising middle classes [represented by Figueres] negotiated with the economic sectors formerly dominant [represented by Ulate] to establish a new political system." Respect for rules, laws and public order, as well as support for a modest welfare state, are hallmarks of Costa Rican democracy (Piscopo 2002).

Although Costa Rica experienced "civil war, *golpes de estado* [coups d'état], election violence, *caudillo* rule, popular uprisings and military rule" (Holden 2004, 96), compared with the other nations in

the region it became more peaceful at an earlier point in time. Relatively speaking, Costa Rica developed the strongest democratic institutions in Central America and a tradition of respect for the law (Barker 1986, 274). The sparse population, lack of surplus funds to buy armaments, the need for all able-bodied persons to do productive work, the country's position at the southern end of Central America, early consolidation of localized fighting forces into a national army under civilian rule, and reluctance to get involved in regional conflicts all kept Costa Rica from developing the type of large military that dominated national politics in the other countries in the region (Holden 2004, 39).

This is not to say that political life in Costa Rica has been perfect. Not all citizens have been treated equally; for example, Africans brought to the eastern coast to work on building railroads and harvesting bananas were not granted full citizenship until 1952. Today, Costa Rica is nonetheless the only country in the region committed to permanent neutrality and without a standing army (although it does maintain an armed force for national defense). Thus, military careers have not provided a path to power for legislators in Costa Rica; women (as well as men) have had to seek civilian alternatives.

This emphasis on education and de-emphasis on militarism led Costa Rica to be the only Central American republic to spend more on education than on weapons (Dunkerly 1988). Costa Ricans enjoy higher educational levels, less economic and social inequality, and less political instability than other Central Americans. With a democratic culture based on norms of civility and cooperation, Costa Rica is a pluralistic state that disperses resources among many recognized groups through a large bureaucracy. No significant group recognized as legitimate in Costa Rica has been totally excluded, but neither can any one group completely monopolize every facet of power. The elite in Costa Rica have been conservative but flexible and pragmatic. This has allowed gradual change to take place while preserving stability. There is an informal, friendly tradition of rotation in power in Costa Rica, so that all interests are guaranteed a piece of the pie, if only they wait their turn (Peeler 1987).

Despite its regional isolationism, Costa Rica maintains a high level of participation in international organizations. Costa Ricans consider themselves to be leaders in the region (although other Central Americans regard them as both isolated and aloof). Costa Ricans have brought their high regard for human rights to bear in their

participation in regional initiatives. For example, former Costa Rican President Óscar Arias won the Nobel Prize for Peace for his regional peace plan. Costa Rica has ratified many U.N. Conventions on women's rights, including CEDAW. These international treaties and conventions are treated as the law of the land in Costa Rica and are taken seriously, which bodes well for women's participation in politics. In fact, Costa Rican women have seen more political success than women in other countries and, in recent years, have increasingly reached out to their Central American sisters.

GENDER

Costa Rica was unique in using revenues from export crops to fund a free, universal, and compulsory public education system for both boys and girls beginning in 1869. These schools reduced the control of the Catholic Church over education and promoted an educated citizenry as essential for both economic and democratic development (Nelson 1983). Girls were included because Costa Ricans needed every citizen to contribute to national development. Diminution of the influence of the Catholic Church coupled with strong norms of egalitarianism helped attenuate the effects of *machismo* in Costa Rica. For example, Manuela Escalante argued successfully in the 1850s that guarantees of equality in the Constitution allowed her to study traditional men's fields in the university (Rivera Bustamante 1981). Despite their regional isolation, many Costa Ricans (including women) went abroad for higher education, which continually exposed them to new ideas.

Women were important participants in strengthening democracy throughout Costa Rican history, especially in their role as the majority of school teachers. Women participated in the overthrow of the Hugo Tinoco dictatorship in 1919. For example, María Isabel Carvajal (better known as "Carmen Lyra") organized the burning of the offices of a newspaper rather than have it fall into the dictator's hands. One of the first feminist groups in Central America, the *Liga Feminista*, formed in Costa Rica in 1923, repeatedly urged the national legislature to adopt women's suffrage. Eight thousand women staged a pray-in to resolve an electoral stalemate in 1948 (Moreno 1995).

Women also organized within the major Costa Rican political parties. After winning the vote in 1949, women made swift gains, being elected to the national legislature in 1953, appointed to judgeships by 1956 and to government ministries by 1958, named as governor of a province and appointed as ambassador by 1970, and elected

vice-president in 1986. Women in universities and schools; in ecumenical, professional, and non-governmental organizations; in government bureaucracies; and in community groups have all developed a strong presence on the Costa Rican political scene. Women participated in campaigns for land reform and urban housing in the 1960s and in demonstrations against high electricity prices and against opening a Soviet embassy in the 1980s. In the 1990s, they became active in region-wide campaigns against violence and for the recognition of women's rights as human rights. Most recently, Costa Rica became the first Central American nation to adopt formal quotas for women's political participation in 1996.

EL SALVADOR
The history of El Salvador is a history of repression, discrimination, violence . . .
CANDELARIA NAVAS, author, El Salvador, 1993

GEOGRAPHY
El Salvador is the smallest and most densely populated of the Central American republics. It is the only country that does not span the entire isthmus, but the coastline on its Pacific Ocean side has miles of white, sandy beaches. Several mountain ranges divide the country into valleys and plains, where volcanoes have created fertile soil. The higher elevations are covered with rain forests and cloud forests, while the lower elevations support rich croplands.

CONQUEST
The Spanish *conquistadores* were at first defeated by the numerous Pipil Indians but subsequently gained control. The Spanish colonial administration started the practice of growing agricultural crops (cacao and indigo) for export rather than for domestic consumption (CIAO 1988). When all the other Central American countries declared their independence from Spain and formed a union in 1821, El Salvador instead petitioned the U.S. government for statehood (U.S. Department of State 1999). Denied statehood, El Salvador joined the Central American federation.

ECONOMY
Land was even more valuable in densely populated El Salvador than in the other countries in the region. The small elite of European or-

igin continued the colonial practice of confiscating the communal plots that indigenous people and poor *mestizos* used to grow subsistence crops and using those displaced as forced labor. The elite (sometimes referred to as the "Fourteen Families," although larger in actual numbers) introduced the cultivation of coffee, using the military to put down any resistance.

At independence, the elites in El Salvador adopted the plans for expanded markets and trade that were characteristic of the Liberal parties in Central America (CIAO 1988). Unlike the other countries in this region, there was little foreign involvement in the economy of El Salvador. The landed classes developed the country's infrastructure and industries with little need of foreign capital. This also gave them a measure of independence from the United States (Holden 2004). Elite women played important roles among the 1 percent of the population that owned over two-thirds of the land (Anderson 1982).

Among the dispossessed, men migrated for seasonal agricultural work while women and children remained behind. In a rich agricultural country, most Salvadorans had one of the lowest caloric intakes in Central America. These harsh conditions periodically erupted in protests that were quelled by the armed forces, as early as 1833. Nearly 100 years later, workers' wages were cut in half after a fall in the price of coffee on the world market. An uprising led by Augustín Farbundo Martí in 1932 caused few initial deaths, but the reprisals by the military killed tens of thousands of *campesinos,* mostly of indigenous or mixed heritage (CIAO 1988). The elite adopted a policy of systematic military repression to prevent another revolt, rather than offering improved conditions. Similar patterns developed with the elite's modernization programs and the urban poor. The scarcity of land and jobs led many Salvadoran peasants to occupy land illegally over the border in Honduras. Their expulsion led to the brief "Soccer War" between the two countries in 1969 and again increased pressure on El Salvador for land reform.

After the end of the 12-year civil war in 1992, the demobilization of thousands of government security forces as well as former guerrillas swelled the ranks of the unemployed. Land distribution to former combatants was not followed up with the lines of credit and technical assistance necessary for success. The United States was also deporting native Salvadoran gang members from urban areas such as Los Angeles back to El Salvador, which increased the violence of everyday

life. Kidnapping of middle- and upper-class businessmen for ransom was so common that most drivers in the capital, San Salvador, would not stop for red lights after dark.[8]

POLITICS

Salvadoran elites and the military developed a symbiotic relationship, with the former controlling the economy and the latter controlling the government (Krennerich 1993). The military intervened in 1931, taking over the executive branch to manage an economic crisis and then continuing to maintain political control. For 50 years, political power alternated among various military factions (U.S. Department of State 1999). Under international pressure to democratize, El Salvador progressed from a virtual one-party state in the 1930s and 1940s to allowing other political parties to take part in electoral contests, but the opposition was seldom allowed to win (Ameringer 1992). During the mid-twentieth century, military administrations pursued some redistributive reforms in urban areas (following the Costa Rican model of agro-export diversification and social welfare investments), but socioeconomic development remained limited and political expression remained restricted (Bird and Williams 2000, 28–29). Both military and civilian moderates who attempted to introduce gradual changes such as land reform were often overthrown by the conservatives who wanted to preserve the status quo. Even right-of-center Christian Democrats were perceived as too radical; their electoral win in 1972 was canceled by a military takeover.

The combination of economic deprivation and lack of political outlets for redress led not only to polarization of both the right and the left, but eventually to the creation of groups outside the traditional political system on both sides (Krennerich 1993). Proposed land reforms in 1976 led to the creation of the right-wing ARENA political party (*Alianza Republicana Nacionalista* [Nationalist Republican Alliance]), led by hardliner Major Roberto D'Aubuissón Arrieta, who was alleged to be involved in death squad activities. Armed insurgent groups also began to form on the left. Moderates lost control of the far left and far right ends of the political spectrum over disagreements about reforms for solving social and economic problems (Kurian 1998). A moderate ruling junta was overthrown in 1979, again over the issue of land reform. A military coup replaced old guard officers with a military-civilian junta in an attempt to rein in death squad activities and forestall a civil war. But in 1980, the popular Archbishop Óscar

Romero was assassinated while saying Mass in San Salvador's main cathedral, and four U.S. churchwomen were kidnapped, raped, murdered, and mutilated by government soldiers. These events violated the state's part of the implied bargain under corporatism: to keep the peace among warring factions, to stay out of the organized sectors, and to respect the private homes and physical integrity of citizens.

In this context, armed insurrection became a viable alternative. In 1980, several armed groups united as the FMLN (*Frente Farabundo Martí para la Liberación Nacional* [Farabundo Martí Front for National Liberation]) and launched into a civil war against the Salvadoran state. For most of the 12-year civil war, the Salvadoran military government carried on a counterinsurgency campaign of terror as well as rounds of negotiations and bargaining over new constitutional and electoral rules (Bird and Williams 2000, 30). This paradoxical combination of procedural democracy (commitments to elections in 1982 and the election of a Constituent Assembly in 1984) with low-intensity warfare continued during the 1980s. *Pactos* between military leaders and traditional civilian elites over the distribution of political power (formation of political parties, administration of government agencies) dominated the entire decade (Walter and Williams 1993).

The countryside was the locus of a battle between the FMLN guerrillas and the military government to control the hearts and minds of the *campesinos*. The FMLN attempted to bring participatory democracy to the rural territories under its control, delivering agrarian reforms and social services to these areas and organizing citizens into community groups. The government responded with its own rural development strategies, using USAID (U.S. Agency for International Development) monies to establish rural civic action programs that brought public works programs into rural communities while permitting military surveillance and control of the communities' activities (Stahler-Sholk 1994). The government trained thousands of peasants in counterinsurgency operations, using obligatory service to forcibly create rural paramilitary forces that militarized the countryside and compelled neighbors to monitor and sanction each other (CIAO 1988). International reports later verified many massacres (e.g., *El Mozote*) by the military of peasants who were suspected FMLN supporters.

The space for autonomous civil society organizing was limited due to widespread fear of government (or, to a lesser extent, FMLN) retaliation. During the war years, elections were routinely held for the presidency and the national legislature, but they were problematic, to

say the least. The only recognized political actors were the far-right and center-right political parties and the military (Bird and Williams 2000, 32–33). Rural populations remained completely marginalized from a series of nominally democratic elections between 1982 and 1991; fear and terror kept the popular sectors from speaking and voting. Nonetheless, women's groups, Christian base communities (CEBs), and neighborhood associations managed limited, small-scale protests against the war (Walter and Williams 1993, 57). U.S. President Jimmy Carter cut off all military aid over concern for human rights in 1980, but President Ronald Reagan restored it in 1981.

The push for a democratic transition in El Salvador began in earnest in the late 1980s, when both the government and the FMLN realized that neither could win through military means. Peace talks began in 1986, but violence continued; in 1989, six Jesuit priests who taught at the university were murdered. The January 1992 peace agreement (Chapultec Accords) between the rightist ARENA government of Alfredo Cristiani and the FMLN represented important lessons in the cooperative dialogues that underpin procedural democracy (Karl 1992), even though they had little civil society participation. The Chapultec Accords entailed a ceasefire, reduction of the armed forces, creation of a civilian police force, establishment of an attorney general for human rights, formation of an international truth commission led by the U.N., and demobilization of the FMLN and its reconstitution into a political party. Essentially, the military ceded to electoral democracy while the FMLN ceded to neoliberal market economics (Silber 2004, 569).

Another significant provision of the peace accords created a civic forum for widespread dialogue on economic and social issues via the *Comisión Nacional para la Consolidación de la Paz* (COPAZ) [National Commission for the Consolidation of Peace]. This forum, an "epitome of political engineering" among elites (Karl 1992, 160), established policy task forces composed of one government representative, one FMLN representative, and one representative each from the six leading political parties. The policy task forces built consensus among key political actors on needed legislative reforms. Operational from 1992 to 1995, COPAZ helped "expand the political community committed to the accords and encourage the habit of compromise begun in the peace negotiations" (Karl 1992, 161). However, the peace accords generally and COPAZ specifically located all discussions of socioeconomic inequities within the restricted realm of the political sphere, dampening the

enthusiasm for democracy within civil society and limiting citizens' participation in these processes (IRIPAZ 1991). Nonetheless, the government and the FMLN made eloquent statements about the populist nature of the accords. An FMLN commander announced that "from now on the entire nation will be the protagonist in its own transformation," and President Cristiani stated that "democracy now belongs to everyone" (quoted in Best and Hussey 1996).

Yet the formal end of the war in 1992 did not mean the end of violence. A number of candidates for office were assassinated, including several ex-FMLN guerrilla leaders. The 1993 report by the Commission on the Truth for El Salvador placed the blame for 95 percent of deaths and disappearances on the government military and paramilitary forces (Commission on the Truth, 1993). Death squads continued, targeting especially youth gangs and street children. Precisely how democracy in El Salvador would spread from political society to incorporate civil society and to bring about peace, economic development, and social justice still remained unclear in the mid-1990s.

GENDER

Elsa Moreno (1997, Chapter 1) has documented the historical context of women's participation in politics in El Salvador. Women's voices—especially those of the non-elite classes—were historically ignored. In 1902, Victoria M. de Fortín, writing under the pseudonym "Olympia," called (in vain) for women to have the same civil and political rights as men in El Salvador. In 1922, after a peaceful women's demonstration for electoral reform was shattered by gunfire, most women's organizations dispersed or went underground. As women were not allowed in the military, they were excluded from this traditional path to political power. In 1930, Doña Prudencia Ayala demanded to be allowed to exercise the right to citizenship and to vote, extended by the Constitution to "Los Salvadoreños," but the term was interpreted by the courts to include only men. In 1939, women were made eligible to vote, but the necessary changes in electoral law were not adopted. It was not until 1950 that women were allowed to vote and a free public education system was established that included girls; in 1961, women were allowed to be elected for the first time. The vote came about not because of a strong women's suffrage movement, but rather from the desire of different political factions to capture women's interest and energy for electoral campaigns. After gaining the vote, it took

11 years for a woman to be elected to the national legislature, in 1961, and 39 years before the appointment of the first woman minister, in 1989 (Moreno 1997, 11).

During much of El Salvador's history, there was little participation in formal politics by women who supported the government, either as voters or as candidates, and there were few legitimate opportunities for women to express opposition to the government. Many women were *de facto* heads of household as men migrated for seasonal agricultural work or were recruited into (or fled from) military service. With very few available channels for pursuing claims against the state, women learned how to organize in private spaces, such as the home or church. At first there was very little contact among women of different classes or different political parties: those from unions, human rights or student groups, and Christian base communities (CEBs) supported the left, while those from the landowning and business elites supported the right. But they all put the civil war first, and women's issues second. This, along with a state policy of gendered repression and terror, frustrated the emergence of a strong women's movement. A turning point came when, despite widespread poverty, the government spent over $1 million to host the 1975 Miss Universe contest. Police killed three dozen protesters, who said the money could be better spent on food and who opposed the blatant objectification of women.

The eruption of the civil war changed the lives of many women in El Salvador. Some women joined the revolutionary forces and were assigned support tasks considered women's work, such as cooking, radio communications, and public relations, but others participated in armed combat and rose to relatively high positions of leadership. Some rural women did not formally enlist but supported the revolutionary forces by providing food, offering shelter, and completing other tasks. Some urban women met with international delegates, raised funds, or worked to bring news of the revolution to marginalized groups; others carried out urban guerrilla warfare. In 1977, a group of mothers of political prisoners and disappeared youth formed COMADRES.[9] Other women opposed the revolutionary forces by forming countervailing political parties or supporting government initiatives. Nearly all these women experienced a rupture in their normal roles of woman-wife-mother, and all were legitimate targets in the low-intensity war in El Salvador. The FMLN attracted an unprecedented number of women to its forces; in turn, the government

of El Salvador developed the systematic use of gendered violence and terror against women (Aron et al. 1991). At first, many women who put aside obligations of marriage, children, and family to become involved put solving the conflict as their top (or only) priority. However, as a result of their involvement, they began to acquire a new political consciousness; many would ultimately develop gender consciousness as well. With a new awareness of gender issues, things such as domestic violence and working conditions for women, especially in foreign-owned factories, were publicly denounced. Women in the national legislature began working across party lines to promote legislation on issues concerning women and children.

GUATEMALA

In the independence era, the republican system [of government] was adopted, a purely Western system. This system has been functioning, but it has developed autocratically. The Guatemalan system copied the North American presidential system, but with concentrated power in the executive branch. And that converted our country into a long chain of very hard dictatorships. Our country finished the nineteenth century with a 30-year dictatorship, where the president fell in love with the office. And the twentieth century dawned with a 22-year dictatorship . . .

JOSÉ LOBO DUBÓN, President of Congress, Guatemala, 1993

GEOGRAPHY

Guatemala has the largest total population, as well as the largest surviving indigenous population. It has several distinct climates, such as the hot Atlantic (Caribbean) lowlands and the fertile Pacific Ocean plains, as well as the Petén in the north, an internationally recognized tropical bio-reserve. The central highlands, with volcanic peaks and deep valleys, offer a bracing climate known as "eternal spring."

CONQUEST

At the time of conquest, a large number of indigenous peoples lived in Guatemala, descendents of the Maya who put principles of architecture, math, and astronomy to work in building great temples and cities. Perhaps because of the remoteness and ruggedness of the Guatemalan terrain where many of the Maya lived, or their very large numbers in relation to Europeans at the time of the conquest, or perhaps because the cultural heritage of the Maya was very old and strongly rooted, more of the indigenous population survived, and

with their culture more intact in Guatemala than in any other Central American country. Over 20 dialects of Mayan and other ancient languages are still spoken in the Guatemalan highlands. Indigenous peoples today form about half of the population (although their total numbers may not be accurately estimated).[10] They are the most impoverished group, the most likely to be illiterate, and the most rural. Much of Guatemalan history revolves around nearly 500 years of attempts by settlers to either assimilate or annihilate this native population.

ECONOMICS

At independence, elites took over lands from both indigenous communities and the Catholic Church to create a market economy. Unlike Costa Rica and El Salvador, foreign interests were allowed to gain control of valuable resources. Bananas and other fruit, which accounted for 90 percent of exports, were controlled by a U.S. company, United Fruit. Coffee was initially controlled by German firms, but their lands were nationalized during World War II. To ensure an adequate labor supply, indigenous people were subjected to forced labor laws that required them to work for large landowners, in foreign-owned enclaves, or on public projects to benefit the economy, such as road building (Kantor 1969). As in El Salvador, worsening conditions would stimulate the poor to seek redress for social inequalities and economic injustices. The elite, opposed to even small reforms, would call upon the military to reassert the status quo. Intensified repression would lead to the buildup of stronger pressures for reform and continue the cycle.

In later years, the Guatemalan military became one of the country's largest economic powers and began to use the tools of intimidation, terror, and repression against its economic rivals. The civilian elite balked at paying ever-increasing taxes to support the military's prosecution of the civil war and opposed the military's plans to develop the protected Petén region. The military's use of terror also limited Guatemala's ability to attract international aid, which further reduced its economic output, and further exacerbated the miserable conditions of the least well off and their demands for reforms. At the same time, Guatemala was spending more of its annual budget on arms and less on social services, maintaining a larger armed force than any other Central American country (Holden 2004). After the peace accords

were signed in 1996, the extent of military involvement in the economy began to be exposed in a series of corruption scandals.

POLITICS

The first years of independence were marked by competition for power between the Liberals and Conservatives that excluded the majority of Guatemalans—indigenous natives, the landless *campesinos*, and poor *mestizos*. As the quotation beginning this section notes, Guatemala was often ruled by military dictators, whose accessions to power were accomplished by force or sham elections (Kantor 1969). Most Guatemalans had few legitimate outlets for expressing their interests and had little experience with Western-style government, democracy, or politics. The numerical majority of Guatemalans of Mayan descent were never accepted, accommodated, or absorbed by the Hispanic culture of the white and *mestizo* (or *ladino*) minority that controlled the political, economic, and social realms. This left Guatemala without a unifying national identity. While indigenous people achieved some rights on paper, in practice their treatment was more akin to that of blacks in the Jim Crow era in the southern United States (if not the apartheid era in South Africa).

The United States more strongly supported the military and police forces in Guatemala than in any other Central American country. The Guatemalan military used the threat of communism not only to obtain weapons and other resources from the United States, but to do so while rejecting demands for accountability on human rights (Holden 2004, 150, n73). Guatemalan society was further polarized after World War II into pro- and anti-reform factions, where reform was equated with communism. Beginning in 1944, for a brief 10-year period, some progressive elements of the military and middle class attempted to introduce reforms, such as banning forced labor and giving most women the right to vote in 1945. In 1954, a proposed land reform program would have taken land from United Fruit in return for compensation. This provoked a military overthrow of the government with assistance from the United States Central Intelligence Agency (CIA), which had compiled a list of 58 Guatemalan leaders to be assassinated (Holden 2004, 141). The Guatemalan military assumed power and controlled the executive apparatus until 1986. The United States also sent advisors to train Guatemalan military and police forces in counterinsurgency methods beginning in 1956

(Holden 2004, 151). In return, Guatemala allowed its territory to be used for training ex-Cubans for the Bay of Pigs invasion. As the most powerful group in Guatemala, the military furnished presidents who declared states of siege, suspended Constitutions, dissolved national legislatures, and presided over widespread violations of human rights. Normal electoral politics remained absent during these decades.

As in El Salvador, the government was dominated by a military-elite coalition to which a guerrilla insurgency became the only alternative (Jonas and Walker 2000). In 1960, a small group of disaffected army officers left the military to begin the longest-running civil war in Central America, which was carried on for 36 years by the URNG (*Unidad Revolucionaria Nacional Guatemalteca* [Guatemalan National Revolutionary Unity]), an umbrella for four insurgency groups.

During the 1970s, the Guatemalan military collaborated with civilian elites in a "politico-military co-governance project" that unleashed terror, repression, and violence in the countryside (Schirmer 1999). Violence was the principal mechanism employed by the Guatemalan military to express and maintain power (May 1999), as well as by the opposition insurgents. The Guatemalan military trained thousands of rural indigenous groups to use counterinsurgency tactics and weapons. Government policies were referred to as "scorched earth" (Jonas 1999, 2) or the Vietnamization of Guatemala, and resulted in massive destruction of indigenous villages in the highlands, forced relocations, and floods of refugees. The government employed right-wing death squads to repress any dissent from their policies and programs. Civil society had only the traditional routes of *denuncia* [denouncing crimes] or *amparo* [claiming constitutional rights] or turning to strikes to express grievances over incomplete agrarian reform and economic inequality (Jonas and Walker 2000).

The period of greatest repression occurred during the administration of General Efraín Ríos Montt, who initiated a government-led holocaust against the insurgents from 1982–1983. Entire towns in the (mostly indigenous) countryside were massacred by government forces for merely being impoverished, a status that implicated these communities as insurgent sympathizers. A later study found that over 200,000 people had died and 50,000 had disappeared, with the government responsible for 93 percent of the deaths (CEH 1999). In urban areas, entire political party executive committees were "disappeared," along with labor organizers, activist priests, university

professors, and students. Most of the officially sanctioned political parties differed little in ideology, and all supported the military and the economic status quo. Any party or other group that did not was either declared illegal or repressed by paramilitary death squads. For example, government forces assaulted and burned the Spanish embassy, killing most of the protesters who had taken refuge there, including the father of future Nobel Peace Prize winner Rigoberta Menchú. These harsh tactics polarized public opinion and prevented the formation of any centrist political organizations.

By the mid-1980s, the URNG accepted the impossibility of total military victory over the Guatemalan military state (Jonas and Walker 2000, 16). Simultaneously, the Guatemalan government recognized that its counterinsurgency brutality had both exceeded its legal authority and damaged the public legitimacy of the state (Jonas and Walker 2000, 15). Facing an impending political and economic crisis, the military initiated a liberalization process beginning with the 1984 Constituent Assembly and elections for the national legislature in 1985. Yet final peace accords would not be signed until 1996.

This liberalization was an elite-led, top-down process that incorporated only the most significant actors (Sieder 2002; Jonas 2000). Leftist parties were excluded from participating in the 1984 Constituent Assembly and the 1985 elections; only those rightist and center-right parties that made individual bargains with the military government received permission to contend for seats in the elections (Jonas and Walker 2000, 11). The 1985 Constitution protected the military's security prerogatives, defining citizens' political and civil rights as conditional upon the military's perception that internal security remained unthreatened (Schirmer 1999). The popular organizations within civil society—active in campaigning against the terror and in bolstering community ties during the genocide—received no representation and no voice in this process. While not fraudulent, the 1985 elections underrepresented large sectors of the population because only military-endorsed political parties could participate. Civil society played almost no role in the liberalization of Guatemala in the mid-1980s (Torres-Rivas 1996), which Jonas and Walker (2000, 11) describe as a "façade of constitutional democracy."

The election of Christian Democrat President Vinicio Cerezo Arévalo (1986–1990) prompted the URNG to open peace negotiations, but the Cerezo administration stubbornly refused the URNG's rapprochement, insisting that the guerrillas must first lay down their

arms. The Catholic Church then intervened and hosted a series of national dialogues between representatives of the URNG, the legally recognized political parties (mostly center-right), the business sector, religious organizations and, finally, in 1990, the government and the military (Jonas and Walker 2000, 16).

The next civilian president, Jorge Serrano, assumed office in 1991 and initiated secret negotiations between senior government officials, military leaders, and URNG delegates. From 1991 to 1992, these elites negotiated *pactos* providing for demobilization, democratization, and human rights. With the exception of the powerful *Comité Coordinador de Asociaciones Agrícolas, Comerciales, Industriales y Financieras* (CACIF) [Coordinating Committee of Agricultural, Commercial, Industrial, and Financial Associations], which represented the business elites during the Church-sponsored negotiations, almost no civil society organizations (and particularly no indigenous organizations) participated in these dialogues (Krujit 2000). All peace negotiations broke down in 1993, when Serrano attempted to consolidate his power by closing down the legislature and the government. However, this threat to the process of democratization galvanized civil society into peaceful protests. When these protests were not violently repressed by the military, the popular sectors became more powerful and more vocal proponents of democracy.

Following the replacement of Serrano with human rights ombudsman Ramiro de León Carpio, peace talks resumed in January 1994. Talks were this time conducted more transparently and moderated by the United Nations. This second attempt at democratic transition also marked a shift from exclusive elite *pactos* to broad-based societal agreements (Jonas 2000). Civil society entered the peace process through the vehicle of the *Asamblea de la Sociedad Civil* (ASC) [Assembly of Civil Society]. Composed of over 120 civil associations (Krujit 2000, 23), the ASC and its sectors (including representatives of indigenous peoples and women) received seats at the bargaining table. The ASC thus became a "vehicle for popular participation in the peace process," reflecting both citizen acceptance of democratic procedures and citizen participation in democratization (Jonas and Walker 2000, 18).

After six years of negotiations, the civil war was winding down; the army began to downsize and to be brought under civilian control. The URNG reconstituted itself as a political party, the *Frente Democrática Nacional Guatemalteca* (FDNG) [National Democratic

Front of Guatemala], and leftist organizations began working with the FDNG to develop policy platforms.

While the final peace accords in 1996 established a national vision of democracy as participatory and with social equity (Jonas 2000), Guatemala remained an illiberal democracy, or *democradura*, in the mid-1990s (Schirmer 1999). With high unemployment, thousands of demobilized military, paramilitary, and guerrilla fighters, and the widespread presence of weapons, everyday violence increased precipitously in Guatemala, especially against street children. Some groups, especially in rural areas, took the administration of justice into their own hands, resulting in the lynching deaths of accused or suspected criminals (Amnesty International 2002).

The challenges for Guatemala remain profound. At the close of the 1990s, it still lacked "democratic reference points" (Walker and Williams 1993, 40). To be viable, democracy in Guatemala (as well as in its neighbors) must address the social grievances that underpinned decades of conflict (Stahler-Sholk 1994; Karl 1995; Torres-Rivas 1996; Sieder 2002).

GENDER

The majority of the population in Guatemala traces its heritage back to Mayan culture, which had female along with male deities as well as a different concept of gender relations. Women and men were not seen as polar opposites but as two complementary parts of a whole. They traditionally performed different tasks, but both were seen as necessary for survival as well as for harmony and equilibrium. It fell to women to transmit Mayan cultural heritage from generation to generation, for which they were esteemed and protected. However, little of this paradigm of gender relations was absorbed into Spanish social or political culture.

There is scant documentation of the early history of women in the eras of conquest or colonialism in Guatemala. The majority of ethnic Mayan women were poor, and many participated in seasonal migrant labor, although their wages were usually paid to the father or husband. *Ladina* women (Mayan women who adopted Spanish language and culture) or *mestiza* women (of mixed ethnic backgrounds) were also mostly poor. Many women were left as *de facto* heads of household while the men were indentured, obliged to serve in the military, fled the country, or were killed. Women obtained the vote through the adoption of a new Constitution during the reform era that also ushered

in other modernizations, rather than from a sustained campaign for suffrage. After receiving the vote in 1945, few women were elected to the national legislature or other representative bodies; the first woman government minister was not appointed until 1983. Fewer Guatemalan women were elected as city councilors, mayors, or governors (especially in rural areas), or appointed to high government posts or the judiciary, than women in other Central American countries.

The story of the participation of women in formal or informal politics during the 36-year civil war that followed the end of the reform era is still to be told. One insight was offered by Rigoberta Menchú (1984), who won the Nobel Peace Prize in 1992 for her activism on behalf of indigenous rights. Much of what women did was not widely known because of the Guatemalan government's notorious use of state terror against its own population, including gender-specific terror (Aron et al. 1991). For example, a group of women who encountered each other at the Guatemala City morgue searching for the bodies of their loved ones founded GAM (*Grupo de Apoyo Mutuo* [Mutual Aid Group]) in 1984. Widows in the indigenous highlands formed CONAVIGUA (*Coordinadora Nacional de Viudas de Guatemala* [National Coordinating Committee of Guatemalan Widows]) in 1988 to protest murders by the armed forces. Groups such as these became targets for state terror, since the mere formation of these women's support groups was denounced by the Guatemalan military as an act of subversion; nevertheless, the women persevered. The formal peace agreement in 1996 did not put an end to violence. An Amnesty International report in 2005 revealed that over 1,188 Guatemalan women and girls had been murdered in just the past four years. The report noted that the murders were accompanied by "exceptional cruelty and sexual violence . . . including signs of rape, torture, mutilation or dismemberment."

HONDURAS

In the independence period, women's education regressed, since education for women was considered to be an "adornment." For 70 years, women were completely excluded from formal education. From the legal point of view, a woman was the property of her father or her husband; a woman could not exercise rights or ownership by herself. In that period of instability, women were humiliated, direct victims of the injustice of political factions.

DE OYUELA 1989, 26–27

GEOGRAPHY

The interior of Honduras is divided by steep mountain ranges into small, isolated valleys not hospitable to agriculture. The tropical coasts on both the Pacific and Atlantic (Caribbean) sides have long been involved in large plantations of export crops. More than half the population is still rural, and few have ever traveled far from their homes, as the topography makes the construction and maintenance of roads difficult. Even in the 1980s, remote areas were still often dominated by local strongmen, elite landowners who sometimes gave themselves the honorary title of "colonel."

CONQUEST

Honduras was claimed by Columbus in 1504. Little is known about the indigenous inhabitants, whose population dwindled under harsh treatment and exportation as slaves (CIAO 1993a). European settlers were not numerous but often squabbled over control of the land. Honduras's main cities were not on the major north-south trade routes through the region. Most of the early work of development, such as establishing schools and hospitals, was carried out by the Catholic Church rather than by a central government.

ECONOMICS

Throughout the colonial years and at the dawn of independence, Honduras was desperately poor; not much changed over the ensuing years. The territory was divided into *encomiendas* that gave settlers control over both the land and its native population. Settlers were entitled to indigenous labor in exchange for providing religious instruction. Abuse of this relationship led to an uprising in 1537 by an indigenous chief Lempira that was put down in 1539 (CIAO 1993a). Gold and silver mines were soon exhausted, and coffee cultivation failed to thrive; only cattle ranching succeeded in producing beef for export.

The extreme poverty of the population, its isolation in remote valleys, and the difficulty of travel combined to produce few of the mass uprisings seen in other Central American republics. Rather, there were constant fights between elite families and their private armed forces for domination. Those who controlled the government could raise money by selling, leasing, or giving away large tracts of land or mineral rights to foreign companies, but often the terms were unfa-

vorable to Honduras (tax exemptions, few restrictions, long leases at cheap prices, etc.). For example, land was granted to foreign companies in exchange for building railroads, but the railroads connected only plantations and ports, not major cities or other Central American countries. In 1974, an export tax was adopted but not implemented.

Honduras produced one-third of the world supply of bananas in the 1930s (CIAO 1993a), but the foreign-owned plantations invested little in the country. Workers organized a strike against the U.S.-owned company United Fruit in 1954 for better working conditions. Landless Salvadorans occupied some of Honduras in the 1960s to grow subsistence crops; their expulsion led to a brief war between the two countries. In 1990, Honduras was concerned that the disbanded *Contras* would stay in Honduras, exacerbating the already high unemployment and poverty rates. In 1998, Transparency International listed Honduras as one of the five most corrupt countries in the world. Honduras has been so poor for so long that international lenders recently forgave much of its foreign debt.

POLITICS

Honduras holds the regional record for having the most changes in government and the most constitutional revisions. One reason is that Honduras was a target of interference by both regional and international powers. Other Central American countries intervened in the struggles between the Honduran versions of the Liberal and Conservative parties. British forces briefly claimed part of the northern Caribbean coast as British Honduras (which later became the country of Belize). The United States invaded several times to protect U.S. citizens and corporations. At times U.S.-owned corporations appeared to have more power over the country than did the official government.

Another reason is that politics in Honduras was extremely personalistic, using a feud or vendetta approach to politics. *Caudillos* (also called *caciques*) gathered devoted and armed supporters to take over the presidency. Winners often outlawed the losing party; losers then appealed to neighboring countries (or corporations or foreign powers) to intervene and promote them to power. This pattern also served to retard the development of a central state. Patronage was so widespread that judges on the Supreme Court were removed by each new head of government and replaced with others more supportive of the winning party.

For many years there was little in the way of a national state or

military. From 1932 to 1949, a right-wing dictatorship made progress in centralizing the state and consolidating the military. By 1956 the untrained armed bands of individual *caudillos* gave way to a more professional military with the help of training from the United States (Holden 2004). By 1957, the military had the constitution amended to remove them from any civilian control; the armed forces were also given complete control over their administration and budget. Members of the military were exempt from civil law and subject only to military discipline for their actions.

U.S. military aid to Honduras increased greatly during the Cold War; in exchange, Honduras allowed the United States to use its territory for launching the Bay of Pigs invasion of Cuba, for housing the anti-Sandinista *Contras,* and for training U.S. National Guard units. Large military installations were constructed by the United States in Honduras during the 1980s for the latter purpose. The Honduran military became a key player in the economy, with *de facto* control of the government from the 1960s to the 1980s (Ruhl 2000, 49–51). Members of the military were accused of involvement in drug trafficking in the 1980s but were not prosecuted, due to impunity.

Although the military rulers in Honduras engaged in periodic campaigns to suppress popular, peasant, and working-class organizing, some viewed the Honduran military as more accommodating and less confrontational than the repressive militaries in Guatemala and El Salvador (Walker and Armony 2000, xx). Indeed, the briefly tenured civilian president from 1971 to 1972 was deposed for failing to enact the military's desired agrarian reforms (Ruhl 2000, 50). In the early 1970s, the military regime pursued some populist policies and demonstrated tendencies of inclusion: the military permitted limited but significant organizing in civil society, redistributed land to peasants, and maintained dialogues with civilian elites and popular groups (Sieder 1995).

By the late 1970s and early 1980s, however, regional developments eroded this tolerance. The Honduran armed forces supported the Somoza dictatorship in Nicaragua; fearing internal instability and bolstered by financial assistance from the United States, the military began repressing dissidents and shutting down state-society communication networks. Despite the lack of economic development and the dearth of civic space, no large anti-government revolutionary force developed in Honduras as it had in the other countries. The rugged terrain, isolation, and extreme poverty were factors, and some

potential opponents may have been co-opted in the 1970s and 1980s (Sieder 2002; Walker and Armory 2000). It could be argued that the small-scale, loosely organized guerrilla movements in Honduras never presented a credible threat to the Honduran state; nevertheless, the Honduran military launched a "dirty war" (counterinsurgency campaign), reversing the country's tradition of accommodation (Ruhl 2000). Little official documentation of those abuses exists, but a number of human rights organizations in Honduras were formed, including Comité de Familiares de Detenidos-Desaparecidos en Honduras (COFADEH) [Committee of Families of Detained-Disappeared Hondurans] and Movimiento de Mujeres por la Paz *"Visitación Padilla"* [Women's Peace Movement *"Visitación Padilla"*].

In the 1980s, Honduras approximated the classical definition of a *democradura:* civilian presidents who permitted fraud and corruption and rights-less citizens who remained suborned to military authority (Ruhl 2000, 54–55). For years, the only two legalized parties had colluded on a formula for splitting the seats in the national legislature between themselves (Taylor-Robinson and Sky 2002, 16; Ruhl 2000, 54). These presidents permitted the military to manage external and internal security, allowed drugs and arms trafficking (often by military officers) to continue, and ignored ballooning unemployment and inflation (Ruhl 2000, 55).

The 1990s, however, marked a new period in Honduras's protracted and limited democratic transition; civilian politics became more proactive, and military influence declined. The end to civil war in Guatemala, El Salvador, and Nicaragua meant the subversive threat had disappeared, and the United States cut funding for the Honduran military's counterinsurgency campaigns. The elimination of this aid eroded the military's prerogatives just as a new civilian assumed the presidency in a peaceful, legitimate transfer of power (Ruhl 2000, 55). Still, democratic consolidation in Honduras faced challenges: maintaining the electoral cycles that worked effectively in the 1986 and 1990 elections, negotiating further withdrawals of the military from political life, managing the economic crisis triggered by neoliberal reforms, and establishing viable political parties.

Peace accords signed in 1987 provided amnesty from any previous crimes for both government and opposing forces. It was not until 2000 that the military consented to constitutional reforms that would bring it under civilian authority; however, at the close of the century there was concern that death squads were still operating.

GENDER

During the colonial period, Honduran women were deprived of opportunities for education, as no orders of nuns were permitted to establish schools for girls. Grandmothers passed on whatever education they could to their daughters and granddaughters. In the movement for independence from Spain, one or two wealthy women played a part by making loans to the fledgling republic or donating silver to be made into coins (de Oyeula 1989). In 1859, Honduras remained rural and underdeveloped, with no libraries or regular newspapers (CIAO 1993a). In the 1900s, commercial schools for girls opened to teach them banking and business skills, a unique occurrence in the region that would later have implications for women in politics.

As women were not permitted in the military, there was scant opportunity for them to participate in formal politics in Honduras. In 1924, Visitación Padilla helped to lead a protest against one of many foreign invasions, but a constitutional revision in 1936 expressly denied citizenship and voting rights to women (CIAO 1993a). Politics was perceived as too violent for women, as the argument by a male Honduran legislator of that era demonstrated:

[Voting takes place amid] vices and crimes that no mother, wife, daughter, sister, fiancée, or female friend should participate in if we wish to fully preserve their decency and decorum. . . . Women would capitulate to the blows of evil, descending to the lower corrupting swamps. . . . The three rights—the exercise of suffrage, having and bearing arms, and undertaking public service—are intimately related to one another by their very nature . . . so whoever participates in electoral [politics] resorts to supporting troops. . . . (Holden 2004, 34)

Nevertheless, in 1944, women were involved in protests to free political prisoners as well as in large strikes against foreign-owned corporations (where three women were killed), which helped them to become more influential in union movements. Rural women organized groups to advocate for land reform (Rosales 1980), which could also be a dangerous undertaking.

Women received the right to vote in 1955, but no women were elected to the national legislature or appointed to head government ministries until 1967. Most women's groups were wings of political parties because few sources of funding existed outside of legal political parties. Also, few avenues for political expression were available outside of recognized parties, and there was a real threat of repression against groups that did not have a powerful protector.

Women suffered the effects of the militarization of Honduras in the 1980s. Some were recruited as human pack animals for the *Contras*, toting sacks of grain and other supplies through the jungles on their backs and carrying the male combatants' packs on their heads. Others were pressed into service near U.S. military bases, where they experienced high rates of sexually transmitted diseases and infection with HIV (Enloe 1993). In the 1990s, foreign-owned sweatshops that exploited girls and young women were denounced for supplying clothing to well-known U.S. brands. In 1991, public outrage over the rape and murder of a 17-year-old student, Ricci Mabel Martínez, caused the military to discharge the two officers accused of the crime so they could be tried in civilian court. This signaled the beginning of the end of impunity for the military.

NICARAGUA

Women in this country have always been a very, very strong element, due to their maternal power. [During the overthrow of Somoza,] mothers threw themselves onto the *Guardia* [soldiers] defending their children, nothing mattered to them, not bayonets, grenades, nothing. So for me that is her essence, defending her country, defending her children, defending her family, it is extremely impressive. . . . And now women are capable of demanding from society, not only repayment for what they have contributed, but also demanding the rights they have as women.

ANGELA ROSA ACEVEDO, Nicaraguan legislator, 1988

GEOGRAPHY

Nicaragua is the largest country in Central America, but it is relatively sparsely populated. Some active volcanoes still erupt on occasion. The Pacific region is hot and dry, suitable for growing cotton, while the Atlantic (Caribbean) region is drenched by rain. Forests range from tropical to evergreen. Lake Nicaragua, the largest in Central America, allowed travelers heading from the U.S. Atlantic coast to the gold fields of California to cross the isthmus almost entirely by boat. At first a saltwater lake, it gradually changed to freshwater, as did the sharks that still inhabit it.

CONQUEST

Nicaragua was more influenced by conquest than was its southern neighbor Costa Rica. *Conquistadores* reduced the native population

from about 1 million to only 10,000 (Close 1988) through fighting, disease (Radell 1969), or exportation as slaves to work in Spanish mines in South America. Indigenous populations such as the Sumu, Rama, and Miskito in the eastern regions were more isolated from the centers of settler population and retained more of their language, culture, and customs.

ECONOMICS

Economics in Nicaragua after the colonial era generally followed the pattern set in the other Central American republics. In addition to crops for export, the fertile lands of Nicaragua were suitable for growing a large variety of foods both for national and regional consumption, leading to its reputation as the "breadbasket" of Central America. After the establishment of the National Guard in the 1940s as the dominant military force in Nicaragua, the Somoza family parleyed its control of the Guard into a dominance over nearly 40 percent of the economy as well. In the 1950s and 1960s, consolidation of communal lands for growing cotton exacerbated the situation of the rural poor, while attempts at industrialization worsened the conditions of the urban poor. As in the other Central American countries, most people had no effective avenues of recourse for either economic or political injustices, leading to mass uprisings or other forms of protest that were severely repressed (Velázquez 1986). During the 1980s the United States launched the counterrevolutionary *Contra* army against Nicaragua, adopted a trade embargo (including the mining of Nicaraguan harbors), and waged a campaign against any international lending to Nicaragua, bringing the economy to a halt. At the worst point, inflation soared to a rate of 33,000 percent per year in 1988, followed by a decrease to only 1,690 percent in 1989 (Walker 2000, 76). International lenders insisted on the adoption of strict structural adjustment policies (SAPs) to curb government spending on social programs and to reduce the size of the state. Upon winning the presidency in 1990, Violeta Barrios de Chamorro's administration adopted a neoliberal economic model but faced resistance from much of the population, including demobilized government and *Contra* combatants. Due to plans to privatize much of the economy, state revenues fell drastically. Nicaragua joined Honduras at the bottom of the economic stratum; much of its foreign debt was forgiven by international lenders in 2005.

POLITICS

Sectarian violence between political parties (often aided or abetted by external interests) became an established part of Nicaraguan politics early on. The spoils system characteristic of the region arose in Nicaragua, as well as the practice of foreign intervention in its internal affairs, first by other Central American forces and later by Britain and the United States. In the eighteenth century, Britain wanted to dominate the Caribbean, whereas U.S. involvement began in the nineteenth century because Nicaragua offered the shortest route from the Atlantic to the Pacific for the California gold rush (before transcontinental railroads crossed the United States).

Politics in Nicaragua was dominated by armed groups, either because the president was a military commander or because a foreign military power backed one or another political faction. The U.S. military eventually became deeply involved in Nicaraguan politics as well, more so than in any other Central American country. When the dominance of one party was challenged by the other, U.S. Marines were dispatched to protect the U.S. embassy as well as U.S. economic interests in plantations, mines, and timber. By 1909, the United States had become identified with the Conservatives, and U.S. Marines participated in the overthrow of the Liberal president of Nicaragua. Off and on until the 1930s, the United States supported candidates favorable to its economic interests, promoted revisions in electoral laws, supervised elections, and defeated uprisings by the losing party. U.S. Marines finally withdrew in 1933 after reaching a truce with a Liberal and nationalist leader, Agusto César Sandino, who waged a guerrilla-style war against them (Vargas 1989).

As the Marines left, the United States created the National Guard, a theoretically neutral armed branch of the state, combining police and army duties, intended to have more power than the personalistic forces of any *caudillo* so that it could put an end to the constant battles for power. As Holden (2004, 91) notes, however, one unintended effect would be to provide an unprecedented level of power to whoever controlled the state. The first head of the National Guard, Anastasio ("Tacho") Somoza García, converted it into an instrument for his political party and his personal ambition. The nationalist Sandino, who wanted the National Guard demobilized, was assassinated by Somoza loyalists in 1934 as he left a peace conference. Somoza García and his extended family, supported by the dominant armed force in Nicaragua, maintained direct or indirect control of the presidency for

over 40 years. The influence of the traditionally organized groups recognized by the corporatist state (Catholic Church, landowning elite, businesses, university) was weakened, and nearly all civic action was prohibited. Protests outside these legitimate channels were severely put down by the National Guard, leaving no legitimate avenues for promoting political change. Only one opposition party was allowed to exist, and it was allocated one-third of the seats in the legislature. Somoza García was assassinated in 1956, but his two sons took over control of the presidency and the National Guard.

Even with some economic liberalization in the 1960s, there was no commensurate political opening and no effective opposition could develop (Envío 1990, 25). The Somozas kept U.S. support by adopting a strong anti-Communist stance and by allowing the use of Nicaragua as a base for overthrowing the Guatemalan government in 1954; for launching the Bay of Pigs invasion of Cuba in 1961; and for contributing to the U.S.-led invasion of the Dominican Republic in 1965 (Close 1988).

In the last years of the Somoza dynasty, however, the level of grassroots organizing in civil society in Nicaragua was extremely high. Amid widespread discontent, a number of groups began to plan how to best get rid of the Somozas, through either peaceful negotiations or an armed uprising. The *Frente Sandinista de Liberación Nacional* or FSLN (Sandinista National Liberation Front), named after the earlier leader Sandino, was formally launched in 1961 with the intention of overthrowing the Somozas. A major earthquake that leveled Managua in 1972 increased popular discontent with the Somozas because of National Guard looting and profiteering during reconstruction. In 1978 the popular opposition newspaper publisher Pedro Joaquín Chamorro was assassinated. National Guard repression increased so much that U.S. President Jimmy Carter halted aid to Nicaragua and called for an improvement in human rights. Finally, in 1979, the FSLN led a coalition of forces that defeated the National Guard; the Somozas fled the country.

Taking over the government in 1979 with a five-person junta that included Violeta Barrios de Chamorro (widow of Pedro Joaquín), the FSLN ushered in a Transitional Period of National Reconstruction. They inherited a *machista* political culture, an infrastructure bombed by the retreating National Guard, and a huge international debt. As the only successful revolutionary group in the region, the Sandinistas attempted to change the traditional distribution of

wealth and exploitation of the rural and urban poor that had so often led to cycles of revolt and repression in the past. The level of popular mobilization—organized by the FSLN—fairly exploded (Williams 1994). They created several mass organizations to represent sectors such as growers, ranchers, workers, students, and peasants, as well as women. The FSLN nationalized the economic holdings of the Somozas and instituted a number of programs designed to benefit the working class and the poor. Amnesty International and other human rights groups found that Sandinista policies to treat prisoners humanely and to provide fair trials for those accused of crimes were followed with few exceptions in practice (CIAO 1993b).

The Sandinistas also attempted to create a pluralistic, corporatist government. They initiated a 47-seat advisory Council of State to replace the traditional legislative Assembly and appointed representatives from recognized sectors. In contrast to liberal democracy, the FSLN government sought a "true participatory democracy" where civil society groups achieved direct representation in political institutions (Walker 2000, 74). These groups had representatives in one-third of the 47 seats in the Council of State, a corporatist institution that perpetuated the Central American tradition of interest articulation through structured, hierarchical organizations. By late 1984, more than one-half of the Nicaraguan population aged 16 and over belonged to some FSLN mass organization (Williams 1994, 173). In addition to the Council of State, government ministers convened *consultas populares* (town hall meetings) to elicit citizens' comments on policy matters. The Sandinista government essentially sought the "democratization of civil society" during this period (Williams 1994, 173–174).

However, opposition groups that wanted to return to the *status quo ante* took the traditional route of appealing to a foreign entity (the United States) to restore them to power. U.S. President Ronald Reagan established the anti-Sandinista *Contras* in 1981 to engage in low-intensity conflict (Close 1988), but the *Contras* were not able to overthrow the Sandinistas through military means. The conflict finally reached a negotiated end in 1989–1990 as part of the regional Esquipulas peace process.

Despite the ongoing conflict, in 1984, the FSLN convened elections for president and replaced the corporatist Council of State with a liberal democratic Constituent Assembly: citizen representation was based on more "traditional" geographic formulas, and FSLN mass organizations were not represented. FSLN candidate Daniel Ortega

won the presidency, and the FSLN party won a majority of seats in the legislature. The 1984 elections resulted in a gradual change of the locus of democratization from civil society to the political sphere. While the 1984 legislature held widespread town meetings across the country to develop a new Constitution (approved in 1987), this period witnessed the gradual decline of grassroots participatory democracy in Nicaragua and the emergence of a more formal, liberal democracy. Thomas Walker (2000) and Jennifer Leigh Disney (2003) suggest that the Sandinistas' eleven-year reign prepared Nicaragua for democracy. In other words, the transition began with Somoza's overthrow in 1979 and ended with electoral competition in 1990.

Nevertheless, the downturn in the Nicaraguan economy and the casualties inflicted by the *Contras* were hard felt by a population that had already lost tens of thousands in the war to oust the Somozas, and a compulsory military draft was turning some popular opinion against the Sandinista administration. Opposition also increased from traditional political parties, the Catholic Church, and the opposition newspaper *La Prensa*. These pressures brought the Sandinistas and the *Contras* to the negotiating table.

The Nicaraguan government agreed to participate in the Esquipulas II peace process in 1987, and began planning for an end to the conflict with the *Contras*. It also adopted some economic adjustments mandated by international lenders to curb runaway inflation. The Sandinistas were confident of another electoral victory in 1990. However, the opposition UNO coalition headed by Violeta Chamorro won the presidency as well as a majority of seats in the national legislature (although the FSLN party amassed the single largest bloc of seats). Armed conflict officially ended in 1990, but many demobilized army and *Contra* combatants took up arms again in common banditry; the U.N. and the OAS became concerned about human rights violations in Nicaragua.

Bargaining, negotiations, and pacts have flourished in Nicaragua from 1979 to the present. As early as 1982, the FSLN negotiated with opposition parties to establish rules for procedural democracy; Barnes (1998, 87–89) argues that popular mobilization established a legacy "of participation and dialogue" with regime friends and foes. Nonetheless, the FSLN still dominated as the major political force. Esquipulas recognized the legitimacy of the FSLN government; in exchange, the FSLN initiated a National Dialogue between the Sandinistas and the opposition *Contras*. Talks began in March 1988 and

concluded in 1989. Significantly, these *pactos* were negotiated while fighting continued, and during an accelerating economic crisis.

The process of democratic transition continued with the elections of February 25, 1990, resulting in the opposition victory of Violeta Chamorro and her UNO party. The outgoing FSLN government and the incoming UNO government signed the Procedural Protocol for the Transfer of Executive Power in March 1990. The Transition Protocol excluded participation by the military leadership, emphasizing civic control of the transition process.

Doña Violeta Barrios de Chamorro assumed the presidency in April 1990, and her government marked a radical change for the direction of democratization in Nicaraguan politics and society. Chamorro abandoned the FSLN mixed-economy strategy and pursued uninhibited free-market economics; hyper-inflation returned to 13,490 percent in 1990 (Catalán Arevena 2000, 58). The rapid reduction of the public sector (expanded under the Sandinistas) sent unemployment rates rising, particularly among the middle-class and university-educated sectors that had comprised the Sandinista bureaucracies. Chamorro's new privatization scheme met with vocal opposition among FSLN-affiliated trade unions, and strikes and chaos ensued. In a series of meetings known as *La Concertación* (Coming Together), the Chamorro administration attempted trilateral negotiations with conservative business groups and socialist unions, seeking consensus about the pace of structural adjustment.

Legislative deadlock and the refusal of some legislators to follow parliamentary procedures resulted in Chamorro's suspension of the legislative Assembly from September 1992 to January 1993. Following the reconstitution of the legislature, reforms passed in 1995 dismantled much of the innovations in the 1987 Constitution, such as its social and economic guarantees for the organized sectors.

While the Chamorro government brought about formal peace through the official cessation of military hostilities, it could establish neither the political nor the socioeconomic basis for the completion of democratic transition in Nicaragua. After two more opposition governments (elected in 1996 and 2001), the FSLN finally regained the presidency with the elections of 2006. It remains to be seen what shape a democratic consolidation in Nicaragua will take.

GENDER

There were few gains for women in Nicaragua during the colonial era, and there were not many more during the first hundred years

of independence. One woman, Josefa ("Chepita") Toledo de Aguerri, struggled to obtain the right to public, secular education for girls, and another Nicaraguan woman, Josefa Vega, petitioned the government to allow her to attend the country's only university in 1852 (Nuñez de Escorcia 1996, 9).

While in theory some of the ten Nicaraguan Constitutions between 1838 and 1950 might have permitted women to vote, none did so in practice. Women petitioned to vote in 1932 but were turned down by the U.S. Marines overseeing the election (González and Kampwirth 2001). A close relative of Somoza made a speech to an American women's organization outlining how women were thought of in Nicaragua:

A woman, to us, is the woman of whom the poets of the middle ages sang—a fragile being to be protected, a comfort to which to fly, a loving wife and a wise mother—and, in fact, in our homes she is often all of these things (Debayle 1933).

Women were given the vote in 1955 by Somoza. The two official political parties had women's sections that were designed to involve women in the electoral process in support of the status quo. Some women were elected to the national legislature, appointed to Minister and Vice-Minister of Education, elected to mayor and city council positions, served in the diplomatic corps, and named to judgeships; others benefited from nepotism, as when Somoza appointed his wife, Hope Portocarrero de Somoza, to head a newly created social service agency.

By the year of its formal debut in 1961, the FSLN was integrating women into a wide gamut of its activities (unlike traditional political parties). In 1966 the FSLN created the party-based Patriotic Alliance of Nicaraguan Women. One of the FSLN's earliest proclamations, in 1969, promised to end discrimination against women and establish economic, political, and cultural equality between women and men. Specifically, it aimed to:

- Pay special attention to the mother and child;
- Eliminate prostitution;
- Put an end to the system of servitude that women suffer, especially abandoned mothers;
- Establish equal rights for children born out of wedlock;
- Establish child-care centers;
- Mandate a two-month maternity leave for working women;

- Raise women's political, cultural, and vocational levels through their participation in the revolutionary process (FSLN 1987).

In response to repression by the Somoza state, groups of mothers of political prisoners, families of the disappeared, and widows began to form and to hold silent marches, candlelight vigils, and other peaceful activities. As women outside of official circles were organizing to protest government abuses, the FSLN renamed its women's organization AMPRONAC (*Asociación de Mujeres Ante la Problemática Nacional* [Association of Women Facing the National Problem]) to appeal to a broader spectrum of Nicaraguans (Randall 2000). The massive earthquake of 1972 led to looting by the National Guard and monopolization by the Somozas of international aid. It stimulated a network of women that would play a pivotal role in the downfall of Somoza in 1979. After 1979, the FSLN's organization for women was again renamed, as the *Asociación de Mujeres Nicaragüenses Luisa Amanda Espinosa* (AMNLAE) [Luisa Amanda Espinosa Association of Nicaraguan Women]. The FSLN adopted a statute of rights and guarantees for the Nicaraguan people featuring provisions for women that were unique in Central America. Women benefited from a literacy crusade, public health campaigns, agrarian reform, and child-care centers. Women were also organized as never before, both in women's organizations and as members of unions, cooperatives, neighborhood development, and other groups. Women comprised about half the new police force and one-quarter of the Sandinista army; they were appointed to head ministries and to serve as ambassadors; and they were elected in relatively large numbers to the national legislature in the first elections of 1984.

During the push to oust Somoza and then to reconstruct the Sandinista state, women were often asked to put gender-related issues and concerns on hold. Once the counterrevolutionary (*Contra*) war was over, women were told, they would have adequate time and resources to address their concerns. Most women agreed, rationalizing that without the revolution, women would never have had these opportunities to begin with. Thus, the new role for women in politics promised by the 1979 revolution slowed considerably. With the electoral defeat of the FSLN party in 1990, AMNLAE debated for the next two years over whether to become an autonomous organization (González and Kampwirth 2001). The defeat of the FSLN was also marked by the creation of literally hundreds of non-governmental organizations

(NGOs) in Nicaragua, focused on a wide variety of issues. Some of these were founded by FSLN party members who lost their positions in the legislature or in the government with the change of party in power; others were encouraged by international organizations. The perspective of gender consciousness that had begun to emerge several years before in Costa Rica (and other countries) permeated discussions as never before, as women struggled to (re)define their needs and their goals. Stories of women's problems and issues that had been withheld or ignored before came tumbling out, including an accusation by Zoilamérica Narváez that she had been sexually molested by her stepfather, Daniel Ortega. Nevertheless, women continued to form a major part of the FSLN party members elected to the national legislature throughout the 1990s.

CHAPTER 2 WHAT GETS WOMEN ELECTED

> A woman needs to have the desire to be a legislator. People often wonder, "Why isn't she—an intelligent and capable professional—in the legislature?" Women have to overcome fear and indifference and doubt.
> EDA ORBELINA NAVARRO DUARTE, legislator, Honduras, 1991

Worldwide, the number of countries with national legislatures has increased, as has women's participation in them. The Inter-Parliamentary Union (2005) reported that the number of nations having a national legislature increased from 26 in 1945 to 176 in 1995. Over the same period, the percentage of women in those legislatures rose on average from 3 percent to 11.6 percent. There has been considerable variation by region, however. Nordic countries now average nearly 40 percent women in their national legislatures, while Arab states average 6.7 percent, and a few states have none at all. Nations in the Americas are the second highest, at 18.7 percent, and European countries (other than Nordic) average 16.9 percent. Asian and sub-Saharan African states are nearly tied at 15 percent.[1]

Upon first winning the vote and the right to be elected, the percentages of women in the national legislatures of Central America were consistent with that of most other countries (Table 2.1). However, women's presence in the national legislatures of Costa Rica, El Salvador, Guatemala,

TABLE 2.1. WOMEN IN CENTRAL AMERICAN LEGISLATURES

Country	Year of Suffrage[a]	First Year Women Elected[a]	Percent Women[a] Elected	Year with Highest Percent[b]	Highest Percent Women[b]
Costa Rica	1949	1953	6.7	2002	35.1
El Salvador	1950	1961	3.7	1997	16.7
Guatemala	1945	1954	1.5	1995	12.5
Honduras	1955	1957	5.2	1989	10.2
Nicaragua*	1955	1972	9.0	2001	20.7

*There is agreement on the date of women's suffrage in Nicaragua (1955), but there are varying reports on when women were first elected to the national legislature. Data from the pre-1979 era are difficult to locate. Most of the data on Nicaragua in this book begin with the 1984 elections.
 Sources: [a]IPU 1995; [b]IPU 2005.

Honduras, and Nicaragua was increasing. Women legislators[2] attained the highest proportion of legislative seats in Costa Rica (35.1 percent) in 2002, but increases in the other countries in the region were dramatic as well. Focusing on the election that produced the highest proportion of women legislators in each country, Nicaraguan women rose to over one-fifth (20.7 percent) of the legislature in 2001; women in El Salvador reached 16.7 percent in 1997; Guatemalans increased from 1.5 percent to 12.5 percent in 1995; and Hondurans doubled from 5.2 percent to 10.2 percent in 1989.

It appeared that women were making exceptional headway in Central American national legislatures in the latter decades of the twentieth century. Why did these increases occur at that time? A lively debate has evolved concerning the relative importance of various conditions that could promote or hinder the election of women to national legislatures. These conditions have fallen into three major types of explanations: electoral, structural, and socio-cultural.

Over fifty years ago, in 1955, Duverger noted that, among developed nations, higher proportions of women were found in legislatures using some form of proportional representation (PR) electoral system. A number of other studies echoed these findings (Kohn 1980; Bogdanor 1984; Beckwith 1992). Based on 1980–1982 data for 23 developed democracies, Rule (1987) found that PR systems averaged 12.5 percent women, while non-PR systems averaged 4.1 percent, a three-to-one

ratio. A similar study using 1998 data found PR systems averaging 23.8 percent women elected to national legislatures and non-PR systems averaging 11.1 percent women (Rule 1998), a two-to-one ratio. It appeared that the influence of the electoral system, while still important, was declining over time. However, other studies noticed that not all countries using PR electoral systems had relatively high proportions of women; within countries using PR systems, the proportion of women in the legislature could fluctuate over time; moreover, not all PR systems are exactly alike (Beckwith 1989). More detailed research showed that some variations of PR electoral systems, such as the number of representatives elected per electoral district[3] or the precise formula used to allocate seats, could be more favorable to the election of women than others (Rule 1993; Rule 1998); these findings are not always confirmed in other countries or regions, for example in the Nordic countries (Maitland 1991; Norris 2004).

Looking at this body of research in general, two major things stand out. On the one hand, some types of electoral systems may provide greater opportunities for women's election, but they are not a guarantee of women's election. Also, salient characteristics of certain historical eras can affect the importance of the type of electoral system a country uses for electing women (e.g., the 1980 versus the 1998 studies above). This has led researchers to consider other types of factors that could be important in the election of women, such as structural and social conditions (discussed below). On the other hand, most of the research has been carried out with data from countries with established democracies and/or highly developed economies. One of the few studies on developing democracies (Rule 1998) found much smaller differences in the percentage of women legislators for countries using PR systems (8.8 percent) versus non-PR systems (6.9 percent). The relationship of the electoral system to the election of women for countries in transition to democracy and/or with developing economies has yet to be fully explored. A detailed study using data over an extended period of time from countries with a wide range of levels of development and/or transition is needed.

A second major category of explanation focused on structural conditions such as a country's level of economic development, with the hypothesis that more developed countries would be more favorable to the election of women. The level of a country's Gross Domestic Product (GDP), the ratio of GDP per person, the level of energy consumption, the percent of population living in cities, the national

unemployment rate, and many other indicators of development have been explored in various studies. Considering this large body of research as a whole, again, some of these indicators have been important during some historical eras and in some countries, but not in all, and again most research has been carried out in more developed and more industrialized countries during one point in time only.

Since neither the electoral system nor the level of development explained all the variance among the proportion of women legislators in different countries and/or at different times, researchers turned to a third set of variables, indicators of social and political conditions that were hypothesized to help or hinder the election of women. Countries where women had higher social status were deemed more likely to elect women. Women's social status was indicated by such things as education (e.g., the percentage who were literate, attended school, or graduated from college); health (e.g., the fertility rate, maternal mortality rate, access to health care, or life expectancy); the presence of conservative, patriarchal, or fundamentalist religions and/or traditional or narrow roles for women; and labor-force participation and wage equality for women, among others. For example, Darcy, Welch, and Clark (1987) estimated that giving women the same educational attainment and occupational distribution as men would increase their representation in U.S. state legislatures to 25 percent (compared to the actual 5–8 percent at that time). Other aspects of the political system that could encourage or discourage the election of women included:

- The characteristics people need to be nominated by a party to run for office;
- The extent to which women are present in the candidate pool;
- Whether leftist parties compete in elections;
- The extent to which the political culture is social democratic and egalitarian or liberal democratic and individualistic;
- Whether men dominate in leadership positions;
- Public or private funding for electoral campaigns; political corruption;
- Whether there are affirmative action policies or quotas for women candidates.

Some of these contextual conditions are difficult to measure quantitatively, such as "political culture," but a number of them have been found to be important for the election of women in some circumstances. For example, Rule (1994b) found that long-established democracies with PR systems averaged 19.5 percent women legislators,

compared with 8.5 percent in long-established democracies without PR systems. Beilstein and Burgess (1995) found that the confluence of social democratic political culture and a PR electoral system greatly favored the election of women to the national legislature (e.g., 41 percent in Sweden, 39 percent in Norway and Finland, and 33 percent in Denmark), whereas the combination of liberal democratic culture and non-PR electoral systems did the opposite (e.g., 11 percent in the United States, 9.2 percent in the United Kingdom, 8.2 percent in Australia, and 6.1 percent in France). Liberal democratic cultures linked with PR systems fell in between (New Zealand, 21.2 percent; Switzerland, 17.5 percent; and Italy, 15 percent).

Another study (Rule 1994a) found that higher percentages of women legislators (average 24 percent) were associated with parliamentary governments using PR systems, mostly public election funding, and low levels of political corruption, while lower percentages of women legislators (average 9 percent) were found with presidential governments using non-PR systems, mostly private election funding, and higher levels of corruption. Again, some studies have found some of these indicators of women's social status or political culture to be important predictors of the proportion of the legislature that is female, but other studies have not.[4]

One problem is that many of these electoral, structural, and social indicators are highly correlated, so it is not possible to conduct quantitative studies that consider all these indicators simultaneously. Another problem is that some studies have used one type of measurement for an indicator (e.g., measuring education by the percentage of women enrolled in college), while other studies have used a different type of measurement (e.g., percent of women who are illiterate), so the results are not strictly comparable.

A third problem is that most studies are based on data from a relatively few countries at one point in time, which makes it difficult to find strong cause and effect relationships. Finally, most studies have used statistical techniques such as correlation or linear regression to analyze the data, which are not useful for detecting the presence of nonlinear relationships between electoral, structural, or socio-political indicators and the election of women. For example, using nonlinear techniques, Wide (2002, 11) found a significant curvilinear correlation between level of development and the percentage of women in national legislatures across all world regions. Countries with high levels of economic development tended to have high percentages of

women legislators, and countries with low levels of economic development tended to have low percentages of women legislators, but there were many exceptions: the United States, France, Italy, Japan, and Singapore had high development and low percentages of women legislators, whereas Mozambique, Rwanda, Tanzania, and Uganda had low development but high percentages.

How well do any of these types of indicators predict the success of women in electoral politics in Central America? In the following pages, we explore whether electoral system, structural indicators, or socio-cultural conditions can account for recent increases in the representation of women in the national legislatures of the five countries within the Central American region (compared with other regions). In addition, we explore whether these indicators can explain differences among the five countries within Central America on the level of women's representation.

ELECTORAL SYSTEM

The first type of explanation for why the presence of women in national legislatures differs throughout the world is the type of electoral system used. All the Central American countries are unitary republics. A unitary republic has only one level of government, the national level. In the past there were often no municipal or regional elected bodies or administrative entities; instead, there was a single (national) Department of Education or Police Force. Whoever controlled the national government, therefore, controlled the entire country (although this is currently changing, with greater decentralization). While all power is concentrated at the national level, there is still a division of power with separate executive, legislative, and judicial branches of government. Each of the Central American republics has a unicameral national legislature; that is, it is made up of only one chamber (instead of two separate legislative chambers, such as a House and a Senate).

Central American republics use many of the types of electoral arrangements that have favored the election of women, such as proportional representation (PR) and party list (PL) systems, a greater number of deputies elected per district (district magnitude), and a greater ratio of total deputies to national population (Beckwith 1989; Norris 1985). Competition by left-of-center parties, lower incumbency rates, and women's sections of political parties (Beckwith 1984) have also been observed in some of the countries in this region. The total

number of parties competing may also be a factor in some countries, since parties that expect to win only one or two seats are less likely to nominate women (Maitland 1991).

While all Central American countries use similar electoral systems, the representation of women is not uniform across the region. During the 1980s and early 1990s, there were no reserved seats for women, mandated quotas for women on party lists, or other affirmative action measures promoting the election of women to national legislatures. Clearly, there were other factors that contributed to the differences in the percentage of women among these national legislatures. One may be the slight differences in electoral systems (Table 2.2). For example, the total number of seats in the legislature varies not only across the countries in the region, but also from election to election. In Nicaragua and Honduras, in addition to the seats filled by direct election, extra seats are created for defeated presidential candidates after each election. The number of districts varies by country as well, from a low of 7 in Costa Rica to a high of 22 in Guatemala, as does the number of seats per district. In addition to department-based districts, three countries have used, on occasion, a national (country-wide) electoral district with 16 to 20 seats. All countries except Costa Rica elect both a principal representative for each seat and an alternate or substitute representative (called a *suplente*) at the same time. In case the principal representative cannot serve, the *suplente* takes over. Voters cast separate ballots for president and legislature in all countries except Honduras. Presidential and legislative terms coincide in some countries but are staggered in others. Legislators serve nearly year-round in Nicaragua and El Salvador, with shorter sessions in Guatemala, Honduras, and Costa Rica. The length of the term varies; all legislators are eligible to serve consecutive terms except in Costa Rica. In the following sections we consider whether these differences are related to the presence of women in the national legislatures of Central American republics.

MULTIPLE-MEMBER DISTRICTS

Even though many countries in the world consider themselves to be democracies, few practice direct democracy, where every citizen votes directly on proposed legislation. Instead, where the national legislature is concerned, most countries use some form of representative democracy, where people vote directly for representatives who are then responsible for voting directly on proposed legislation.[5] The manner

TABLE 2.2. CENTRAL AMERICAN NATIONAL LEGISLATURES

Country	Costa Rica	El Salvador	Guatemala	Honduras	Nicaragua
Name of Legislature	Asamblea Legislativa	Asamblea Legislativa	Congreso de la República	Congreso Nacional	Asamblea Nacional
Number of Districts	7	14	22	18	16
District Seats	57	64	64	128	70
At-Large (National) Seats	0	20	16	0	20
Additional Seats	0	0	0	Losing Candidates for Pres. & Vice Pres.	Losing Candidates for Pres.
Total Seats	57	84	80	128+	90+
Substitutes Also Elected?	No	Yes	Yes	Yes	Yes
Years of Term	4	3	4	4	6
Immediate Reelection?	No	Yes	Yes	Yes	Yes
Minimum Age	21	25	18	21	21
Sessions held	May 1– July 31 and Sept. 1– Nov. 30	Begins May 1 of Election Year	Jan. 14– May 15 and Aug. 1– Nov. 3	Jan. 25– Apr. 30 and June 1– Oct. 31	Jan. 1– July 14 and Aug. 1– Dec. 15
Monthly Salary	$2,100	$3,429	$3,000	$1,200	$1,607
Expense Allowance	Cost of Travel	$200/day Travel	—	$300/month Travel Expenses	$193/month Travel Expenses

Sources: IPU 1986; Kurian 1998.

in which representatives to national legislatures are selected varies greatly in democracies around the world. National legislatures are generally made up of representatives from a number of electoral districts. Most countries are divided geographically into many electoral districts. National legislatures in some countries, like the U.S. House of Representatives, use a single-member-per-district system. For each electoral district, only one member (candidate) is selected by the voters to represent that district. Each political party nominates only one person to run in each district, and the candidate with the most votes wins. If an absolute majority of votes is required, it may be called a "winner takes all" system; if only a simple plurality is required, it is referred to as a "first past the post" system. One drawback is that the people who voted for the winning candidate may feel their views will be represented, but the people who voted for the losing candidate(s) may not. In Central America, the losers often took up arms against the winners. Other countries, such as Sweden, use a multiple-member-per-district system. More than one representative (member) is elected for each district, so each district has multiple seats to fill.

PROPORTIONAL REPRESENTATION

Seats in legislatures that use a multiple-member system may be filled in a number of ways. One of the most common is by the method of proportional representation (PR). In this method, citizens vote not for individual legislators but for a political party. Seats are then awarded not to individuals but to each political party based on the proportion of the total votes gained by that party. Usually in multiple-member PR systems, political parties nominate as many people to run in each district as there are seats to be filled from that district. One of the advantages of this system for women is that candidates do not run head-to-head against one another (as they do in a winner-take-all system). In fact, there are usually more than two parties that put forth candidates for the national legislature, and many parties win at least one or two seats. Thus, people who voted for any of the parties will feel their views are being represented to some extent (see Box 2.1). All the Central American republics use some combination of proportional representation and multiple-member district systems.

PARTY LIST

All Central American electoral systems use what is called a party list (PL). Only candidates nominated by legally recognized political

Box 2.1. Differences in Electoral Systems

Single-Member District

Assume two candidates, A and B, are running in District No. 1. If candidate A receives over 50 percent of the vote (a majority), then candidate A is elected and B is not. Now assume three candidates, A, B, and C, are all running in the same district. Candidate A may get only 40 percent of the vote (a plurality), but if that is more than either of the other two candidates get, then A will win.

Multi-Member District with Proportional Representation

Assume District No. 1 has 10 seats to be filled, and there are two parties running, Alpha and Beta. If Alpha gains 60 percent of the vote and Beta gains 40 percent, then the Alpha party will fill 6 of the seats and the Beta party will fill 4 of the seats. There may be three parties running, Alpha, Beta, and Delta. If the Alpha party wins 50 percent of the vote, then it will get 5 seats. If the Beta party wins 30 percent of the vote, then it will get 3 seats. If the Delta party gets 20 percent of the vote, then it will get 2 seats.

parties may compete in elections for seats in the national legislature. Each party presents the voters with a list of candidates for all the seats in each district. This system is advantageous to women because parties are under pressure to put together lists with diverse candidates, to appeal to the widest possible spectrum of voters, although, in Central America, it has not been as advantageous to members of ethnic minority groups as it has for women (Saint-Germain 1993a). In the closed party list system, voters do not vote for each candidate individually but have only one vote, which they must give to one of the political parties' lists. Closed party lists do not permit voters to express a preference for one candidate on a party's list over others on that same list. (There are open list variations, where voters may express preferences for certain individuals on the list and/or move them to a higher rank, but these are not used in Central America.)

Democratic countries that use PR/PL systems and multi-member districts generally have higher proportions of women in their national legislatures than countries that do not. This relationship holds true both in countries with established democracies and in countries with developing democracies. One reason may be that the basic premise of PR—that all groups need to be represented in a society in order for democracy to work—is theoretically more favorable to the representation of women (as long as women are seen as a group that needs representation) than the basic premise of non-PR electoral systems; it

is certainly congruent with the underlying corporatist traditions of Central America. Countries that adopt PR electoral systems, therefore, may be more predisposed to the representation of women than countries that do not adopt PR systems. Costa Rica has used proportional representation since 1949; El Salvador adopted it in 1962, and Nicaragua in 1984. Guatemala uses a hybrid system combining some party-based proportional representation with some geographic-based representation. Honduras uses proportional representation but with a "fused vote." Only one ballot is cast for electing both the president and the national legislature. The party with the most votes wins the presidency; legislative seats are allocated to the parties on the basis of their proportion of the popular vote.

SIZE OF LEGISLATURE

One reason for intraregional differences in the proportion of women elected to the national legislature might lie in the differences in the total number of seats to be filled in each election. The total number of seats is different in each country, from a low of 57 in Costa Rica to a high of over 128 in Honduras. A national legislature with a larger number of total seats—either absolute or in relation to total population—is thought to be more advantageous to the election of women than a legislature with a smaller number of seats (Caul 1997). This hypothesis is difficult to investigate in Central America because the total number of seats in the national legislatures has sometimes fluctuated from one election to the next (decreasing as well as increasing). However, analysis of the elections in Central America over this time period revealed that the largest legislatures did not have the highest proportion of women (Table 2.3). Nor was the amount of population per seat related to women's presence. Although Guatemala had the highest amount of population per seat and the lowest proportion of women, the population-to-seat ratios were generally similar for the remaining countries, but their proportions of women varied widely.

Within a single country, however, changing to a larger number of seats in the national legislature may be associated with an increase in the number of women elected (Table 2.4). For example, a larger number of seats is significantly correlated with a larger number of women in the national legislature of El Salvador,[6] which increased from 54 seats in 1961 to 84 seats in 1991, and from 2 to 14 women; Honduras[7] increased from 53 seats in 1971 to 128 seats in 1989 and

TABLE 2.3. LEGISLATIVE CHARACTERISTICS AND WOMEN'S ELECTION

Country	Size of Legislature	Population per Seat	Percentage of Women (Last Election in 1990s)	Year Women First Elected	Total Years Women Voting (1999)
Costa Rica	57	56,123	19.3	1953	51
El Salvador	84	65,679	16.7	1961	50
Guatemala	80	125,363	7.1	1954	55
Honduras	128	43,711	9.4	1957	45
Nicaragua	90	47,389	9.7	1972	45

Sources: IPU 1995 and 2005.

from 1 to 12 women. But since these two legislatures increased in size over time, the increase in the size of the legislature may have been less important than other changes taking place over that same time period (from the 1960s to the 1990s) that would have affected the number of women elected. That is, women may have been increasing their numbers over time in national legislatures regardless of whether the legislatures increased in size. For example, women legislators in Costa Rica increased from 1 in 1962 to 11 in 1998, while the number of seats remained stable at 57.

INCUMBENCY

In all the countries except Costa Rica, incumbent legislators may stand for reelection. Incumbency is a double-edged sword for women. Most incumbents who get elected stay elected. Since most incumbents are men, it is difficult for women to break into the system. Once women are elected, however, it should be easier for them to be reelected as incumbents. But instability in the political party system in every country (except Costa Rica), with numerous parties appearing and disappearing between elections, has often defeated the presumed incumbency advantage for elected legislators, including women. Until the 1990s, few women had ever been reelected. The steady increase in the proportion of women legislators in Costa Rica is even more impressive because no legislator may be immediately reelected. The entire 57-seat legislature turns over every four years.

TABLE 2.4. WOMEN IN CENTRAL AMERICAN NATIONAL LEGISLATURES

Costa Rica

Year of Election	1953	1958	1962	1966	1970	1974	1978	1982	1986	1990	1994	1998
Total Seats	45	45	57	57	57	57	57	57	57	57	57	57
Number of Women	3	2	1	3	4	4	5	4	7	7	9	11
Percent Women	6.7	4.4	1.8	5.3	7.0	7.0	8.8	7.0	12.3	12.3	15.8	19.3

El Salvador

Year of Election	1961	1964	1966	1968	1970	1972	1974	1976	1978	1982	1985	1988	1991	1994	1997
Total Seats	54	52	52	52	52	52	52	54	54	60	60	60	84	84	84
Number of Women	2	1	6	2	2	2	3	3	4	7	4	7	7	9	14
Percent Women	3.7	1.9	12.0	3.8	3.8	3.8	5.8	5.6	7.4	12.0	6.7	11.7	8.3	10.7	16.7

Guatemala

Year of Election	1964	1966	1970	1974	1978	1982	1984	1985	1990	1995	1999
Total Seats	66	55	55	60	60	66	88	100	116	80	113
Number of Women	1	2	1	2	1	2	3	6	6	10	8
Percent Women	1.5	3.6	1.5	3.3	1.6	3.0	3.4	6.0	5.2	12.5	7.1

Honduras

Year of Election	1971	1972	1976*	1980	1981	1985	1989	1993	1997
Total Seats	53	60	31	68	82	134	128	128	128
Number of Women	1	4	4	4	3	10	13	9	12
Percent Women	1.9	6.7	12.9	5.9	3.7	7.5	10.2	7.0	9.4

Nicaragua

Year of Election	1980*	1984	1990	1996
Total Seats	51	96	92	93
Number of Women	3	13	15	9
Percent Women	5.9	13.5	16.3	9.7

*Appointed Council of State.
Source: Compiled by author from national records.

Only a handful of people have ever been elected more than once to the Costa Rican national legislature, but women were among them.

Another difference between countries is the number of years that legislators serve. It varied from a high of 6 years in Nicaragua to a low of 3 years in El Salvador, but there is no relationship between the number of years per term and the presence of women (number or percent). Some countries have held more elections than others, but the sheer number of elections in each country has no relationship with the number or percent of women elected.

YEARS OF SUFFRAGE

Most women in all these countries gained the vote within a relatively brief time period, from 1945 to 1955, so there is not much variation in the number of years women have been able to vote (although illiterate women did not gain the vote until many years later in some countries). The total number of years since women gained the effective right to vote is not significantly related to the proportion of women elected in Central American republics (see Table 2.3 above), although there is a trend. In 1999, women had been able to vote in Costa Rica and El Salvador for over 50 years, and both had relatively higher proportions of women in their national legislatures (19.3 percent and 16.7 percent, respectively). Also in 1999, women had been able to vote in Nicaragua and Honduras for nearly 45 years, and both had relatively lower proportions of women in their national legislatures (9.7 percent and 9.4 percent, respectively). For all of the Central American nations except Costa Rica, many of these years were marred by revolution, civil war, or other disruptions in the civic and political life of the country. For example, in 1999, literate Guatemalan women had also had the vote for over 55 years, but only 7.1 percent of seats in the legislature were held by women; much of that period was afflicted by the 30-year civil war. The relative ranking among these five countries with respect to the proportion of women in the legislature has shifted many times since women won the vote. Nearly any one country could have the highest proportion of women elected to the national legislature during one era or another. Therefore, any short-term trends need to be accepted with caution.

Looking at the number of women elected in each country since suffrage, the representation of women seems to move at first in fits and starts, with sudden advances and just as sudden retreats. However, two different patterns have emerged over time. One is charac-

terized by a steady, continuous increase in the proportion of women legislators (Wide 2002, 5), as found in Costa Rica since 1982. The longer women have voted and been elected, the more experience they have gained and the more proficient they have become in winning seats and holding on to them. They have also been able to create more favorable conditions for the election of even more women, through voluntary affirmative action programs, suggested party list quotas, or other changes in the recruitment, nomination, and election of national legislators. The other pattern is one of continuing reversals of fortune, when current events that either opened or closed windows of opportunity seemed to have more of an impact on the proportion of women who gained legislative seats than did years since suffrage, electoral system, or women incumbents. This pattern can be observed in El Salvador, Guatemala, and Honduras, as well as in the scant electoral history of post-1979 Nicaragua. Thus, years since suffrage cannot explain the proportion of women found in these legislatures at any one point in time.

DISTRICT MAGNITUDE

The number of seats to be filled from each district is referred to as district magnitude. Having a larger number of members elected from each district has been found to be conducive to the election of more women legislators in some cases (Caul 1997; Darcy, Welch, and Clark 1987; Rule 1993). Each of the Central American countries has a different number of electoral districts, and each district can have a different magnitude. In addition, an "at-large" (or so-called "national") district has been used in some of the countries for some elections. An analysis of all the electoral districts for which data are available in the five Central American countries under study here shows that there is a statistically significant—although not linear—relationship[8] between the size of the district and the number of women elected from the district. A regression of seats per district on women elected per district shows that each seat added to a district will increase the number of women elected by 0.12 seat. That is, it takes an increase of about 9 seats per district, on average, to get one more woman elected from that district.[9]

In a single country, analysis of the legislative results by district in El Salvador for the past 15 elections also shows that in larger districts, more women will be elected.[10] That is, knowing the size of the district can help to explain why more women are elected from

some districts compared with others. These findings are fairly consistent for small districts (1 to 5 members) and for large districts (11 to 20 members). Most small districts in El Salvador, with only 1 to 5 members each, have never elected a woman; larger districts with 11 to 20 members each have elected up to three women per district on average. This is logical because in small districts, with multiple parties competing for seats, only 1 or 2 nominees from each party will actually win a seat, and men are nearly always the top nominees on every party list. In larger districts, even with multiple parties competing for seats, each party can win more than 1 or 2 seats and can reach the third or fourth name on the list of nominees, where the top woman may be found. The same trend between district magnitude and the number of women elected per district was found for the data from Costa Rica and Nicaragua but did not reach statistical significance.

The relationship between district magnitude and the number or percentage of women elected, however, does not hold for medium-sized districts (6–10 members). Some medium-sized districts had very low numbers of women, and others had very high numbers. The number of seats per district explained only part of the variance in the number of women elected per district. Something other than district size is also important in influencing how many women will be sent to the national legislature from each electoral district and needs further study.

PARTY ORIENTATION

Another factor that influences the number of women elected is the presence of leftist or center-left political parties. Traditionally, leftist parties have elected more women than have rightist or centrist parties (Norris and Lovenduski 1995; Beckwith 1992; Rule 1987; Nuss 1985). In this discussion we use Nicaragua as an example, where the leftist Sandinista party sent an average of 20 percent women to fill its seats in the national legislature after each election (Table 2.5). Benigna Mendiola expressed the feeling that the FSLN party values its women members:

Women have a voice and voting power in the legislature because of the [1979] revolution. That is, the participation of women in the work force and their importance in the revolution were valued, as much as before and during the triumph [of the revolution] as after the triumph. (Mendiola 1988)

TABLE 2.5. ELECTION OF WOMEN BY PARTY IN NICARAGUA

	1984			1990			1996		
	Party Seats	No. of Women	% Women	Party Seats	No. of Women	% Women	Party Seats	No. of Women	% Women
FSLN Party	61	12	19.7	39	9	23.1	36	8	22.2
All Other Parties	35	1	2.9	53	6	11.3	57	1	1.8
Total	96	13	13.5	92	15	16.3	93	9	9.7

Source: Compiled by author from national records.

In the Nicaraguan Council of State, a quasi-legislative body appointed by the Sandinistas after the 1979 revolution, women averaged about 12 percent of the seats (although the number of seats as well as the membership varied over the five years of the Council's existence). In 1984, in the first legislative elections after the revolution, the Sandinistas won a majority of seats. Women occupied 13.5 percent of the total legislative seats but 19.7 percent of FSLN seats. In 1990, even though the Sandinistas lost the presidency, they still retained a large number of seats in the legislature. Women's presence increased to 16.3 percent of the total legislative seats, mostly because they formed 23.1 percent of the Sandinista delegation,[11] but also because of an increase from the other parties (from 2.9 percent to 11.3 percent). There may have been a "year of the woman" effect of the 1990 electoral campaign that culminated in the election of Violeta Barrios de Chamorro as the first woman president of Nicaragua. Women not only increased their presence in the national legislature, but one of their members, Miriam Argüello, was elected the first woman president of the national legislature. Finally, in 1996, women decreased to 9.7 percent of the total seats. Women maintained their high proportion (22.2 percent) of FSLN seats but sharply reduced their presence in the other parties (1.8 percent). The majority of women elected to the Nicaraguan national legislature (78 percent) have come from the

Sandinista party. Without this party, women's presence after the 1996 elections would have been almost nil.

The effect of the presence of leftist parties is not as clear in the other Central American republics over this time period. In Costa Rica, the majority of women deputies were elected from the centrist National Liberation Party (PLN) rather than the center-right parties. No parties were considered leftist in Honduras during these years. In Guatemala and El Salvador, leftist parties were long banned and were permitted to reenter the elections for national legislatures only in the latter half of the 1990s, after the signing of peace accords ending their civil wars; nevertheless, the percentage of women legislators did increase in the short term after leftist parties were included in electoral contests in both these countries. Having leftist parties compete in elections appears to be helpful but not sufficient to guarantee that larger proportions of women will be elected, and it remains to be seen whether this trend will continue over the long term.

PARTY STRENGTH

The number of seats won by a political party (Maitland 1991), also called effective party magnitude (Jones 2004), is also important in some cases. An analysis of all the parties winning seats in the national legislatures of the Central American countries during the period under study here (for which data are available) showed a statistically significant[12] relationship between the number of seats won by a political party and the number of women elected from that party. A regression of seats won per party on women elected by that party shows that each seat added to a party's cohort in the national legislature will increase the number of women elected from that party by 0.10 seat. That is, on average, a political party would need to win 10 more seats to get 1 more woman elected from that party.[13] Knowing the number of seats won per party explains more of the difference in the number of women elected per party in Nicaragua and Costa Rica,[14] but much less of the variance in the other countries. Other factors must also be considered in explaining these differences among Central American countries.

One reason it takes so many seats before a party includes a woman in its delegation to the national legislature is the way the closed party list system has traditionally functioned to discriminate against women. In a closed party list system, each political party presents the voters in each district with a list of candidates for the national legis-

lature in rank order. For each electoral district, the party will present a list of names of candidates for that district numbered from 1 to n, where n is the total number of seats to be elected from that district. When the party is awarded a number of seats in the legislature from a district, say six seats, the party sends the first six candidates on the list to be representatives. In the past, few women's names were at the tops of party lists for any districts, so parties had to win a large number of seats in a district before they reached the women's names. While some parties claimed that substantial proportions of their candidates were women, the women's names were placed at the bottom of the lists, with little real chance of election. When many parties compete for seats, it is unlikely that any one party will win a large number of seats, so it is unlikely that people whose names are far down on the list will become elected representatives. For example, there were over two dozen parties competing in the 1990 and 1996 elections in Nicaragua, some of which won no seats.

WOMEN'S SECTION

Knowing the number of seats won per party in Nicaragua and Costa Rica is a good predictor of how many women will be elected from that party because women in these two countries are well-organized within the major political parties. In addition, the major parties have persisted over time, and women have learned how to operate within the parties' formal mechanisms for the nomination of candidates. As a result women in Nicaragua and Costa Rica have had more success at getting their names put at or near the top of their party's list in the parties that most consistently win the majority of seats (Saint-Germain 1993b). In the other countries, knowing the number of seats won per party is not a good predictor of how many women will be elected per party because the party structure is still in flux, or there are no strong parties, or women have only recently begun to organize within parties to secure the top spots on the list.

ELECTION OF ALTERNATES

In countries where an alternate (*suplente*) is elected at the same time as the primary representative, the practice of whether to show the names of the *suplentes* on district lists varies. In most cases, women's names make up a greater proportion of the places on the *suplente* list, and they are listed in the higher ranked places as well. This may be a way of seeming to value the election of women without advancing

women as serious candidates on the primary list. It may not be a coincidence that women legislators have made the highest and most consistent electoral gains in the only Central American country that does not elect *suplentes*, Costa Rica. On the other hand, acting as a *suplente* could potentially give a woman the training and exposure needed to become a candidate on the primary list in the next election. In Nicaragua, from time to time, it was known that one of the prominent people on the primary list would be appointed to an important full-time post away from the legislature, and so some highly regarded women were deliberately placed on the *suplente* list to fill in as *de facto* representatives for the entire legislative term.

APPOINTMENTS

In some countries women may get their start by being appointed to fill a vacant seat in the national legislature until the next electoral cycle (Beckwith 1989). But in Central America this is not a viable avenue, since vacant seats are filled either by the elected alternate (*suplente*) or by the next person on the party's list. Some opportunities for appointments exist at the sub-national level (Table 2.6). In Central American countries, there were traditionally no legislative bodies at the regional (provincial) level, although there were governors of provinces and mayors of towns; in some cases there were town councils. Where these offices existed, however, they were often appointed by the national government (although this is changing with a move toward greater decentralization). Some of the women interviewed for this study had been appointed to high administrative posts before being elected to the national legislature.

The state can also promote the election of women through appointments that increase women's political visibility. For example, women were first appointed in 1958 to head the Ministry of Education in Costa Rica; in 1967 to head the Ministry of Work and Social Services in Honduras; and in 1979 to head the Ministries of Education, Social Service, and Public Welfare in Nicaragua (Valdés and Gomáriz 1995, 161). After the 1975 International Women's Year and the 1976–1985 U.N. Decade for Women, Central American countries created governmental offices to consider women's issues and appointed women to run them. However, the institutional placement of these offices varied greatly, as did their funding, focus, and perspective. Judges can also be appointed, and increasing numbers of judges are women. While they remain concentrated at the lower levels of

TABLE 2.6. WOMEN IN POLITICS AND POLICY IN CENTRAL AMERICA (1990s)

	Costa Rica	El Salvador**	Guatemala	Honduras	Nicaragua
Number of Women Elected President	0	0	0	0	1
Number of Women Elected Vice-President	2	0	0	2	0
Percent of Ministers*	11.1	6.2	13.3	10.0	15.8
Percent of Vice-Ministers*	35.2	27.0	22.2	15.9	17.9
Percent of Governors	57.2	21.4	11.2	—	—
Percent of Mayors	—	11.1	1.2	12.7	9.8
Percent of City Councilors	14.0	15.4	—	—	13.2
Percent of Supreme Court	9.1	13.3	11.1	11.1	25.0
Percent of Appellate Court	30.1	8.3	11.5	11.1	25.0
Percent of Local Court	45.7	35.6	11.7	63.5	46.2
Percent of All Govt. Workers	—	—	—	38	—

*IPU 1997.
**Moreno 1997.
Source: Valdés and Gomáriz 1995.

the justice system, women are making their way onto higher-level courts and even the supreme courts of some countries. And women are ever more visible in the diplomatic corps of Central American nations. Service in such visible positions can serve as a path to the national legislature, but appointments are usually the prerogative of the elected president of the nation. Perhaps the election of more women

to top jobs will increase the appointment of women. To date, only Nicaragua has elected a woman president; only Costa Rica and Honduras have elected a woman vice-president. Hence, Central American women cannot afford to wait for more women to be elected president or vice-president in the hope that women in positions of power will be more likely than men to appoint other women.

In sum, there are many characteristics of the electoral systems of the Central American republics that bode well for the election of women, such as proportional representation and party lists, multiple-member districts, and the presence of leftist parties. However, some Central American countries with relatively high proportions of elected women share many of these electoral system characteristics with their sister countries that have relatively low proportions of elected women. Clearly there are other factors that explain the variation in the presence of women in the national legislatures of these republics.

STRUCTURAL EXPLANATIONS

Structural-level explanations of why different countries have more or fewer women in their national legislatures focus on country-wide characteristics, such as the total economic output or Gross Domestic Product (GDP) of a country, the ratio of a country's GDP to its total population (GDP per person), or the percentage of the population that lives in large cities. Previous research has found that countries with higher GDPs, higher ratios of GDP per person, or higher rates of urban population tend to have higher percentages of women in their national legislatures because they tend to have more highly educated populations, more women in the work force, and more women in professions (such as law) that lead to politics (Beilstein and Burgess 1995; Rule 1987).

GDP

In recent years, the Latin American region as a whole has increased its standing on measures of these indicators, compared with other developing world regions.[15] But in Central America between 1980 and 1995, none of the countries were considered highly developed in terms of structural indicators. If the percentage of a nation's legislative seats held by women was strictly determined by such indicators, then there should have been only a few women in the national legislatures of Central American countries during this period. Central American countries ranked far below the Latin American region as a whole (to

TABLE 2.7. STRUCTURAL INDICATORS FOR CENTRAL AMERICA, 1990s

Indicators	Costa Rica	El Salvador	Guatemala	Honduras	Nicaragua	Latin America (average)
Population (millions)	3.0	5.2	9.2	4.9	3.7	n/a
Percent Urban 1990	47	47	38	41	55	71
Total GDP (billions U.S. $)	4.84	3.74	9.20	3.40	1.77	n/a
GDP per Capita (U.S. $)	1,516	693	945	657	449	3,670
Percent in Poverty	21	48	56	50	50	10.5

Sources: Valdés and Gomáriz 1995. Population (1990), p. 39; percent urban (1990), p. 49; total GDP (1992), p. 20; GDP per capital (1992), p. 20. World Bank 1999. Percent in poverty based on national definition of poverty for Central American countries and based on population living on $1 per day or less for Latin American average; year of information for each country varies.

say nothing of more industrialized nations) in terms of total GDP, the ratio of GDP per person, and the percentage of the population that is urban (Table 2.7). For example, in 1990, only Nicaragua was more than half (55 percent) urbanized, but none of the Central American countries reached the Latin American average of 71 percent.

POVERTY

The total GDP of the Central American countries was small, but they also had relatively small populations. A better measure of the level of development is the ratio of GDP per person. Central American countries had lower ratios of GDP per capita than the average for all Latin American countries; they also had higher percentages of their populations in poverty. Over the decades of the 1980s and 1990s, due to many factors, the numbers and percentages of persons and households in poverty in Central America soared. Income inequality also increased in most of these countries. The incomes of the top 10 percent of the population climbed, while the incomes of the bottom 10 percent of the population plummeted (Valdés and Gomáriz 1995; World Bank 1999).

One reason for mounting poverty was that all the Central American countries, which derived much of their revenues from the export of agricultural products, were hit by worldwide recessions and declines in the prices for their most important products, as well as by a string of devastating natural disasters (volcanic eruptions, hurricanes, tidal waves, earthquakes, droughts, and floods) that adversely affected their agriculture and, hence, their GDP. Violent political and military conflicts also reduced economic output. The result was that all of these countries experienced some periods of negative growth (i.e., a decline in GDP).

Another reason for rising poverty was that even when the GDP of Central American countries did increase, it could not keep up with the simultaneous increases in national population, so the ratio of GDP per person remained flat or fell (Table 2.8) from the 1970s until well into the 1990s. In addition, these problems were compounded by soaring inflation (Table 2.9), although the phenomenon of hyper- (or runaway) inflation in some countries during this period makes comparisons nearly impossible. Many people saw their hard-earned savings wiped out overnight. Prices in shop windows changed daily or even hourly. During one of the worst periods of inflation in Nicaragua (reaching over 14,000 percent in 1998), banks were stamping extra zeros on existing paper money because they could not afford to print new higher-denomination notes, and citizens were melting down nearly worthless coins to make eating utensils or other saleable items.

TABLE 2.8. GROSS DOMESTIC PRODUCT PER PERSON, 1970–1998 (U.S. DOLLARS)

Country	1970	1975	1980	1985	1990	1998*
Costa Rica	1,201	1,403	1,552	1,355	1,461	2,780
El Salvador	720	821	773	667	669	1,850
Guatemala	856	979	1,128	925	923	1,640
Honduras	561	589	705	643	647	730
Nicaragua	969	1,056	738	662	484	410
Latin America (Regional Average)*	1,596	1,855	2,160	1,981	1,966	n/a

*Computed by author from data in sources.
Sources: Valdés and Gomáriz 1995, p. 20; World Bank 1999.

TABLE 2.9. INFLATION, 1980–1998 (IN PERCENT PER YEAR)

	1980	1985	1990	1993	1998*
Costa Rica	18.1	15.1	19.0	9.8	11.7
El Salvador	17.4	22.3	24.0	18.5	2.5
Guatemala	10.7	19.2	41.0	13.4	7.0
Honduras	18.2	3.4	23.3	10.7	13.7
Nicaragua	35.3	220.3	7,485.2	20.4	13.0
Latin America (Regional Average)	34.7	747.5	1,149.3	20.6	n/a

*World Bank 1999. World Development Indicators 1999. http://www.worldbank.org/data/archive/wdi99/home.html.

Source: Valdés and Gomáriz 1995, p. 28. High regional averages were due to hyperinflation in 1985 in Bolivia (11,749%), and in 1990 in Argentina (2,314%), Brazil (2,901%), and Peru (7,482%), as well as in Nicaragua.

STRUCTURAL ADJUSTMENT PROGRAMS

Central American countries made very few of the goods they needed, and so they relied on imports for many manufactured products; some imported food at times as well. Because the export earnings of the region did not match the amount spent on imports, Central American countries borrowed heavily during this period from international lenders (Table 2.10). Repeated borrowing led each country to amass a substantial external debt, reaching billions of dollars. Borrowing to meet current expenditures, moreover, led to a vicious circle of events. More and more of the country's earnings (generally from export crops) had to be dedicated to paying the interest on outstanding loans. But as export revenues declined, there was less of the national budget left over (after interest payments) to meet current needs, fueling a new cycle of borrowing, and so on.

International lending organizations attempted to force governments to impose structural adjustment programs (SAPs)[16] in an effort to achieve a balance between revenues and expenditures. But those SAPs ushered in sweeping economic changes, resulting in the curtailment of many public services; women were often the hardest hit. For example, programs such as child care, health care, and education that facilitate careers for women, including political careers, were targeted for cuts (Sparr 1994). These developments will be more fully explored in Chapter 6 on public policy.

TABLE 2.10. CENTRAL AMERICAN EXTERNAL DEBT, 1980–1998
(BILLIONS OF U.S. DOLLARS)

Country	1980	1985	1989	1998*
Costa Rica	2.209	4.140	4.513	3.284
El Salvador	1.176	1.980	2.169	3.469
Guatemala	1.053	2.694	2.731	4.616
Honduras	1.388	3.034	3.374	5.007
Nicaragua	1.825	4.936	8.079	6.033

*World Bank 1999. World Development Indicators 1999. http://www.worldbank.org/data/archive/wdi99/home.html. Retrieved September 2003.
Source: Facultad Latinoamericana de Ciencias Sociales 1992, p. 42.

MILITARY SPENDING

Another element that contributed to the heavy borrowing was the dramatic increase in the size of the armed forces in most of the Central American countries during the conflictive decades of the 1980s and the 1990s (Table 2.11). In Nicaragua, the revolutionary Sandinista (FSLN) government was battling the counterrevolutionary *Contras*; in El Salvador, the government army fought the FMLN guerrillas; and in Guatemala, the government continued its war against URNG insurgents. The portion of the public budget spent on arms increased as well, to nearly 30 percent in some cases, to the further detriment of spending on social programs (World Bank 1999).

COUNTRY DIFFERENCES

Based on this evidence, we should have seen only a few women in any of the national legislatures of Central America, since women typically have not been elected to such posts in economically disadvantaged countries. There were clear variations among these republics, but were the differences on these structural indicators important in relation to the percentage of their national legislators who were women? For example, Costa Ricans had the highest standard of living in the Central American region, with the consistently highest GDP per person (see Table 2.8 above). Much of Costa Rica's relative advantage on structural indicators has been credited to their early adoption of public policies that required both girls and boys to attend public schools and the setting of a minimum wage for agricultural workers. Agriculture in Costa Rica in the 1980s and 1990s, while still occupying over half (57 percent) of the land, employed only about one-fifth of

the labor force, and was not relied upon for GDP to the same extent as in the other countries in the region (Valdés and Gomáriz 1995; World Bank 1999). In the 1980s, tourism was beginning to contribute more to Costa Rica's economy than agriculture. Costa Rica still had class distinctions, concentrations of land, inequalities in incomes, a rising poverty rate, and other problems. Nevertheless, based on its GDP per capita, we would expect Costa Rica to have the highest proportion of women in the national legislature of all the Central American countries. It did, and it sustained that higher percentage the most consistently over time.

Due to a relatively high birth rate, El Salvador had a consistently low ratio of GDP per capita. With nearly 2 out of 5 Salvadorans below the age of 15 during this period, the GDP had to increase just to maintain the standard of living, to say nothing of keeping up with the devastating effects of inflation. El Salvador's international debt nearly doubled from 1980 to 1989, and tripled by 1998. This inability to increase GDP per capita was due in part to the civil war, which pitted the Salvadoran military against the FMLN forces. During the civil war, a great deal of infrastructure was destroyed, and a climate of uncertainty was created that both prompted national capital flight and limited international capital investment. Agriculture still occupied 64 percent of the land, employed 2 out of 5 workers, and contributed substantially to GDP. Half of all households lived in poverty, and the bottom 10 percent of the population collected only 1.2 percent of the total national income (FLACSO 1992; Valdés and Gomáriz 1995; United Nations 1998; World Bank 1999). El Salvador also increased

TABLE 2.11. NATIONAL DEFENSE

	Costa Rica	El Salvador	Guatemala	Honduras	Nicaragua
Persons in National Defense					
1985	8,000	48,000	43,000	21,000	74,000
1995	8,000	22,000	36,000	18,000	14,000
National Defense as % of Budget					
1985	2.8	29.1	17.0	14.0	26.2
1995	2.7	7.4	14.2	8.7	5.2

Source: World Bank 1999. World Development Indicators 1999. http://www.worldbank.org/data/archive/wdi99/home.html, p. 294–297.

the size of its armed forces in the 1980s as well as the percentage of the budget dedicated to national defense during the civil war. This structural profile did not auger well for women to be elected to the national legislature in El Salvador; as might be expected, their percentage did not reach double digits consistently until 1994.

Given the structural indicators for Guatemala, as a largely agricultural and rural nation, it would not be expected to have a high number of women in the national legislature. Agriculture occupied 41 percent of the land, employed more than half (58 percent) of the labor force, and generated almost a quarter of GDP. But worldwide recession and lower prices for agricultural products produced an economic crisis. The Guatemalan government responded with austerity measures (SAPs) that left 56 percent of the population living below the poverty level. With over 44 percent of its population under age 15, a falling GDP per person, and rising inflation, Guatemala's situation was compounded by a high level of foreign debt and exacerbated by high levels of expenditure on national defense. Guatemala also had the most unequal distribution of income of any of the Central American republics. The top 10 percent of the population received almost half the national income, while the bottom 40 percent received less than 8 percent (FLACSO 1992; United Nations 1998; World Bank 1999; Valdés and Gomáriz 1995). As might be expected, Guatemala had one of the lowest percentages of women in its national legislature among the countries in the Central American region. Indeed, the proportion of seats occupied by women hovered between 3 and 5 percent during this period.

Honduras has historically been the poorest country in Central America. In the western hemisphere, only Haitians historically fared worse than Honduras in terms of poverty, landlessness, illiteracy, unemployment, and disease. A land reform program that might have improved this situation was adopted by the Honduran Congress in the 1970s, but implementation was frustrated both by its numerous loopholes and by resistance from landowners. Land occupations that erupted in the 1980s were crushed by the military. Only a small amount (32 percent) of the land in Honduras is suitable for agriculture, yet it still occupied 37 percent of the labor force, produced 18 percent of GDP, and furnished 45 percent of the total export dollars. Coffee never succeeded here as in the other Central American countries; rather, land in Honduras was primarily used for grazing beef cattle, a fairly lucrative export commodity. Scarce natural resources such as forests were disappearing due to the practice of slash

and burn agriculture and to the use of wood as the sole source of energy for most rural homes. With the second lowest GDP in the region, Honduras had little with which to improve its ratio of GDP per person. In addition, Honduras sustained one of the highest rates of population growth in the region, due both to a high birth rate and to an influx of refugees from its war-torn neighbor, El Salvador. Nearly 45 percent of the population was under age 15 in 1997 (FLACSO 1992; United Nations 1998; Valdés and Gomáriz 1995; World Bank 1999). The problem of population growth in Honduras was further exacerbated by the sizeable influx of counterrevolutionaries (*Contras*) from Nicaragua.[17] Although it did not suffer the runaway inflation of the other Central American countries, it still had a high level of external debt. In 1992, roughly 47 percent of the population subsisted on less than $1 per day (World Bank 1999). Honduras continued to maintain a large armed force and to spend a large percentage of its budget on national defense, both because of the military's perceived threat of Communism and strident anti-Communist stance and because the military had complete control of its own budget and administration. There was little in theory to promote the election of women to its national legislature, which was reflected in actuality.

By the 1980s, many of these adverse events had occurred in Nicaragua as well. The little infrastructure that survived the 1972 earthquake or the bombing by Somoza during his overthrow in 1979 fell to the low-intensity warfare of the *Contras*. Farms that had barely recovered from the revolution were now losing agricultural production under *Contra* attacks. Nicaragua was the most urbanized of the Central American countries, but it still depended to a great extent on traditional agricultural exports. Over half the land (56 percent) was still dedicated to crops or pasture, employed 31 percent of the labor force, and furnished 34 percent of total GDP. Yet much productive agricultural land was abandoned under *Contra* attacks as the frightened population fled to the cities. This loss of a valuable source of GDP was compounded by a rise in population. In 1997, almost half the Nicaraguan population was under age 15, which reduced the ratio of GDP per capita (FLACSO 1992; United Nations 1998; Valdés and Gomáriz 1995; World Bank 1999). Even with international aid, half its households were living in poverty. As noted previously, its currency became nearly worthless, and inflation soared to unbelievable heights. Nicaragua went deeply into debt, spending more than one-quarter of its total budget on the military in 1985. Nicaragua fell

into the unenviable position of competing with Honduras to become the poorest country in the region. Despite this negative structural profile, Nicaraguan women were reaching among the highest proportions of seats in the national legislature of any of the countries in the region, albeit concentrated within just one leftist political party, the FSLN.

From this discussion, we can see that national-level data such as GDP, the ratio of GDP to population, and level of urbanization cannot by themselves provide a consistent explanation of why some countries in Central America have twice as high a percentage of women serving in national legislatures as other countries. This may be for two reasons. First, with data from only five countries, it is not possible to reach a definitive conclusion about the effects of structural indicators on the proportion of women in the national legislature, at least not in any statistical sense. Second, all Central American countries score on the low end of the scale relative to the Latin American region as a whole (or to more-developed countries), so there is relatively little variation among them on these measures.

To gain more insight into whether differences in structural-level indicators among Central American countries can be useful in explaining differences in the proportion of their national legislatures that are female, we now turn to more direct measures of differences among these countries in terms of development, specifically the level of education of the population (especially of women), the strength of women's participation in the paid labor force, and the presence of women in professions that lead to success in politics.

EDUCATION

Countries where women have higher levels of education tend to have more women in their national legislatures than countries where women have less education (see for example Carroll 1985; Caul 1997; Darcy, Welch, and Clark 1987; Haavio-Mannila et al. 1985; Jaquette 1976, 55–76; Rule 1992). Overall, the educational levels of most Central American women would not seem favorable to their election to national legislatures. Not only do women's educational attainments on average lag behind those of the Latin American region, but the absolute levels attained by women are generally low compared with more-developed countries (Table 2.12). In Central America in 1990, the majority of women had only a primary school education or less, and many women remained illiterate; the situation was even worse

TABLE 2.12. EDUCATION OF WOMEN IN CENTRAL AMERICA, 1990

	Costa Rica	El Salvador	Guatemala	Honduras	Nicaragua	Latin America
% Women Illiterate	6.9	30.0	47.8	29.4	24.1	14.6
Years of School %						
None	5.8	33.1	54.4	—	27.8	16.3
1–6	54.2	58.3	34.0	—	41.5	49.3
7–12	28.1	6.6	10.4	—	26.9	26.2
13+	11.9	2.0	1.2	—	3.8	8.2
Total	100.0	100.0	100.0	—	100.0	100.0
Women as % of						
All College Students	45	31	—	43	—	48
% GDP Spent on						
Education	6.0	2.0	1.3	4.5	6.1	3.2
Spending per Person						
(U.S. $) on Education	88	13	12	29	38	48
Percent Change in $						
Spending 1970–1990	114.7	−37.9	−29.9	57.5	69.5	46.5

Source: Valdés and Gomáriz 1995. Percent women illiterate (all 1990, except Nicaragua 1992), p. 99; educational levels (Costa Rica 1992, El Salvador 1980, Guatemala 1981, Nicaragua 1992), p. 101; percent of college students who are female (circa 1990), p. 108; percent GDP spent on education (circa 1990), p. 30; spending per person on education (circa 1990), p. 30; percent change in spending (1970–1990), p. 30. Latin American average computed by the author from the same source.

among women of indigenous heritage. Although public education is nominally free, students must pay for transportation, textbooks, uniforms, lunches, and other fees that put schooling beyond the reach of many families; in addition, any earnings the child might produce from formal or informal employment to meet the family's basic needs must be foregone. If there is only enough money to send one child to school, generally a male child will go. Even if there is enough money for more than one child, girls have traditionally been kept home from school to help the mother with household chores or child care; even girls who attend school drop out to help out at home more often than boys do. Government support for public education varies across the region from a high of 6 percent of GDP in Costa Rica and Nicaragua to a low of 1.3 percent of GDP in Guatemala (compared with a regional average of 3.2 percent for Latin America). Even though Costa Rica and Nicaragua spent the same proportion of GDP on education in 1990,

the absolute dollar amount per person was higher in Costa Rica ($88) than in Nicaragua ($38) because of the difference in the total value of GDP. Over the long run, El Salvador and Guatemala actually reduced their spending per person on public education (again, both were still involved in civil war in 1990). Some public spending supported adult literacy classes, but women did not benefit fully if these programs were aimed at people in the formal labor force or conducted at night, since women tended to work in the informal labor force and/or were constrained by custom to remain home in the evenings.

However, there were many differences among women across Central American countries in 1990, and even some differences among different groups of women within the same country. Costa Rica had the lowest percentage of illiterate women (6.9 percent), and Guatemala had the highest (47.8 percent, reaching 63 percent among Mayan women). The same ranking holds true for the proportion of all women who completed one or more years of college, which reached 11.9 percent of Costa Rican women but only 1.2 percent of Guatemalan women. One reason may be that Costa Rica spent the highest proportion (6 percent) of its GDP on education—by constitutional mandate—while Guatemala spent the lowest (1.3 percent). If election to higher office is facilitated by higher education, Costa Rica provided the most opportunities for women in terms of women's literacy, years of education, women as a percentage of all college students, percent of GDP spent on education, and spending per person on public education, while Guatemala provided the fewest. Education therefore would seem to be an important indicator of the election of women to the national legislature, as Costa Rica consistently had the highest levels of both education and election of women while Guatemala consistently had the lowest. However, there were numerous other, important differences between these two countries (e.g., the presence of indigenous populations) that complicated the relationship between education and women's election (Saint-Germain 1993a). The effects of women's social class on election will be discussed in Chapter 3.

LABOR-FORCE PARTICIPATION

Another structural explanation considers the presence of women in the paid, formal work force to be related to the presence of women in the national legislature (for example, Caul 1997; Jaquette 1976; Randall 1987; Rule 1987). The working life of most women in Central America did not bode well for the representation of women in their national legislatures. Official statistics showed less than one-third of

all women working in the formal, paid labor force in Central American countries in 1990, from a low of 15.6 percent in Guatemala to a high of 32 percent in Nicaragua (Table 2.13); the average for the Latin American region was 27.2 percent. When women did go to work outside the home, they began at very young ages. Some countries' statistics include girls as young as 10 years old when computing the percentage of economically active women, while others use 12 or 15 as the minimum age. In all, working women and girls made up about one-quarter of the formal, paid labor force in Central America. Although difficult to measure, women were generally regarded as having higher rates of unemployment and underemployment than men in Central America (García and Gomáriz 1989). Many women were employed only in part-time jobs, were working fewer hours than they liked, or were working in jobs for which they were overqualified.

Many women who work, however, whether inside the home or outside it, do so as part of the informal sector of the economy. The informal sector includes goods and services exchanged through barter, through remuneration that is not reported or taxed, or by illegal means. It may include such things as unlicensed child care, street vending, informal trading, fly-by-night businesses, making and selling things from home, rides in private cars or trucks, day laborers paid in cash (e.g., gardeners), dealers in contraband, unregistered sex workers,[18] and the like. Few countries are able to measure in any detail the number of female participants in the informal sector or the contribution they make to the national economy, but estimates during this time period ranged from 38 percent of all women in Costa Rica to 57 percent in Nicaragua (García and Gomáriz 1989). Thus a great number of women's contributions to the gross domestic product were unreported, unregulated, and poorly paid. In addition, women in the informal sector are not entitled to paid maternity leaves, or any of the other protections of labor law, social security coverage, or the right to sue for mistreatment. In most Central American countries, women working in the informal sector could not establish the types of resources, networks, or career paths that would lead to elected office (although Nicaragua proved to be an exception, as will be discussed later).

Finally, more than half of the Central American population was still rural during this era. The old saying that "a man may work from sun to sun, but a woman's work is never done" was certainly applicable to women in Central America. In rural areas, for example, the male head of the family traditionally received the wages earned by

the woman's (and the children's) seasonal agricultural work, such as harvesting coffee or cotton; in fact, women's names seldom appeared on the employee roster. Other work women do, especially for family survival, is mostly unpaid. Traditionally, it is assumed that men work outside the home and women keep house, but rural women's reality is quite different from that of urban women. In addition to all the work required for subsistence farming, rural women have primary responsibility for fetching and carrying water and firewood; growing grains, fruits, and vegetables for household consumption; raising chickens, goats, and other small animals; and producing products for family members such as clothing. Many rural women are *de facto* heads of household during at least some part of the year, while rural men migrate to seasonal agricultural jobs (Deere 1995). Rural women may work as many as 18 hours a day in the home and the family garden as well as in family croplands. Rural women may also leave the home to work for pay at seasonal or temporary jobs on other farms. Yet rural women—and their work—have traditionally been undervalued. Their farming work tends to be seasonal, non-remunerated, and considered part of their household chores. Within the family, the man and the male children often receive the best food and the opportunity to go to school because it is assumed that they are or will become the family breadwinners. In sum, whether urban or rural, employed in the formal or informal sector, or engaged in rural subsistence agriculture, there was little in the way of women's work that would be thought of as favorable to women's election to national legislatures during this time.

PROFESSIONAL AND MANAGERIAL OCCUPATIONS

Is the presence of women in the national legislature related to the distribution of working women by sector of the economy (agriculture, industry, or services) or by occupation, and especially in professional, managerial, and administrative jobs? Some studies have shown that because legislators in general around the world are most often drawn from these occupations, having more women professionals, managers, and administrators means there will be more women in the "pool" from which to select people for legislative office (see Caul 1997; Norris and Lovenduski 1995; Thomas 1994). Few Central American women, however, were found in managerial or administrative occupations. Most women working in Central America were employed in the service sector; about one-quarter in industry; and about 5 percent in agriculture

(although this may be underestimated, as women's formal employment in agriculture for pay was often not recorded and much women's informal work in agriculture was unremunerated) (see Table 2.13 above). The occupational categories of personal services, artisans or skilled workers, and commercial or vending work accounted for the bulk of working women. About as many women worked as office clerks or as maids as worked in professional or technical occupations. The pattern of women's labor-force participation in Central America was generally close to the average for the Latin American region, in both the proportion of women working and their distribution among sectors and occupations.

The proportion of women in the types of occupations considered favorable to election (professional, managerial, or administrative) did not closely correspond to the proportion of women in the national legislature in any given country. For example, in 1990 both Costa Rica and Guatemala had similar percentages of women in professional and technical occupations (15 percent), but vastly different percentages of women in their national legislatures (12.3 percent versus 5.2 percent). However, none of the Central American countries approached the extent of or the patterns of labor-force participation by women in more-industrialized countries, seemingly affording women little opportunity for seeking and obtaining high elected office. Regional differences on structural indicators of women's status offer little help in explaining why some countries have more women in the legislature than do others.

SOCIO-CULTURAL EXPLANATIONS

There are several political, social, and cultural factors thought to promote or hinder women's presence in national legislatures, such as the values of the government; the presence of a crisis, women's pressure groups, or a strong women's movement; women's quality of life; and the presence or absence of strong religious influence and *machismo.*

SOCIAL DEMOCRATIC GOVERNMENT

The values underlying the principles of government and political culture prevailing in a nation, for example liberal democratic or social democratic,[19] individualistic or egalitarian, are thought to be associated with the election of women (Caul 1997). Liberal democracies are not the only configuration favorable to women; in fact, social democratic countries have often had higher proportions of women in

TABLE 2.13. WOMEN'S LABOR FORCE PARTICIPATION IN CENTRAL AMERICA (1990s)

Country	CR	ES	GU	HO	NI	Latin America
% Women Working Outside the Home	21.3	24	15.6	21	32	27.2
Women as % Total Labor Force	22.1	25.7	20.8	17.8	34.4	28.1
% Women Workers by Sector:						
Agriculture	5.5	2.7	16.0	5.7	—	8.3
Industry	25.0	22.4	22.8	22.9	—	17.8
Services	69.5	74.9	61.2	71.4	—	73.9
Total	100.0	100.0	100.0	100.0	—	100.0
% Women Workers by Occupation:						
Prof/Technical	15.1	8.5	15.0	11.5	—	15.5
Mgr/Admin	2.6	0.4	1.8	1.3	—	2.0
Office Worker	13.8	10.4	17.0	5.9	—	15.3
Commercial	12.0	31.3	25.8	26.9	—	21.1
Agriculture	4.7	2.5	0.3	4.8	—	4.7
Artisans	21.7	23.5	18.4	22.9	—	15.1
Personal Svcs.	29.3	23.0	21.0	26.7	—	26.3
Total	100.0	100.0	100.0	100.0	—	100.0
% Working Women Who Are Maids	15.7	—	18.1	16.4	—	16.1
% Women Workers Informal Sector*	38	33	30	—	57	n/a
Maternity Leave for Women**	4 months	12 weeks	80 days	10 weeks	12 weeks	—
% Wages Covered by Maternity Stipend**	100	75	100	100	60	—
Maternity Stipend Payor(s)**	Soc Sec & Firm	Soc Sec	Soc Sec & Firm	Soc Sec & Firm	Soc Sec & Firm	—

*García and Gomáriz 1989. Data for each country collected, respectively, from pages 51, 122, 205, 266, and 339.

**United Nations 1999. Table 5.4, Maternity Leave Benefits, Early 1990s, http://www.un.org.

Source: Valdés and Gomáriz 1995. Percent of women working outside the home (1990), p. 67; women as percent of labor force (1990), p. 69; distribution of working women by sector (Costa Rica 1992, El Salvador 1990, Guatemala 1989, Honduras 1990, Nicaragua 1990), p. 79; distribution of working women by occupation (1990), p. 83; percent women working as maids (1990), p. 94.

their national legislatures than liberal democratic countries. In many instances, countries changing from social to liberal democracies (for example, in Central and Eastern Europe) saw a stark decrease in the proportion of women legislators (see Beilstein and Burgess 1995; Jaquette and Wolchick 1998; Rai, Pilkington, et al. 1992; Wolchick and Meyer 1985). In Central America, a social democratic government occurred only once in Guatemala (1940s) and once in Nicaragua (1980s), and only for a short time in each case. It is difficult to assess the impact of a social democratic government on women's representation in Central America because the government in Guatemala was overthrown shortly after women got the vote, and the Sandinista government was voted out of office after only six years and replaced by non-Socialists. Nevertheless, the brief duration of these governments did result in the adoption of some public policies that were favorable to women (discussed later in Chapter 6). The reintroduction of social democratic governments might be advantageous to the election of women in Central America in theory, but there is little evidence on whether it would work in practice.

CRISIS

Another political condition that can increase the representation of women is the presence of a crisis. Crisis can include economic depressions, natural disasters, epidemics of disease, and shocking scandals, as well as armed conflict. During a crisis, there is a time when politics as usual is suspended, and new and creative ideas may emerge. For example, rules governing elections may be rewritten, new political parties may emerge, or traditional power arrangements may be undone. In the resolution of the crisis and the transition to new formal rules, there is an opportunity to negotiate new political understandings and power arrangements before society rebounds back into a relatively rigid state. The presence of a social, political, or economic crisis—practically endemic in the years covered by this book—did furnish women unique opportunities for political participation, especially in Nicaragua and El Salvador, and provided one of the chief reasons why the women interviewed for this book became involved in politics (discussed more fully in Chapter 3). Yet all too frequently women—who are so active in the unfolding of the crisis—have been shut out of the transition process so that the resulting new political configuration is no more favorable to women than the old one (again, countries in Central and Eastern Europe provide numerous examples). Chapter 5

will discuss the participation of women in the political crises of the last decades of the twentieth century in Central America, especially women's contributions to the process of democratization under way in the region. It remains to be seen whether women's electoral gains in the region will persist under post-crisis conditions.

WOMEN'S MOVEMENT

The higher a woman's social status within a given country, the more likely women are to be elected to national office, other things being equal (Nuss 1985; Caul 1997). Women often have higher social status in countries where there was an assertive campaign for the right to vote, and where there is a longer tradition of women's suffrage (Beilstein and Burgess 1995). In Central American countries, however, campaigns for votes for women were not widespread.

According to Elsa Moreno (1997, 17), the following events in El Salvador were typical of the countries in the region. The first activity was undertaken by one well-known woman who sued (unsuccessfully) to be allowed to vote in 1930. In 1939, the military ruler in power called for an assembly to draft a new Constitution, which included women as citizens with voting rights for the first time. However, the regulations necessary under Salvadoran law to implement these rights were not drawn up until another constitutional reform, in 1950. Women's groups organized toward obtaining suffrage did not emerge until around the end of World War II.

In Central America the vote for women was not obtained generally until the 1940s and 1950s because repression and isolation of women had frustrated formation of strong suffrage movements. When women did receive the vote, it was in the interests of ruling authorities to be seen as keeping up with modern trends in democratization and the international recognition of women's rights as well as to pursue the political possibilities represented by women as a new, large voting bloc. Guatemalan women received the vote in 1945, from a reformist president. Women in Costa Rica gained the vote in 1949, after a brief civil war ushered in a new president who undertook constitutional reforms. A military junta gave women the vote in El Salvador in 1950. Nicaraguan women were awarded the vote in 1955 by the military dictator Anastasio García Somoza; and Honduran women gained suffrage in 1955 from an appointed Council of State (Fernández Poncela 1997, 36–51). Gaining the vote was not immediately advantageous to

women's representation in the national legislature. Differences in the mode of gaining the vote do not help to explain the differences between Central American countries in the percentage of the legislature that is female.

Another political factor associated with higher proportions of women in national legislatures today is the concurrent presence of strong women's pressure groups or a successful women's movement on a national level (Caul 1997; Craske 1999). Women's pressure groups can take direct action to increase women's numbers in targeted elected positions. Women's movements can expose women to the world of politics, offer opportunities for leadership, and create pathways to political office. These organizations can be critical for women shut out of leadership positions in traditional groups or organizations that traditionally furnish candidates for political office, such as political parties, labor unions, professional associations, businesses, universities, cooperatives, and the military. Organizing in pressure groups or as a movement can present women with visibility, resources, and other opportunities that mostly male groups traditionally provide to their membership. In the past, women's groups and movements in Central America did not greatly affect the presence of women in the national legislature. One reason was that women's groups, like most of the rest of civil society, were suppressed for many years under dictatorships, martial law, and civil wars. Another reason is that women's groups often focused on issues of sheer physical survival for themselves and their families. Third, women's groups that derived their legitimacy from their status as mothers, or from their opposition to authoritarian regimes, were expected to return to the home once the regime was toppled and the crisis subsided. And even women's groups in social democratic Nicaragua were urged to focus their energy on preserving the revolution first, putting gender concerns aside until the right moment should present itself. Nevertheless, Costa Rica had the longest tradition of women's activism in the region, and it had the highest proportion of women in the legislature. Nicaragua is probably second on both counts, although this is difficult to measure. These two countries where women's movements developed earlier and more strongly have higher proportions of women in the national legislature than the other three countries (El Salvador, Honduras, and Guatemala), where these movements developed much later and/or were less robust.

QUALITY OF LIFE

The social status of women in any given country can also be judged by current indicators of women's quality of life. For example, countries with longer life expectancies for women and fewer children per woman tend to have higher percentages of women in the legislature (Rule 1998). Life in Central America could not have been easy during the 1980s and 1990s, since the life expectancy for women in the three countries with civil wars fell below the Latin American regional average of 71.4 years (Table 2.14). Honduras tied the regional average; only Costa Rica substantially exceeded it, with 78.8 years. Central American women tended to have more children than the average for all of Latin America, except for Costa Ricans. For the Central American region as a whole, the average number of children per woman decreased from the 1950s to the 1990s (Table 2.15), but childbearing remained a nearly universal female experience, regardless of the woman's marital status.[20] Compared with other studies (Waring 2000), such a high average number of children per woman would militate against Central American women's election to national legislatures. Death from childbearing (maternal mortality) was still common, greatly exceeding the Latin American average in Guatemala and Honduras; fewer than half of all births were attended by a health-care provider, except in Nicaragua (67.6 percent) and Costa Rica (96.4 percent). Infant mortality was low only in Costa Rica. Use of contraception fell below the heavily Catholic Latin American regional average in Guatemala, Honduras, and Nicaragua, even when considering any possible method (including sterilization, IUD, pills, injections, abstinence, rhythm, withdrawal, and folk recipes).

The elements that contribute to a longer—as well as a higher quality of—life were scarce during these decades. For example, barely half the people in El Salvador had access to safe drinking water, although three-quarters had access to sanitary facilities (including flush toilets, latrines, outhouses, etc.). However, there was much disparity within the country, as 95 percent of the urban population had access to safe water, whereas only 16 percent of the rural population had access (Valdés and Gomáriz 1995, 118); the situation was similar with access to health care. With much of their life spent in having and caring for children under challenging conditions, most Central American women would not have been expected to pursue education, employment outside the home, or political involvement that could result in their election to the national legislature.

TABLE 2.14. WOMEN'S HEALTH STATUS INDICATORS IN CENTRAL AMERICA (1990s)

Indicators	Costa Rica	El Salvador	Guatemala	Honduras	Nicaragua	Latin America
Women's Years of Life	78.7	68.8	67.3	70.1	68.5	71.4
Average Births per Woman	3.1	4.0	5.4	4.9	5.0	3.1
Infant Deaths per 1,000 Live Births	13.7	45.6	48.5	43.0	52.2	38.0
Maternal Deaths per 100,000 Live Births	40	140	220	220	150	123.9
Births Attended by Health Worker (%)	96.4	31.8	28.0	45.6	40.3	67.6
% Women Using Contraception	68.0	47.3	23.2	34.9	27.0	44.5
% Pop. with Access to Safe Water (%)*	100	53	67	77	62	75
% Pop. with Access to Sanitation*	97	77	67	82	59	68
% Pop. with Acces to Health Care*	100	53	67	77	62	n/a

*World Bank 1999. World Development Indicators 1999. Table 2.14: Access to Health Services. http://www.worldbank.org.

Source: Valdés and Gomáriz 1995. Women's life expectancy (1990–1995), p. 115; average births per woman (1990–1995), p. 44; infant deaths per 1,000 live births (1990–1995), p. 126; maternal deaths per 100,000 live births (Costa Rica, Guatemala, and Nicaragua 1992, El Salvador 1991, Honduras 1990), p. 131; births attended by health worker (circa 1991), p. 130; women using any contraception (Costa Rica 1986, El Salvador 1985, Guatemala 1987, Honduras 1984, Nicaragua 1981), p. 133. Latin American average computed from the same source.

Nevertheless, there were differences among these Central American countries that tended to support the quality-of-life hypothesis. Costa Rica consistently had the longest life expectancy for women, the fewest children per woman, fewest infant and maternal deaths, highest proportion of births attended by a health worker, the most women using contraception, and best access to water, sanitation, and

TABLE 2.15. AVERAGE CHILDREN PER WOMAN IN CENTRAL AMERICA

Country	1950–1955	1970–1975	1990–1995
Costa Rica	6.7	4.3	3.2
El Salvador	6.5	6.1	4.0
Guatemala	7.1	6.5	5.4
Honduras	7.5	7.1	4.9
Nicaragua	7.4	6.8	5.0

Source: Valdés and Gomáriz 1995. *Mujeres Latinoamericanas en cifras: Tomo comparativo.* Santiago, Chile: Facultad Latinoamerica de Ciencias Sociales (FLACSO) and Instituto de la Mujer, Ministerio de Asuntos Sociales de España, p. 44.

health care, as well as the most women in the legislature. Guatemala had the shortest life expectancy, the most children per woman, higher than average infant and maternal deaths, lowest proportion of births attended by a health worker, and the worst access to water and health care, as well as the fewest women in the legislature. It may be that even small differences on these indicators can be related to the election of women in developing countries, whereas this little variation would not be significant in more economically advanced countries.

MACHISMO

In Central America during the 1980s and 1990s, many cultural factors were present that have been found in previous research to mitigate rather than promote women's election (see Rivera-Cira 1993, 27–38). The strength of traditionalism; the dominance of the Catholic religion; the authoritarian, centralized, and patriarchal nature of the state; *machismo*; and the vigorous suppression of civil society (except in Costa Rica) throughout much of the history of Central America have all worked against the election of women to national legislatures. The perpetuation of *machismo* may be subconscious as well as conscious and may occur among women as well as men, said Costa Rican legislator Mireya Guevara from the centrist National Liberation Party (Partido de Liberación Nacional, or PLN) in 1989:

Education [of children] in the home is also important, by the mother as much as by the father. Costa Rica is practically a matriarchy; here the mother is very powerful. The child leaves the mother's lap and goes to school where about

90 percent of the teachers are women. Yet mothers and teachers say, "The boy is a man. He can't wash the dishes; he can't cook; he can't clean or make his bed." (Guevara 1989)

Cultural patterns such as *machismo* that discriminate against women can have concrete results, such as lower levels of educational attainment for women, which are disadvantageous for the election of women, as María Ramírez, an elected Nicaraguan legislator from the leftist Sandinista party, commented in 1990:

I think we have to start with the characteristics of this society and the fact that while there have been advances in combating *machismo* during the 10 or 15 years since the [1979] revolution, the reality is that you can't get rid of it overnight. And there are still many, many residues from the Somoza era, and what the Somozas represented in terms of *machismo*. So we have not been able to establish, in general terms, proper relationships for couples at this time. Inequality remains. There is injustice. There are still many problems for women. (Ramírez 1990)

This appreciation of the influence of *machismo* crossed party lines. Carmen Elena Calderón de Escalón, a legislator from the right-wing ARENA party in El Salvador, gave this specific example in 1993 of how *machismo* directly affected women's political participation:

Because of our *machismo*, we have certain problems. For example, in the Department of Santa Ana there are some towns that are *machista*, where to this day the *campesino* still doesn't let his woman go to vote. So we started [a campaign] to educate *campesinos* that women have to be on a par with men in the struggle to save our country. (Escalón de Calderón 1989)

One extreme example of the insidiousness of *machismo* was provided in 1988 by a Nicaraguan political activist who had put up with domestic violence from her husband while he carried out clandestine activities for the FSLN during the years leading up to the 1979 revolution. She had believed she needed to support the revolution no matter what, and that this domestic violence was her own personal problem instead of a widespread consequence of the culture of *machismo*.

My husband would hit me for the least little thing. He would return home from his clandestine activities with accusations, saying "You are sleeping with so and so." A blow. Sometimes there wasn't any food ready when he got home. Another blow. He hit me for anything and for everything. I wanted a father for

my children so I never fought back. I just cried and didn't say a word. (Woman legislator, 1988)

The institution of the Catholic Church continues to be a strong influence in Central American society, both through custom and in some cases through its legal status as the official state religion. In some countries, priests were still paid a yearly salary by the government even after independence from Spain. In the words of one of the older women in the national legislature in Costa Rica, Norma Jiménez, in 1989:

Christian principles are very deeply rooted here, and since the Roman Catholic Apostolic religion is the official religion, we have been brought up under those principles in which priests and teachers are the highest authorities in the community and the most important people in our *campesino* society. (Jiménez 1989)

Costa Rican Alda Facio, an internationally known lawyer and scholar, elaborated in 1989 on how the traditional Catholic Church has perpetuated women's secondary status in society.

The Catholic Church insists on the subordinate role of women and that the peace of the household depends on women's submission and silence. [In Costa Rica] the church is traditional, conservative, and hierarchical; not like liberation theology. Many battered women report that they first went to the priest to talk about the problem and were told, "You must bear it, my child. It is your cross to bear." Instead of trying to solve the problem, the priest tells her to hang on because she will be rewarded [in the next life]. (Facio 1989)

Many of the dominant political, social, and cultural values in Central America have generally been perceived to be unfavorable for women seeking high elected office. Previous research has compared countries where these values, e.g., Catholicism, were present (or strong) to countries where these values were absent (or weak), using a simple coding scheme such as present = 1 and absent = 0. However, all of these values were present to some extent in Central American countries in the 1980s and 1990s. More sophisticated quantitative measures of these cultural factors (traditionalism, Catholicism, patriarchy, and so forth) that would distinguish their relative strength or weakness in one or another of the Central American republics are lacking. Nevertheless, the presence of women in the national legislatures of these countries has varied, both within each country and

across countries over time. These dominant values may bode poorly for women's election to national legislatures in theory, but their influence is far from deterministic across this region in practice.

CONCLUSION

Certainly the electoral systems of the Central American republics provide the most positive elements favoring the election of women: proportional representation, party lists, multiple-member districts, relatively low incumbency rates, women's sections of political parties, and even a few left-of-center parties. Women candidates are more successful in relatively large electoral districts than in medium districts (where the outcome is uncertain) or small districts (where women are few). The political party instability typical of Central America has reduced the negative effects of incumbency that usually militate against women candidates. Having one or two large political parties that persist over numerous election cycles can be advantageous for individual women if they are successful at moving up within the party, and for women in general if they are successful at organizing to promote women's candidacies within the party.

It is difficult for individual women to counteract structural factors that bode against women's election, such as low levels of GDP per person and high rates of poverty. Nevertheless, women can support educational programs for girls since higher levels of education are related to higher levels of women legislators. Women can also organize to insist that they be included in economic development projects and to resist the imposition of structural adjustment policies that discriminate against women.

The impact of socio-cultural factors on the election of women is mixed. The positive factors of social democratic government, egalitarian norms, and women's activism in some cases have prevailed over the negative factors of *machismo* and low levels of quality of life. The presence of a crisis can also provide opportunities for women to enter the "pool" from which political candidates are most often drawn, allowing them to overcome the barriers that have traditionally kept them out.

However, with only five countries, it was not possible to provide a definitive assessment of the relative importance or contribution of electoral factors compared with structural or social factors to the election of women to national legislatures. For now, we cannot say with confidence that there is one particular electoral feature or one

specific structural indicator that definitively helps women get elected in Central America, just as we cannot point to any one cultural value that deterministically hinders their election uniformly across the region (or vice versa). Rather, some trends were suggested that will require future studies. One direction points to the need for the development of more sophisticated ways of describing qualitative differences among countries on socio-cultural factors. Another direction points to the need for larger samples of countries that would be required for quantitative hypothesis testing.

CHAPTER 3: ELECTED WOMEN'S PATHS TO POWER

> When I was elected, I won precisely . . . because of my merits . . . for the capacity, the force, the dynamism that I put into the process of getting to be a representative. Because I don't think that you have to give a woman all kinds of privileges just for being a woman; no, she has to earn them.
>
> DAISY SERRANO, legislator, Costa Rica, 1990

INTRODUCTION

How did women gain election to Central American national legislatures in the 1980s and 1990s? As we saw in Chapter 2, the situations in most Central American countries during these decades were not propitious for the election of women to national legislatures. The electoral systems, in theory, were conducive to the election of women (proportional representation, party lists). However, most of the structural and socio-cultural situations mitigated against women's election, including widespread poverty and illiteracy; few women working in any occupations linked to electoral success; a lack of strong women's movements; high average numbers of children; and cultural traditions such as *machismo*. How did Central American women legislators take advantage of opportunities and overcome barriers to election? What—or who—do elected women themselves credit for helping them to get elected? We now turn to the personal

stories of the women legislators elected during the 1980s and 1990s. What prompted them to enter into politics? How early in life did they become interested? Were there differences in women's paths to power between countries, or even between different women within each country? What lessons can be learned from their stories to formulate actions in order to increase the number of women in national legislatures in the future?

COMPARISONS TO UNELECTED WOMEN

In the following pages, we present discussions of three major characteristics that typify how these elected women reached political prominence. First, they were markedly different from the majority of unelected Central American women: women in national legislatures form an elite group (although one not always based on wealth). For example, many had mothers who worked outside the home at a time when this was unusual. Second, the formative years of women legislators included politically active families as well as the development of an interest in politics at a very early age. Again, many had politically active mothers. Third, although they arrived by different paths, these women put in many years of hard work to reach the national legislature.

CLASS

As seen in Chapter 2, most Central American countries had a low ratio of GDP per capita and a high percentage of persons in poverty. Obviously, there was substantial variation among countries. But there was also some variation within each country. Central American countries tend to have great disparities in the distribution of wealth. A small upper class receives nearly half the national income; a small middle class receives about one-quarter. The remaining one-quarter covers the vast majority of the population, who are very poor.

Historically, representatives in national legislatures all over the world have tended to come from the elite (i.e., the upper or upper-middle classes); those in Central America were no exception (Rodríguez 2002; Rivera-Cira 1993; Bogdanor 1985; Boynton and Kim 1975; Kim and Patterson 1988; Mezey 1983). Gladys Rojas, a legislator in Costa Rica in 1990, described how class and wealth had figured in the traditional recruiting of representatives for the national legislature at an exclusive social club:

You know that the principal Costa Rican export product is coffee. So the big coffee growers got together in an aristocratic club and picked the candidate for president, the candidates for the legislature. They went to the towns and the one who had the most money, even if he was illiterate, he was the representative from our town or our province. (Rojas 1990)

Judging by their fathers' occupations, most of the Central American women legislators in this study also tended to come from the upper or middle classes. The women were not asked directly about their social class origins; instead, fathers' occupations served as an indirect indicator of social class (mothers' occupations are discussed further below). In general, in most Central American countries, the majority of men (60 percent) are found in working-class occupations, often as *campesinos* (itinerant farm workers) or unskilled laborers. But, in contrast, the majority of women legislators' fathers worked in professions such as business, ranching, law, medicine, or education, especially in Costa Rica (85 percent), Guatemala (80 percent), Honduras (80 percent), and El Salvador (78 percent). Few fathers in these countries were reported as being working class, except in Nicaragua, where half the women legislators' fathers were in working-class occupations (Table 3.1).

Those women legislators whose fathers were from the working class emphasized the sacrifices their parents made for them. For example, in Honduras, parents moved from rural areas—where there were no secondary schools—to the capital so that their children could get an education. Honduran Deputy Marta Delia Herrera Andrade spoke respectfully and with much appreciation for her father, who relocated but managed to still support his family. "Oh, my father, he was a laborer, *fíjese* [imagine that], a laborer; a *campesino* who came here to the city and converted himself into a laborer" (Herrera Andrade 1991). In Costa Rica, Representative Norma Jiménez explained that after her father died quite young, her mother took up work as a seamstress, sewing late into the night in order to raise her six children and ensure that they got an education; all six obtained professional university degrees (Jiménez 1989).

EDUCATION
Countries where women attain higher average levels of education tend to have more women in their national legislatures. In countries where women's average levels of education are low (e.g., Mexico), in-

TABLE 3.1. OCCUPATIONS OF WOMEN LEGISLATORS' PARENTS

Occupational Sector	Father (n = 64)	Mother (n = 65)
Farming, ranching	27%	9%
Business	22%	11%
Skilled trade	9%	0%
Activist, organizer, politics	8%	3%
Laborer, vending	8%	2%
Law	6%	0%
Education	6%	9%
Construction	5%	0%
Engineering	3%	0%
Medicine	3%	2%
Arts	3%	2%
Servant, seamstress	0%	14%
Housewife	0%	48%
Total	100%	100%

Source: Data for women legislators compiled from author's interviews with elected women legislators in Central America.

dividual women elected as representatives tend to be more highly educated than unelected women (Rodríguez 1998). In all Central American countries in the 1980s and 1990s, while most women in the population had only a primary school education or were illiterate, the educational achievements of most women legislators exceeded the national average. Many more elected women had university degrees than unelected women. This higher educational attainment for elected women held true across the countries considered here, despite differences in their ages or the decades in which they attended schools.

In this respect, Central American women legislators resembled their counterparts from other regions. A worldwide study of women legislators indicated that 73 percent had a college degree and 14 percent had graduate degrees; the minimum level was reported as a high school education or equivalent training (13 percent) (Waring 2000, 9). Detailed data from Costa Rica provide one example of the extent to which women legislators were more highly educated than unelected women (Table 3.2). In Costa Rica, nearly all women legislators (93 percent) had a bachelors or graduate degree, compared with only

TABLE 3.2. EDUCATION OF WOMEN LEGISLATORS IN COSTA RICA COMPARED TO NATIONAL AVERAGE FOR ALL WOMEN (IN PERCENTAGES)

Years of Education	National Average[a]	Women Legislators[b]
None	5.8	0
1–6	54.2	0
7–12	28.1	7
13+	11.9	93
Total	100.0	100.0

[a]Valdés and Gomáriz 1995, p. 101.
[b]Data for women legislators compiled from author's interviews with elected women legislators in Central America.

11.9 percent of all Costa Rican women; one female deputy had two Ph.D.s. The most common college majors among Costa Rican women legislators were languages, education, and social work. Similarly, most women deputies in Guatemala (80 percent) and El Salvador (60 percent) also had university degrees, although less than 3 percent of all the women in their countries did. Law was the most common major in Guatemala, while economics predominated in El Salvador among elected women.

In the remaining two countries, Honduras and Nicaragua, women legislators had less formal education than their legislative counterparts in the other countries studied here, and there was more variation in the educational attainments among women legislators within each of these two countries. Only one-third of Honduran women legislators reported obtaining a college degree, but that far exceeded the 2 percent of the total female Honduran population with degrees; legislators most often majored in business administration. More common among Honduran women deputies (60 percent) was the completion of high school or technical school, most often in secretarial or business subjects. One older Honduran deputy had completed only primary school. Another Honduran deputy, Carmen Elisa Lobo de García, a high school graduate, pointed out rather proudly that "all my brothers and sisters have university degrees except me; they all studied professions at the university, but none of them are deputies" (Lobo de García 1991).

Half of Nicaraguan women deputies reported earning a college degree, compared with about 3.4 percent of the total female Nicaraguan population. Law, education, and medicine were the most popular majors among elected Nicaraguan women. But Nicaragua was unique in the region in that 1 in 5 of its women deputies completed only a primary school education (sixth grade or less) at the time of election. Nicaraguan representative Benigna Mendiola, a leader in the agricultural sector, explained how she learned to read in her rural home in the 1950s before the introduction of widespread education:

At that time there weren't any schools in the remote rural areas. There weren't even roads; only trails, goat paths. To be honest, I only got through the first six pages of the little prayer book. After that, I didn't place much importance on reading and writing. But with the triumph of the revolution we started over, and now I can acquit myself pretty well. (Mendiola 1988)

Many of the women deputies from poor families in all the countries studied here had to overcome great obstacles to obtain even an elementary- or secondary-level education. Their families placed great value on education, for daughters as well as sons. Marcia Quezada Abarca, a Nicaraguan representative and schoolteacher, described her struggle to obtain an education.

I was in a girls' school until fourth grade, then I went to fifth and sixth grade in a boys' school. With the *machista* education that we had, they separated the sexes, but that made it worse if a girl wanted to continue her education because she had to go to the boys' school, which was embarrassing. (Quezada Abarca 1990)

One final educational difference from the general female population is that study abroad—often in Europe or the United States—was undertaken by many women legislators (again, this is consistent with their class backgrounds). An interesting (although by no means typical) story of this type was told by Ana Isabel Prera Flores, a Guatemalan legislator:

Until I was six years old, my father was the governor of various provinces, and so I lived in Puerto Barrios, Quetzaltenango, Antigua, El Quiché, and then here in the capital [Guatemala City]. When I was 8, they sent my father to be ambassador in Chile, where I lived until I was 12. Then I lived in a boarding school in Guatemala for a year until I joined my parents in the Dominican Republic. Then I came back here again to Guatemala and continued my studies.

When I was 15 I went to Boston for six months to the College of the Ursulines, then I came back here and got my high school diploma. After high school I studied law; I graduated in law from the Universidad Rafael Landivar; one year later, I got married, and we lived in Costa Rica for one year. We came back to Guatemala and I began to study pedagogy. In the middle of the pedagogy track I switched disciplines and completed a doctorate in mercantile law at the Universidad Rafael Landivar. This is around 1980; at the end of 1980 I went to London and I was there until the end of 1981. In London I went to study at the Davis School of Art where I studied art history. After London, I went to live in Madrid for 2 years. During this whole time I was married, and my husband was also studying. In Madrid I took courses in philosophy, literature, and I also took courses in gastronomy, so I also have a degree in haute cuisine. And then I came back in 1983 to Guatemala where I became involved in political work. . . . (Prera Flores 1991)

MARITAL STATUS

Women elected to the national legislatures of this region were atypical in terms of their marital status (Table 3.3). In the Central American region, half or more of the women in the population report being legally married or living in common-law marriages. The poorer the country, and the poorer the woman, the more likely she is to be in a common-law marriage rather than a legal marriage. The remainder of women report being single, separated, divorced, or widowed.

Throughout the region, women legislators were more often married than were unelected women. More than twice as many women legislators were married in El Salvador and Honduras compared with their countrywomen, nearly twice as many in Nicaragua, and 40 percent more in Costa Rica. Only in Guatemala did the percentage of married women legislators (40 percent) approach the national average for all women (37.5 percent). In this study, none of the women legislators reported her marital status as common law; all who reported that they were married phrased it as legally married, reflecting their higher class status. However, even when the countrywide averages for both married and common-law women were combined, there was still a higher percentage of women legislators who were married in Costa Rica, El Salvador, and Honduras than women in the general population; Nicaraguan legislators were nearly equal to the female population (50 percent versus 53.5 percent); only Guatemalan legislators fell appreciably below (40 percent versus 62.2 percent). The proportion of married women legislators in Central America was roughly equal to

TABLE 3.3. MARITAL STATUS OF CENTRAL AMERICAN WOMEN (IN PERCENTAGES)

	National Average for Women	Central American Women Legislators	World Average for Women Legislators
COSTA RICA			
Single	35.1	14.0	15.6
Married	45.6	64.0	61.3
Common Law	9.6	0.0	4.3
Separated/ Divorced	4.6	14.0	12.4
Widowed	5.1	8.0	6.4
EL SALVADOR			
Single	38.3	30.0	15.6
Married	24.3	60.0	61.3
Common Law	23.1	0.0	4.3
Separated/Divorced	5.4	10.0	12.4
Widowed	7.8	0.0	6.4
GUATEMALA			
Single	22.4	20.0	15.6
Married	37.5	40.0	61.3
Common Law	24.7	0.0	4.3
Separated/Divorced	6.0	20.0	12.4
Widowed	9.4	20.0	6.4
HONDURAS			
Single	23.5	19.0	15.6
Married	26.5	67.0	61.3
Common Law	26.3	0.0	4.3
Separated/Divorced	15.8	7.0	12.4
Widowed	7.8	7.0	6.4
NICARAGUA			
Single	22.0	38.0	15.6
Married	26.6	50.0	61.3
Common Law	27.1	0.0	4.3
Separated/Divorced	16.1	12.0	12.4
Widowed	8.0	0.0	6.4

Source: Central America national data from García and Gomáriz, 1989, pages 69, 143, 223, 285, and 362. Note that figures for El Salvador do not add up to 100 percent in source. Data for Central American women legislators compiled from author's interviews with elected women legislators in Central America. Data for world average for women legislators from Waring 2000, p. 9.

the proportion (61.3 percent) found in a worldwide study of women in legislatures. The regional averages for divorce (12.6 percent) and widowhood (7 percent) among Central American women legislators were also about the same as were reported in the worldwide study (12.4 percent and 6.4 percent) (Waring 2000, 9).

Women legislators in Central America were more likely to be single (24.2 percent) compared with the worldwide average of all women legislators (15.6 percent) (Waring 2000), and were nearly twice as likely in Nicaragua and El Salvador. However, the percentage of single women in Central American legislatures was about the same as the percentage of single women in the national population in El Salvador, Guatemala, and Honduras. In Nicaragua there were many more single women in the national legislature (38 percent) than in the national population (22 percent); the opposite was true for Costa Rica (14 percent versus 35.1 percent). Deputies who had never married were reluctant to elaborate on it, and for good reason. Unmarried women legislators are not exempt from the harassment that any unattached woman in Central America past the age of puberty receives. In some legislative sessions, unmarried women legislators—especially those over 40—were derisively referred to by their male colleagues as "Señorita" (Miss) Last Name. The word was given an exaggerated enunciation, as "Sen-ñor-RI-ta," delivered with winks and leers, and received with laughter on the part of the other men. The customary form of address for women over 40 is "Señora" (Mrs.) Last Name, while an even more respectful term for older women in Central America is "Doña" (godmother). Speculation on why women legislators remain unmarried ranges from loud ridicule for a perceived lack of good looks to whispered questions about sexual orientation. Only married women or a woman living with a male partner, who is seen to "belong" to a man, are treated with a modicum of respect from other men. One unmarried deputy in El Salvador, Mercedes Gloria Salguero Gross, described with almost religious fervor why she had never taken a husband; rather, she felt a higher calling:

I became a deputy in 1982 and have twice been reelected. I was also a member of the executive board of the constituent assembly and have tried to work as hard as I can for the people. I am an old maid and don't have any relatives. My mother and father died, all my brothers and sisters died, and I was left alone. So, I am committed to public service. (Salguero Gross 1990)

CHILDREN

In Central America, childbearing is a nearly universal female experience, regardless of the woman's marital status.[1] As was shown in Chapter 2, on average, all women in Central America could expect to have a high number of children in the 1980s and 1990s. There was some variation among countries in the region, with the lowest average number of children per unelected woman (3.2) in Costa Rica and the highest average number of children per unelected woman in Guatemala (5.4). Among the women legislators in this sample, the number of children ranged from a low of 0 to a high of 9.

However, most women elected to the national legislatures of Central American countries differed markedly from unelected women in their respective countries, having fewer children—or none at all. In all the countries except Honduras, from 12.5 to 40 percent of all the women legislators were childless (Figure 3.1). When a woman legislator did have children, she had fewer than the average woman in her country. Nationally, Guatemalan women had the highest average number of children per woman (5.4) of any of the countries in the region, but Guatemalan deputies averaged only 1.2 children, the lowest average in this study. Similarly, Nicaraguan women nationally averaged 5 children each, but Nicaraguan deputies averaged only

Figure 3.1. Women Legislators: Average Number of Children. Source: Interviews with Central American legislators.

half that (2.5). Women in El Salvador nationally bore 4 children, but Salvadoran deputies averaged only 1.9 children. Honduran deputies reported an average of 3.3 children, well below the national Honduran average of 4.9 children per woman. Only Costa Rican deputies, with 2.9 children each, came close to the Costa Rican national average of 3.2 children per woman.

It may be expected that women legislators would have fewer children than the national average, since the number of children tends to decline as educational level increases. For example, in 1985, women in El Salvador with no education had an average of 6.0 children, while women with 7 or more years of education had only 3.5 children on average (Valdés and Gomáriz 1995, 47). Even when the relatively high educational levels of women legislators are taken into account, however, they still have fewer children on average than other similarly situated women in their respective countries, although they had more children on average than all women legislators in a worldwide study in 2000 (Widner 2000, 9). One reason may be that while nearly all Central American women want to have children, politically active women may be reluctant to seek election to the national legislature while their children are still young. Most of the younger women elected to the national legislature were likely to put off having children until later in life. Most of the older women elected to the national legislature had postponed their candidacy until their children were finished with grade school. Two exceptions were women legislators who had unusually large families, where the children could help one another and/or rely on hired help.

For the Central American region as a whole, the average number of children per woman has decreased from the 1950s to the 1990s. Taking into account the age of the women legislators in this study, they too show a trend toward fewer children over time. According to information from the personal interviews, Central American women legislators born in the 1920s and 1930s averaged 3.5 children apiece, while those born in the 1940s averaged 2.9 children. For women legislators born in the 1950s and 1960s, the average was only 1 child each. For this last group, who were interviewed when they were 30–50 years old, it was still possible to have more children, but there was a clear trend for elected women to have fewer children than the unelected women in their respective countries. At every age group, and in every country, most women legislators tended to have fewer children than other similarly aged and similarly educated women. In this aspect,

TABLE 3.4. CHILDBEARING AMONG WOMEN LEGISLATORS
(PERCENT DISTRIBUTION)

Number of Children	Costa Rica	El Salvador	Guatemala	Honduras	Nicaragua	Worldwide Average
0	14.3	30.0	40.0	0.0	12.5	26.2
1–2	28.6	40.0	60.0	40.0	41.6	40.1
3–4	42.8	20.0	0.0	26.7	33.3	25.7
5+	14.3	10.0	0.0	33.3	12.6	8.0
Total	100.0	100.0	100.0	100.0	100.0	100.0

Source: Data for Central American women legislators compiled from author's interviews with elected women; worldwide data from Waring 2000, p. 9.

too, women elected to national legislatures in Central America are different than other women (Table 3.4).

MOTHERS' LABOR-FORCE PARTICIPATION

Most Central American women legislators come from homes that are atypical in terms of their mothers' participation in the labor force (Table 3.5). As we saw in Chapter 2, none of the Central American countries approached the rates of labor-force participation of women in more industrialized countries, seemingly affording women little opportunity for obtaining high elected office, and there was little variation in the labor-force participation rates of women in the countries considered here. However, one of the differences that set elected women apart was the much higher participation rates of their mothers in the paid labor force than the mothers of unelected women. On this theme, again, the similarities among elected women in all the countries studied here were greater than the differences between elected and unelected women in each of the individual countries.

In most Central American countries, few women are officially counted as working outside the home. In the earliest data available (1950), only about 15 percent of all women were counted as working in the formal, paid labor force. Yet half or more of the mothers of women legislators in Costa Rica, El Salvador, and Honduras worked outside the home; in Guatemala and Nicaragua this figure reached about 40 percent. Legislators born as long ago as 1915 and as recently as 1966 reported having employed mothers, so their mothers were working

TABLE 3.5. EMPLOYMENT STATUS OF MOTHERS OF WOMEN LEGISLATORS

Country	Total Female Population in Paid Labor Force (%)					Legislators' Mothers Ever in Paid Labor Force (%)
	1950	1960	1970	1980	1990	
Costa Rica	15.6	15.0	16.7	19.3	21.3	62
El Salvador	16.6	16.5	20.9	22.5	24.0	50
Guatemala	13.1	12.0	11.8	12.6	15.6	40
Honduras	–	13.7	12.3	15.8	21.0	60
Nicaragua	13.2	17.3	17.7	26.8	32.8	39

Sources: National data from Valdés and Gomáriz (1995, 67); data for women legislators compiled from author's interviews with elected women legislators in Central America.

from the earliest decades of the twentieth century. The mother was most often engaged in domestic work (14 percent), business (11 percent), farming (9 percent), or education (9 percent). These mothers expressed hopes that their daughters would have a better life, like the modest hopes of the mother of Juana Santos Roque from Nicaragua:

My mother's dream was that I work in a shop because she had to grind corn on a stone to make tortillas and had to walk to the market to sell them. She did the most menial work, and she didn't want us to have to do that. So she hoped I would become a salesgirl in a shop. "I want to see you there measuring out fabric, attending to the customers." That was her dream for me, not grinding corn to make tortillas. (Santos Roque 1988)

In sum, Central American women legislators are different from unelected women in their countries in terms of their education, socio-economic class, marital status, number of children, and having a mother who worked outside the home.

DIFFERENCES IN SOCIALIZATION

From some of the earliest writing on women and politics, a recurring theme has been how girls are socialized differently than boys and whether this difference in socialization is related to the lower number of women than men elected to national legislatures. Socialization is the general process that prepares girls and boys to live in the society

they will enter as women and men. Some nineteenth-century scholars approved of differences in socialization that resulted in women's exclusion from the business and political realms (Nuss 1985), but the opposite view is more widely expressed today, in, e.g., United Nations documents such as the Convention on the Elimination of All Forms of Discrimination Against Women (CEDAW).[2] Few studies have demonstrated significant differences in the political attitudes of children. Moreover, exposure to the wider world outside the immediate family, such as education and labor-force participation, have been found to overcome the effects of gender-role socialization in childhood (Randall 1987, 85).

In much of the writing on socialization, it is assumed that preparing a girl to adopt the accepted role for women in society is antithetical to preparing her to be an active participant in politics, since adult women are often perceived as apolitical (Craske 1999). However, in her study of Chile and Peru in the late 1960s, Chaney (1979) argued that women could parlay their roles as mothers into high elected office by becoming *supermadres,* extending their domestic roles into the public sphere. Women in Latin America successfully demonstrated that the values, skills, and interests of the private sphere did apply to the problems of the nation. This is somewhat reminiscent of the social housekeeping rhetoric of the progressive era in the United States, with its emphasis on the moral and educated mother, its crusades against what were perceived as social ills, and the establishment of the professional welfare worker.

What type of childhood socialization did women legislators in Central America experience? The following sections describe how most of them grew up in families where politics was important; how they became aware of politics at an early age; and how they also participated in politics while still quite young.

POLITICAL FAMILIES

A recent worldwide study found that women legislators describing their backgrounds "consistently commented on their family's involvement in political life" (Waring 2000, 76); Rodríguez (1998 and 2002) found the same in Mexico. There is ample support from women legislators in Central America for the finding that women who take formal positions of power grew up in political families. The majority of the women legislators interviewed in this study reported that they were influenced while growing up by a variety of family members

TABLE 3.6. WOMEN LEGISLATORS' INTEREST IN POLITICS

	Costa Rica	El Salvador	Guatemala	Honduras	Nicaragua	Average
Politically Active Family (%)	92.9	70.0	66.7	84.6	55.6	74.1
Age of First Political Interest	15.0	15.4	17.8	13.1	18.4	16.0
Age of First Political activity	21.2	17.2	17.8	14.7	19.0	18.2
Years from First Interest to Activity	6.2	1.8	0.0	1.6	0.6	2.1
Age at First Election	51.8	42.0	36.4	47.0	40.6	44.3
Years from First Activity to Election	30.6	24.8	18.6	32.3	21.6	26.1

Source: Data for women legislators compiled from author's interviews with elected women legislators in Central America.

active in politics, from a high of 92 percent in Costa Rica to a low of 56 percent in Nicaragua (Table 3.6). In Central America, some families tend to become active in politics and identified with one party over time, as Honduran Carmen Elisa Lobo de García explained:

In Central America, you begin to like politics in childhood because you hear about it in the home. My grandfather was a legislator, and then my father. Generally, it is a matter of heredity. Those who were leaders in the times of our grandparents, they were the parents of the leaders of the times of my parents, and now the grandchildren of those leaders are the leaders of my generation. And this is how these families become recognized for generations. (Lobo de García 1991)

Many of the women legislators interviewed in our study cited family influences as important factors that spawned their interest in politics. For example, one was the daughter of a vice-president. Two fathers

were ambassadors. One father was the leader of a national political party. Dozens of fathers, brothers, uncles, and male cousins had been or were legislators. One woman's grandfather served in the legislature for 40 years. Another woman reported that she was the unrecognized (illegitimate) daughter of a former head of the national legislature. Many other women reported fathers who were political party activists; some fathers ran for or held locally elected posts such as mayor. Among the women interviewed in this study, more than one had a father who had been jailed for being in the political opposition.

The women interviewed in our study did not cite any elected women relatives as influential, but most grew up in an era when their mothers were not able to vote or run for office. Nevertheless, a majority of women legislators explained that their mothers and grandmothers were political party activists and/or the person in the household most interested in politics. More recently, two women legislators had sisters serving as ambassadors. In fact, of all the deputies interviewed in this study, only one, Mercedes Gloria Salguero Gross, arguably the most successful woman politician in the national legislature in El Salvador, stated that her family had expressly voiced negative objections to political involvement or to politics as a career for any of their children:

When my brothers and I were young, my father always told us that we should never participate in politics. Never! Because, like now, politics in those times was discredited because of very corrupt politicians who had done very ugly things. (Salguero Gross 1990)

All the other women in this study, however, noted family support, acceptance, or at least an absence of opposition. This is most unusual, given the traditional association of politics with behaviors and events antithetical to values for young girls, i.e., as male-dominated, corrupt, sordid, dirty, dangerous, etc. It is also quite unusual for women to pursue professional careers or public office without family support. One Guatemalan deputy, Ana Isabel Prera Flores, said that whether they like politics or not, her family supports her.

I come from a very close family, from parents without much schooling, but with great intelligence. They support us no matter which road of life we choose. They think their opinion doesn't matter; it is my life. So whatever decision I make, they back me 100 percent. They are content because they like what they see in me. The truth is that all of us are proud of each other. (Prera Flores 1991)

EARLY INTEREST

A phenomenon that has not been documented previously in Central America is the early age at which elected women become not only exposed to but interested in and active in politics (see Table 3.6 above). As a group, women legislators interviewed in this study avowed they had become interested in politics before the age of 16, with the youngest at age 5 and the oldest at 42. Responses such as "always," "by heredity," "it's in the genes," "it's in the blood," "since I was little," or "ever since I can remember" were common among those who became interested early in life. One deputy reported that she "dreamed of politics" as a little girl, and another said that her interest in politics began "when I was in my mother's womb."

There are no reliable national data with regard to political involvement for Central American families, so it is not known how much women who become legislators differ from their sisters in each country in this regard. Perhaps the political socialization of all Central American women has been vastly underestimated. Nevertheless, the phenomenon of becoming interested in politics at an early age was demonstrated consistently across the region by elected women legislators. The average age at which these women became interested in politics varied by country, from a low of 13 in Honduras to a high of over 18 in Nicaragua. This early interest among women legislators was influenced by the current events occurring in each country as they were growing up (see Chapter 1). Examples of early experiences with political activities ranged from conversations around the kitchen table to participation in armed conflicts, from involvement in school projects to political campaigns for elected office. This is not surprising, given that all of these countries experienced at least one armed conflict and/or extra-legal overthrow of government since the 1940s. The oldest Constitution in the region is Costa Rica's, from 1949. Thus these women lived through years of often tumultuous political change in their formative years. There were four typical stories of what exactly sparked that early interest in politics: participation in student politics; living through traumatic events; gaining a social conscience; and participation in national electoral politics. These stories are not mutually exclusive, and all four types of stories could be found in nearly every country. In addition, any two elected women who experienced the same events may have interpreted them quite differently.

STUDENT POLITICS

The first type of story (n = 11, 18 percent) told how involvement in student politics, running for class president, becoming a student council representative, joining a student union, or starting a student movement sparked an early interest in electoral politics at the national level. Luisa del Carmen Lario, a legislator from a Social Christian party in Nicaragua, related this story:

> When I was only 14, I became aware of what the [social] problems were. When you start secondary school at night, when you begin between the ages of 14 and 16, night school itself plants a seed, makes you aware of the social conflict—the squatters' neighborhoods, the people's needs, the mass imprisonments. Education produced young people who threw themselves into the fight against *Somocismo*. These events stirred things up, which made for a dedicated youth. So I joined the student movement in 1970; in '72, I was a member of student groups, I was a leader of study groups. (Lario 1988)

TRAUMATIC EVENTS

A second type of story (n = 14, 22 percent) told how interest in politics began as a direct result of personal experience of extraordinary or traumatic events, particularly in El Salvador and Nicaragua. This involvement could take the woman on the path toward either right-wing or left-wing politics. In El Salvador, several women legislators became involved in politics when some of their family lands were earmarked for expropriation by an agrarian reform program. As one Salvadoran, Carmen Elena Calderón de Escalón, explained:

> My property was taken away by the agrarian reform. I didn't think that was any way to solve the country's problems, taking away from one to give to the other. That was what motivated me to get involved in politics. (Calderón de Escalón 1990)

In Nicaragua, many of the women legislators who belonged to the Sandinista (FSLN) party became interested in politics in the years leading up to the 1979 revolution. The story of Nicaraguan Berta Rosa Flores is typical of the experiences of the younger FSLN women legislators.

> It was when I was about 17 or 18 when I was studying [at the university] and working. I managed to get connected to a woman at work who worked in the Nicaraguan women's association, AMPRONAC, and through school linked up with some friends who were involved in clandestine work. I finally had to

stop studying and working altogether because I was involved full-time with the Frente Sandinista [FSLN]; that's how it was before the triumph of the revolution. (Flores 1988)

SOCIAL CONSCIENCE

A third type of story (n = 11, 18 percent) was told about gaining a social conscience. Exposure to the poor, through teaching or doing charity work, was credited by several deputies. In Costa Rica, elected legislator Olga Zamora began teaching primary school and noticed that many students arrived at school without breakfast. She began taking food to their homes, as well as shoes and clothing, and so became aware of the dire socio-economic conditions of the poor, which concerned her very much. As one of the oldest women in the Costa Rican national legislature, Zamora had been involved in improving women's conditions long before they had obtained the vote.

My interest in politics began when I started working in the school system (1932). I became aware of the conditions of my students, conditions of poverty, lack of education, and of the subjugation of women by their husbands. I have always thought it was very important for women to participate in politics, and so I started my work. Even when we didn't have the vote, I was already helping in the political campaigns and forming the party. (Zamora 1989)

In Nicaragua, Angela Rosa Acevedo taught poor children in the mornings, and then tutored rich children in the afternoons for extra money. The contrast between the malnutrition and disadvantages of the poor and the health and advantages of the rich prompted her interest in politics. In Guatemala, Ana Catalina Soberanis Reyes was introduced by her mother at age 8 to charity work with the poor, whose terrible living conditions awakened her political interest. Hazel Law, a representative from Nicaragua's Atlantic region, also had such an experience:

When I was 6 or 7, my mother sent me to give some soup to a sick man in front of our house, as [an act of] Christian charity. And when I went to give him the food, he was spitting up blood. So I asked my papá, "Why is he vomiting blood?" He had TB from working in the mines. And when I went to school, there were other things that really impacted me. It was [seeing] our [tribal] people, who came from the outlying communities to the market to sell bananas, with only a little fried rice to eat, having to sleep overnight on the sidewalks, exposed to the elements. (Law 1988)

Many of the older Nicaraguan deputies, like Gladys Baez, witnessed disturbing violence as a child or young adult, which led them to begin to question things.

In 1956, in León, there was an event that moved the whole nation. Our national hero, Rigoberto López Pérez, brought to justice [assassinated] the older Somoza, and Cornelio Silva was implicated in the plot [and murdered by the National Guard]. Cornelio Silva was from here, from La Libertad, Chontales, and the National Guard drove his cadaver around from town to town to show the crowds the horrible things they did to the corpse. That day my mother told me about all the horrible things that the Somozas had done and that some of my family had been assassinated by the younger Somoza in 1944. (Baez 1988)

Baez was later imprisoned and tortured by the Somoza regime for her involvement with the FSLN, spending two years in physical therapy after her release from prison.

Another older Nicaraguan woman, Rosa Julia Esquivel, arrived at her social consciousness through participation in religious groups:

It wasn't until 1958 that I went looking for new horizons, and began to work with the poor. In about 1966, I helped found the Christian Base Community of St. Paul the Apostle in the Barrio Oriental. The rector was a Spanish priest, José de la Jara Alonso. He came completely disposed to teach us. He said, "Here, who is the real Christ?" We had some courses in consciousness-raising, ending with a retreat, an encounter, where there was a series of talks on how one could truly discover his path to follow, to get out of what he was living through. (Esquivel 1988)

Esquivel later helped to organize a union of health workers, participated in a health workers' strike, and was fired from her job.

Another Nicaraguan, Benigna Mendiola, was greatly impacted by the conditions of her fellow *campesinos* in the rural countryside where she was born and raised:

Many *campesinos* were disappeared because they were members of a union. Things weren't good under the Somoza regime, because people didn't have rights to anything—study, vacations, Sundays off, not even a minimum wage. They had only minimal food with no variety in their diet. Just beans. A man was paid five pesos, a woman three, that is, if they met their quotas of 400 cans of coffee beans. What the *campesinos* suffered was complete barbarity. The same landowner had a company store, and the prices were exorbi-

tant. With five pesos, the *campesinos* could hardly afford to eat. The suffering of the *campesinos* of Nicaragua is such a dark history that one needs patience in these times to be able to analyze it all. (Mendiola 1988)

Although her parents were relatively well off, another Nicaraguan representative, Doris Tijerino, also grew up in a rural area, where as a child the radio was her link to the outside world:

I was born into a family with a petit bourgeoisie origin, a land-owning bourgeoisie, owners of great extensions of land, cultivators of coffee, and raisers of beef, of English origin on my mother's side. My father's family was from the east of this country, from a family of liberals, professionals, wealthy people, and on the political plane they represented a sector of the nascent bourgeoisie of this country, the liberal bourgeoisie. My mother, or rather her family, represented politically the most conservative and traditional sector. In the mountain zones we received an awful lot of propaganda on the radio during World War II. We were so isolated that the Nicaraguan radios didn't reach us. So we mostly listened to international radio, and there was a terrible anti-Communist, anti-Stalinist, anti-Soviet campaign. And this campaign was linked to the role that the United States had played in Nicaragua, in relation to [the defeat of] Sandino, a man who my mother personally admired a lot. She taught us to know, admire, and respect him, Sandino, to understand his fight, to understand the role played by the United States. So this, plus World War II, the contradictions over Communism within my own family, the fact that my family were exploiters of the *campesinos*, gave me a consciousness of class very early. (Tijerino 1990)

NATIONAL POLITICS

The most common story (n = 26, 42 percent) related how the woman became interested in politics through early direct experience with national electoral politics. Two deputies in different countries recounted astonishingly similar stories about how as girls they had witnessed their fathers trying to protect ballot boxes from being stuffed or stolen by opposing parties. Some deputies helped their fathers run for office, or helped their mothers to run political campaigns for male candidates. Some were put to work as young girls carrying drinks and sandwiches to voters or party workers on election day; another sang political songs at campaign stops. The women I interviewed cited a long list of well-known candidates for office from the left to the right—all male—who had inspired them to become involved in electoral campaigns.

However, as children they were also recruited into electoral politics by women who were not candidates for office but party activists. Nury Vargas, a center-right representative in Costa Rica, described how she was influenced early on by her mother:

> I think I became interested in politics as a very young girl because the person who liked politics was my mother. My mother was a great leader and in fact we were persecuted during the civil war of '48 because my mother and my father—but my mother more—were up to their necks in politics. She is a woman who, despite only reaching the third grade, is a person, even now in her old age, who is up to date on all the international news, not only on what is occurring in this country but what is occurring in the outside world, and she reads a tremendous amount. I think that through her, I developed a liking for politics at a very early age. (Vargas 1990)

In sum, Central American women legislators were exposed to politics at an early age, some by school experiences, others by natural disasters, wars, revolutions, poverty, social disruption, or some other crisis. Some were radicalized by government actions or inactions, others through religious experiences. Still others gained ideas from national elections or from foreign sources, either by traveling abroad or by listening to international radio broadcasts. As unusual as the events that make up the history of Central American countries seem, those events were the reality of the people who lived through them, and they greatly impacted women. Many repressive forces were at work to prevent the development of political consciousness, or, at least, political action, on the part of Central Americans in general; and forces such as *machismo* and gender-specific terror attempted to reinforce that suppression on Central American women in particular (Aron et al. 1991). Certainly no Central American women who were alive during these years could have escaped exposure to these conflictive events. While we do not know whether all women in Central America developed a political awareness or interest at such an early age, or to such a high degree, it is a fact that not all women went on to become involved in formal, electoral politics in the 1980s and 1990s as the women legislators interviewed here did. How then did some women's political awareness and interest evolve into electoral politics? How did some women find a path to the national legislature? Was there only one type of path, or were there many? Which path(s) dominated in one country as opposed to another?

PATHS TO POWER
No matter when or how they became interested in politics, it was a very short leap from interest to involvement. The average number of years from the date of first interest in politics to the date of national-level political activity for elected women legislators was only two years (see Table 3.6 above). However, after that, it was an average of 26 years from first involvement to election to the national legislature. Nominations for election to the national legislature can be put forth only by recognized political parties, so women who aspired to that office had to work through a political party to get there. Most of the women legislators in Central America were quite active in their political party for many years before being nominated. What did Central American women legislators do for their political party? Some began in party-sponsored organizations for students, women, or other interest groups. Others first held elected office at the municipal level and then ascended to the national level. Still others were highly placed government ministers or served abroad as ambassadors. Several different profiles of political party activism emerged among the women interviewed, including 1) the traditional path of women related to prominent men; 2) postponing politics until after completing a family and/or career; 3) combining family and a political career; 4) rising in party leadership through activism in a women's section; 5) a career in community activism; and 6) participating in a military. Some of these paths are found only in one or two countries, while others are found across the region.

TRADITIONAL ROUTE
Around the world, until relatively recently, women who achieved high political office (elected or otherwise) nearly always did so through some family connection. Many such women had family ties to a powerful political patron, e.g., Indira Gandhi with her father in India, or Isabel Perón in Argentina, Corazón Aquino in the Philippines, and Sonia Gandhi in India with their husbands (Richter 1990–1991). A Central American example of a woman who married into a political family was provided by Violeta Chamorro, the first woman president of Nicaragua, who was clearly nominated—and elected—because she was the widow of the highly esteemed, assassinated newspaper publisher Pedro Joaquín Chamorro (Saint-Germain 1993a). Typically, women who achieve high office this way serve during a

period of transition between one type of regime and another, and they generally do not serve more than one term. Similarly, widows have often been appointed to fill out the remainder of their deceased husbands' terms in national legislatures, generally as placeholders until the next election; or a woman might be elected to a new term if her husband is ineligible for reelection.

But only two of the deputies interviewed for this study could be seen as taking this traditional path based on family ties. One, Karen Olsen, was the widow of a former president of Costa Rica. She had been active in the political party all along, but during her husband's lifetime she was not nominated for any elected office. After his death, she was listed among the top five names on the list of candidates nominated for the national legislature by his political party, virtually ensuring her a seat in the legislature (the first five spots on the list are reserved for names selected by the party's presidential candidate, whereas the remainder of the spots are filled through intraparty competition by would-be nominees). This is not to say that this woman could not have won a spot on the list on her own. But she is one of the older women interviewed in this study, and her story illustrates a traditional path that is now falling into disuse among younger women legislators. More often now, women who initially reached the national legislature through such connections will go on to subsequently establish their own political careers (i.e., the male patron does not have to die first).

The other woman who took the traditional path, Santos Buitrago Salazar, was the mother of a man who was an important member of his political party in Nicaragua until his death. Again, this woman was well known for her own activities, and may well have been able to win a place on the list of nominees on her own. But in the public's mind, she will always be linked to the memory of her son, and it was her son's death that set her on her political career. The way she transformed her sorrow at his death into political activism, however, was her own unique contribution to the political scene.

When my son died, I was in bad health, physically and emotionally. I felt worthless. But thinking about the young men who kept on fighting so hard, some in the mountains, others in the prisons, others in the underground, I couldn't just sit on my hands. So I helped found the Committee of Mothers of Political Prisoners in 1969. We started to work hard, denouncing what was going on in the prisons. If the boys got sick, we had to denounce the sickness in order to get a

doctor to see them; if they were tortured, we told the whole world what was going on behind those bars. They were terrible dungeons, and if one of the boys fell prisoner, we had to immediately denounce it to the newspapers. We staged demonstrations, and we had a lot of hunger strikes too. (Buitrago Salazar 1988)

POLITICS POSTPONED

A second common path to power for women in Central America is to first complete a professional career and/or raise a family before dedicating themselves full-time to political activity. Flory Soto, a representative from a conservative party in Costa Rica, related how she did not want to mix raising a family and politics:

I always followed politics very closely. That is precisely what makes me think that women are not only marginalized but many times marginalize themselves, because I did that for a time. I kept myself isolated, especially while my children were little. I was not rejected, I just never wanted to really approach that type of activity, except for complying with my civic duty to vote. Immediately after the children were older, I made my first appearance in politics. (Soto 1990)

Although she was obviously dedicated to her home, Flory Soto also was a schoolteacher for 30 years and served on her city council from 1974 to 1982, including a term as president of the council. From 1978 to 1982 she was also Costa Rica's delegate to the Inter-American Commission on Women of the Organization of American States (OAS). During that time she also was a political party officer in her home district and was active in the women's section of the party, of which she rose to be vice-president.

Another example of a woman postponing political work until after completing a career is provided by Costa Rican representative Gladys Rojas, who worked for 30 years as a pharmacist. She was then elected to the national legislature based on a long history of dedication to her political party but no previous electoral experience. Yet running a pharmacy allowed her to meet about 600 people daily, and she jokes that as she was packaging each pill, she was also dispensing advice about which political party to support.

CAREER PARTY ACTIVISTS

A third profile is provided by women legislators who have always been full-time party activists and have held other electoral offices. One Nicaraguan legislator, Maria Teresa Delgado, let no opportunity to do political work slip away:

Of course, it is my duty as a revolutionary woman, that no matter where I go—in a taxi, in a street, in a horse cart, wherever—if I hear people talking about politics, then I have to clarify things because maybe they aren't in agreement, or maybe they are a bit confused. So it is my duty as a militant for my political party to set that person straight. (Delgado 1988)

Often women have to start out in the lowest echelons of a political party, making coffee and serving sandwiches, greeting visitors to party headquarters, pasting posters on walls all over town, and so forth. Some, however, like Miriam Eleana Mixco Reyna of El Salvador, rebelled against being automatically expected to perform those tasks.

At the beginning, I was in the youth section of the party, but we only had two or three women in that section, and they were young, about 18 or 20 years old. So whenever there was some activity, the men said, "Women, prepare the food; women, make the posters." Well, I didn't like that very much, so I remained distant for a while. I participated in the party, but not so directly. Afterwards I said, "No, if I'm going to get involved, I'm going to get involved with something challenging," so I went to work in the campaigns of '86 and '87 in the eastern sector of El Salvador, which was the most conflicted zone. I think that I earned a certain respect for the work of women. (Mixco Reyna 1990)

Other women legislators also reported taking on the worst, most difficult, most demanding, or even the most hopeless assignments in order to work their way up in their political party. A young legislator in Guatemala, Maria Eugenia Castillo Fernández, was asked to become a candidate for the legislature from her party by representing Quetzaltenango, a large province with the second-largest city in Guatemala, in the central highlands surrounded by active volcanoes and one of the most heavily damaged by the government forces in the civil war.

They talked to me about whether I wanted to take on that candidacy, and it was something that I had to think about a lot. Because it's true, I'm single, and I don't have children, but for me it meant a lot of responsibility and a lot of work because I would have to take on all the 22 townships in the province of Quetzaltenango, and besides that I had to hold meetings, and give press conferences, right, and that's a lot. (Castillo Fernández 1991)

Maria del Carmen Lario was elected to the Nicaraguan national legislature in 1990 as part of the United National Opposition (UNO),

an amalgamation of 12 political parties and 2 coalitions of smaller parties aligned against the FSLN. The coalition included parties from the far right, center, and far left—just about every political party except the FSLN. Lario's colossal task was to defeat the incumbent party and win the critical vote in the capital city, Managua.

I poured all my efforts into winning Region III, Managua and its townships. And whenever [our campaign team] got down, we said to ourselves, "We have to keep working. Remember, if we lose Managua, we lose everything. We have to win Managua." (Lario 1990)

Most deputies reach the national legislature after a lifetime of service. Several women in El Salvador were founders of their political party, ARENA. Political party positions held by some women before they became legislators include head of the district, town, or provincial party office; head of a national election campaign; head of a party section (youth, artisans, women); and head of a transition team for an incoming or outgoing president. Examples of government and civic positions held by women legislators in Central America include government minister, ambassador, university dean, school principal, Chief of National Police, city councilor, mayor, governor, presidential advisor, head of the national chamber of arts and small industries, and head of 4-H clubs. Women legislators had previously served as delegates to international organizations, such as the Central American Parliament, the Inter-American Commission on Women of the Organization of American States (OAS), and the United Nations' organization for culture, UNESCO. One woman in Honduras was the official voice of her party on the radio for ten years. A few women owned their own businesses, and a Honduran was chosen woman of the year in 1984 by Zonta International, a women's service organization. A Guatemalan woman was the national coordinator of the 500th anniversary of Columbus celebration and the inter-Iberian conference on the anniversary, held in Guatemala. Even when they have relatively few years in politics or public service, they still manage to accumulate substantial experience before their election to the national legislature by taking on a wide range of tasks, such as Leda Lizeth Pagán Rodríguez in Honduras:

I had never attended any type of political meeting, not because I didn't want to, but because I was studying outside of the country and my time was very limited. But when I returned with my degree, a friend invited me to a meeting

of the Partido Nacional, and there they began to talk of [Rafael Leonardo] Callejas announcing his candidacy. I was still working at the national port authority, but for political reasons, I was fired. So, I dedicated myself full-time to politics and began to climb up the ladder of positions from the very lowest to the very highest. First I was secretary of the directorate in Monarca. Soon I was president of the directorate in Monarca. After that I went on to the secretariat of the local affairs committee of the Partido Nacional. Soon I was president of the local affairs committee. Afterwards I was on the city council, first in Choloma because I was a candidate for mayor, but the other party won, so I was first councilor. Later, I was deputy in the national legislature. First I was a substitute deputy, now I am a proprietary deputy. (Pagán Rodríguez 1991)

WOMEN'S SECTIONS

Although none of the Central American countries in the 1980s and 1990s had reserved seats for women in the national legislature, nearly all the major political parties included a section specifically for women. In some parties, sections are allowed to put forth a certain number or proportion of nominees for the legislative electoral slate who did not arise from a specific geographical base but rather represented the interests of the organized section (this varies greatly by party). Most of the women elected to the national legislatures of the Central American countries were not nominated by the women's sections of their respective political parties. Some legislators saw the presence of a women's section as isolating women within a women's ghetto. For example, the major leftist party in Nicaragua, the FSLN, did not have a women's section *per se*, although it sponsored one of the nation's largest women's organizations (AMNLAE). One Costa Rican legislator characterized her party's section as "too confining," and as a symbolic gesture that kept the women "tranquilized" so that they would not demand too much from the party. Other women said they needed to compete for nominations on an equal basis with men (i.e., not through the women's section) if they wanted to be taken seriously within the party (see the opening quotation to this chapter). Even women who were officers of the women's section sometimes preferred to be nominated as representatives of their hometown or province. Nevertheless, the women's section of the centrist PLN party in Costa Rica was successful at mobilizing female party members to attend regional and national nominating conventions to support their demands that women candidates for the next elections in

1994 be nominated in proportion to their numbers as party activists (roughly 15–25 percent), and that the party dedicate 15 percent of its financial support to promoting the political participation of women (Saint-Germain 1993b). This could be seen as a precursor to the adoption of legal quotas for women, which Costa Rica later did (in 1996).

Although they did not have a formal women's section, activists in the FSLN party were successful in getting the party to adopt a voluntary 30-percent quota for women nominees to elected office, including the national legislature as well as local government. To ensure that women who were nominated had an actual chance of winning seats, they demanded that the party list be put together like a "braid," alternating one male name and then one female name, and so on down the list (see Luciak 1998).

COMMUNITY ACTIVISM
A fifth route to the legislature is through a community group, nonprofit organization, union, independent women's group, or other activist role. Although all the women in Central America who were elected to national legislatures obtained their seats by virtue of being at least a titular member of some political party, some women stressed that it was their activism outside the party that was really responsible for their success. Hazel Law from Nicaragua's Atlantic coast credited her activism within indigenous communities with her success in becoming a national legislator.

I was a founding member of [the indigenous organization] Misurasata. At the triumph you could count on your fingers the Miskitos who were professionals, and in 1979 there were no Sumos with a university degree. So when it was time for elections, the government called me and said, "The FSLN invites you to participate in their delegation." (Law 1988)

Of course, some women attributed their activity in more than one area as providing a winding but nonetheless successful path to power, as Marielos Sancho from Costa Rica explained:

My activities have not been directly political, the way we define political here in Costa Rica. I have formed part of the most diverse groups of the community, as many cultural groups as sports groups, even popular festival groups. I have participated in marathon fund-raising efforts, for example, for the hospital of Grecia, and all the most diverse civic groups. I have been the coordinator of industrial fairs. In sum, the whole diverse gamut of activities that I have

participated in, that I have patronized, is what has made the people of Grecia see me as a person who will not rest. . . . (Sancho 1990)

MILITARY CAREERS

One of the most common routes to national political office for men in Central America has been through participation in the military, often with experience in armed conflict, but this option has not traditionally been open to women. However, with the presence of overt hostilities in the latter half of the twentieth century, some women attained their seats in the national legislature by their distinguished service not only in an armed force but through combat, especially in El Salvador and Nicaragua (Luciak 2001a).

The national armed forces of Nicaragua before 1979 (Guardia Nacional) were nearly all male, with women only in support units, so there was little opportunity for women to distinguish themselves in a military career. In the revolutionary forces (FSLN) that sprang up in Nicaragua in the 1960s, women formed a larger proportion of armed combatants than ever before. After the 1979 revolution in Nicaragua, the new armed forces were directed to integrate even more women, although women were never subject to the military draft as men were. The national police force in Nicaragua was also changed to include women, and Doris Tijerino served as Chief of Police before being nominated to the national legislature. Nicaraguan women legislators who had been commanders in the FSLN during the revolution were still often addressed as *"Comandante,"* even if they were no longer active militarily, as a measure of respect for their service; most had spent some time in prison, been tortured, or been wounded in combat. Another Nicaraguan legislator, Azucena Ferrey, had established her credentials through service in the armed counterrevolutionary forces (*Contras*) that arose in the 1980s to fight the FSLN government forces. She, too, had been imprisoned for her military role and was accorded some measure of respect because of it. This situation in Nicaragua, with women legislators who were wartime adversaries both serving during the same electoral period, was later replicated in El Salvador and Guatemala as well.

In El Salvador, a similar situation existed with regard to the traditional armed forces and police, and the revolutionary forces of the FMLN. Some of the armed combatants of the FMLN were women, and some of the women who were nominated as candidates for the Salvadoran national legislature were considered based on their military

experience. A Guatemalan ex-combatant known as Comandante Lola was elected to that national legislature in 2003. So far, this has not been the case in Honduras, and Costa Rica has not had an army since 1949, so that path is not open to either women or men in that country.

CONCLUSION

The path to the national legislature for most Central American women legislators was not a short one, but rather a slow and steady climb up from their first involvement in a grassroots neighborhood organization, a school, or the lowest ranks of the party faithful. Nearly all shared the common experience of working their way up to national office through participation in a political party organization at the local, regional, and national level. The positions they held varied from neighborhood organizer to national president of the political party. Many of these initial experiences or motivations echoed the findings from a worldwide study of women legislators that included North Americans, Asians, Africans, and Western and Southern Europeans. Some began in student politics, some were the daughters of traditional leaders, some followed family members into politics, and others cited wars, uprisings, new Constitutions, and democratization as motivators to become involved in electoral politics (Waring 2000, 78–80).

Most Central American women legislators worked hard for many years to attain a position at or near the top of their party's list of candidates for the national legislature. They came "directly from the base, from the bottom up." They "pasted papers and painted political slogans on the walls" and "got totally involved in local elections." Other Central American women legislators worked their way up through specialized sectors of a political party, such as a women's auxiliary, a student wing, or in national campaigns in literacy and health. Several women won elections to local and regional positions, such as city councilor, municipal treasurer, mayor, or governor, before becoming a candidate for the national legislature. Others were appointed to high political posts, such as Minister of Health, ambassador, or head of Social Security. Finally, a few women legislators in Nicaragua climbed up through the ranks of the military and had served in such posts as national Chief of Police.

The recipe for becoming a representative in the national legislatures of Central America included early socialization into politics—often by a working or politically active mother—and a long and hard

climb through the ranks of a political party or success in obtaining other elected or appointed positions. It required substantial family financial resources or other means of support. Nevertheless, the long process by which women typically built political support often went unnoticed, so that women seemed to "suddenly" win seats in the national legislature. But from 1980 to 1995 there were no special privileges for women seeking legislative office in Central America, no statutory affirmative action plans, and no legal quotas, goals, or timetables that would favor them over their male rivals.[3] There was no secret passageway by which women entered the national legislature—they had to earn the right to come in through the front door like everyone else.

However, the paths they took to get to that door varied by country and as a function of the different political, social, and economic circumstances that evolved over time. Costa Rican women generally worked their way up through a stable, two-party-dominant system, relying on higher education, successful professional careers, and hard political work to get their names at the top of the party list. Most Nicaraguan women took advantage of changing social and political conditions brought on by crises (beginning with the overthrow of the Somoza government and continuing throughout the twentieth century) to break down class and cultural barriers to elected women. Many Honduran women combined private sector experience in business with political activism from an early age to attain a place on the nominating list of their respective political parties. Guatemalan and Salvadoran legislators represent a new, younger generation of women who became politically active during the civil wars of the 1980s, attaining a high level of education and limiting their family commitments in order to dedicate themselves to politics full-time. This variety in the paths to power should increase over time, and within each country more paths should become available as more women—and more different types of women—become involved in politics and seek to exercise self-determination in the affairs of their nation. In the future, exposure to and interest in politics will hopefully depend much less on crisis, trauma, and radicalization, and more on economic, legal, and civic opportunities.

CHAPTER 4
ELECTED WOMEN AS LEGISLATORS AND REPRESENTATIVES

> Unfortunately, we as women politicians in general—and as women in particular—get no rest, because I think that if we neglect things just a little, the men politicians will leave us with nothing, right? They will monopolize everything.
>
> MILAGRO DEL ROSARIO AZCÚNAGA DE MELÉNDEZ,
> legislator, El Salvador, 1990

INTRODUCTION

As we have seen in previous chapters, there are some differences among the electoral systems of Central American national legislatures, and elected women legislators can arrive there via quite different paths. Therefore, we could expect women legislators in different countries to conceive of the function of the legislature in different ways. This is important because it has implications for how women function in legislatures and how they—as elected representatives—impact public policy. This chapter explores elected women's concepts of the legislature and of the nature of representation, divided between functions carried on within the national legislature and functions carried on outside it. Elected women's impact on public policy will be discussed in Chapter 6.

INTERNAL FUNCTIONS

What do Central American women legislators think about the internal functions of the legisla-

ture? That simple question evoked a variety of answers. Some legislators answered in just a few words, while others discoursed at length on the subject. Responses fell into two major categories: legislation and intergovernmental balance. They also remarked at length about their committee work, leadership positions, and time commitment to these activities.

LEGISLATION

Elected women responded that on the most basic level, the first function of a legislature is to legislate, but the duty of the legislature does not necessarily end with the adoption of a law. It may also include the interpretation, promulgation, and implementation of the law as it becomes public policy. Elected women in Central America are also keenly aware that the national legislature can engineer national development and bring about social change through targeted resource allocation. The most common first response by most legislators to this question was to refer to the legislature's internal or policy-making function, saying, "to legislate." Responses often started with the words "of course," "obviously," or "like every other one in the world." A commonly used phrase was that its "primordial function is to legislate." Some deputies distinguish among various forms of legislative functions, such as to propose, elaborate on, and enact laws; to revise, rectify, and reform laws; and to emit, promulgate, and distribute laws. Some deputies believe that the legislature should fulfill the additional important functions of ensuring that laws are implemented, enforced, and obeyed, as well as evaluating or assessing whether the goals expressed by laws are being attained.

While acknowledging the European roots of the Guatemalan congress, legislator Ana Isabel Prera Flores remarked in 1991 on the perennial debate in Central America on whether to import ideas from abroad versus the development of home-grown approaches. She stressed the need to adjust the function of the legislature to the national reality:

In the case of our country, the political and legal superstructure sometimes does not correspond to the social and cultural reality of the country, so there is incongruence between the legal systems and the reality of the country. You have to take into account that 60 percent of Guatemalans are indigenous. And so they have a totally different worldview; their values, aspirations, and goals are distinct. And this at times makes for incongruence between the laws that

we make because the majority of us who are here [in Congress] have a Western education, and we don't know the reality of the indigenous world. Sometimes we import [foreign] laws and institutions, and that's why it is so difficult for the whole diverse population to use the same framework. (Prera Flores 1991)

Many deputies see the purpose of the national legislature as not only to make laws, but to make laws for a particular purpose. That purpose can be general, for example to secure public order, state security, and national defense. Another set of general purposes includes obtaining justice and liberty for the benefit of the country and its people; for the common good; for national development; for community development; to attain better living conditions and better quality of life; or for the functional and spiritual actualization of the people. A final purpose is to benefit particular groups, such as children, youth (or students), women, specific geographic (sub-national) areas, and a group variously described as the disadvantaged, the poor, the popular classes, those with the fewest resources, and those without a voice.

The second function of the legislature was intergovernmental balance, in relation to other branches and institutions of government. This function was derived from the configuration of the governments of the Central American republics. All these republics had unitary forms of government, with all power held at the national level. Although sub-national units such as provinces, departments, or *cantónes* existed for administrative purposes, they had no independent powers. For example, there are no sub-national-level legislatures (analogous to state or provincial legislatures in the United States or Canada). Nevertheless, these republics do have a separation of powers at the national level, divided between three (or four) branches of government, including the executive, the legislative, and the judicial (and sometimes an electoral branch). Many deputies stressed the need for the national legislature to be independent from other state powers, so that it can take on the role of checks and balances in relation to them and to stem the tide of erosion of legislative power by the executive branch. Some deputies expressed the role of the national legislature as one of helping to "maintain the equilibrium" among the various national powers by "putting the brakes on runaway executive power" (Pagán Rodríguez 1989). As Ana Isabel Prera Flores from Guatemala summarized elegantly:

The Guatemalan state, like all democratic states, is composed of three powers. And of course the legislative function is a specific faculty of Congress in

accordance with our law. Of course, the equilibrium suggested by Montesquieu, well, it is maintained in the equilibrium of the three powers, each with its important function. Congress is certainly the political forum *par excellence,* the confluence of all the ideological currents, all the parties, and the most direct representation of the people, because we are directly elected by the people, we are representatives. So the function of Congress, in addition to maintaining an equilibrating control on the other state organs, is to legislate in relation to our country, in relation to our real necessities. . . . (Prera Flores 1991)

Nevertheless, other deputies wanted the legislature to work more closely with the executive branch, to carry out the programs of the party in the presidency, and to "make good on promises to voters" (Henriques 1990). They reasoned that by developing a working relationship with other branches of government, the legislature can generate support for the entire government and for the maintenance of the system. National legislatures can also function to strengthen support for democracy and the Constitution, and respect for the law. Legislators, by their very behavior, can set an example and educate the people on how to conduct themselves in politics. As Salvadoran deputy Carmen Elena Calderón de Escalón (1990) remarked, legislators "live democracy" and thereby transmit it to the people.

LEADERSHIP POSITIONS

The national legislatures of Central America have internal governing bodies, which are elected by the members from within their ranks. Generally the members are elected for one-year terms, and it is considered a high honor to serve on a governing body. These bodies will usually consist of a president of the national legislature, one or more vice-presidents, and several secretaries, with a total of five or more members. The presidency often goes to the head of the majority political party. Representatives who hold offices in the governing body of the legislature have additional meetings to plan the legislative calendar, administer the budget, prepare reports, hire professional staff, assign legislators to committees, and perform other functions as prescribed in each country. It may include some ceremonial duties, such as receiving visitors to the legislature from government agencies, business interests, foreign countries, the media, research institutes, and so forth.

The representation of women on these governing bodies has historically been slight. Worldwide, only about one-quarter of all leg-

islatures had ever elected a woman as presiding officer, and women occupied only about 10 percent of all such offices in 2000 (Waring 2000, 105). In this regard, Central America is unusual, since all the countries except Honduras elected a woman as president of the national legislature for at least one term in the 1980s or 1990s.[1] Women were also more prominent in legislative governing bodies in Central America than the 8 percent found in Latin America in general (Rivera-Cira 1993, 50). For example, women held 27.3 percent of the seats on the governing board in the legislature in El Salvador between 1994 and 1997 (Moreno 1997, 78); in Nicaragua, women held 2 of 7 seats (28.6 percent) in the most recent legislature (Asamblea Nacional de Nicaragua 2004). Since these positions are filled by majority vote of the members of the national legislature, women in majority political parties have better chances of being elected than women in minority political parties. Notwithstanding, women have also been elected president of national legislatures where no party had a majority of seats, but rather several parties formed a majority coalition, for example, in both Nicaragua in 1990 and Guatemala in 1991. On the one hand, this may imply that women are seen as mere figureheads or placeholders while the men sort out the new power arrangements; on the other hand, it also suggests that women—because of their qualities such as interpersonal skills—may be seen as more acceptable candidates for leadership positions in situations where compromise and cooperation are necessary, where no party can impose its will through an absolute majority of seats.

In addition to seats on the governing body, women legislators can also be elected to be an officer of one of the committees they serve on, such as committee president, vice-president, or secretary. The presidency of a committee usually goes to a member of the political party with a majority of seats in the national legislature; lesser offices may be filled by members of minority parties. Until the 1980s, it was unusual for women to be elected as committee officers, which were hotly contested within the party with the majority of seats. Rose Marie Karpinski, serving her second (nonconsecutive) term in the Costa Rican legislature, described her experience:

I was the first women to be elected and later reelected for a second period as president of the Economic Commission. Later I was the first woman elected to the presidency of the Finance Commission, that is, taxation. It is a pretty difficult commission [to work in]. I think that to have made this path, what you

would call a "historic first," it proves that we women can do it. And in the last election for [the presidency of] the Finance Commission, it was very rough. I had to wage a very big political battle, confronting many of my very dear [male] friends. But I waged that battle, a little for women in general, because I wanted to set an example of what women can do, and so that the men—because all those who voted were men—could know that women who work, study, and demonstrate their capacity can reach whatever goals they set. (Karpinski 1989)

In the most recent elections in Nicaragua, women legislators were elected as heads of 17 percent of permanent committees (Asamblea Nacional de Nicaragua 2004). In earlier years, however, not all women were as satisfied with their situation concerning committee assignments or leadership positions within the national legislature. Nicaraguan Hazel Law addressed this issue in 1988 (during the first legislative term of 1984–1990):

Do women have equal opportunities for work inside the National Assembly, for example within the commissions? With the exception of *Comandante* Leticia Herrera, with her [military] career, who won the vice-presidency of the Directorate of the National Assembly, it is very difficult for a woman to be elected or nominated for president of a commission. I think that there are still some subtle aspects because the problem of women's equality can't be resolved formally at the level of legislation. We can't lose sight of the fact that this is a social problem—it's part of the mentality of women's and men's beliefs that it is the man who is the first to lead. And despite all the women's legislation that has been passed, this thinking prevails. (Law 1988)

COMMITTEE WORK

Most legislatures conduct much of their internal business through various permanent and/or ad-hoc committees. One question that is often asked about women in national legislatures is the nature of the committees on which they sit. This question is difficult to answer in Central America, because the legislative committee structure has varied considerably, both among the countries within the region and within each country's legislature over time. For example, Honduras often restructures its entire committee system with each new administration, and recently had 28 committees functioning, while Costa Rica maintains seven permanent committees and appoints only a few additional, special committees. In some countries, the concerns on which committees focus often change as well, from land reform to

drug trafficking, depending on current events, while in other countries committee issues are more stable. In addition, it is not uncommon for legislators to be rotated to different committees each year of their term. The opportunity for participation on committees varies as well, with women legislators in Guatemala serving on an average of four committees, while women in Nicaragua served (on average) on only one. Nevertheless, while women constituted just 13.5 percent of all representatives in the Nicaraguan national legislature in the 1990–1996 term, they occupied 15.7 percent of all committee seats.

A study of the population of women legislators in all Latin American countries in the early 1990s classified the committees on which legislators serve into five broad categories (Rivera-Cira 1993, 60). The largest proportion of women legislators served on committees dealing with social affairs, followed by political, economic, administrative, and judicial affairs. Using a similar classification system, we analyzed the transcripts of women we interviewed. The committee membership of women in Central American legislatures varies widely (Table 4.1). Service on committees dealing with social issues predominates, accounting for 76 percent of women legislators' committee assignments in Honduras, 47 percent in Nicaragua, 40 percent in El Salvador, and 38 percent in Guatemala. In Costa Rica, however, more of women legislators' service occurred on committees dealing with administrative issues (43 percent) than on any other type of committee. In particular, they served on the committee that actually writes the legislation, since many of the women legislators had degrees in languages or linguistics. This is seen as quite an important committee—one of the few that is assisted by full-time staff—and the women serving on it were proud of their role. Another arena in which women have played important roles is in foreign affairs or foreign relations; this was reflected especially in Nicaragua (23 percent of women's committee seats) and Guatemala (31 percent). Women are making important inroads into the diplomatic service in several Central American countries (Moreno 1995); some women legislators served previously as ambassadors or consuls. Perhaps as a reflection of the national obsession with justice in El Salvador, Salvadoran women legislators (20 percent) were more likely than those in other countries to have assignments to committees dealing with justice issues.

Committee seats are often assigned (or awarded) by the president of the governing body of the legislature, who may be of a different political party than the woman legislator. Not all legislators are assigned

TABLE 4.1. DISTRIBUTION OF WOMEN AMONG LEGISLATIVE COMMITTEES IN CENTRAL AMERICAN LEGISLATURES, 1990 (BY PERCENT)

Committees	Costa Rica	El Salvador	Guatemala	Honduras	Nicaragua
Social Women, children, family, health, education, culture, sports, youth, population, housing, environment	25	40	38	76	47
Political Foreign relations, national defense, interior, politics, communications media, regional government	2	20	31	0	23
Economic & Development Agriculture, ranching, finance, debt, budget, natural resources, industry, commerce, fishing, mining, planning, development, infrastructure, construction, transportation, science & technology, tourism	21	20	8	12	0
Administration Internal organization, oversight of government ministries, legislation	43	0	23	0	18
Justice Constitution, human rights, crime	9	20	0	12	12
Total	100%	100%	100%	100%	100%

Source: Interviews with women legislators in Central America.

to their first-choice commission, especially when their party does not control the legislature, as Nicaraguan Marcia Quezada Abarca of the FSLN party recounted in 1990:

I am on the community service committee. They [the opposition ruling party] wouldn't let me stay on the education committee. Nevertheless, I am working with a colleague [from my political party] who has a lot of experience as a member of the legislature, and I think his experience will be very valuable to me as I am just starting. So, I feel OK, but I would have liked to also be in education, which is my field. Nevertheless, I won't stop contributing [to education]. (Quezada Abarca 1990)

Another FSLN party member, Doris Tijerino, while not unhappy with the substance of the committee to which she was assigned, did have some qualms about its day-to-day functioning with its executive branch counterpart, which was controlled by the opposition political party after the 1990 elections.

Unfortunately, they put me on the foreign relations committee, and I say unfortunately because I would rather have been on any other except this one. I have not felt that we are going to have any really productive work that will benefit the people, because the [government office on] foreign relations doesn't consult us, and they don't ask us for our opinions. So more than anything else we are trying to pursue that information which will let us see what things we can do as deputies. (Tijerino 1990)

A more detailed analysis helps in understanding the representation of women on legislative committees. In Central American countries, many legislative committees deal with social issues. Taking Nicaragua as an example, the majority of all committee seats during the 1984–1990 term dealt with social issues (36 percent), followed by economic (22 percent), justice (16 percent), political (16 percent), and administrative issues (10 percent). Thus, it is not unusual that the majority of committee seats occupied by all legislators (female and male) in Nicaragua dealt with social issues. Compared with the overall availability of committee seats, however, women still occupied more seats (47 percent) on committees dealing with social issues than would be expected (36 percent), as well as on committees dealing with political issues (23.5 percent actual versus 16 percent expected) and administrative issues (17.6 percent versus 10 percent); and fewer seats than expected on commissions dealing with judicial (11.8 percent versus 16 percent) and economic (0 percent versus 22 percent) issues.

EXTERNAL FUNCTIONS

The important external functions of a legislature involve its relationship with citizens. It is the branch of the state that is closest to the people, since it is the only branch whose members are all directly elected (unlike the executive or judicial branch, whose members are mostly appointed). Because of this, the national legislature is the only branch that is appropriate for some important functions, such as considering new ideas for legislation, holding debates on national problems, airing opposing viewpoints, and functioning as a "sounding board" [*caja de resonancia*]. The legislature can provide a forum where all voices can be heard in decision-making; it can serve as a tool for national integration of diverse groups and interests. The legislature can become the focus of groups mobilizing for policy change. For individual citizens, the legislature may be seen as the last resort for resolving personal problems. Nicaraguan representative Hazel Law was elected to the first session of the new (post-Somoza) national legislature in 1984, which was responsible for drafting a new national Constitution. She also commented on the legislature's educational function:

In the case of Nicaragua, the National Assembly should play an educational role, to ensure that the law be comprehensible to the people and the interpretations be understandable. [The Assembly] has among its powers the ability to interpret relevant laws. So in order to interpret the laws, it is important for the legislature to carry out an educational function. (Law 1988)

This representational quality also has a down side, in that the legislature in general—and legislators in particular—becomes a place of last resort for everyone in the country who has a problem that needs to be solved. In El Salvador, the national legislature has a Committee on Mercy and Pardons that hears petitions from individuals, for example for postponement of taxes, and a Committee on Public Good that hears from people who have problems with paperwork in some public agency. In the other countries, however, it is the individual legislator who is most likely to be contacted by many such persons.

All these functions of the legislature are characterized by women legislators as "important," "a huge responsibility," or "a big role in society." In some of the electoral periods, Central American national legislatures have been called upon to formulate new Consti-

tutions, new electoral codes, or settlements that end years of war. For Nicaraguan Martha Mungía (1988), the national legislature is the strongest branch of government in determining what the society will look like.

But Central American women legislators are not wholly content with the conditions of their national legislatures. Several deputies voiced severe criticisms of current conditions. A Costa Rican, Marcel Taylor Brown, expressed some regret:

As I understand it, the primordial function [of a legislature] is to legislate, but that spirit has been lost. We deputies dedicate ourselves to a series of things, not only legislation, but taking information to the communities, political proselytizing and, in the case of the party in power, distributing resources. (Taylor Brown 1989)

In Honduras, Ana Chávez Petit complained about the need to focus on patronage.

The truth is that we come here to legislate. But, once installed as legislators, we are expected to do a bit of everything. We look for help for communities in the form of projects. We have to see to the placement of party members in positions in the government because sometimes we are indebted to them for their hard work for our party candidate. In short, we have to make our presence felt socially. (Chávez Petít 1991)

In Nicaragua, Doris Tijerino commented on the legislature's failure to function as a forum for political debate.

During the campaign we have been discussing and debating about the nature of the Assembly. The Assembly has a very specific function, which is to legislate, to revise existing laws, and to repeal them when necessary. In addition to that, we think that the National Assembly should be an arena of political debates; it should be the space where political concordance and national reconciliation have their principal forum. (Tijerino 1990)

Yet as another Nicaraguan, Marcia Quezada Abarca, observed, when a population changes, the national legislature must be prepared to alter its ways to keep up with social change.

Now we don't have the same terrified, fearful public as we had during the dictatorship of Somoza. Now it is a public with a different vision, one that claims its rights with strikes and civic protests. So it is not the same public

[of pre-1979]; this public is already making demands, now it won't be kicked around; rather, it is fighting and will keep on fighting to maintain these gains. (Quezada Abarca 1990)

HOME DISTRICT

In addition to committee work inside the legislature, there is also work to be done in the legislators' home districts. In Central America that work has ranged from ceremonial appearances to serving on armed community self-defense teams. Many district activities are of a political nature, for example contact between the legislator and the local chapter of her political party. Legislators are expected to respond to constituents' needs, including symbolic, resource distribution, service, and policy-related activities (Jewell 1983; Kim et al. 1984; Lowenberg and Patterson 1979).

Nearly every legislator described performing some type of symbolic activities, such as ribbon-cutting ceremonies. Even seemingly symbolic activities, however, could be quite dangerous in some areas at certain times. For example, in El Salvador during the civil war, mayors were often targets of political violence. So attending a town meeting in one's home district to show support for the mayor was part of the civil war's battle for the hearts and minds of the population, as Morena Disnarda Cruz de Chavarría explained in 1990, before the peace accords were signed:

The department of Usulatan is in the eastern sector of the country. It has 22 towns, 5 of which I would say are controlled by the [FMLN] guerrillas, where we can't go. Nevertheless, the deputies work with some of the mayors to push for public works in the towns. In addition to that, we also donate to their different activities. (Cruz de Chavarría 1990)

Resource distribution activities are very popular. Mercedes Gloria Salguero Gross, a legislator from El Salvador, described some of the ways she has, in U.S. terms, "brought home the bacon."

I've been able to get funding to construct the police station in Santa Ana. In addition, I arranged for the old national police building in Santa Ana to be donated for a cultural center. Also I am very supportive of a Catholic school where I was educated. I helped *Padre* Rossi [a Silesian priest] obtain a million and a half *colones* for his school. And I also got half a million *colones* from the Ministry of Planning to help the *padres* who have an old-folks home in Santa Ana. (Salguero Gross 1990)

Another legislator in El Salvador, Milagro del Rosario Azcúnaga de Meléndez, drew on international connections to bring resources especially to the women in her district.

Through my participation in the Inter-American Commission on Women as the head delegate, I was able to get various projects and training for women's self-help groups. Why? So they could produce, for example, canned fruits, marmalades, pickled vegetables, and canned meat, chicken, and beef. Through training, these groups of women can process their produce and generate income themselves. That home can then have a higher standard of living because it has two sources of income. How do we do this? On the one hand, through training a woman as a micro-entrepreneur, so that she can learn to keep her own books, and she won't lose her production; on the other hand, she is also trained as a micro-businesswoman in the most simple and rudimentary techniques so that she can accomplish her labors and transform herself into a productive entity. (Azcúnaga de Meléndez 1990)

However, it can be more difficult for a legislator from a minority political party to obtain government resources for her community, as Marcel Taylor Brown from Costa Rica commented:

In terms of what we can accomplish as a deputy in the opposition party, it is difficult, because the opposition deputies aren't included in government projects; we aren't included in the famous special projects. Yet people think that the work of a *diputado* begins and ends with special projects. That is, the *diputado* is good if he brings special projects and bad if he doesn't. (Taylor Brown 1989)

Sometimes bringing government largesse to a district solves one problem but creates others, as Leda Lizeth Pagán Rodríguez, a Honduran legislator, explained:

In my municipality, we have about 100,000 inhabitants. So now we have great affluence in terms of sources of work because industrial parks are being created. The industrial parks have come to resolve many of our problems, but they have also brought us others because now we have greater-than-ever needs for housing and for water. (Pagán Rodríguez 1991)

Legislators are also expected to perform many service activities, such as being responsive to personal requests from constituents. Given the working-class background of many Nicaraguan women legislators, perhaps the extremely participatory nature of their district visits is not surprising. Various legislators in Nicaragua reported

participating in mass child-vaccination campaigns, in other public health campaigns such as mosquito eradication days, in neighborhood cleanups, and serving once a week on a 24-hour shift in a community self-defense squad during the war with the *Contras*. Olga Zamora, a deputy from Costa Rica, described how she performs personal favors:

> Besides visits to see what the needs are, one donates a lot to those community improvement projects. To give you an example, now we are pushing for an old-folks home for my town. Because we think that the old people have worked hard, and they need a rest. But they also need a building that is in suitable condition. I have also taken several basic book collections for the schools in my town; now I am also about to take a book collection to a penal center here in San José because there are some prisoners who want to study by correspondence. (Zamora 1989)

Juana Antonia Irías García, a legislator in Honduras, felt that women deputies were more often sought out than male deputies for solving the personal problems of constituents.

> If someone is sick, they ask the *diputado*—and more so the women than the men—to take them to a clinic. I think we *diputadas* get more pressure put on us. (Iría García 1991)

The demands of patronage, for example in securing government jobs for constituents, also occupy much of legislators' time, explained María Eugenia Castillo Fernández:

> I arrive at my department with the desire to try to help with the projects that are going to improve the community, not any one person in particular. But our people don't understand that. They want jobs, for example, for each and every one. It is impossible for me to get a job for the whole world. (Castillo Fernández 1991)

María Teresa Delgado, an FSLN legislator in Nicaragua, describes how her constituents give her tasks to solve with various branches and institutions of government:

> When [constituents] come to me to present some problem, I go before the state to take action on that problem until it is solved. We deputies are not like the deputies in the times of Somoza, who by just wagging a finger got everything done. Today we deputies are people who take up causes before the state to help in that way to solve the problems that citizens present to us. (Delgado 1988)

However, these tend to be one-on-one interactions, between one legislator and one constituent. Some women legislators in Central Amer-

ica also see responsiveness as involving the larger community and as a two-way street. They not only bring and give to the district, but they also pause to listen and gather input to take back to the legislature, especially with respect to potential public policy issues. Most of the women legislators in Nicaragua described their policy-related district activities in the same fashion as Hazel Law:

When I finish my work here [at the legislature] I go to the Atlantic Coast, to Puerto Cabezas, where I have an office, and we see what we can do about the most important tasks from the point of view of the population there: deepening the dialogue on [regional] autonomy, seeing what programs can be carried forth with the help of friends and organizations of the peace commissions, and getting to know the trends in the region and the problems. For example, the mining sector, which is one of the most important regions, has a series of infrastructure problems. We then determine what to propose in the Assembly and make some calls to some ministers to speed up some programs. (Law 1988)

At the time of these interviews in Nicaragua, women who were elected as representatives to the national legislature from the Sandinista (FSLN) party were not encouraged to think of women as a "sector" in the same way that workers, students, landless peasants, and others were considered to be a sector. Nevertheless, some legislators from the FSLN party did focus their activities on women. For example, Nicaraguan Martha Munguía got around this dilemma by using clever semantics:

One of the general tasks that I assume is to explain the law and [political] process to the people of my town and to educate women a little so that they can get to know all the [legal] instruments [they are entitled to]. I also consult my sector, which in this case is women. They are not a "sector" but serve as one for the purposes of discussion. We explain the laws to them; we receive their opinions about these proposed laws; and to the extent that I become aware of their problems and difficulties, I formulate proposals to benefit or resolve particular problems for women that are raised to the National Assembly. (Munguía 1988)

Some women legislators use their visits as opportunities to investigate the conditions of women in the district with an eye to developing public policy, as Benigna Mendiola, an FSLN Nicaraguan legislator, explained:

Now we have a plan of work: go to the regions as representatives of the people and start to hold assemblies with them to transmit the [new] municipal code to them. But on the other hand, you have to get in there to see how the

women are, what is the participation of the women in the [farm] cooperatives, and why aren't the women participating? And why are women in the minority? What are the problems they face that keep them from participating? And we have found that now, the obstacle is the question of the infants, of the children; they have a lot of children but nowhere to leave them. Another obstacle could be called the men's jealousy—we call it *machismo*. (Mendiola 1988)

TIME COMMITMENT

The internal work of a representative includes preparing for and attending the general plenary sessions of the legislature; preparing for and attending work sessions of the permanent and ad-hoc committees of the legislature to which the representative has been assigned; and participating in meetings with other members of the same political party or coalition to plan legislative strategy. The external work of a representative was also described above. A question put to the women legislators about how much time they spend on these tasks often got a very animated response. Clearly, the demand this job places on one's time is something that cannot be fully grasped by outsiders. Many of the women said that it was impossible to calculate; others offered responses such as "all day, every day" or "there is no time for anything else" or "more than twenty-four hours a day." Some compared the frenetic pace of legislative work to a nest of ants. Even Nicaraguan Azucena Ferrey, who had been a leader of the counterrevolutionary *Contra* forces in their war against the Sandinista government, confessed her surprise.

Really, I tell you that sometimes one is astonished that one's body can endure all these things. Because on top of it all, it is my responsibility to represent a population that is a two-and-a-half-hour to three-and-a-half-hour drive away, and I wish it were just the one city, but it's all the little towns and villages too. And the whole world wants their problems heard. So really it takes up a lot of time; sometimes one just doesn't have the strength. What suffers the most from this work, I think, are household concerns and family relations in general. One doesn't have time available to dedicate to the children, and that is what is most difficult. But it doesn't impede one, it [just] makes it more difficult as one tries to balance, tries to compensate. (Ferrey 1990)

Legislator Nury Vargas in Costa Rica found herself in a different but no less distressing situation. She explained that representing the capital city made it too easy for her constituents to seek her out, day and night, at the legislature as well as at her home. She also explained

that sometimes as many as 40 people a day wanted personal audiences (Vargas 1990).

Though each legislator's typical workday varied, the common themes of long hours and competing demands emerged. Most workdays for these legislators began very early each morning and lasted late into the night. Rising early is a way for one to tape a radio or TV interview, while for another it is a way to attend early morning classes at the university before starting her day at the legislature. Late at night, others try to leave time for reading or studying legislation. Salvadoran legislator Lilian Díaz Sol (1993) joked that her bed was so full of books and papers, there was barely room to sleep. Costa Rican legislator Mireya Guevara's (1989) life seemed to consist entirely of going from her home to the Assembly, and from the Assembly back to her home. Costa Rican Flory Soto (1990), whose party controlled the legislature in 1990, commented that she had no time to sleep or rest but believed it was the price of being in the party in power. Many legislators pointed out that they took no vacations, and, during campaign time, their families had no days off either. Salvadoran Macla Torres (1990) joked that she saw her children only once every two weeks.

Even for these accomplished women, nothing in their pasts could compare to the demanding work of a national legislator. Many stressed that there is no fixed schedule; that one has to be flexible in response to demands; and that one just keeps working until it all gets done. Some worked this way because they felt that the public's eye is on women more than on men. Milagro del Rosario Azcúnaga de Meléndez, a deputy in El Salvador, was more blunt:

I leave my house, sometimes before 8 in the morning, and I get home in general around 11 at night, at 12 midnight, at 2 in the morning; in other words, I am working continuously. There is no resting on Saturdays or Sundays. During the August recess, for example, I worked the entire time. I think that it is one of the most self-sacrificing vocations, because you get no vacations, you get no Saturday, you get no Sunday, and you have to see how you can make some time with your family. And many times, you neglect your children, you let the house go a little because [legislative] work is very hard. That is, we can't rest, because if we are inattentive legislators, we will be left behind. (Azcúnaga de Meléndez 1990)

Another Salvadoran, Lilian Díaz Sol (1993), said that it was better to remain single, because there weren't enough hours in the day for both

politics and a family. "Politics consumes you. You can't say, 'No, I can't do that, I have to go home to attend to my husband.'"

Many women in Central America work as maids (see Chapter 2). This largely invisible work force no doubt facilitates the work of many elected women. Nevertheless, Nury Vargas felt that women legislators in Costa Rica still have a dual role of family responsibilities in addition to their political work that their male counterparts don't have, even when household help is present.

> Where there are differences is in the double role that one carries, the role of the home and the role of work. Because when you get home from work, you are still the head of the household. You can't rest. You have to get things ready for the next day. I get home at night looking for what I can heat up for dinner, but when men get home they want someone to prepare and serve them dinner. I work full-time at being a deputy. Now my children are grown and I have a very good domestic, and that helps me a lot. Even though I am a national legislator, I have to assure that at home there is food, the house is cleaned, the clothes are washed, etc., etc., etc. So it is not the same as for a man, who simply gets served his breakfast, comes here, and sits down to work. (Vargas 1990)

IDEAL QUALITIES

GENERAL QUALITIES

Given the above as the functions of the national legislature, what qualities should a legislator ideally possess? And would they be different for women? The women legislators interviewed for this study were first asked to name the qualities of a legislator (male pronoun) in general. A content analysis sorted them into educational, moral, leadership, interpersonal, and professional categories; a list of the qualities most frequently mentioned appears in Box 4.1. There was considerable variation in the types of qualities mentioned by country (Table 4.2). Costa Ricans stressed professional qualities above all others, with interpersonal qualities second. Costa Rica has the longest uninterrupted legislative history and the most professionalized legislature among the Central American republics. The professional quality of "hardworking" was mentioned more than any other. Costa Rican deputies have also developed traditions of peaceful coexistence between the two major parties in the legislature, with considerable interaction among members of all the different parties in the normal course of business. Good interpersonal skills are an asset in this situation.

Box 4.1. Ideal Qualities for Legislators in Central America

Leadership Qualities

accomplished
activist
aspirations
authoritative
belligerent
certain
charismatic
clear objectives
decisive
dignified
distinguished
dynamic
exemplary
experienced
good self-image
hustle
ideologically grounded
initiator
intellectual
interlocutor
lead by example
leader
linked to community
mystical
poised
political
prestigious
revolutionary
seeks opportunities
self-satisfaction
social contacts
spontaneous
visionary
well-known

Educational Qualities

educated
legal knowledge
parliamentary rules
prepared
public administration

reads
researcher
studious
technical knowledge
trained
up-to-date
well-informed

Interpersonal Qualities

affable
amiable
attend the public
authentic
believes in self-calm
caring
close to the people
connected
consultative
convivial
direct
empathy
enthusiastic
equanimity
feeling
flexible
frank
goodwill
heart
holistic
humble
identifies with people
interprets needs
listener
loyal
nondiscriminatory
not egoistic
of the people
open
participates
party supporter
representative
respectful

(continued)

Box 4.1. (*continued*)

responds
sacrifices
serene
service-oriented
sharing
sincere
tranquil
understanding
volunteers
warm
winning

Professional Qualities

accountable
capable
clear
communication skills
competent
completes tasks
coordinator
dedicated
desire to work
diligent
disciplined
effective
fieldwork
goal-oriented
handles controversy
hardworking
healthy
informative

intelligent
interested
investigative
knows problems
meritorious
motivated
organized
perseverant
problem solver
professional
punctual
realistic
self-supporting
straightforward
talented
team player
tenacious

Moral Qualities

conscientious
ethical
faith in God
fulfills obligations
good of all
honest
honorable
moral
responsible
solvent
truthful

Source: Author's interviews with elected women legislators in Central America.

El Salvador presents a different profile. Salvadoran deputies most often mentioned moral qualities, the only ones to do so, and the quality of being "honorable" was mentioned most often. At the time of these interviews, El Salvador was just beginning to emerge from an extremely divisive 12-year civil war. As part of the process of concluding the war, a truth and reconciliation commission was set up to uncover atrocities committed during the war and to affix blame for

TABLE 4.2. IDEAL QUALITIES OF LEGISLATORS BY COUNTRY (PERCENT OF TOTAL QUALITIES MENTIONED IN EACH CATEGORY)

Qualities	Costa Rica	El Salvador	Guatemala	Honduras	Nicaragua
Leadership	12	18.5%	35%	23.3%	34.7%
Education	15%	18.5%	25%	12.3%	12.0%
Interpersonal	21%	26.0%	25%	34.2%	37.3%
Professional	36%	7.0%	10%	19.2%	9.3%
Moral	16%	30.0%	5%	11.0%	6.7%
Total	100%	100%	100%	100%	100%

Source: Interviews with women legislators in Central America.

them. Thus politicians were extremely concerned with establishing who had been "right" and who had been "wrong." There had been very little cooperation between or among political parties in El Salvador, and politicians were concerned with winning electoral support based on claims of moral authority. With the political opening that followed the cessation of hostilities, however, they began to recognize a new need to cultivate more interpersonal skills, especially the ability to "work with the [common] people." Given the lack of continuity between Assemblies and the low level of professionalization of the Assembly, it is understandable that professional qualities were hardly mentioned.

A third profile emerged in Guatemala, where deputies focused on leadership qualities as most important. The quality of "being a leader" was mentioned most often. During the time these interviews were conducted, Guatemala was still undergoing a violent 30-year civil war. Traditional political parties had splintered into many small groups surrounding individual leaders. Guatemalan political parties compete for power by attempting to attract voters to candidates by stressing personal qualities such as leadership. Education and interpersonal skills are secondary, serving as necessary but not sufficient qualities for a legislator. A large number of Congresses elected in Guatemala have been overthrown, dissolved, or otherwise shut down—often due to corruption. Neither professional skills nor moral qualities were often mentioned as ideal qualities.

In Honduras, a fourth profile emerged, where interpersonal skills predominated as ideal qualities. As denizens of one of the poorest

countries in the hemisphere, many Hondurans often have no resources except for the goodwill of other people. In this situation, interpersonal skills are not just a nicety but a key to survival. When obtaining resources by force is not a realistic alternative, people depend on their interpersonal skills to persuade, cajole, and charm the powers that be. Leadership qualities are secondary; and the most often mentioned leadership skill was "political ability." Due to the low educational level in Honduras, educational qualities were rarely mentioned as ideal. Rather, "knowing the problems" of the country was mentioned most often.

Nicaraguans stressed both interpersonal and leadership qualities almost equally. Interpersonal skills are necessary in a poor country, and are also valuable in a country emerging from a long period of upheaval, first from the FSLN's 1979 overthrow of the Somoza regime and then from the counterrevolutionaries' (*Contras*) war against the FSLN. The most often cited interpersonal quality was the ability to "work with the [common] people." Unique in Nicaragua, interpersonal skills were teamed up with leadership skills. Many Nicaraguans had risen to positions of leadership in turbulent times and had developed new styles of leadership. Being a "revolutionary" leader, having "political ability," and having a "wide network of influence" were the leadership qualities most often mentioned. Most of the women in the Nicaraguan National Assembly were from the FSLN party, which had a long history of mobilization of its supporters through a combination of charismatic leadership and seemingly endless rounds of highly personal education, meetings, and consultations. In a country with a low educational level, educational and professional qualities were seen as less important. Unlike El Salvador, there was no formal "truth and reconciliation" process at the end of the conflicts of the 1980s and 1990s in Nicaragua, so there was less emphasis on moral qualities (or who had been "right" and who had been "wrong").

DIFFERENCES FOR WOMEN

After elaborating on the ideal qualities for a (male pronoun) legislator in general, the deputies were asked to comment on whether there were different or additional ideal qualities for a woman legislator in particular (Table 4.3). Nearly all the deputies had something to say on this subject, and nearly all responded that there are additional and/or different qualities that women need to succeed as legislators, compared with their male counterparts. Whether those differences *should*

TABLE 4.3. ADDITIONAL DESIRABLE QUALITIES FOR WOMEN LEGISLATORS BY COUNTRY (PERCENT OF TOTAL MENTIONS IN EACH CATEGORY)

Qualities	Costa Rica	El Salvador	Guatemala	Honduras	Nicaragua
Leadership	38	25	0	31	48
Educational	0	0	0	0	4
Interpersonal	9	0	0	0	0
Professional	53	65	100	69	48
Moral	0	10	0	0	0
Total	100	100	100	100	100

Source: Interviews with women legislators in Central America.

exist or not was a matter of some debate. Even deputies whose initial response was "no" often continued with an explanation that generally started with "but...". In all the countries, some of the additional or different qualities that women bring to the job of legislator are advantageous for women, such as superior interpersonal skills, higher educational levels, and higher ethical standards. However, the reason that women needed different or additional qualities (to those for men) was because women had special barriers or disadvantages to overcome, for which they needed these additional resources and skills. This is one measure of how politics changes women, or changes their perceptions of what they should be like.

A small group of deputies maintained that there were no differences in the skills and abilities needed by male and female legislators in a very technical, legal sense. In most Central American countries, a person must be 21 years old and a citizen by birth to serve in the national legislature. A few women deputies pointed to these requirements and noted that there were no differences stipulated on the basis of gender. Another small group of women deputies maintained that there were no differences in the ideal qualities that every legislator should have, whether male or female. Women possessing these generic ideal qualities could be representatives in the national legislature, if they wanted to, with the proper preparation, dedication, and will.

A much larger group of women deputies, however, insisted that there were differences for women. Some of them revealed that men doubt women's capacity for the job, and that when women are put

forth as candidates, their credentials are examined under a microscope. So while women are not required to have any different qualities than men, women do need to have more of the same qualities in order to be considered viable candidates. These deputies exposed a subtle set of gendered mathematical rules used to compute expectations for women legislators. For example, if hard work is required of men, then women need to work twice as hard (González 1989; Karpinski 1989; Romero de Torres 1990). If an ideal legislator must be service-oriented, then women legislators must perform three times as much service (Díaz Sol 1993). If educational credentials are a must, then women must have four times the education of a man to be considered for office (Pagán Rodríguez 1991). "In the end," said Milagro del Rosario Azcúnaga de Meléndez (1990) of El Salvador, "women legislators must be five times better just to be acknowledged as credible." But women deputies are resigned to this treatment and, when expected to do more, do not object, because they are used to it.

A few deputies implied that, rather than be better than men, women legislators had to become men. For example, when speaking of qualities a *woman* legislator should have, Berta Lyria Fuentes de Fajardo (1991) began with "Well, it has to be a man (*un hombre*) who . . .". Ana Isabel Prera Flores (1991) of Guatemala said, "That is, we women have to take on the perspective of man (*el hombre*) in his essence, man (*el hombre*) in his history and social and sociological problems. . . ." These deputies could have used other terms, such as "a person who" or "a woman who" or the more general terms *humanity* or *humankind*, but they did not.

A larger group of deputies was of the exact opposite opinion. Yes, there were differences for women, but women legislators should not become like men; rather, they should emphasize their female characteristics. Mireya Guevara, a Costa Rican deputy, outlined the proper rules of behavior for women legislators in this way:

> She must also be very careful with the attitudes that she takes; a woman should never be insulting, not even in politics. The great task for women in politics is quite the reverse—it is to be a serene person, who always looks for understanding and does not oppose things just to be contrary. A woman should always conserve her femininity. (Guevara 1989)

Another Costa Rican, Marcel Taylor Brown, asked rhetorically what would happen in a world without women:

It is true that there are some political functions where brute force is needed, where I think it should be the man who does it, for example some jobs. But there are others where women can integrate ourselves perfectly and give examples of our understanding, our mystique, above all the honesty of women. Dear God, woman is what keeps equilibrium with man. God forbid that the world be made up only of men; it's the equilibrium [between women and men] for better or for worse. (Taylor Brown 1989)

A Honduran deputy, Ana Chávez Petit (1991), felt that women can draw on their differences from men to help themselves as politicians: "As a woman, I feel that this [difference] helps the woman parliamentarian. I use the word *empathy* a lot, to put myself in the place of the other. I think that is it."

Some deputies think that women have attributes that are not only different from those of men, but superior. For example, some of the representatives we interviewed said that women legislators are more responsible, more efficient, and better at carrying out assignments than men; that women deal better with intangibles than men and have better interpersonal skills; that where men see only black and white, women see a rainbow; and that women have higher ethical and moral standards and are more honest than men. Legislator Carmen Elena Calderón de Escalón from El Salvador echoed this view:

I am a married woman with three children. I adore my husband. We get along very well. I have been married for 20 years. We have a family life. When it's campaign time, we all campaign; we've been able to live with both politics and the family, but never neglecting the family. So I think it costs a woman politician more, it's more difficult, because she shouldn't neglect the role of wife, of mother, and of politician. [But] being a woman lets her have greater insight into the people, by the fact of being more human. (Calderón de Escalón 1990)

Most women legislators agreed that having these extra qualities is a good thing for women, because they are going to need them.

Many deputies were able to come up with a list of additional skills or abilities that women need to cultivate. One theme was that of visibility. Candidates for the legislature need to be more visible both inside their party and outside to the general electorate. Women should master public speaking. They need to learn how to use the media, including radio, TV, and print.[2] As Costa Rican Gladys Rojas (1990)

noted, "If the journalist doesn't come to me, I go to the journalist to let him know what is going on." However, with increased visibility comes increased exposure to criticism. Therefore, women must develop their pride and self-esteem along with a thick skin. They must not let men frighten them out of the political arena, because women need considerable political experience before they attempt to be a candidate for the national legislature.

Many women legislators suggested qualities that women interested in elected office should possess to make them more active participants. Women need to take the initiative and be ready to compete. They must be prepared for anything, so that they will never be surprised; if they are, "don't make excuses, just pick yourself up and go on." Women deputies need to be strong, valiant, forceful, and able to adapt to the man's world of politics. Politics is a job; don't expect to treat working in the national legislature like working in the home. Women deputies need drive, ambition, and a will to succeed. They will have to dedicate whatever amount of time it takes to get the job done. It also helps to develop the ability for teamwork. One Costa Rican, Norma Jiménez, noted that if women stand up for their rights, then men will recognize them.

It's like they sort of want to keep us on the margins in the Legislative Assembly, but then it's up to us women to have the guts to say, "No, sir, I'm just as much a deputy as you are." Then they'll immediately recognize whatever we are demanding. (Jiménez 1989)

Most deputies agreed that women face more restrictions than men, not only in the national legislature but in society in general, in terms of opportunities, expectations, acceptable behavior, traditional roles, and so forth. Central American society was routinely characterized by the women we interviewed as authoritarian, patriarchal, paternalistic, and *machista*. In other words, cultural patterns, past traditions, and leftover prejudices have deemed politics a man's world. For example, much political activity in Central America is carried on in the evenings. But some men forbid their wives to leave the house at night, while other women do not go out because of fear for their personal safety. A Honduran deputy, Carmen Elisa Lobo de García, explained that women must actively participate in electoral campaigning in order to be candidates for the national legislature, but the difficulty of campaigning in rural areas discourages many women or their families.

We have to travel to the farthest mountains in Honduras, where we could be there a week without seeing our children, without seeing our husbands, and that doesn't appeal to everyone. So the woman who wants to be a legislator has to overcome, or has to have the force of personality so that her husband lets her become active, because you have to abandon the home for politics. You have to go to visit the town, the tiny village, the house where a party member lives and the house where no party member lives. And there are campaigns that last weeks, in far-off hamlets, and you have to get there by mule, on foot, on horseback, by walking, in trucks, or sometimes in small planes. Generally our work is very hard; it is not easy for women or for what women are accustomed to in Honduras. (Lobo de García 1991)

One Nicaraguan, Rosa Julia Esquivel, talked about the advantages and drawbacks of increased visibility within a society that still has a double standard for women's behavior:

How would it be if, as a deputy in the National Assembly, I go to a party and I down a couple of shots, and I mount some kind of scandal, and I fall down drunk, or go off with a man. No, it can't be, it just can't be. It is ordinary and normal to want to have fun, but under the norms at this time, we [women] sometimes need to forget, let us say, our own desires, we could call them, because we have to cultivate an image [for our party], and we can't trample on it or muddy it up. (Esquivel 1988)

Along these lines, women in El Salvador may be criticized as "too liberated" if they are active in politics, even though women are responsible for solving most of the country's problems. Salvadoran legislator Morena Disnarda Cruz de Chavarría explained:

Women here are considered to be very liberated, you know, if they are active in politics, they think she doesn't belong there. But I consider it to be very important for women to participate in politics, because in reality we have perhaps more women than men in this country, and the woman is almost always completely absorbed by our problems. Because here in El Salvador the surveys tell us that the majority of women raise their children alone and many times women are raising their children without a father. She is working to keep them fed, she is sacrificing herself, and I think that's all the more reason why women should be represented in the Legislative Assembly. (Cruz de Chavarría 1990)

There seems to be little congruence between the types of qualities that are seen as ideal for legislators in general (i.e., men) in each country and the additional qualities that are recommended for women

legislators in particular. Only in Costa Rica are professional qualities listed as the most important for both legislators in general and for women legislators in particular (Table 4.3). However, professional qualities were highly recommended as additional qualities for women in every country. El Salvador is the only country that suggests that additional moral qualities are needed by women legislators, which is consistent with its stress on moral qualities for all legislators, but even so, professional qualities predominate as those additionally needed by women. Whereas only 10 percent of the ideal qualities originally listed by Guatemalans were professional, wholly 100 percent of the additional qualities needed by women legislators fell into this category. Similarly, with Honduras, while interpersonal qualities were the most important for all legislators, professional qualities were most often cited as those additionally needed by women legislators. Nicaragua is consistent in naming leadership qualities as important both for all legislators and additionally for women legislators, but adds that women need more professional qualities as well.

However, women legislators also need different qualities than men. The additional qualities mentioned as needed by women legislators were recoded into different categories to help us better understand what is being recommended. The different qualities needed by women legislators consist of strategies for personal betterment; for codifying women's needs into laws; for promoting women; and for overcoming *machismo* (Table 4.4). These additional qualities form a continuum from the most conservative, through liberal, feminist, and radical strategies. Personal betterment strategies promote a conservative view, addressing the need for women to improve themselves and to not make excuses, not be timid, and not be inexperienced. Translating demands into law is more of a liberal democratic strategy for obtaining equal opportunity for women, *de facto* as well as *de jure*. Pro-women strategies include developing a gender perspective, developing more organizations to lobby for women, transforming society to integrate women, supporting and motivating other women, and integrating women from all social classes into politics. These strategies take women's traditional concerns and address them seriously without trying to change them or to make them into a campaign against male privilege. Finally, strategies for overcoming *machismo* are the most radical, such as fighting the patriarchal system and political parties that shut women out, combating overt discrimination against women, adopting affirmative-action programs, changing men's doubts about women's capacity or the perception that "it's a

TABLE 4.4. DIFFERENT QUALITIES RECOMMENDED FOR WOMEN LEGISLATORS BY COUNTRY (PERCENT OF TOTAL MENTIONS IN EACH CATEGORY)

Qualities	Costa Rica	El Salvador	Guatemala	Honduras	Nicaragua
Personal Betterment	50.0%	9.5%	42.8%	46.2%	19.0%
Legal Strategies	5.6%	4.8%	0.0%	0.0%	9.5%
Pro-Woman Strategies	11.1%	4.8%	0.0%	7.6%	42.9%
Overcome Machismo	33.3%	80.9%	57.2%	46.2%	28.6%
Total	100%	100%	100%	100%	100%

Source: Interviews with women legislators in Central America.

man's world," and addressing women's fears about going out at night, men who try to frighten women out of politics, and men who don't let their wives participate in politics. It also includes overcoming and changing different social expectations for women, such as the traditional assignment of certain functions to women, that women must sacrifice for the home and family, that women must carry multiple responsibilities (home, work, politics), and that women must not neglect the home. These strategies will be echoed in the final chapter in the vastly different types of public policy that women legislators in Central America have proposed.

The need for the most radical strategies, i.e., to overcome *machismo*, was recommended by 81 percent of women legislators in El Salvador, 57 percent in Guatemala, 46 percent in Honduras, 33 percent in Costa Rica, and 29 percent in Nicaragua. This additional quality vastly dominated all others in El Salvador. In Guatemala, personal betterment (42.8 percent) was also highly recommended, along with overcoming *machismo* (57 percent), and both qualities were equally important in Honduras, with each recommended by 46 percent of women legislators. Costa Rica placed strategies for personal betterment (50 percent) first and for overcoming *machismo* (33 percent) second. Only in Nicaragua did the need for pro-women strategies rank first. Very few legal strategies were recommended. As we shall see in the last chapter, women in Central America do have many guarantees of equality in the law; the problem has been that the laws are not implemented.

Nicaragua presents an interesting departure from the other countries. At first, Nicaraguan women legislators advised that women need the additional qualities of professionalization (48 percent) and leadership (48 percent) over and above the ideal qualities for a legislator in general. Under the second coding scheme, pro-women strategies (42.9 percent) and strategies to overcome *machismo* (28.6 percent) were the most highly recommended. In other words, women in Nicaragua who want to be legislators do not lack education, interpersonal skills, or moral qualities; rather, they need to display more professional and leadership skills. Consequently, women who want to become legislators do not need to adopt personal betterment strategies but instead to adopt pro-woman strategies and strategies to overcome *machismo* through their leadership and professional skills. As an alternative to recommending that women improve themselves first, Nicaraguan legislators prefer adopting strategies that give women more support by developing alternatives that favor women first, and then dealing with *machismo* second.

In the other countries, the emphasis is much more on individual women and their personal responsibility to develop these additional qualities. For example, legislators are advised to develop a support system for domestic needs and not to treat politics like the home. There is an emphasis on developing personal betterment strategies, as if women who want to become legislators need to become "*supermadres*," individually superior women who can have it all and do it all (Chaney 1979).

CONCEPTS OF REPRESENTATION

All the Central American countries practice representative democracy. A proportional-representation form of democracy, as the name suggests, is highly concerned with representativeness. But what form does that representation take? What or whom is represented, and how? What should representatives do, and what do they actually do? The form that representation takes is not completely determined by the electoral system but also by other political and cultural factors. In the following pages, we will explore how Central American women legislators define and practice representation.

DISTRICT

Deputies were asked an open-ended question about what or whom they, as representatives, represent in the national legislature. Most

TABLE 4.5. FOCUS OF REPRESENTATION (PERCENTAGE OF WOMEN NAMING EACH CATEGORY)

I Represent:	Costa Rica (n = 14)	El Salvador (n = 10)	Guatemala (n = 5)	Honduras (n = 15)	Nicaragua (n = 24)
My political party	35.7	0	80	33.3	29.2
My geographic district	78.6	70	20	40	54.2
My sector or group	35.7	20	40	0	50
All the people	35.7	50	80	53.3	29.2
A social class (low, middle, high)	35.7	10	80	0	25
Women (before prompting)	23	37.5	60	33.3	74
Women (after prompting)	91.7	87.5	100	93.3	90.5

Note: Multiple responses possible, so totals do not add up to 100%.
Source: Interviews with women legislators in Central America.

deputies mentioned at least two groups, the most popular being a geographic district, followed by "all the people" (Table 4.5). Geographic district is mentioned by a high percentage of legislators in Costa Rica, where prospective candidates for the national legislature must compete in local and then regional party caucuses to finally win a place on the party list. Also, there is no national district in Costa Rica, so all legislators represent an actual city or village where they are usually quite well known.

District was also mentioned quite frequently in El Salvador where, until recently, there was no "national district," and, again, most legislators are elected from provinces where they have a long history of political activism. However, the proportional-representation system often results in one geographical area being represented by legislators from several different political parties, as Morena Disnarda Cruz de Chavarría (1990) in El Salvador commented:

I represent the department of Usulután, where more than 100,000 persons currently live. We four representatives of the department are from four different political parties, so among the four of us we are representative of the vast majority of the department.

Geographic district was not mentioned as often by legislators in Honduras and Guatemala. There, candidates are sometimes assigned by their political party to campaign in an area which, if the party wins enough votes, they will represent, but to which they have no real ties. A legislator in Honduras, Soad Salomón de Facussé (1991), remarked on the difference between her official assignment and her actual practice:

I represent the people of Honduras, but especially the people who live in the central district and in the department of Francisco Morazán. But my real work has been here in the central district. So although I have departmental responsibility, I think that my dedication is more to the capital city.

Arabella Castro de Comparini (1991) was originally elected to serve the capital city in Guatemala, but feared she might be reassigned to one of the outlying provinces:

I participated in the coordination of some aspects of the political campaign in the interior of the republic. Nevertheless, I was elected for the capital city district. But now the party is going through a restructuring, and it will depend on that where it will correspond to me to do my political work.

POLITICAL PARTY

Given the nature of the PR/PL systems in these countries, only parties can put forth candidates. It seemed strange that political party was not mentioned as often as geographic district as a focus of representation. On the one hand, it may be that all the respondents assumed that party representation was obvious, e.g., in Nicaragua nearly all women in the legislature were from the FSLN party. On the other hand, many political parties were in flux during these years, so party loyalty was not that great. For example, at least three women legislators changed parties during their term in El Salvador. In Honduras, within the two major political parties, there tended to be factions surrounding individual candidates vying for the presidential nomination. Deputies in Honduras like Eda Eulalia Herrera de Nasar (1991) often say they represent not only their political party, but a specific faction within the party: "In my party, I represented the

faction that corresponded to Mr. Flores, and for that I received a majority [of votes] which carried me to be selected as a deputy for the Liberal Party."

POPULATION

A third category of representation concerned which part of the population was being represented. One category, "all the people," was named more often by deputies whose political party controlled the most seats in the legislature, either as a legitimation of their majority status, or an obligation of it, as stated by Salvadoran Milagro del Rosario Azcúnaga de Meléndez (1990):

We deputies represent the people. It is true that there are a number of people who voted for us and others who did not vote for us. But according to the Constitution, deputies represent the people as a whole, and we should respond to that.

Deputies claiming to represent "all the people" were often emphatic that they did not represent any "special interests" or had not been bought out by some influential group. Costa Rican legislator Nury Vargas's comments reflect this attitude.

I represent the population of the central district, but I want to or I prefer to be the representative of the most poor, marginalized people, the most needy. And so the people who arrive here [at my office], you see my clientele, there are no rich here, nor those from the tobacco industry, nor those from the silver cooperatives, the foresters, nor the liquor distilleries, or the breweries of Costa Rica, none of that. What's more, I get invited to go to all those places, and I decline them because I know they're not inviting me because I am me, but because of my post and the function that I perform. Because at any given moment, the public relations of those businesses is to make one feel some sympathy for them, and I want to be very free to decide. So normally I don't go to those functions so I can be freer. If it is beneficial to the people, I'll go, but if not, I reject it. (Vargas 1990)

In contrast, "group" or "sector" was another category of representation. This category was most often cited by Nicaraguan deputies, due to the fact that most were from the FSLN party, which is organized along sectorial lines. Sectors in Nicaragua included ranchers, farm workers, students/youth, small businesses, artists, and so forth. People who wanted to become deputies for the FSLN party in the 1980s and 1990s had to compete within their sectors to get their names on

the party slate of nominees. María Ramírez, the youngest elected legislator in Nicaragua, came from the student/youth sector:

I think that an important role is to approach the youth sector, which is the sector I represent. It is a sector which has had to shoulder the brunt of the war [against the *Contras*] most heavily because of military mobilizations and other types of actions during these 10 years [of war]. So I think that the Assembly has a role to play with regard to the making of laws that could favor or defend the rights of youth in this country, those who are going to guarantee the future. (Ramírez 1989)

Deputies in other countries also identified themselves with a group or sector, as legislator Mireya Guevara de Badilla did in Costa Rica:

I am in charge of two villages, Escazú and Acosta. I [also] am very involved with small businesses. [Thus,] it has become my responsibility to attend a lot of meetings and conferences at an international level on this subject, on handicrafts and small business. I have traveled a lot, attended a lot of seminars, and now I am going to the World Congress of Small Industry in Brazil. (Guevara de Badilla 1989)

There were also some deputies who expressed that they represented the demands, issues, or aspirations of a particular social class. Eleven of the deputies across all countries claimed to represent the poor, while only two mentioned the middle class, and two the wealthy or propertied class. Costa Rican legislator Norma Jiménez attributed her interest in the poor to her own personal background:

I am partial to projects that benefit the popular classes, the poor and marginalized of the country, because my own family's [financial] situation was so miserable. That's why I support the purchase of a building to house programs whose fundamental objective is to help the most needy. I have taken up these fights because I am convinced that my first obligation is to my people and because I am imbued with all the Social Christian principles which are in favor of the poor. The rich can defend themselves by themselves because they have money and influence. But nobody defends the poor, so I think that we should fight for them. (Jiménez 1989)

Another deputy in Costa Rica, Flory Soto, attributed her election to votes from the middle class and poor majority:

As a deputy I feel pride at being in the premier power of the republic, mixed with a very large dose of responsibility, that's something that I always want to be very conscious of. Really, I was elected by a group of people, especially the

middle class and a majority of the poor. Our party has a tremendous covenant [with them] and we have taken up the reins of the country at a critical time, and we are obliged to provide a solution. (Soto 1990)

Very few deputies spoke about the representation of the interests of the propertied classes, but Carmen Elena Calderón de Escalón (1990) in El Salvador was very clear about it: "I am the representative of all those who have something that is theirs and who want to protect it."

REPRESENTATIONAL STYLE

Along with the variety of things or people that can be represented, there is also the question of how they are represented. This concept is often characterized as the representative's role or style.[3] Two different representational styles are the "delegate" and the "trustee." On the one hand, the delegate embodies or typifies her constituency and acts in accordance with their wishes. Delegates carry the exact policy wishes of the electorate to the legislature. The trustee, on the other hand, acts in what she perceives to be the best interests of her constituency and is empowered to select the policies that would be of most benefit to them. Nicaraguan Deputy Yadira Mendoza saw her role as that of the traditional delegate:

During my free time away from the National Assembly, I am involved in the regional work of the women's organization, AMNLAE. I attend their assembly meetings, as well as civil defense group meetings. I talk with women about the laws; visit cooperatives to see how they are working and what problems they have; and serve as a channel for the transmission of the demands of women. For example, last month I went to a cooperative where there are women members. They told us that they need a child-care center (CDI) for their children because they are working in the cooperative. So I transmit those concerns directly to the corresponding person in the Institute of Social Security. Basically I get involved in community activities, where they say, "Here's a bridge that needs to be fixed, there are some streets that need to be paved," those types of things. (Mendoza 1988)

Another Nicaraguan, Gladys Baez, also expressed another aspect of the delegate perspective with respect to representing women:

It is fundamental that close linkages exist between the [legislators and the] persons who elected them; otherwise, one is only representing oneself. I can't go to the National Assembly to represent either women or the people if I haven't lived with those women and those people, and if I don't know their problems

in depth, their concerns, their way of being, because that is what I am going to represent there, that's what I'm going to go fight for there. (Baez 1988)

Hazel Law, from Nicaragua's Atlantic Coast region, expressed the mutual understanding that a representative should have with the electorate she represents. The two most important aspects are to be one of the electorate, and to be certified by them to represent their demands.

For me, one of the primordial qualities is the representativeness of that which we say we are going to represent in the National Assembly. Who should inspire our legislative activity? In this case, those who elected us. We were elected because we have influence with the Indigenous Movement and local communities. I think that one fundamental quality is the close connection with the sector that we represent. The idea is that we should be certified by the voters and that we manage their demands. Another thing that we haven't reached in the National Assembly is that our work as legislators not be divorced from our [political] base. Because how are you going to legislate if you have not consulted your base? (Law 1988)

The representational styles of Central American women legislators are varied, depending on the focus of representation, the political party, and their personal preferences (Table 4.6). While only the styles or roles of delegate and trustee are discussed here, many of the women legislators expressed different styles in relation to different focal areas of representation. For example, one could take a trustee role in representing "all the people" but a delegate role in representing a farm workers' union. As one deputy in El Salvador, Macla Judith Romero de Torres, put it:

What do I represent? The whole department. I was elected by my department of Cuzcatlán, but upon arriving here at the Assembly, now I no longer repre-

TABLE 4.6. STYLE OF REPRESENTATION (PERCENTAGE OF WOMEN IN EACH CATEGORY)

Style	Costa Rica (n = 14)	El Salvador (n = 10)	Guatemala (n = 5)	Honduras (n = 15)	Nicaragua (n = 24)
Delegate	7	10	40	47	50
Trustee	93	90	60	53	50

Source: Interviews with women legislators in Central America.

sent only the department of Cuzcatlán, but rather the whole country. (Romero de Torres 1990)

More will be said about representational style below concerning the representation of women.

Nearly all the deputies in Costa Rica and El Salvador preferred the role of trustee. In Costa Rica, deputies can act as a whole body to pass legislation. But in addition, permanent commissions are also empowered to emit some laws that do not need approval of the entire Assembly. This gives the representatives in Costa Rica, like Rose Marie Karpinski, the feeling that they are there to make decisions in the best interests of the citizenry, irrespective of the political party, area, or interests they may individually represent.

I [represent] all the Costa Ricans who want to make the country better. I feel myself representative of my party, but [also] representative of the Costa Ricans, and that's why I have proposed many laws which are supported by members of both political parties. I have been bi-partisan in many of the laws because I think that any project that benefits the Costa Ricans should be supported. (Karpinski 1989)

Another Costa Rican, Marielos Sancho, described how she does not take sides, but looks for the best for her community:

I represent the *cantóns* of Grecia, Valverde Vega, and Poás. Indubitably, I work on the interests of those *cantóns*. Another area which has a lot of support from me is education. But beyond that I represent the interests of the community in general. (Sancho 1990)

A high level (90 percent) of Salvadoran deputies also chose the trustee role. Whereas the majority of the Salvadoran population is poor or working class, Salvadoran deputies are generally from the middle or upper classes. Salvadoran deputies, like Gloria Salguero Gross, expressed their obligation to make decisions for the majority with a spirit of benevolent maternalism, or "mother knows best."

When one speaks of elections, it refers to the entire population. I do not represent any one part of the population. I have worked to benefit everyone, right? When it is time to fight for projects, it is no secret that here in the Assembly, what I try to do is, according to my values, do what is best for now. (Salguero Gross 1990)

Deputies in Honduras tended to see their role as that of a faithful party delegate (47 percent), carrying out the program of their respec-

tive political parties, almost as often as that of a trustee (53 percent). Here more of the women were elected from middle- and working-class backgrounds, with long histories of party activism. Several Honduran deputies said they enjoyed doing political work with the people out in the towns more than they enjoyed working in committees and on bills in the legislature. In fact, Honduran deputies said that, within each party, some deputies specialize in the work within the Congress, while others specialize in the work out in the field. Although the sample in Guatemala was small, trustee was preferred to delegate by a ratio of three to two. In Nicaragua, deputies also often saw their role as that of a delegate, not only of a political party, but also of the specific sector they represent, such as market vendors or small farming cooperatives. This was especially true for the deputies from the FSLN party and for those with working-class backgrounds. Also, many women in this study were interviewed during their first year in office, when legislators are most likely to say that they practice a delegate role (Bell and Price 1975).

REPRESENTING WOMEN

After asking about representation in general, we asked the deputies whether they also felt any obligation to represent women; nearly all said "yes" (Table 4.5 above). The highest percentages of legislators who identified women as a focus of representation without being prompted were in Guatemala (60 percent), which had the fewest women in the national legislature, and in Nicaragua (74 percent), which had the highest number of women in the legislature at the time. The women legislators in Guatemala were only too aware of their status as outsiders, as "the other" compared with the rest of the (male) legislators.[4] In contrast, some women legislators in Nicaragua were included in their party's slate of nominees precisely because they had been active on behalf of women before being elected. There was also a multi-party women's caucus inside the Nicaraguan national legislature and a strong presence of women's groups and organizations outside it, both of which Guatemala lacked.

Hazel Law from the Nicaraguan Atlantic Coast clarified that women were chosen to be candidates for the national legislature in Nicaragua during these years primarily because of the social or economic sector they represented, not for representing women. They were politicians who had organized a particular sector to vote for the FSLN, but it could have been any sector, not just women.

In spite of the fact that a framework at the national level has been established by the revolution for the participation of women in the political and administrative life of the country, they did not select us because we were women, but rather they selected us precisely for our sector. In my case, [we were selected] because we represent the indigenous sector; in the case of the rest of the women on the Sandinista bench, they were selected because they were part of a regional committee. As far as representing women, I think that only in the case of those who have represented the women's organization in the *Consejo de Estado*, in this case Glenda Monterrey, became National Assembly candidates for their role in the women's movement. The rest of the women on the Sandinista bench were not called on as women; as politicians, yes, but not as women. (Law 1988)

Fewer women in Costa Rica, El Salvador, or Honduras mentioned women as a focus of representation before being asked specifically about it. In these countries, most legislators did not see women as a specific focus of representation, nor did they deem activism on behalf of women as a legitimate basis for nomination to their party's slate for the national legislature. In Costa Rica, a strong women's section operated in one of the major political parties, but most of the women on the party slate had won their nominations through other paths, generally by representing a geographic district. One Costa Rican, Daisy Serrano, pointed out that she was not elected because she is a woman, but she still definitely represents women:

I consider myself a representative of the *patria* [fatherland]. I think that little by little we women have gained political power, well, I think it's an honor that we keep on advancing and we are faithful representatives of women. Therefore, everything that benefits women gives me personal satisfaction. (Serrano 1990)

With respect to representing women, there are two major representational styles or roles that can be adopted: passive or active (Pitkin 1967). On the one hand, passive representation is largely symbolic, based on shared demographic characteristics, where the representative "stands for" the constituency. A deputy in El Salvador, Carmen Elena Calderón de Escalón (1990), typified how in the national legislature she was symbolic of the women from her electoral district: "I represent the people of Santa Ana. I feel very representative of the Santa Ana woman, or of the thinking of the women of Santa Ana. I feel that I have identified with the thoughts that women have in Santa Ana."

Active representation, on the other hand, is the pursuit of substantive policies on behalf of the constituency. Simply because the legislator is a woman does not mean that she will actively pursue policies focused on women. In fact, she may deny that she represents women at all, either symbolically or substantively. However, several deputies pointed out that people tend to see women legislators as representing women, whether the legislators like it or not.

The women who spontaneously identified women as a focus of representation were more likely to take the role of active representation than women who did not so identify. After the question on focus of representation, the legislators were asked if women were also one of their foci. Nearly all the women legislators agreed that they do represent women, with no more than one or two women in each country explicitly answering "no" to this question. Perhaps so many women said "yes" just to please the female interviewer, or circumstantial factors may have played a role. For example, coincidental to some of the interviews in Honduras, all the women in the Honduran national legislature had just been invited to form a bi-partisan women's committee to work on passing legislation for women, and they were very excited about it. Only one of the Honduran women said "no." However, even women who said "no" often talked about how they were involved with women's issues, women's organizations, or policies oriented toward women. Of course, much of women's lives in Central America are spent with other women in one homosocial context or another. Most of the women who said "no" qualified their answers to clarify that they did not represent *any* group exclusively, including women, or that they gave no more representation to women than to other groups. So we believe that the high percentage of women responding "yes" is representative of the orientation of women legislators in Central America. However, more of those who said "yes" only after prompting expressed their representation role as more passive or symbolic for women than for other representational foci. A more detailed discussion of what it means to adopt a gender perspective in Central America and/or how women legislators respond to the concept of feminism can be found in Chapter 6.

Five of the sixty-five women deputies interviewed in this study explicitly answered no to the question of whether they represent women, or feel an obligation to represent women's interests specifically. Some of the deputies, like Miriam Argüello (1990), the first woman president of Nicaragua's National Assembly, give women

equal representation with men and children, but no special consideration: "I consider that the responsibility I have is general, as much for men as for women, children, everybody. It is independent of my quality of womanhood." Another Nicaraguan, Azucena Ferrey, rejected the concept of representing women more explicitly, even though she is the founder of a women's organization.

When I spoke of fighting against the [Somoza and Sandinista] dictatorships, I did it for the Nicaraguan people, and the people is made up of both sexes. I have found a tremendous acceptance of the work that I have done in both sectors of the population and that gives me hope. If I set out only to defend women, then I distance myself from the possibility of establishing myself as a competent representative with the masculine sector. (Ferrey 1990)

Hilda González, even though she is active on behalf of legislation to benefit women in Costa Rica, still rejects altogether the notion of representing any sector of special interests, including women.

I would say in the first instance that I represent all the people of the Province of Heredia because I do not represent any sector in a special way. I sympathize, meet with, and identify with workers, educators, youth, and women. But I don't like to represent only women. It seems to me that this is not right, because we women do not live alone. I do not advocate the separation of men and women, nor of establishing wars between the sexes. On the contrary, women should integrate themselves totally into men's work, and men should also accept and compensate women's work, that is, equality in fact. I don't consider myself an exclusive representative of any sector, but rather of all the people. (González 1989)

Dolores Eduviges Henríquez in El Salvador echoed similar sentiments with respect to representing women's interests only or as a first priority:

[I represent] those interests that are favorable in general to everybody, not only women, because I am not a feminist. If women work [hard], just as men, they can occupy any position. There is no need to go around exploiting the fact that she is a woman and paying her homage or favoring her in anything. If a policy is favorable in general to the nation, then I am in agreement. A while back, we attended a conference in Honduras. It was organized to discuss the case of women, but from the point of view of defending the family. There was a need for legislation because the woman is the one who acts as father and mother within the home in nearly all the Latin American countries because our

men are absent [from the home] and go around making babies. So an agreement was reached that there would be an effort to enact a regional law to protect that aspect of women. I think that, here, something has been done by the attorney general from the perspective of the nuclear center of the family, so it is an indirect [women's] issue. (Henríquez 1990)

Carmen Elisa Lobo de García in Honduras (1991) had similar reasons for saying that she does not represent women exclusively:

In principle, we [women legislators] have the same obligation as all the deputies, not only for women. It is the general problems of the country that we address because we are elected by both women and men.

The largest group of deputies, 56 of 65, fully supported the concept of representing women and women's interests in the national legislature. Maria Eugenia Badilla in Costa Rica fully embraced her role:

Of course, I represent women when I am a deputy and when I am not a deputy. One of our principles as women of the Social Christian party is to fight so that a woman in general terms can develop herself as wife, as mother, in her work, and also in politics. We have seen, and day after day we analyze it more, that to be a politician, a woman doesn't have to neglect the most sacred function which the All Powerful has given us, which is to be a mother. So with a lot of pride, a woman is a mother on the same level as she is a politician. (Badilla 1989)

Yet another Costa Rican from the same Social Christian party, Nury Vargas, was willing to fight for women at any cost.

My fight for the defense of women did not begin here [in the legislature]. I've been the Director of Social Security; what don't I know about the organization of the Costa Rican family and the tons of women who are heads of household and the tons of families where there is only the woman and no man? I have a very clear idea of my role; all my life, and even more now that I am defending women. For example, I introduced a proposal for a law to recognize the rights of the common-law family and also of mistresses. This will probably bring me a lot of criticism from the Catholic Church, but that doesn't matter to me. I came here to accomplish something. . . . But even if they [Catholic Church] excommunicate me, that's not important to me either. (Vargas 1990)

One deputy in El Salvador, Macla Judith Romero de Torres, pointed to women in history who had struggled for advances for women.

But even though we are not feminists, we consider—or at least I consider—that we have a large moral debt to try to legislate on problems that concern

women, because as women we are not ignorant that these problems exist. I think that in all our Latin American societies the phenomenon exists that *machismo* reigns, and if we women don't do something to overcome that *machismo*, it will be even more difficult. Remember that if the women of the past had not set themselves the goal of gaining the vote for women, then at the present time we would still be marginalized. So I think that we have moral obligations to see what can be done for women. . . . (Romero de Torres 1990)

Deputy Maria Eugenia Castillo Fernández in Guatemala explained why she feels a special need to represent the needs of women to the legislature.

I know that women have been relegated in the past. But in the last decade she has tried to get out of that ignorance and that discrimination in which she had been maintained. And so my being a woman places more demands on me to try to do something for the education of our women because everything comes from education. The majority of Guatemalan homes have scarce economic resources, so the father says [to the mother], "No, we have to put the girl to work helping you in the kitchen, and the other child, he is a boy, so he has to go to school." So the girl doesn't go to school because among our women, there are only one or two who distinguish themselves, who earn a degree in higher education like me. (Castillo Fernández 1991)

Women deputies in Honduras expressed the feeling that they have a lot of support from the leadership of the national legislature to represent women, as Ana Chávez Petit said:

We have taken advantage of our status to represent women. Because women here in our country are the largest part of the electorate—we are 52.2 percent of the electorate, so I think that we have an obligation to give back a lot to women. And with this government—thanks to God—Mr. Callejas [President of the Republic], and Mr. Díaz [President of the National Congress], we have a lot of support in favor of women, tremendous support. They are both democratic men with open doors, good upbringings, and Christian moral principles and they are supportive of the Honduran woman. (Chávez Petit 1991)

Another Honduran deputy, Leda Lizeth Pagán Rodríguez (1991), was very clear about her priorities: "We represent the interests of women first and then of the Honduran people; not the interests of the Honduran people first and the interests of women second." And a third Honduran deputy, Gloria Paula Mejía de Jalil, wants to get more women to run for office:

I am personally trying to awaken women's conscience so that they can aspire to political office. Because the majority of the electorate in this country is female. But since there is a *machista* framework, we are trying to break that framework. Because we know that we women are more responsible with and more often complete the tasks that are assigned to us, and we are more compassionate than men. And we are demonstrating it through organizations like the Pan American Health Organization, where they give preeminence to woman because she is more responsible. (Mejía de Jalil 1991)

Deputy Berta Rosa Flores in Nicaragua represents women because she sees their problems as identical to the problems of the country as a whole.

There is not much difference between being the representative of the population in general and being the representative of women. Because we say that the tasks of women are not just the tasks of women as such, but rather they are the tasks of all the society too. There are some very particular interests of women that we feel have to be represented. But in a general way the interests of women have to be interests of the whole society; the problems of women can't be unlinked from the rest of society, because we women are not an island but part of a whole society. Of course, we have many problems, all products of the negative history of our country, of Central America. But with a history of revolutionary involvement, this is beginning to change things. It has changed women a lot, and men as much as women. (Flores 1988)

Another Nicaraguan, Rosa Julia Esquivel, echoed this perspective.

The interests of women are the interests of men as well. We know that women alone can't transform this new society, but rather it is in conjunction with men. That is, just as we jointly participated in the [1979] insurrection, even before the insurrection, we have to keep on doing the same thing now, participating together to reach the new society, which is what we want to gain. (Esquivel 1988)

Deputy Gladys Baez in Nicaragua cannot rest on the assumption that, once women's rights are contained in the Constitution, women need no more special representation.

I don't believe that the political Constitution of Nicaragua has changed concepts and values to benefit women. That is to say, for the first time in the history of the political Constitution [in Nicaragua], you find women by name. That is, it establishes through all its articles the duties and rights of men and women in society. Part [of the Constitution] has to do with the concept of the family that we want to form in the revolution, but am I going to be content

with that because it says so on paper? No, sir! I have to bring it out, sell that project to women so that they make it their own, so that they can intervene in their social sector where they live, so that they can intervene in the family, so that they can change conceptions, traditions, and values, so that it is effectively carried out in society and in real life. Because we can't be content with people coming from abroad and showing [the Constitution] to them, saying "This is a very pretty paper, this is what the Constitution prescribes," and then immediately putting it away as soon as the delegation leaves. (Baez 1988)

A final Nicaraguan Social Christian deputy, Luisa del Carmen Lario, talked about the importance of women legislators working together for the benefit of women.

I have always affirmed that we women [legislators] have a common goal and that independent of the party in which we each are politically active, we women as such have a greater responsibility for our own essence as women. This does not mean that I have to fight with a man or think that I am superior; rather it means that I have to locate myself anew and find my own essence and that which I can contribute to the good of society. So I think that it is necessary that we women really find ourselves anew as women and that we know that politically we can be in the front lines of confrontation. (Lario 1990)

CONCLUSION

Elected women in Central America expressed many varied opinions about what it means to serve as a legislator and a representative. They tended to emphasize the lawmaking function of the legislature over its role as a check and balance for the executive and judicial branches, and to highlight the intimate connections of the elected with the electorate.

Women are becoming more visible in Central American legislatures, not only as elected representatives, but also in leadership positions on the governing boards of these bodies. They are active in a wide range of legislative committees, although their committee assignments have varied widely by country and over time. One indicator of the commitment of Central American women legislators to their duties was the staggering investment of time and the wide gamut of activities they undertake as part of the job.

There was great variation in how the job of "legislator" was described in each country with respect to the general qualities that are required for the job. Such qualities as educational and professional skills might be emphasized in one country, whereas leadership and

interpersonal skills might be emphasized in another, depending on the historical and contemporary political situation. In most cases, it was recommended that women seeking the job have or acquire additional qualities to those stipulated in general. These additional qualities ranged from more conservative strategies stressing personal betterment to more liberal strategies stressing an egalitarian approach. More feminist, pro-women strategies were recommended by current women legislators in some of the countries, but more radical strategies to overcome *machismo* were recommended by some women legislators in all the countries.

As representatives, there was wide variation in the definition of what that term entailed. Perhaps because these are all national legislatures, there was an emphasis on representing all the people above any particular geographic region, party, or other identifiable group. Nevertheless, there were clear variations among countries in the types of entities represented, generally depending on the characteristics of the candidate selection process used by the legislator's political party. Nearly all the elected women said they represented women to some extent. For some, there was little choice in the matter, as other people would assume they must represent women simply because they are women (passive representation). For others, women were a number-one priority (active representation). And a great many opinions fell in between these two extremes. There was increasing recognition of the conditions that all women—even elected legislators—-share, as well as recognition that women constitute an important group or sector that not only can be but should be represented. Finally, the representational style adopted by women legislators varied also, sometimes in relation to the group or sector that was being represented. The majority chose the trustee orientation, which provided them with more latitude in decision-making than that of the delegate orientation, which remains more faithful to the wishes of those being represented. These are all indications that when a woman enters politics, she is changed by it, but they also indicate that women are striving to change politics as well. The two most visible ways in which women are changing politics—through demands for democratization and through public-policy proposals—are the subjects of the final two chapters of this book.

CHAPTER 5: WOMEN AND DEMOCRATIZATION IN CENTRAL AMERICA

> Women are the first to call for democracy because we have always been on the margin of everything . . . since the beginning . . . judicially, politically, economically, within parties, we have been marginalized in everything. Our primordial objective [for democratization] is to be taken into consideration.
>
> SILVIA HERNÁNDEZ, *Oficina de la Mujer*, El Salvador, 1993

INTRODUCTION

This chapter discusses the relationship of women to the process of democratization in Central America. We first provide a brief summary of three major types of democratic practice, including liberal, social, and radical democracy, to inform our findings on the characteristics of the unique democracies being developed in Central American republics. These include not only formal institutions, rules, and electoral procedures, but also peace, popular participation, economic development, and social justice as essential components for a sustainable democracy. We then revisit the crisis-transition-consolidation framework developed in the overview in Chapter 1 to discuss how women's beliefs about democratization shaped their participation in democratization in Central America at the end of the twentieth century.

This time period provided a rich opportunity to compare the experiences of women and de-

mocratization across countries in detail. But after the worst moments of crisis in Central America passed, some observers of the region turned their attention away from the conceptual issues of transition and consolidation of democracy and focused on more routine aspects of governing, such as candidate recruitment and voting patterns (e.g., Crisp et al. 2004; Taylor-Robinson 2001; Taylor-Robinson and Sky 2002). Debates about the best means to the end of transforming politics—whether by working within formal structures (such as political parties) or by working outside them—gave way to counting women's share of political offices and public expenditures. International concerns over building women's capacity for and quality of strategic political participation were displaced by practical self-help programs, such as poverty alleviation, that were not concerned with fostering opportunities for civic participation.

In this chapter we return to more traditional concerns expressed in studies about democracy. What constitutes democracy? What should be the relationship between political and civil society? How should citizens participate? What do citizens want their democracies to do? What type of democracy can create opportunities for Central American citizens to network, critique, and strategize to solve their mutual problems (Sternbach et al. 1992)? It is important to examine what Central American women leaders, activists, and critics think, because each country's democracy and its objectives—as well as women's opportunities within it—were influenced by the beliefs and actions of these women. In a dialectical relationship, Central American women's beliefs about democracy shaped their actions during the crisis and transition, and those experiences in turn further influenced their perspectives on the form that democracy should take. Addressing the questions posed here through women's lived experiences also provides an opportunity to reflect on some of the earlier democratization literature and its applicability to the Central American region, as well as to make comparisons to women in transitioning regimes in Central and Eastern Europe.

The period under study in this book was notable for the growth of women's movements generally in Latin America and the increasing public roles played by women in struggles against authoritarianism, which opened up space for women's representation and influence on the policy agenda. Women activists in Latin America argued that a transition to democracy, with its values of equality and fairness, required that women participate in political decision-making on equal terms with men. These arguments compelled studies of democratiza-

tion to pay attention to the political activity of women, rather than assume women were apolitical (Htun and Jones 2002, 32–56; O'Regan 2000). While our study focuses on women in national leadership, we acknowledge the important role that women's movements in Latin America have made in transforming politics. Scholars such as Craske (1999) and Molyneux (1998) have contributed to the understanding of the pivotal role that women's movements have played in initiating fundamental and often radical change in the region.

DEFINITIONS OF DEMOCRACY

There is no doubt that women were active in the democratization of Central America. All the people interviewed for this book had clearly given democratization much thought. They responded quite readily to the question "What does democracy mean to you?" But what sort of democracy did they work to bring forth?

In general, Central Americans think of democracy as a legitimated political regime that preserves peace and public order, provides broad opportunities for citizen participation, and has definitive goals for economic development and social justice (Table 5.1). These threads are so intertwined that it would be impossible to have a democracy without the realization of all of them, as Mario Rolando Cabrera from the *Fundación Para la Paz, la Democracia, y el Desarollo* [Foundation for Peace, Democracy, and Development] (FUNDAPAZD) in Guatemala remarked in 1993:

For us, peace is the practical realization of democracy with the corollary of development with equity for all in Guatemala. That is to say, if there is no development, there is no democracy, nor is there peace. If there is no peace, neither is there democracy or development. And if there is no democracy, there is no development, and there is no peace. The idea is very simple . . . all or nothing. (Cabrera 1993)

Central Americans' definitions of democracy highlighted a range of possible interpretations, from procedural definitions stressing rules and laws to more teleological definitions stressing human rights and popular participation. Many definitions varied with the person's socioeconomic class, political party allegiance, generation, and background. But one common theme was that their countries sought a uniquely Central American model of democracy.

Central Americans were quick to distinguish between their own struggles to determine their political affairs and the efforts of outsiders to dictate to them. Vilma Nuñez de Escorcia, head of the *Centro*

TABLE 5.1. DEFINITIONS OF DEMOCRACY

	Liberal Democracy	Social Democracy	Radical Democracy	Central American Democracy
Basic Premises	Public order; individual liberty	Public order; individual liberty constrained by social needs	Public order; collective needs	Public order; collective organization according to individual needs
Liberty or Freedom	Negative; freedom to pursue own ends	Balance of individual and social ends	Positive; freedom from economic wants	Positive; to collectively influence social decisions
Civil Society	Buffer between the person and govt.; based on individual interests	Realm of consensus between individual and govt. for the common good	Disappears; becomes one with the state; all groups are creatures of the state	Realm of consensus between organized sectors and government for the common good
Goals of Democracy	No social goals; up to each individual	Mitigate excesses of capitalism	Guarantee social and economic well-being	Mitigate effects of development with minimum guarantees

Source: Interviews with Central Americans.

Nicaragüense de Derechos Humanos [Nicaraguan Center for Human Rights] (CENIDH) in 1993, offered these words:

Here [outsiders] have wanted to think that Central America is one sub-region where the economic, social, and political problems of all the countries are the same. And so, in a very intentional way, they try to establish symmetry between the situations that happened in Guatemala, in El Salvador, and in Ni-

caragua. They are pushing democratic processes here, formal processes of democracy in Central America, [the same ones for] Guatemala, El Salvador, and Honduras. (Nuñez de Escorcia 1993)

Nuñez's words foreshadow that, while outsiders' suggestions for "formal processes of democracy"—the rules and procedures of elections—might offer guidelines, the actual interpretations of democracy must differ across Central American countries. César Arostegui, advisor to the Nicaraguan national legislature during the Chamorro government (1990–1996), echoed these sentiments:

There are an infinite number of interpretations of the concept of democracy. Personally, I believe more in a participatory democracy, from the point of view of the involvement of the individual in the daily business of the nation. There can be alternating parties in power through periodic elections, but if the great social and economic problems are not solved, that democracy is not effective. We are in a process of finding our own democratic path, so, when it comes to imposing democratic models, especially from abroad, those imported democratic models, well, they would have to be adjusted to the national reality. (Arostegui 1993)

Mario Rolando Cabrera from FUNDAPAZD in Guatemala used the metaphor of tailoring a suit to emphasize Central Americans' desires to adapt democracy to their own realities.

Your [U.S.] democracy is like a big suit but we are a small country. We want to wrap ourselves up in this big suit but it doesn't fit us. So what do we have to do? Make a suit that is our size. (Cabrera 1993)

Central Americans augment the formal and procedural definitions of democracy (those emphasizing rules and elections) with two other definitions: participatory democracy (emphasizing citizen involvement) and social democracy (emphasizing economic development and social justice).

Most of the people interviewed for this book did not espouse a theoretically pure model of democracy. Rather, they described their interpretation of democracy as a mix of elements from various traditions, such as liberal, social, and radical democracy. Through analysis of their descriptions, however, a uniquely Central American hybrid model of democracy (Vilas 1996) appears, one that focuses on the formal rules of democracy (laws and procedures) as well as the substantive dimensions of democracy: public order (how citizens are protected); social justice (how equitable the society becomes); civil

society (reaching consensus about laws and policy); and individual rights to collective participation. Similarly, Jonas (2000, 24) defined a unique *"camino centroamericano"* [Central American path] of "multidimensional democratization." This means not only the establishment of structures, rules, and processes for elections, but also the attainment of social and economic goals.

In order to better understand the Central American hybridization of procedural democracy with other elements, we must unpack the concept of democracy. Derived from the ancient Greek, democracy literally meant "rule by the many." It was practiced in public forums where citizens would deliberate and strategize on issues of common concern. While deliberation in the public sphere represented the highest possible achievement of human nature and the greatest societal good, in reality only a few participated; many (including the propertyless, slaves, women, and children) remained isolated in the private sphere. Since these ancient beginnings, democracy has evolved into several variants: liberal democracy, social democracy, and radical democracy. One element of democracy has nonetheless remained constant: "all types of democracy presume that people who live together in a society need a process for arriving at binding decisions that take everybody's interests into account" (Gutman 1993, 411). The next section explores Central American democratic "suit-making"—the tailoring of a Central American version of democracy—by referencing traditional definitions of the term.

LIBERAL DEMOCRACY

Liberal or procedural democracy, by privileging elections within the political sphere and protecting citizens' private activities within the civil sphere, is most prominent in the United States. Liberal democracy negotiates the tension between the accumulation and wielding of power with the limitation of power (Zakaria 1997, 30). The U.S. Constitution reflects this classic political balancing act: to minimize the tyranny of individuals or groups over one another (with majority rule and minority rights) and to minimize the tyranny of government over citizens (creating institutional checks and balances by dispersing power through the executive, legislative, and judicial branches of the federal as well as state levels of government). In liberal democracy, individual rights have supremacy; the premier individual right, liberty, is defined negatively, as "freedom from interference" (rather than positively, as "responsibility to take action"). Government has no ultimate goal; government is merely a process of decision-making.[1]

These constitutional measures protect citizens' private initiatives and limit government intervention in the economic and social spaces of civil society and the home (the private sphere). Linz and Stepan (1996, 8) define the government/political sphere (or political society) as "an arena of democracy" where political leaders "vie to contest the legitimate right to exercise control over public power and the state apparatus." In other words, political leaders, political parties, inter-party alliances, electoral rules and elections, and legislatures constitute the political sphere. The civil sphere (or civil society) is a sphere of equal, atomized individuals with no shared vision of the societal good. Civil society serves as a buffer between the public (government/political) and the private (household) spheres by providing a place for public-but-not-partisan interactions and associations, such as book clubs, softball leagues, or scout groups (Walzer 1991, 296–297). The civil sphere (or civil society) is the arena of democracy "where self-organizing groups, movements, and individuals, relatively autonomous from the state, attempt to articulate values, create associations and solidarities, and advance their interests" (Linz and Stepan 1996, 7).

Together, political society and civil society form the cornerstones of liberal democracy. Accepting that both are necessary for liberal democracy establishes certain conditions upon which competitive elections become possible. The formal institutions and organizations of the government/political sphere, along with the voluntary associations and networks of the civil sphere, constitute the minimum necessary to make Schumpeter's (1976) and Dahl's (1989) definitions of democracy—competitive elections and negative freedoms—sustainable. In this framework, civil society becomes the realm of citizens' voluntary interactions and associations. These groups within civil society might not have political components; rather, they might form around nonpolitical, personal, and/or leisure interests, such as bird-watching or garden clubs (Rosenblum 1998). As Schmitter and Karl (1993, 44) write, "civil society provides an intermediate layer of governance between the individual and the state that is capable of resolving conflicts and controlling the behavior of members without public coercion." The associational life of civil society teaches civility: through interactions and dialogues in this intermediate realm, citizens develop and practice the virtues of democratic citizenship while pursuing personal goals. Norms of decorum and rules of comportment generally enforce socially acceptable behavior among individuals without state intervention and without violence (Almond and Verba 1963).

Central Americans from conservative and right-wing political parties defined democracy principally in liberal constitutional terms. Miriam Eleana Mixco Reyna (1993), a Salvadoran legislator from ARENA, explained, "Well, for me, democracy is the capacity of any person to express themselves and to be able to elect the person whom they want to represent them." Azucena Ferrey (1993), a Nicaraguan elected legislator and former *Contra*, offered this definition: "[Democracy is] to ensure the possibility of pluralistic competition for the electoral process."

Ferrey stresses procedural and legalistic elements of democracy such as political parties and electoral processes. Her pluralism refers strictly to the representation of different ideological platforms in the electoral competition. Politicians and activists on the right generally preferred a limited, liberal democracy, where equality is defined as juridical, and they believed that laws would eliminate citizen inequalities. A Salvadoran legislator from ARENA, Mercedes Gloria Salguero Gross, articulated this viewpoint most clearly in 1993 (while her party was in power):

For me democracy is a system where everyone, men and women, are equal before the law, where there is a balance of forces, where there is no dictatorship, where there is a government legally constituted, in terms of popular election, where it is the people which manifests itself and delegates its power to [representatives], who can at no time exercise totalitarianism, that is not allowed in democracy. Rather it is a system in which we all have equal opportunities, men as well as women, in everything, whether it is in jobs, in the social sphere, or in the economic sphere. (Salguero Gross 1993)

Salguero's emphasis on law and the due process of law as the basis of equality among citizens is the hallmark of liberal democracy. Political procedures and social norms are codified in law, understood by citizens, and respected by the state.

Liberal democracy has many critics. Feminist scholarship has exposed the fallacies of separate public and private spheres, revealing the identification of male political agents with the former, and female domestic agents with the latter (Phillips 1998). By relegating citizens' nonpolitical interests to the private sphere, women—as residents of the home and as nurturers and caretakers—lack public voices; their interests lack representation in the political sphere where formal deliberations over laws and policies occur (Brennan and Pateman 1979; Molyneux and Razavi 2003). Moreover, the private sphere, as the realm

of hearth and home, protects values of altruism, caring, and cooperation; the public sphere, as the realm of electoral and market competition, promotes individualism and self-interest. In liberal democracies, as women and other previously marginalized groups (indigenous peoples, ethnic minorities) enter politics, a key debate has focused on whether community-oriented group values can—or should—transform the aggressive individualism of politics (Okin 1998). That is, when many women enter politics, how does or how should politics change? The equality privileged by liberal democracy, and favored by Ferrey, Mixco Reyna, and Salguero Gross, has a problematic relationship to difference (Nash 1998). All citizens are legally equal and legally entitled to the same opportunities, yet socioeconomic and other ascriptive differences fundamentally relegate women and minorities to second-class status. Can citizens enjoy legal equality when cultural preferences and structural conditions deny certain groups meaningful opportunities to engage in the civil or political spheres? Some feminists have challenged liberal democracy's public/private divide by attempting to bring traditionally private issues—such as women's unpaid household labor or domestic violence—into the public sphere of politics. Other feminists have challenged liberal democracy's emphasis on individual liberties by focusing on the discrimination and problems experienced by identifiable, marginalized groups.

SOCIAL DEMOCRACY

Social democracy appeared in Europe as an effort to address the effects of capitalism in the nineteenth and early twentieth centuries (Heywood 2002). Whereas liberal democracy champions markets and individualism—and therefore unrestrained capitalist enterprise—social democracy sought a balance between the market and the state, between the individual and the community. Social democrats recognized that individualism and competition in the political and economic marketplaces created underdogs. They expressed a concern for the socially weak and vulnerable, stressing both individual responsibilities and positive freedoms, such as guarantees of certain standards of living (Jaquette 1976). Social democracy consequently extends the "democratic principles" of equality into the work force and into the home: workers and women earn certain rights as members of identifiable groups (Gutman 1993, 415). The state intervenes to protect laborers and to protect women within civil and private spaces that liberal democracy regarded as intervention-free; the state

assumes redistributive burdens for these groups (e.g., subsidized child care for working families). The public sphere in social democracy is thus larger than in liberal democracy. Social democracy (also referred to as economic democracy) may be corporatist in style, wherein organized interest groups with socioeconomic demands may voice their concerns to, and receive benefits from, a sympathetic state.

Social democratic values appear in some definitions of democracy offered by Central Americans, generally from center-left political parties. In social democracy, the process of democratizing economies and households allows for more deliberation and debate in civil society as a third sphere. Social democracy makes social and economic policy areas—housing, health, education—the subject of citizen action, and it advocates for congruence between the values of political life and the values of social and economic life. All arenas should be moderated by the social democrat's respect for equality.

In 1993, Salvadoran legislator Amanda Villatoro, from a leftist political party, also spoke of democracy in three spheres:

> For me, a democracy should not be centered on elections, nor should a democracy be measured by elections, because they are just a tool of democracy. Democracy as such should be reflected in a political democracy, in an economic democracy, and in a social democracy. To say that we are in a democracy in this country, I think that would be overlooking much of our reality; insofar as a democracy presupposes public security, democracy presupposes access to education for all of the many who want it, democracy presupposes that there is a right to housing, democracy presupposes that there is a right to a job. (Villatoro 1993)

Villatoro emphasized democracy as an objective. Democracy extends equality into social and economic life rather than merely serving as a process for the conduct of competitions.

Critics of social democracy often focus on the ideology's incompleteness. Some feminists have charged that the premier concern of social democracy—protecting the underdog from capitalist exploitation—ignores how women laborers experience both productive (work force) and reproductive (household) burdens (Tuana and Tong 1995). Subsidies for working women might alleviate women's financial burden, but state redistribution does not fundamentally challenge women's lack of reproductive and sexual freedom within families (Randall and Waylen 1998). Other critiques highlight how, despite social democracy's focus on the group needs of workers or

women, the rights and responsibilities of individual citizens remain as the dominant juridical category. Treating women as a group is problematic when the *de facto* basis for many social policies is still the individual. As a result, social democratic feminist activists often propose mechanisms to increase the presence and the voice of women in government. These mechanisms have included specialized policy making machineries for women, such as women's agencies or women's ministries, as well as affirmative action quotas for women's nomination to public offices. This struggle continues as many social democratic governments, particularly in Europe, respond to the pressures of globalization by withdrawing economic and household welfare programs (Heywood 2002, 58). Nonetheless, social democracy remains notable for expanding and protecting civil society as a place where many dialogues about individual and group needs can unfold.

RADICAL DEMOCRACY

Whereas social democracy has the state ameliorating certain socioeconomic inequalities through bargaining and policy, radical democracy relies on a strong commitment to eradicating nearly all private inequalities through government/political action. As practiced by the former Soviet and Central and Eastern European republics, radical democracy—based in the intellectual traditions of socialism—privileged the material needs of the community and advocated common ownership and centralized planning (Heywood 2002, 51–52). In radical democracy, civil society becomes absorbed into the political arena (Linz and Stepan 1996, 40–42).[2] The state (*laissez-faire* in liberal democracy, and moderately interventionist in social democracy) becomes totalitarian and prescribes individual rights according to economic needs. As the sole arbiter of politics, economics, and society, the state acts to benefit all citizens but does not generally tolerate citizens' formation of independent associations. In 1993, Sylvia Hernández from the government *Oficina de la Mujer* [Office of Women] seemed to propose a radical democracy for El Salvador:

At this time, the immense majority of the population lives in unfavorable conditions, in conditions unworthy of a human being. It is shameful. For me, democracy is when we all have the opportunity to participate in everything that there is in our country, and there is a lot. Yes, share it all, without cost. (Hernández 1993)

The majority of Central Americans who defined democracy in radical terms were from leftist political parties, and they often equated it with the Arbenz administration in Guatemala (1944–1954) or the Sandinista administration in Nicaragua (1979–1990). José Lobo Dubón, president of the Guatemalan Congress in 1991, described how the modestly redistributive policies associated with the Arbenz administration were so different from the norm in Guatemala that they were perceived as Communist within the polarized context of the Cold War:

That period of 10 years of democracy brought unanticipated things to the country, for example, a Labor Code. This country had never had a Labor Code. And a Guatemalan Institute of Social Security, which had never before existed either. So the most basic democratic advances occurred in that brief period of 10 years. (Lobo Dubón 1991)

Julieta Bendaña of CENZONTLE, an NGO dedicated to raising the voices of all Nicaraguans, noted the progress made during the Sandinista administration in eliminating socioeconomic inequalities and in bringing marginalized groups into the political system:

For me there was one moment in which democracy was initiated in this country. It was at the beginning of the [1979] revolution when the Council of State functioned, when all the social forces of the country were represented. That is, those same civil societies gathered to discuss their differences in that institution in the exercise of governance of the country. That was the last moment in which, as I understand it, there was a form of democracy in this country. (Bendaña 1993)

In this activist's view, the sectorial representation of all groups within the Nicaraguan state permitted the Sandinista administration to assess and address the material needs of all socioeconomic classes when designing law and policy.

While radical democracy certainly proposes that the community "share everything that exists" and strives to eliminate the barriers that make resource enjoyment prohibitive to the many, critiques of radical democracy center on the extremes of this state-mandated redistribution. For example, in 1993, Nicaraguan legislator Azucena Ferrey (a former *Contra*) regarded the former Sandinista administration as a dictatorship of the left:

What, someone has told you we have a democracy here? Our problem is that we have always lived in periods of dictatorship, of two kinds, of the right and of the left. We have never had the opportunity for a democratic and dignified

development. We haven't had any education in politics. We have lived on confrontations, on impositions of rules. (Ferrey 1993)

Radical democracy is often critiqued because it forecloses upon the civic spaces for deliberation and contestation. Organized groups do have their representation and voice on state councils but cannot articulate any interests, needs, or objectives outside those sanctioned by the state. Moreover, under radical democratic regimes women shoulder a triple burden: they must work within their sector politically, as well as continue with paid labor-force production and unpaid household reproduction.

TAILORING DEMOCRACY FOR CENTRAL AMERICA

Since winning independence from Spain, Central American nations have experimented with North American and European democratic practices (liberal, social, and radical), often while simultaneously sustaining the authoritarian practices of previous institutions, appearing at times more like *democraduras* than Western-style democracies (see Chapter 1). The non-democratic legacy in Central America has been manifest in elite oligarchies, dictatorships, and dynasties; in epochs of military rule; in the hierarchical Catholic Church; in dominance by large landowners and impoverishment of the landless; and in the patriarchal values that dictated men's and women's roles.

Nevertheless, in their most recent attempts at democratization in the 1980s and 1990s, Central Americans sought what most democracies promise: a legitimate form of decision-making that ensures public order. In addition to these basic conditions, however, Central American democracy goes further and also focuses on people: on social justice, individual rights to group representation, and broad social participation in decision-making (Jonas 2000; Disney 2003). Central Americans conceive of democracy as being multidimensional, with establishment of public order, guarantees of social and economic justice, legitimation of participation in civil society as the realm of consensus between state and society, and individual freedom to collectively influence decisions affecting society. In the following sections we explore each of these dimensions of Central American democracy.

PUBLIC ORDER

The first cornerstone of Central American democracy is public order. During authoritarian eras, the chilling phrase "public order" often connoted arbitrary state repression (Aron et al. 1991). In con-

trast, democracy theoretically eliminates violence from politics by installing a legitimate, predictable, and regularized decision-making system backed by laws and courts (O'Donnell 1999). Yet this democratic vision of public order—of pacific relations among citizens and among political actors—remains elusive for Latin America (Torres-Rivas 1999, 295–299), for several reasons. During the transition to democracy, paramilitary groups continued their activities and tolerated increases in criminal activity to exacerbate endemic insecurities (Koonings and Krujit 1999). Death squads continued to harass, assault, and assassinate activists, often disguising their activities as common crimes (Aron et al. 1991).

After peace accords were signed, guerrillas and opposition forces were swiftly demobilized, often before new civilian police forces could be recruited and competently trained. Incomplete agricultural resettlement programs led former combatants—many still in possession of weapons—to fall into criminal activity (including drug trafficking, kidnapping, and extortion) to generate incomes (Macías 1996; Glebbeek 2001). The poor and the excluded sometimes turned to petty crime to combat their marginalization (Moser and McIlwaine 1999). The failure of the state to fully implement judicial reforms led other citizens to (re)arm. Vigilantism also rose: in activities reminiscent of medieval witch hunts, citizens patrolled their communities, detained suspected wrongdoers (often social or economic outcasts), and carried out extralegal sentences (generally lynchings) (Godoy 2002; Sieder 2002). As political and economic instability continued, violence and fear "reached the stage of mass production and mass consumption" (Koonings and Krujit 1999, 15).

Multidimensional analyses of democracy have focused on how ongoing human-rights abuses perpetuate "societies of fear" rather than "civil democracies" (Koonings and Krujit 1999; Caldeira and Holston 1999). Public order is what will enable a democracy to fulfill its promise of social justice, through the elimination of the basic conditions that generate the inequalities and insecurities that perpetuate violence. As Sieder (2002) believes, democratic consolidation requires that coercion lose its political and social acceptability; civilian leaders, military leaders, activists, and citizens must solve problems without violence and through dialogue. The de-legitimizing of coercion will only occur, however, when and if some level of equitable socioeconomic development is achieved, as indicated by Aíra Rodríguez from *Tierra Viva* [Living Earth] in 1993 in Guatemala:

> What does peace mean for us? We know that for a lot of women, peace means minimally to have a place to live with basic services like water, electricity, an economy. [It means that] we have something to eat and to feed our children, to give them a minimal education, and to improve the quality of life of the Guatemalan. (Rodríguez 1993)

Her comments focused on the ending of not just political violence, but the violence of living. Development and democracy become indispensable components of the process of pacification, which depends on all citizens to uphold law and order. Central American democracy aspires to use public order to replace exclusion and violence with participation and justice. María Chaka from the *Coordinadora Nacional de las Viudas de Guatemala* [National Coordinating Committee of Widows of Guatemala] (CONAVIGUA), speaking in 1993, expressed how the ongoing violations of human rights coupled with common violence—the *de facto* absence of *de jure* rights—inhibits democracy:

> There is no democracy now in Guatemala, that is, for us there is no democracy because there are still violations of human rights, there is still discrimination, there are still kidnappings, there are still threats, there are still assassinations, still massacres. (Chaka 1993)

As this widow's comments indicate, the absence of respect and the presence of violence restrict democratization along all dimensions.

SOCIAL JUSTICE

The second cornerstone of Central American democracy is a belief that democracy should have goals, with one of the most important being social justice. Miller (1991, 52) explains that since the early twentieth century, female activists in Latin America "have had one primary goal: social justice. . . . For them, social justice means the reestablishment of the common good over the private good." Women's mobilization during the crisis and transition to democracy was prompted by a lack of social justice. The quest for public order and social justice drove much of women's organizing to focus on community protection, survival, and rehabilitation.

Another reason for women's concerns for social justice was the dual nature of democratization in Central America in the 1980s and 1990s, involving their desired conversion of the political system to a form of democracy, as well as their undesired conversion of the economic system with neoliberal, market-oriented reforms. These

mandated reforms were based on an economic ideology that blatantly rejects political or cultural or social-justice motivations for government intervention in the economy (Vilas 2000). In Central America, the neoliberal reforms (or recipes) imposed by important lending organizations such as the International Monetary Fund (IMF) and the Inter-American Development Bank (IDB) focused on currency stabilization, structural adjustment, and export-led growth.

The first ingredient, stabilization, drastically reduces the money supply in the economy by freezing wages and pensions, tightening access to credit, devaluing the currency, and cutting government spending. The second part, structural adjustment, reduces government intervention in the economy through privatization and deregulation. The privatization of utilities and social-service programs not only slashes government sector jobs, but eliminates welfare programs that assisted large numbers of people from the poor and working classes. Structural adjustment assumes that if the state stops spending on social services, then these services can be assumed by the household. The state relies on women to assume the responsibility to now provide these services to family members as an addition to their existing roles of household production and reproduction. The third part, export-led growth through trade liberalization, promotes foreign trade by eliminating previous government supports for domestic production and devaluing the currency exchange rate (Vilas 2000, 213–214; Chant and Craske 2003, 48–49). These neoliberal reforms began in Costa Rica in 1983, Guatemala in 1986, Nicaragua and Honduras in 1987, and El Salvador in 1989 (Gideon 2002).

As female grassroots activists realized the gendered nature of their economic burdens and the lack of public order, they began critiquing the inequities of Central America's economic and political relations. This bold outspokenness—given women's previous internalization of suffering—dovetailed with women's longstanding concerns for the common good. According to Alicia Rodríguez (1993) from the Guatemalan government's Office of Human Rights, women never received, either individually or as a group, "an equal quota of benefit for their contributions to [economic] development, nor to democratic development." The redistribution of land in Guatemala following the peace accords offers one example: only ex-combatants or landless peasants could claim land parcels, and the use of masculine pronouns eliminated women from both categories. Many women—particularly single women, abandoned women, and widows—lacked documen-

tation to prove their demobilized or peasant status; married women forfeited their claims to their husbands. Furthermore, women managing to secure land received the least valuable plots and lacked access to credit and technical assistance (Navas 1992; Luciak 2001a). Events were strikingly similar in El Salvador's land distribution program (Fundación Arias 1992). Their wartime suffering and marginalization during resettlement, as well as their disproportionate burden from economic restructuring, led women to strengthen connections between calls for democratization, public order, and social justice.

This social-justice orientation of Central American civil society was also supported by popular women's adoption of human-rights language, particularly the common slogan "women's rights are human rights." Many of the women interviewed for this study equated democracy with the observation of human rights in general and the protection of women's human rights in particular. This emphasis on women's rights as human rights, and the group/community focus it entailed, helped develop the unique model of Central American democracy as both participatory and justice-oriented. Women's mobilization, participation, and calls for social justice may have surprised both authoritarian and anti-authoritarian forces, but Central American women were determined not to return to living under the same isolated social, political, and economic conditions as before.

CIVIL SOCIETY

The third feature of the Central American model of democracy is the innovative interpretation of civil society as a participative realm; it also presents the greatest challenges. In liberal democracy, the civil sphere remains distinct from the political/government sphere; civil society protects citizens in the private sphere of the home from politics, and allows individuals to develop, express, and pursue private or civil interests (Figure 5.1); the private sphere of the home is also respected. In radical democracy, civil society nearly disappears, absorbed into an all-encompassing political society coterminous with the state (Figure 5.2). In social democracy, civil society remains distinct from government, yet social democratic values extend into the civil society as a third sphere. Debates about the needs, the wants, and the interests of citizen groups, as well as respect for these groups, occurs in this third sphere. In Central America, the social democratic notion of democratizing the civil sphere reappears but with greater strength: civil society becomes a dominant space of democratic

Figure 5.1. Relationship of Political, Civil, and Private Spheres in Liberal Democracies

Figure 5.2. Relationship of Political, Civil, and Private Spheres Before Democratization in Central America

values, wherein government and citizens agree upon their lawmaking and policy making objectives (Figure 5.3).

During most of its history, Central America's societies were divided into only two spheres—the public (forum) and the private (hearth)—with the third (civil) sphere weak or nonexistent (Figure 5.2). Central Americans did not need the buffer of an associational, civil sphere between the hearth and the forum because the gendered identity system of *machismo* and *marianismo* (see Chapter 1) and a rigid class system combined to maintain the two spheres as distinct, even as modernization progressed.[3] As Wiarda (1992, 228) suggests, a cosmology "where each individual is rooted and secure in his station" clearly defined the personal identities and public roles of Central Americans.

The rise of military governments and civil wars in the latter half of the twentieth century, however, challenged this time-honored, traditional bifurcation of society into public and private spheres (Craske 1999). Authoritarian regimes repressed civil society in order to maintain their dominance and control. Labor unions and political parties lost their voice; many opposition leaders fled into exile or were killed. The forced recruitment of men and boys into armies and guerrilla forces and the use of terror by the state and its paramilitaries, for example through systematic rape of women, constituted a violent incursion by public forces into the traditional private sphere.[4] The nonresponsiveness of the formal political sphere and the suppression of a civil sphere resulted in the politicization of the private sphere.

Women, the poor, the indigenous, and other previously marginalized groups reinvigorated civil space as the arena for protests over the violation of their private space. In these protest movements, women and the poor encountered less hierarchical and more fluid participatory opportunities. Associations were organized around deeply urgent questions of security and survival, and their political demands—an end to the extralegal terror perpetrated by governments and the redress of rights—could form only in the civil sphere (Chinchilla 1993; West and Blumberg 1990). Salvadoran Sonia Cansino from *Mujer Ciudadana* [Woman Citizen] explained:

Civil society is such an important space because people neither could solve their private sector problems themselves, nor could they find a route to getting

Figure 5.3. Relationship of Political, Civil, and Private Spheres During Crisis and Transition in Central American Democratization

formal actors in the public sphere (political parties or the state) to take up their concerns. People needed a third space in which their problems could be aired. Democracy in El Salvador has to take into account the participation of civil society, making new forms of politics, new ways of doing politics. (Cansino 1993)

A new dimension of participation that has featured prominently in Central America is the concept of *concertación*, a coming together of many different social groups for dialogue and consensus building, or rapprochement. Through this process, the social meaning and social basis of democracy becomes established (Stahler-Sholk 1994; Barnes 1998). As Jonas (2000, 18) explains, "the quality of democracy [in Central America] will also be affected by the degree of citizens' participation (individual and collective) in using democratic institutions to improve their lives." In the struggle for democratization, historically marginalized groups demanded an expansion of the process beyond traditional elite pact-making. *Concertación* became an institutionalized, procedural requirement in negotiations over political democratization and economic liberalization in Nicaragua, El Salvador, and Guatemala. Participation through civil-society organizing and protest constitutes the "new way of doing politics" referred to by Sonia Cansino and described by scholars of Latin American social movements (Dagnino and Alvarez 1998; Hellman 1995). The novelty of this social mobilization lies in actors' "ability to express themselves in an autonomous [nonpartisan] way, addressing their own perspectives and demands" in the civil realm as well as in governments' "apparent enthusiasm for [this] participation" (Vilas 1996, 482–484). Democratizing Central America has witnessed not merely the explosion of voluntary associations, but also organizations that build civil society by focusing on *concertación* and social justice (Pearce 1998, 613–614), especially non-governmental organizations (NGOs).

In emphasizing civil society action and dialogue, participatory democracy further erodes the classical liberal distinction between the public and private spheres. The third (civil) sphere becomes the realm wherein citizens express multiple, diverse interests, both political and personal. Cultures of participatory democracy favor "the extension of democracy to the workplace, the school, and the home . . . because the means of decision-making are as important as the ends" (Saint-Germain 1993b, 270). Costa Rican lawyer Llihanny Linkimer Bedoya (1999, 147) describes democracy in her country "not only as a

political system applied to public order, but as a system of life, of interpersonal relations, as a form of culture, present in the public realm and in interpersonal relations."

Central American democracy seeks congruence: pluralism, tolerance, and respect should regulate political life, civil life, and private life. This vision of congruence also supports the public order and justice-oriented dimensions of democracy. Civil society can properly function as the realm for interest articulation only if the diverse groups within civil society can unlearn violence and learn respect and believe their needs will be addressed.

Central American democracy—in emphasizing participatory decision-making and consensus—takes the democratization of civil society further than social democracy. Civil society itself becomes the premier public space through which groups not only acknowledge their inequities and differences (as in social democracy) but seek their transformation. Civil society in Central America initiates dialogues that search for common ground among social groups and between social groups and the state. Civil society therefore pursues consensus-seeking measures in order to mitigate the deleterious effects of marginalization and inequality.

Yet, the institutionalization of participatory democracy and the democratization of civil society cannot occur without effort. The authoritarian and wartime crisis periods did bring citizens together in broad-based protests, but these same periods also raised terror levels within communities, increased interpersonal distrust, and created widespread and long-lasting legacies of fear (Koonings and Krujit 1999). Generations of authoritarian practices based neither on legal nor traditional equality did little to promote the exercise of autonomy and the tolerance of difference. Procedural and institutional change, once signed into being, is expected to have an immediate, legal effect; but healing distrust and easing fear, in contrast, requires nurturing over time. Putnam (1993), Booth and Seligson (1993), Camp (2001), Power and Clark (2001), and Lagos (2003) have all suggested that interpersonal trust, as well as the willingness to communicate and compromise, constitute important value-bases for democratic civil societies. *Concertación* depends on these values, yet the basis for sustainable and meaningful *concertación* is still fragile in Central America. After the election of the opposition (UNO) presidential candidate in 1990, Nicaraguan legislator Angela Rosa Acevedo from the FSLN referred to this learning process:

We have to enter into an apprenticeship for tolerance for political discussion, and tolerance with regard to respect for institutions which have been independently elected, so that they do not become lost in the exercise of democracy, and tolerance with respect to recognition of the political leadership which the people choose, and tolerance also for those of the opposition who need to act on people's demands. (Acevedo 1993)

Acevedo echoes the comments of other women in explaining how tolerance, respect, and the willingness to dialogue and negotiate must develop as part of democratization.

COLLECTIVE INFLUENCE
The fourth and perhaps most unique cornerstone of Central American democracy is the practice of collective organization to influence social decision-making. This collective strain can be traced back to traditions of authoritarianism and hierarchy in the pre-democratization era in Central America. Rigid economic and political class-orderings influenced how the state pursued its goals:

The "good society" [was] ordinarily pictured as one where each individual is rooted and secure in his station, where representation is determined by status or function and not as a result of certain "inalienable" rights of citizenship, and where decision-making is based upon a number of well-integrated corporate elites, all of whom agree on certain primary values, accept the operating "rules of the game," and are harmonized and coordinated into an organic whole. The various elites (or "estates" or "classes" [or "sectors"]) are connected directly and vertically to the central authority rather than having their interests channeled through a variety of secondary groups or organized horizontally and impersonally across group boundaries. The state, in turn, is expected—even required—to exercise firm but paternalistic authority over this whole national "family." (Wiarda 1992, 228)

Wiarda's description accurately portrays much of Central American history during which elites curbed most citizens' rights to participate in political society and limited their freedoms to form associational ties in civil society. Corporatism resolved the question of how much voice and influence citizens have in decision-making by controlling and dictating that voice.

Democratization in Central America has largely discredited and dismantled corporatism; however, the notion of group representation and collective-interest articulation remains an important, subtle

organizing principle. All these republics have embraced citizen participation, especially at the local level, as a condition of democracy (Siu 1997, 33), and civil society is accepted as an arena for participation, confronting difference, building tolerance, and forging consensus (*concertación*). Central American researcher Ivonne Siu (1997, 22) described civil society as "all of those individual persons or collectives represented in associations, guilds, syndicates, cooperative organizations, popular groups . . . that are outside of the governmental apparatus and that have organized, to a greater or lesser degree, around a common objective."[5] Notably, it is the group and/or the organization (not the lone individual) that form the basic units in this process. In contrast to the individual rights and freedoms privileged by liberal democracies, collective rights and responsibilities form the basis of participatory democracy in Central America.

Individual rights have negative connotations in Central America, implying that persons may act with disregard for their communities; Central Americans see their rights and responsibilities as relating to their membership in families, socioeconomic classes, occupational groups, religious organizations, and so forth. As such, participatory democracy exercised through civil society is about the process of group formation, group solidarity, and group negotiation. This process targets civil society "as a site of struggle for democracy" (Vargas 1999, 304); civil society becomes the place where problems are addressed and resolved by groups (Disney 2003, 554). Through this process, Central American democracy will achieve its goals of defining common social objectives and, therefore, transforming politics.

Central Americans seek solutions for the theoretical and practical challenges of achieving horizontally equal relationships of citizen participation while avoiding vertically unequal relationships of citizen cooptation. Lucy Taylor's distinction between democratic citizenship and non-democratic client-ship reveals two modes of government-citizen interaction. Invoking liberal and social democratic elements, Taylor (2004, 214) defines democratic citizenship as formalized legal rights and responsibilities, including negative rights (civil and political) that regulate state-society and person-person interactions as well as positive rights (social and economic) that mitigate against inequality's systematic restriction of the civil and political rights of certain groups.[6] In contrast, Taylor describes non-democratic client-ship as "not about equality but inequality." Client-ship depends upon the favors and privileges received by the client in exchange for loyalty

to *el patrón* [the military strongman or economic boss or political leader]. Client-ship is mediated not by formal rights and procedures, but by social customs, personal quirks, and expectations (Taylor 2004, 214–215).[7]

This distinction echoes Max Weber's contrast between citizens' acceptance of the impersonal authority of the rational-legal bureaucratic state versus acceptance of the personalized authority of the charismatic leader (Gerth and Mills 1958). Part of democratization in Central America implies a necessary cultural adaptation to the idea that it is better to have an unknown, impersonal agent in control of government and its favors, entitlements, and protections, rather than a known but arbitrary *patrón*. On the positive side, democratic government establishes "clear rules" so that "private arbitrary power does not rule people's lives" (Vargas 1999, 308). On the negative side, many Central Americans remain doubtful about democracy (Lagos 2003); some Central Americans disbelieve that "clear rules"—the legal apparatus of states—can sustain their negative and positive freedoms. Broad collective participation in dialogue represents a Central American approach to reconciling these two modes of interaction.

Democratizing Central America grapples with transforming its corporatist tradition of state-controlled client groups into a democratic practice of interest groups with state access. Leaders of democratization are struggling to design procedures by which groups can receive representation, enjoy rights, and seek favors, but in a manner that is less manipulated by a capricious state and is more equitable and more fluid. Citizen participation becomes a collective, social good; this engagement helps to prevent arbitrary abuses of power and to legitimate democracy (Gutman 1993, 415–416). As Dinorah Azpuru de Cuestas, a Guatemalan analyst from the research institute ASIES, stated:

> For us, democracy means more than the formal aspect. Democracy also means that structures for participation exist: not only political participation individually through parties, but rather social participation in a wide sense. It means also that society enjoys certain minimal consensus or agreement on a national project where all the forces of the different sectors get on board. (Azpuru de Cuestas 1993)

Her words reflect what some scholars champion as the hallmark of Central American democratization: the revitalization of state-society interactions (Williams 1994; Torres-Rivas 1996). Precisely how society

designs its political systems and its rules, and how societal groups participate in the making of decisions that affect their lives, remains a primary concern of Central American democracy.

WOMEN IN DEMOCRATIC TRANSITIONS

As we saw in Chapter 1, the process of transforming a non- or quasi-democratic society into a democratic one is usually described as beginning with a crisis, proceeding through a transition, and ending with consolidation. The crisis, transition, and consolidation phases of democratization in Central America provided differing levels of opportunity for women to participate. One the one hand, some phases lasted much longer than others, providing more opportunity for women's participation (although it is difficult to sharply delineate where one phase ended and another began). On the other hand, the process of democratization did not unfold in a tidy linear fashion but was often carried on in both crisis and transition modes simultaneously, or lurched back and forth between stages, making it difficult for women to develop the new skills that were more salient at each subsequent stage (e.g., protest, negotiation, campaigning). Nor, by 1995, had democratization reached a definitive state of consolidation in any of these republics (except Costa Rica), because of a lack of such basic requisites as public order, rendering participation risky at best. In the following sections we examine women's participation in these phases of democratization.

CRISIS

Unquestionably, women did participate in the democratization efforts in Central American republics in the 1980s and 1990s (Box 5.1), and their participation often reflected their values of social justice and group involvement. In the stage of crisis, women involved in armed groups such as the FMLN in El Salvador, the FSLN in Nicaragua, and the URNG in Guatemala (as well as in other groups) held myriad positions and performed varied tasks: "Not only did women participate in these armed struggles to an unprecedented degree, in actual combat and leadership of troops as well as infrastructure roles, but women in neighborhood and other grassroots organizations were linked to guerrilla organizations through children, kin networks, and friends as well as through sympathy and ideology" (Chinchilla 1993, 41). As Nelly de Cid, a wartime FMLN leader, explained, "During the war, women helped in many ways: as combatants, in logistics,

Box 5.1. Women's Revolutionary Participation in Central America

El Salvador

FMLN membership: 40% women
FMLN combatants: 30% women
FMLN supporters and sympathizers (civilian): 60% women

Nicaragua

FSLN membership: 25–30% women
1967: FSLN leadership permits women to participate as combatants as well as supporters
FSLN combatants, 1967–1977: 6% (conservative estimates) to 30% (high estimates)
FSLN combatants, 1977–1979: 30% [a]
Contra combatants: 7%–15% women [b]

Guatemala (URNG)

URNG membership: 18.3% women
URNG *políticas:* 25.2% women
URNG combatants: 14.8% women
URNG supporters: Guatemalan women's participation in the URNG remained highly secretive due to fear of repression and reprisals from the Guatemalan military. At no time did women's participation in any wing of the URNG surpass 25%.

[a] Unlike the FMLN in El Salvador, the FSLN never released hard data on the number and the position of female members. The high, or optimistic, estimates of 30% female participation definitely refer to the final phase of the struggle, where women joined in great numbers; in the earlier phases, women's participation varied but grew steadily over time (Luciak 2001a, 16–17).

[b] Again, hard data on the composition of the *contra* forces is lacking. The CIAV-OEA mission that assisted in *contra* demobilization in 1990 did not segregate their data by sex. The demobilization records present an image of a young, poorly educated, rural force; nearly 40% were under the age of 20, and most demobilized fighters were men (Luciak 2001a, 22–23).

Sources: Luciak 1999, 2001a, and 2001b; Kampwirth and González 2001.

in making tortillas, working in safe houses in the city, looking after the wounded" (quoted in Best and Hussey 1996, 25). Indeed, many women joined revolutionary forces through support roles by sheltering troops, acting as messengers, and organizing campaigns. Other revolutionary women participated as *políticas,* important political leaders and strategists. Upon demobilization of the FMLN in El Salvador, women constituted 40 percent of the total FMLN membership and 30 percent of combatants (Luciak 1999, 46-47); of the civilian

networks that supported the FMLN, 60 percent were women (Silber 2004, 571); percentages in Nicaragua and Guatemala were lower (Box 5.1) but still substantial.[8]

During crisis, many women experienced murders of husbands, forced conscriptions of sons, and rapes of daughters by military or paramilitary forces. They organized into groups, notably CONAVIGUA (a widows' group) in Guatemala and COMADRES (a mothers' group) in El Salvador, to lobby the government for information about disappeared family members and to demonstrate in the streets for peace. These mothers and widows were arrested, imprisoned, tortured, and raped by government forces in retaliation, yet the women continued their protests, learning more about their human rights in the process (Schirmer 1993; Green 1999; Lievesley 1999, 135). As the introductory quotation to this chapter from Silvia Hernández indicated, women shifted from invisibility and silence to visibility and outspokenness. Given the revitalization of civil society as the hallmark of Central America's crisis and transition, women of all socioeconomic sectors found new opportunities and new voices during the democratization process. Central American women seized this space between the hearth and the ballot box where they could be seen and be heard.

Some literature on South and Central America has explored the participation of non-elites in democratization, including the extensive mobilization of the population from the private sphere into civil society, particularly women (Hellman 1995; Stephen 1997; Basu 1995; Safa 1995). These mobilizations were often a response to the repeated violent intrusion of the state into (or complete absorption by the state of) the civil realm, and/or state disregard for the tradition of inviolability of the private home. During eras of repression and crisis, citizen organizing unfolded outside the repressive state or the unresponsive institutions of the formal political sphere, and participants interacted in "more spontaneous, democratic, decentralized and participatory ways." Civil society groups formed in "the realm of everyday life" to collectively provide those welfare needs—housing, child care, health care, education—undersupplied by the state (Hellman 1995, 166–167). Popular mobilizations, by building upon personal needs and private interests, provided both moral incentives and real opportunities for women's engagement with civil society. Examples include soup kitchens and shelters in Peru and Chile, daycare crèches and rural farming cooperatives in Brazil, and antiviolence groups throughout the region

(Dagnino and Alvarez 1998). Grassroots organizations initially dedicated to sheer survival—many of which were founded and managed by women—often evolved into political movements with voices in the democratization process (Alvarez 1997; Jaquette 2000).

Based on women's experiences in Central America, the traditional framework for considering democratization as a process of pacts between elites can be reformulated to include a greatly expanded role for civil society. Women's public expression of private needs evolved into an articulation of a political agenda within the civil realm, challenging the applicability to Central America of a simple liberal democratic model with civil society as an apolitical sphere. Women's concerns with public order, social justice, civic participation, and collective interests transcended the boundaries of the narrowly defined political sphere, civil sphere, and the private sphere of the home in liberal democracy. For many, widespread state-society dialogues leading to consensus (*concertación*) "constitute[d] the goal" of political participation during the crisis (Macías et al. 2001, 47–49).

TRANSITION

Models of democratic transition often emphasize the negotiating, pacting, and rule-making activities of outgoing and incoming elites as well as (either directly or indirectly) the establishment of formal, institutionalized mechanisms for state-society interaction. The negotiated rules establish mechanisms for citizens (in the private sphere) to communicate with their leaders (in the political sphere) through the civil sphere. During the transition phase, a major goal is to reach agreement on the conditions for holding fair elections, where the results will be respected by both winners and losers. O'Donnell's (1992) model hinged upon negotiated agreements or *pactos* [pacts] between elites, first to end periods of crisis and second to strengthen consolidation. Participation in the second, transition stage, chiefly through negotiations, was much more restricted for women, and not as much is known about women's activities therein. One reason is that some women were active in only one specific phase of democratization (i.e., crisis), while others carried on activity from one phase to the next. In the era of crisis, women interviewed in this study often pursued only one of three principal avenues of participation: armed combat or other involvement with guerrilla or opposition forces; popular mobilization in civil society organizations; or representation in formal political institutions and processes. However, other women, such as FMLN

commanders Nidia Díaz, Lorena Peña, and Ana Guadalupe Martínez, participated both in combat and in formal peace talks in El Salvador (Luciak 1999, 47–48) and then in electoral politics as well. This supports Elisabeth Jean Wood's (2001) notion that leaders of insurgencies and counterinsurgencies can become new categories of elites.[9]

Women in insurrectionist elites played critical roles in their country's crisis and transition. In formal peacemaking, however, these women—as well as women following pathways of popular mobilization, mass-based organizing, and social activism—were often excluded. Nevertheless, their participation in the political and civil spheres legitimated the claims of many organizations that demanded a place at the table for *concertación*. Another explanation for women's reduced level of visibility during the transition was that negotiations spanned several years, from the first Esquipulas agreements in 1987 to country-specific accords in Nicaragua (1989–1990), El Salvador (1990–1992), and Guatemala (1992–1996), and often took place in secret or faraway locales.

A third reason was that only a relatively few persons were chosen to participate in formal peacemaking, and few of them expressed or advocated a gender-based perspective. Elected legislators (male and female) generally played only marginal roles in reaching country-specific accords. Negotiators were chosen instead for personal qualities and/or for connections with revolutionary, establishment, or government groups (Walker and Armony 2000) in response to demands for broad participation (*concertación*).

The few women who were chosen to participate in peace negotiations were often former combatants or *políticas* who believed that armed struggle had provided the foundation for a participatory and redistributive democracy. As Nelly de Cid noted, most women fought not to promote women's interests or women's rights, but to advance the guerrillas' economic and political objectives. In over 200 interviews with female FMLN combatants, no woman indicated she had joined the movement for women's rights; rather, women joined to protect their children and families (Luciak 1999, 63). In Nicaragua, the FSLN guerrilla struggle organized women to protect families from the Somozas' repression (Kampwirth 1998, 271) and transgressions into the civil sphere and the private realm of the home. While many revolutionary women gained awareness of gender-specific problems through their experiences (as objects of discrimination by male leadership, as victims of domestic violence, and as individuals with

triple political, productive, and reproductive burdens), most women identified primarily with partisan political goals. Women active in peace negotiations from guerrilla or opposition groups constituted only a small part of the entire leadership, and generally did not (or could not) introduce women's interests or women's demands with sufficient strength into the negotiations. This is reflected in the fact that all of the Esquipulas documents detailing the plans for the pacification and development of Central America used male pronouns and made little or no reference to women's contributions, women's rights, or women's conditions. The larger political objectives of socioeconomic redistribution, peace, and development remained paramount. *Militantes* expressing gender-based demands were seen at best as divisive, at worst as traitors (Luciak 2001b). In her study based on 80 Mexican women in politics, Rodríguez (2002) concluded that:

Women's political loyalties, first and foremost, rest with the political party or organization to which they belong. Gender loyalty, for all practical purposes, comes in (a distant) second. Even among women of the same party, it is noticeable that their solidarity and loyalty rest with policies and programs, political patrons and mentors, career plans and ambitions—not with the other women in the party. (Quoted in Htun and Jones 2002, 49)

Other events were also unfavorable to the expression of gendered demands in transition. In Nicaragua, Violeta Chamorro's antifeminist image of a "good woman" reuniting the traditional Nicaraguan family undermined the Sandinistas' agenda of economic equality between men and women (Kampwirth 1998). Women in El Salvador participating on the FMLN peace-negotiation team in 1992 privileged its development and redistributive agenda over any gender-based demands (Luciak 2001a, 39).[10] Women activists in civil society were present in the streets during transitional negotiations, expressing a hope for a participatory and justice-oriented democracy to emerge from the negotiations. However, the peace accords tended to focus more on the legalistic and procedural aspects of the emerging democracies than on redistributive concerns (Schmitter 1998, 224) and excluded most women. As one observer of these negotiations, Mario Rolando Cabrera of the Guatemalan organization FUNDAPAZD, remarked:

Without a clear vision of how gender was to be incorporated politically . . . there was no possibility of transmitting with clarity to the state in general and to the government in particular any strictly feminist demands. (Cabrera 1993)

Nevertheless, women involved in negotiations in later years learned from experiences at earlier points in time, as the effects of negotiated settlements spread throughout the region. In the Guatemalan negotiations (1992–1996), the last in the region, a URNG envoy, Luz Méndez, pushed for a gender perspective (though the URNG delegation never officially endorsed women's rights). The advocacy of Méndez and of women's civil society groups meeting in rounds of *concertación* produced special procedures for resettling female-headed families, government commitments to deal with discrimination against women, and promises to incorporate gender planning into development programs in Guatemala (Luciak 2001a, 54–56).

CONSOLIDATION
The third stage of the process entails the consolidation of democracy. All of the negotiated peace accords adopted a proportional-representation, multi-party system for contesting elections, making political parties the key vehicles for participation during and after the transition. By reifying political parties, the *pactos* created a paradox: civil society was the major site of emerging democracy, yet the reconstitution of political parties signified that actual citizen participation would have to be channeled through the formal, political sphere. This institutional focus was disappointing because political parties in Central America historically did not mobilize broad-based citizen support (as do political parties in Western liberal democracies) but preferred to control restricted citizen groups with little independent voice (as in the corporatist tradition). Consequently, the default to political parties heralded a return to the *status quo ante:* limited, formal, institutionalized participation controlled and conducted mostly by men (Friedman 1998; Waylen 1994). Relying on the presence of competitive political parties as indicators of democracy does not take women's disadvantages under this arrangement into account (Rodríguez 1998; Flores-Alatorre 1999); it also ignores the role of the party in supplanting women's gendered interests through demands for undivided loyalty.

The return to political parties meant that activists protesting the crisis or participating in the transition would have greatly reduced roles in the consolidation, unless they joined officially sanctioned parties. Most women who had mobilized within revolutionary organizations, whether classified as supporters (fulfilling traditional roles as wives and mothers) or as combatants (temporarily receiving

non-gendered or honorary male status), were expected to return home as part of democratic consolidation.[11] Luciak (1999, 54) notes that 57 percent of female FMLN members worked as housewives before the war, but 95 percent worked as housewives after the war. Only the most prominent revolutionary women—like Leticia Herrera in Nicaragua or Nidia Díaz in El Salvador, who reportedly said, "I don't want to go back to making tortillas" (quoted in Best and Hussey 1996, 54), became prestigious players within their parties (Luciak 1998).

Some women who had been participants in the formal political sphere throughout this era also fought to retain their status in the newly emerging power configuration. Some attempted to distance themselves from women who did not have a history of political activism. Mercedes Gloria Salguero Gross, a Salvadoran legislator from the right-wing ARENA party, characterized the role of most women as awakening in times of crisis and transition based on their cultural status as mothers and caretakers but returning to the home after the transition:

We, the women, have participated actively from the national point of view, the women who have been the most affected, because it is from women that sons are taken away for war. It is women also who lose their husbands in war. (Salguero Gross 1993)

However, there were many valid reasons for women to withdraw from the public arenas of formal politics or informal protest after transition. The economic and political crises of Central America damaged many individuals and communities, exhausting and traumatizing women. While women were instrumental in starting their countries on the path to democratization, many women—especially activists—experienced post-traumatic stress-related disorders (Green 1999). The physical and psychological pressures of warfare and the need for rehabilitation often threatened to overwhelm women's civil society participation:

The war years were rather painful for many women, who, perhaps directly, carry the burden of the loss of a husband, a partner, of sons or daughters disappeared. And in addition we carried the entire economic burden, the headship of the household during all that time. And so, during the process of negotiation, it was really somewhat frustrating at times for us. Well, we see the advances, and I think it is an enormous achievement that there are no more bullets, no more war of that type, but the whole problem of insecurity

remains, the psychosis that we bore during that period, and that we still bear today one way or another. (Urquilla 1993)

These words in 1993 from Jeannette Urquilla, from the grassroots women's organization ORMUSA in El Salvador, highlight how, for many women, there could be no peace and democratization without a process of healing lives and healing communities. This context threatened the consolidation of democracy for women in Guatemala as well. Aíra Rodríguez, from the Guatemalan women's group *Tierra Viva* [Living Earth], questioned whether her country could achieve an ideal vision of democracy:

I think that for us, democracy is essentially to live in a social context where there is no social injustice, no inequality. So you could translate that to mean no poverty, no lack of resources, no lack of opportunities, and especially access to education. That for us is the ideal democracy, so to speak, which the whole world waits for and every human being, too . . . but it is a little utopian in some ways for these times we are witnessing. (Rodríguez 1993)

The prominence of women's visible struggles on the road to democratization provided "proof of the existence of a vital civil society and reinforced the view that problems could be addressed by organized groups of citizens" (Jaquette 2000). This created widespread expectations that, following the installation of procedural democracy, women would continue to participate as leaders and as activists. Women's activism was sustained by their hope of recognition of civil, political, and social rights for women and other marginalized groups. Women in Central American politics, like their South American sisters, consequently had two hopes: that democratization would, first, "promote innovative and untested forms of participatory democracy and interest representation," and second, "entail broader efforts to erase women's social and economic disadvantages" (Montecinos 2001, 176–178).

Participation in consolidation remained a special concern for women. In Central America, women's social critiques and social justice claims focused on their experiences as members of groups and communities. Whether described as part of a women's movement or not, whether independent or affiliated with a political party, whether local or national, or whether on a small or large scale (Basu 1995, 2–3), Central American women were struggling against inequality. For many women in Central America, the inclusion and participation of

women in democratization defines not only the quality of democracy, but its very existence. In many Central American countries, graffiti read *"si la mujer no está, la democracia no va"* [democracy goes nowhere without women]. In El Salvador, the reverse was also true: *"si la democracia no está, la mujer no va"* [women go nowhere without democracy].[12] Regardless of the phraseology, the messages are clear: democracy and women go together. Ofelia López, an activist from the Salvadoran feminist group *Las Dignas*, echoed this sentiment:

> Democracy? We [women] have two concepts of democracy. One of them is when there is wide [formal] participation, speaking more at the state level. But that democracy excludes us [women]. So I would say the other concept of democracy is when no sector is excluded, when all the sectors are included. (López 1993)

Improvement in the substantive quality of life was, for many Central Americans, the motivation behind the popular mobilizations and guerrilla uprisings of the late twentieth century. Thus, Central American democracy sought a hybrid practice, one that moved beyond liberal democracy's individual rights, incorporated social democracy's concern with systematic group inequalities, and relaxed radical democracy's all-encompassing state. Participation is a cornerstone of this hybrid model. In an interview in 1993, Salvadoran scholar and writer María Candelaria Navas explained, "I think that democracy, more than writing about it, must be lived. And it has to do, I think, with practices, attitudes, and behaviors of men and women at different levels."

Her belief in democratizing civil spaces as well as the realm of daily life is consistent with the experiences of female activists creating their own autonomous organizations. These women deliberately departed from traditions of hierarchical, vertically structured organizations and adopted open, horizontal modes of interaction (Alvarez 1998a). Several women noted how their organizations internally strived for participation and equity, thus mirroring the striving for democratic practices in the external world as well.

Overall, Central American women emphasized the importance of having women present to eliminate their disadvantages. Many hoped that democracy's procedural, participatory, and social dimensions would achieve these objectives. Dora Zeledón, director of the Nicaraguan women's group AMNLAE in 1993, expressed this common viewpoint:

For me, democracy goes beyond what are formal institutions. . . . Fundamentally, I believe that a country's democracy can be measured, or can be determined, by the extent of the integration of women in that democratic process, where all of society together, but particularly women (and here in our country, women are headed for over 53 percent of the population), have the opportunity to participate and to compete on the same plane of equality as the rest. (Zeledón 1993)

In the words of this activist from AMNLAE, women's integration into democracy offers a rubric for measuring the multidimensional progress of Central American democratization. Though no women interviewed denied the connection between democratization and women's participation, two different currents existed about why women should participate in the consolidation of democracy. These currents reflect ongoing practical and theoretical debates about whether women's equality with men hinges on sameness (gender role socialization has little influence on women's and men's capabilities) or difference (gender role socialization reflects natural male and female qualities) (Chodorow 1997; Gilligan 1997; Rhode 1998; Okin 1998). Marina Peña, an activist from the Salvadoran women's group ADEMUSA, illustrated the latter viewpoint, believing that women's caring roles enhance their aptitude for democracy:

Because of her socialization, a woman is accustomed to always give, to share. If we look, for example, at the family, it is a fact that all of a woman's earnings are contributed to her family. So she is accustomed to sharing. But it is very different in the socialization of men, where he is always first and always thinking about his own benefit. So for him the concept of a participatory democracy would be more difficult, where we all have the same rights, the same conditions, the same obligations, you see, and to work collectively for the benefit of the rest. (Peña 1993)

This statement reflects a common perception that women understand dialogue and consensus more than men, and that women use cooperative rather than individualistic values when resolving conflicts. Many women are believed to transfer their private caring into public democracy (Safa 1995, 228; Jelin 1990).

Alba América Guirola, from the Salvadoran women's organization CEMUJER, however, expressed the opposing viewpoint:

If we begin from the basis that we women have more aptitude than men to understand or to construct a democracy, we would be falling into the same rut

that the men are in at this moment, believing that they are the only ones [good for democracy] because they have more aptitude. I believe, definitively, that women and men are capable, that neither the one has more, nor the other has less. (Guirola 1993)

Despite disagreeing on whether democracy promotes women's interests through emphasizing sameness or difference, the two activists both asserted that women must participate and women's participation must be recognized. The general principle of women's involvement in politics enjoys near universal acceptance among the Central American women interviewed for this book.

Other activist women extended the relationship between women and democracy further, focusing not just on why democracy should integrate women, but on whether democracy could transform women's and men's roles. The transformative potential of Central American democracy relates to the democratization of previously nonpolitical spheres, particularly the home. In Latin America, the popular slogan *"democracia en el país y en la casa"* [democracy in the nation and in the home] focused on ending discrimination politically and privately. Similarly, María Candelaria Navas, in 1993, felt that women must work for democracy by "looking out the door [of the home] as well as looking in." These slogans promise that eliminating gender role differences would benefit all of society and so justify the focus on women's productive and reproductive struggles, from unpaid household labor to uncontrolled family planning. Another Salvadoran, Jeannette Urquilla from ORMUSA, made a similar statement in 1993:

We feminists are now talking about democracy in the home in a preliminary way, to be able to fight for democracy for the whole society. So it is important to have those two terms, how to make the relationships between couples and among families more democratic, so that there can be more symmetric relationships between genders and not those huge differences like the ones we have now. And from there, well, translate that relationship into a [democratic] relationship between classes, no more lower class and upper class. (Urquilla 1993)

The democratization of gender relations becomes constructed as "the moral imperative of democratic [participation]" during transitions and consolidations (Friedman 2000, 61). Democracy in the country, the street, and the home reflects the essence of congruence between political, civil, and private life. Yet some, like Salvadoran writer

María Candelaria Navas, expressed doubts about democratizing gender relations:

Let's say in principle, yes [women have more aptitude for democracy than men]. Because of [real differences in] socialization [between women and men], it is very difficult [for women] to find the adequate route for the public practice of democracy. It is difficult for her to find a point of balance: where is it, where should it be? And especially in mixed [gender] spaces. (Navas 1993)

Navas refers to how merely procedural democracy neglects the democratization of the home and the street and thereby privileges masculine modes of interaction: competitive bargaining and aggressive negotiations (Bourque and Grossholtz 1998). In liberal democracy, many women who identify with caring and community may self-select out of formal politics and concentrate on the community and the home. Most Central American women interviewed, however, believed that by emphasizing its participatory and social justice dimensions they could mitigate the masculine bias of liberal democracy.

Multidimensional democratization proceeds slowly and irregularly, often with procedures followed and institutions built before the participatory mechanisms and social values are in place. Comparing the formal political sphere with the broadly participatory civil sphere in 1993, César Arostegui explained Nicaragua's achievement of the former but not the latter:

I think that Nicaragua has advanced considerably in democratizing the country, in effectively channeling the country within the formal democratic framework since the [1990] elections, or from the promulgation of the [1987] Constitution. But I don't think we have advanced much in participatory democracy. . . . In that sense, it's as if there were a lack of democratic culture; there's no tradition. So, yes, we have a formal democracy, but we don't know how to use it in benefit of a participatory democracy. (Arostegui 1993)

By making reference to a "democratic culture," Arostegui, a consultant to the Nicaraguan national legislature, underscored that the democratic norms of tolerance and dialogue must achieve widespread acceptance when nations democratize along multiple dimensions.

It is evident that it will be difficult to quickly establish the procedural, participatory, and social justice elements of this hybrid Central American model of democracy. A multidimensional democracy requires the installation of complex rules, the eradication of daunting socioeconomic inequalities, and the cessation of ongoing political

and criminal violence. This multidimensional nature of Central American democracy was explained by Ulices de Dios Guzmán, an analyst from the research center CEDEM in El Salvador:

> Democracy is not simply the mere procedures of candidate selection. It should give real participation, and to accompany that, there should be respect for a group of fundamental rights of the population. I'm speaking about a group of rights that go from the elementary rights, life and physical integrity, liberty, as well as respect for social and economic rights. If I feel my life or my liberty is threatened by participating in a political party, then no democracy exists, even if it is an open system. The same thing occurs, this is why I mention social and economic rights, if I am dying of hunger, if I don't have access to education, to information, to process it adequately because of my underdevelopment, because of my barest education and culture, then there's no democracy there either. (Guzmán 1993)

Guzmán stressed the social, participatory dimension of democracy as well as its formal dimensions of citizenship and guarantees of civil and political (negative) and social and economic (positive) rights. Consistent with current analyses of democratization in the developing world (Nussbaum 2000; Molyneux and Razavi 2003; Jelin 1998), he recognized that procedures and participation become meaningful only when socioeconomic conditions enable individuals and groups (through access to education, to health care, to employment) to act as citizens. The process of exactly how interests may be collectively articulated by citizens to influence state decisions is still under construction in Central America.

GENDER DISCOURSE

Due to women's visible and effective participation in periods of crisis and transition, nearly all political parties in Central America in the 1990s began to acknowledge women's perspectives and women's demands. Women holding public office had become more vocal, as damages from neglecting a gender perspective in peace accords became apparent and female poverty and inequality accelerated. Widows' groups continued to criticize governments for failing to protect women and children from violence (Luciak 2001a, 39; Schirmer 1993). International publicity from U.N. World Conferences on Women (e.g., Bejing in 1995) also prompted greater attention to women's rights during Central America's consolidation period. As Alvarez (1997, 193) explains, political parties and governments were "still invested in

transforming their electoral support into solidly hegemonic social bases of support for the new democratic regimes." To establish their democratic credentials, seem responsive, build legitimacy, and win votes by appeasing the (previously subservient) women's blocs within the parties, male leaders "needed to be seen" as committed to gender equality and gender issues (Montecinos 2001; Lievesley 1999).

In the mid-1990s a large gap still existed between rhetoric and reality, as analyst Angélica Batres from the think tank IDEAS in El Salvador explained:

> I can attest that the political parties are still not taking women seriously. They think they have to incorporate the variable of gender into their discourse as a way of winning votes. But all the men are demanding to be put at the top of the party list for elections, and since they don't know how many seats they will win, they tell the women to "forget it." They don't think that we are capable of constituting a power bloc. (Batres 1993)

Batres highlights how party leaders adopted the language of gender without extending more substantive power—directorate positions, nominations, and legislative seats—to their female colleagues. Some political parties also used gendered language to attract international funding, but without actually channeling the monies to women-centered projects (Luciak 2001b). While a party might tout its democratic credentials in promoting women, the intensification of electoral competition ("we don't even know how many seats we will win") made promoting female candidates too risky for male politicians with electoral ambitions. Ironically, political parties "incorporated the variable of gender" without incorporating high numbers of women.

Miriam Eleana Mixco Reyna, a legislator from the right-wing Salvadoran party ARENA, offered a more optimistic picture about women's ability to achieve public office during the consolidation period. Speaking in 1993, Reyna remarked on women's trajectory within her party and within the Salvadoran state:

> I think that, in El Salvador, women have participated greatly since the foundation of our political party, because our party [ARENA] was founded on the basis of protests made by women against agrarian reform, against bank reform, in opposition to certain [redistributive] measures, the reform of the export industry, the banking reform, against certain measures which the de facto government in that era took. I think that we have been evolving because now it is no longer rare to see a woman in an important post. We have a very

intelligent woman Minister of Planning; we have a woman Minister of Education. The only place we haven't reached yet is the Supreme Court of Justice. (Mixco Reyna 1993)

Mixco Reyna's comment focuses on the spaces women do occupy in political society, and speaks of mechanisms—particularly education—through which women will gradually conquer more public offices. Elite women in Costa Rica have taken similar approaches to women's under-representation in formal politics. Costa Ricans express pride in their consolidated democracy and in women's comparatively high political status (Biesanz et al. 1998); nonetheless, many male and female Costa Rican parliamentarians believe that Costa Rica remains a "reduced" or "incomplete" democracy without women in all types of positions of formal power (Piscopo 2002). Female legislators have focused on laws and policies ensuring that Costa Rican women and men enjoy the conditions of equal opportunity, with opportunities that will elevate qualified persons of both sexes to the legislature, the executive, and the judiciary (Piscopo 2002). If the experience of Costa Rica is any indication, women should increase their political presence in the consolidation stage of other democracies in Central America.

THE RISE OF NGOS
Perhaps as a reaction to women's marginalization during the consolidation, the process of democratization in Central America has given rise to a new phenomenon: the creation of women's voluntary and nonprofit organizations, known collectively as non-governmental organizations, or NGOs. Historically, most women's groups in Central America were identified with or subsumed by preexisting power blocs (political parties, unions, business associations). During the crisis and transition stages, women's groups—such as the Luisa Amanda Espinoza Association of Nicaraguan Women (AMNLAE) in Nicaragua and the Mélida Anaya Montes Women's Movement (MAM) in El Salvador—were affiliated with guerrilla movements and/or leftist political parties.[13] This structure of affiliation both protected and controlled women (Stanley 1996); independent women with separate agendas endured derision and suspicion. Norma Virginia Guirola de Herrera, who founded the first independent women's organization in 1990 in El Salvador, was abducted, tortured, and assassinated for daring to exist without a strong (male) protector. Given these

conditions, women's organizations' only choices during the crisis period were to accept the protection offered by affiliation with male-dominated groups, or to languish at the margins with few resources, little access to decision-making, and vulnerable to attack (Waylen 1992, 18–19).

During the democratization process, the opening of civil society allowed many women's organizations, such as *Mujeres por la Dignidad y La Vida* [Women for Dignity and Life] (known as *Las Dignas*), to break away from the Salvadoran FMLN[14] in 1990 and establish their autonomy (Luciak 1999, 48–49), i.e., not to be apolitical but to be non-partisan. The Sandinista-affiliated women's organization AMNLAE was discredited for retaining its link to the FSLN and suffered the defection of many female *militantes* to form their own NGOs in Nicaragua (Disney 2003, 557). This lack of autonomy plagued AMNLAE; the organization received substantial criticism for its inability to pursue any women's objectives—such as curbing sexual violence or improving reproductive health—that were unconnected to the Sandinistas' view of women's proper roles. A former FMLN member turned grassroots activist, Nelly de Cid, explained this same impetus for independence among women in El Salvador:

During the war, many [women's] issues were postponed; everything had to wait until afterwards. But the war ended, and there is no "afterwards." Many women's organizations have now broken with the Frente—not a complete break, but simply saying, "Now we are going to work for ourselves on gender issues." (Quoted in Best and Hussey 1996, 25)

Rather than retiring to the obscurity of private life after denouncing government abuse at the national level during the crisis, many women's groups then turned to activities in the civil sphere, laboring at the local level to rebuild communities torn apart by war (Siu 1997). The explosion of popular organizations during the crisis and the transition was continued by the establishment of autonomous women's organizations (NGOs) during the consolidation. These NGOs sponsored literacy classes, educational programs, and occupational training, giving women the language and the skills necessary to understand the laws and politics that affect their lives (Schirmer 1993; Best and Hussey 1996). Central American women began to demand an accounting for myriad issues, from family displacement to domestic violence. In the early 1990s, a women's housing movement besieged the capital of Costa Rica (Sagot 1994), and women seeking water

and sanitation organized throughout towns in Honduras (Rosales 1997). Women's popular organizations became important vehicles for denouncing and protesting the violations of human rights during the political and economic turmoil that followed the peace accords and accompanied the imposition of structural adjustment policies.

As democratic consolidation gradually restricted the political sphere to formal political parties, many women activists entered the civil sphere. When the FMLN, the FSLN, and the URNG were transformed into political parties, female members—whether guerrillas, *políticas*, supporters, or sympathizers—faced two choices: to retain their membership and engage in partisan electoral politics, or to work in newly formed NGOs. Many women began organizing independently, expressing their gender-based demands outside the male-dominated political parties and electoral competitions (Luciak 1999; Disney 2003). One worker for a Nicaraguan NGO that coordinates other NGOs explained that yesterday's Sandinista organizations are today's NGOs: "The popular mass organizations became the NGOs. The NGOs today are doing the work that the Sandinistas were better at! The people who lost their jobs with the Frente formed NGOs" (quoted in Disney 2003, 552).

The decision of many local and regional women's organizations to become autonomous, i.e., to work outside partisan electoral politics, and to make demands from within civil society represents another hallmark of Central American democracy (Molyneux 1998). Many former popular and revolutionary organizations became institutionalized as NGOs during democratization. These civil society organizations often work with one another, but whether working together or separately, they comprise the backbone of the women's movement in Central America and exert ongoing pressure for democracy. Participatory Central American women nonetheless had much to learn about institutionalizing their organizations and developing clear platforms with effective strategies. Actions in civil society may have an influence on Central American democracy, but only if those organizations can capitalize upon the opportunities that that sphere provides. Some, like *Las Dignas* in El Salvador, successfully targeted single-policy arenas, such as ensuring that newly trained civilian police forces respect human rights:

The women's movement in El Salvador has been fighting for the new national civilian police to consider a policy of security and protection in the treatment

of women and domestic violence, and for men who are also mistreated; they can benefit from this as well. (López 1993)

There is a wide gap between understanding women's perspectives and changing laws and policies on women's issues. Even when some NGOs can articulate a gender perspective that criticizes sex- and class-based inequalities, they often lack the ability to translate this perspective and this critique into policy demands. Some organizations lack clarity (with respect to a gender-based agenda), resources (from national or international sources), or political skills (with respect to accessing legislators and bureaucrats for policy proposals).

Civil society and autonomy are double-edged swords for women in Central America. On the one hand, autonomous women's NGOs can privilege their own agendas rather than the army's, the union's, or the party's agenda; but on the other hand, these NGOs lack access to media and connections to elites. The problem of resource constraints restricts many popular and revolutionary women's organizations to working within communities on easily identifiable, local issues (such as sanitation), or manageable projects of rehabilitation or survival. These practically important projects dramatically improve women's quality of life, but nonetheless have little national-level or strategic impact on gender discrimination and gender relations (Molyneux 1998). For example, in Costa Rica, popular women's organizations seeking the state's financial assistance for development projects must adopt state guidelines; their ability to critique these guidelines for practices that discriminate against women is severely limited (Montero Araya and Quesada Saravio 1997, 166–171).

Central American women's organizations, like those in women's movements elsewhere in the developing world, consequently face three critical tensions: between narrow and local or broad and national issues, between practical (survival) or strategic (transformative) agendas, and between atomistic or cooperative advocacy for gender issues. The bifurcation of popular and revolutionary organizations into formal political parties or autonomous NGOs further sharpened these tensions. By the early 1990s, Nicaragua, El Salvador, Guatemala, and Costa Rica all hosted hundreds of NGOs working within the development field; many received international assistance, both technical and financial, and were staffed by foreign as well as domestic personnel. This explosion of NGOs led scholars to describe the "NGO-ization" of the women's movement and the "NGO-ization" of civil

society (Alvarez 1998a; Disney 2003). Some NGOs aimed at accomplishing narrowly defined tasks, including helping women displaced by war to register to vote; providing housing or legal services; addressing women's problems with health, child care, or unemployment; while others set their sights on broadly defined agendas, advocating for women's rights regarding domestic violence, public safety, and nondiscrimination.

The NGO-ization of Central American civil society poses certain challenges for the participatory and social-justice dimensions of democracy celebrated during the transition phase and deepened during the consolidation phase. Traditionally in Central America, people work in groups for their collective interests (rather than as atomized individuals seeking private interests, as in liberal democracy); NGOs are the most modern manifestation of that tradition. The first challenge, however, is that NGOs will be unduly influenced by their funding sources. Formal NGOs with access to domestic and foreign monies have experienced greater success than informal grassroots organizations in delivering goods, services, and training programs to communities. But among the more "technically adept, trans-nationalized, and professionalized NGOs," there has been "a region-wide shift *away* from feminist activities centered on popular education, mobilization, and poor and working-class women's empowerment and *toward* policy-focused activities, issue-specialization, and resource concentration" (Alvarez 1998a, emphasis in original). A second challenge is that NGOs will not increase women's access to civil society's transformative agenda of participation and equity. While NGOs make local rehabilitation and practical survival possible through their expert focus on poverty alleviation (Schild 2000; Craske 1999),[15] their success often entails sacrificing a more transformative agenda envisioned by popular and revolutionary women.

Scholars have documented how NGOs' concern for technical proficiency undermines the horizontal internal structures of women's organizations: the pressures from governments and donors to deliver more services more quickly compel the organizations to adopt the vertical, authoritative command structures discredited after the crisis era (Alvarez 1998b). Moreover, some NGOs work within neoliberal paradigms of individualized rights and responsibilities; they focus on helping individual women, working alone, to take steps to better themselves and their families (Craske 1998). These NGOs often lack the broad-based, incorporative, and participatory impulses

of their grassroots predecessors. While good for development, these NGOs pose certain threats to the Central American model of widely participatory and broad democracy that activist women supported and continue to seek.

A third challenge comes from the sheer quantity of NGOs. Large numbers of NGOs means fierce competition for scarce resources, an erosion of solidarity among activists (even within the same areas of interest), and heightened public confusion about the women's movement agenda. Women and women's groups have not automatically cooperated and coordinated their efforts in the democratization period. Ana Criquillon, a member of the Nicaraguan anti-violence NGO *Puntos de Encuentro* [Points of Encounter], initially supportive of the proliferation of NGOs, later revised her opinion:

> There are now many more NGOs . . . that have risen up in these last few years . . . and [while] this is an advance, a gain . . . it is difficult to coordinate them, it is more difficult to have an impact on the government. So when I say there is less access to decision-making at the government level, it is partly due to that. [Before,] that [government] which appeared to be monolithic was not so monolithic, but at least there was enough consensus to have a public voice, more or less unified, but now that doesn't happen. (Criquillón 1993)

Criquillon's comments suggest that while greater pluralism might advance the democratization of civil society, this pluralism actually inhibits decision-making within political society. Her opinion reflects Disney's (2003) analysis of Nicaragua, which concludes that a pluralistic civil society augments—but cannot substitute for—the formal procedures that institutionalize a participatory democracy. The state-society linkages must exist alongside the civil sphere's intra-society linkages. The state, Criquillon suggests, needs to hear identifiable public voices with clear opinions in forums dedicated to their expression.

To the extent that NGOs remain independent from government sectors and from international donors, incorporate the popular and revolutionary women who originally founded many of the organizations, and work together to influence public policy, Central American civil society retains its vibrancy.

MUJERES '94

Many new Central American NGOs have formed viable networks and on numerous occasions have coordinated and expressed a uni-

fied voice in support of gendered perspectives on women's rights and public policy, noticeably in the areas of nonviolence, health, and women's rights. One example of such *concertación* among the sectors of the women's movements, and among women of political society and civil society, was the *Mujeres '94* platform in El Salvador (Saint-Germain 1997). In January 1993, one year before the first democratic elections, a new coalition named *Concertación de Mujeres por la Paz, La Dignidad, y la Igualdad* [Women's Coalition for Peace, Dignity, and Equality] arranged for a meeting of about 40 organizations to draft a policy document.[16] This document called for political parties to commit to specific actions in the policy arenas of violence, health, education, environment, work, development, land, and internal party structure (Kampwirth 1998, 266). Just weeks before the election, ARENA legislative candidate Mercedes Gloria Salguero Gross endorsed the *Mujeres '94* document on March 8, International Women's Day. Despite the endorsement, the ARENA party largely ignored the *Mujeres '94* platform after winning the elections (Kampwirth 1998, 267–268). More importantly, however, *Mujeres '94* united the Salvadoran women's movement around a common objective:

> *Mujeres '94* was created to elaborate the women's platform, but other things are beginning to arise in that civic space. It is an interesting referent for cooperation in civil society, this phenomenon, because social movements in El Salvador have in the majority been co-opted by the political parties or by urban workers or rural cooperatives, etc. The advantage [of *Mujeres '94*] is that the theme of women has not been of interest to these parties, but this makes it possible to generate space, and I think that other spaces will be generated for other citizen proposals. (Cansino 1993)

As Sonia Cansino from *Mujer Ciudadana* explained, *Mujeres '94* represented the essence of what civil society could achieve in the democratization of Central America.

Many women's organizations in Central America also extended their networking capacities beyond national borders, looking to their compatriots across the region, the hemisphere, and the globe. Jeannette Urquilla from ORMUSA explained:

> We Salvadoran women are making a great effort to really be protagonists in the construction of a new society in El Salvador. And we are also making efforts so that women at the level of the Central American region and at the level of Latin America, too, can wage our struggles together, which will carry us to have better living conditions in Latin America. (Urquilla 1993)

Urquilla's statement reflects the broadening of the women's movement in Latin America (Sternbach et al. 1992). Women within civil society extended an offer of solidarity to their sisters in the region, using networks and contacts to combat the marginalization and neglect that governments and political parties attempted to enforce. These outreach efforts represented the positive effects of the NGO-ization of the region, and one route through which NGOs preserved women's struggle for collective and community well-being.

The positive and negative effects of women's NGOs in Central America reflect the complexities and difficulties inherent in democratizing civil society such that healthy pluralism does not create unstable fragmentation. Many Central Americans resist the idea of a politicized civil society, appalled by the audacity of NGOs to challenge the government and the political parties. After the Sandinistas lost the 1990 elections, some former members of the FSLN government established NGOs as a base in civil society for exerting influence on the new UNO government. However, other Nicaraguans opposed the idea of the existence of NGOs as alternative power structures using international funding to undermine the state's ability to tackle social problems. Another critique was that NGOs are being substituted for actions previously undertaken by the state in developing countries (Tedesco 2003). Defining the rights, responsibilities, and obligations of governments and citizens in the consolidation of democracy remains a work-in-progress in Central America. Nevertheless, these experiences have helped to revise the framework of democratization. Rather than visualizing it as a linear progression from crisis through transition to consolidation, we can see that there are many possibilities for reversal inherent in the process. Rather than focusing mainly on elite pact-making, we can see that mass mobilizations and ordinary women's participation are also critical. Finally, rather than presuming that a U.S.-style liberal democracy will be the inevitable result, we can see that there are many alternative possibilities that can result from a struggle for democratization.

CENTRAL AND EASTERN EUROPEAN COMPARISON

The challenges of recent waves of democratization in two world regions have particularly affected women. Scholars such as Booth and Walker (1999), Coleman and Herring (1991), Landau (1993), and Leiken (1984) analyzed the crisis in Central America as part of the Cold War conflict between the United States and the former Soviet Union.

Other scholars, such as Jaquette and Wolchick (1998), however, have drawn parallels between the waves of political reform in Central America and those in Central and Eastern Europe, especially their impact on women. Ellen Commisso (1997, 3) observed that "Central and Eastern Europeans recovered national sovereignty and moved out from under Soviet control, whereas Latin Americans recovered national sovereignty from their military authoritarian rulers."

Two common themes link these regions: historical rule by authoritarian governments, and the general exclusion of women from formal political power. However, there were also some significant differences. For example, most Central and Eastern European women were already enfranchised (decades ahead of women in Central America) when Communist party governments assumed power after World War II. Women began to vote in Albania, Belarus, the Czech Republic, Estonia, Hungary, Latvia, Lithuania, Poland, Russia, Slovakia, and Ukraine between 1918 and 1921; in Romania in 1929 and Uzbekistan in 1938; and in Bulgaria, Croatia, Slovenia, and Macedonia between 1944 and 1946 (IPU 2005).

Post–World War II Communist governments attempted to change the nineteenth-century problems of economic underdevelopment in Central and East Europe. They faced tasks of reestablishing social order, economic reconstruction, and political consolidation. The rapid integration of women into economic production was critical to sweeping plans of rapid industrialization, land redistribution, and nationalization. Through stringent and repressive policies, serious problems of massive poverty and widespread inequality were somewhat diminished by the 1950s. Although the resulting economies were never as strong as those of developed Western nations, women in Central and East Europe were ranked higher on many indicators of economic development than their Central American sisters.

The rise in standard of living in these nations was not accompanied by an increase in political voice for citizens, as the Communists refused to relax their hold on all political power. Discontent grew as citizens grappled with the social consequences of rapid economic development. Open challenges to the poor working conditions, low pay, and lack of political voice that characterized these Communist regimes began in the late 1950s. Political opposition movements pushed for the democratic reforms that finally resulted in the collapse of the Soviet Union in 1989. Unlike Central America, democratic transition in Central and East Europe was not accompanied by prolonged civil

war and open state brutality. Rather, modernizing reformers steadily chipped away at Communist party rule until, in the words of David Ost (2000, 511), "it was no longer appropriate to the socioeconomic world the Communists had built."

During the Communist era, state ideology of equality and state policy of mass mobilization of women into the work force pushed women out of the home and into political participation in unprecedented numbers. In Central and East European republics, women were highly visible in legislatures. In the last elections before the transition, women held an average of 21.1 percent of legislative seats. Romania had the highest percentage at 34.4; Estonia, Russia, and Ukraine each reported 32.8 percent women; Czechoslovakia, 29.4 percent; Bulgaria, 21 percent; Poland, 20.2 percent; and Yugoslavia, 17.7 percent. Only Albania (5.2 percent) and Hungary (8.3 percent) fell below the regional average. To put these figures in perspective, women made up only 12.4 percent of national legislatures worldwide in 1990 (Saxonberg 2000, 146) and had increased to only 15.9 percent fifteen years later in 2005 (United Nations 2005).

There are also some similarities in the political status of women in the two regions. In Central and East Europe, official women's organizations remained linked to the state and women's interests were subordinated to Communist party interests. Women legislators' numbers were generally due to government-prescribed quotas; women were beholden to the party for their power; and women's political participation was essentially "formalistic and did not necessarily translate into real power" (Rueschemeyer 1998, 215). Despite far-reaching economic change and impressive numbers of women in legislatures, women in Central and East Europe played relatively minor roles in political life and decision-making. Women were generally absent from the real hubs of power such as the politburo, cabinet, and secretariat of central committees (Saxonberg 2000, 146). They, too, failed to develop a gender perspective.

Another comparison between the two regions is the status of women in the post-crisis, consolidation period. Most women in Central America (except for Costa Ricans) had no meaningful experiences of state protections and guarantees prior to the democratic transition (Jaquette and Wolchik 1998; Jaquette 2000); women expected to gain social and economic rights from democratization. As democratic transitions swept across Central and East Europe, post-Communist governments abandoned quotas for women in legislatures. Some women

also chose to withdraw from formal political institutions that were being discredited. The result was a general decline in the percentage of women active in formal politics, and little participation by women in the designing of new Constitutions. Most women in democratizing Central and East European nations actually lost social and economic rights during the transitions from socialism to democracy (in some cases heavily influenced by the Catholic church) (Molyneux 1995; Molyneux and Razavi 2003). Democratic transition involving the adoption or imposition of free-market economic reforms in both regions created new political and economic challenges for women. The increase of women in legislatures in Central America and the decrease of women in legislatures in Central and East Europe were both outcomes of democratic transitions. However, it has yet to be seen whether either transition will eventually result in greater political power for women.

CONCLUSION

The arrangement that will best safeguard public order, provide for collective expression of interests, secure social justice, and preserve civic space in Central America is still under discussion. Some citizens want to hold out for the best possible democracy, while others want to compromise on the first satisfactory version. Optimists believe that women can use the transformative potential of democratization to achieve real gains for women, while pessimists fear that the basic conditions necessary for democratic consolidation will not be achieved soon. Salvadoran legislator Lilian Díaz Sol worried in 1993 about a lack of motivation for people to pursue a lasting democratic consolidation:

Democracy is many things. I feel that the democracy which they [outsiders] want to give to El Salvador is a democracy where you can find separation of powers, constitutionality and its enforcement, representatives, the free-market economy, civilian control of the military, all that. But I feel that there is a problem. You can't make a gift of democracy to a people or force them to be democratic. (Díaz Sol 1993)

In this quotation, the belief is stated that Central American democracies must be constructed, adopted, and practiced from within their own societies and cultures. A Sandinista Nicaraguan legislator, Gladys Baez, criticized some political leaders for failing to establish appropriate examples of tolerance, trust, and compromise through

their own behavior. A member of FSLN opposition during the Chamorro government of 1990-1996, Baez expressed her frustration that even politicians failed to practice democratic congruence:

> They speak of democracy and they won't allow you to speak; they speak of democracy and they won't permit you the free exercise of democracy. They propose a democracy that is neither popular nor participatory, but a democracy in which they alone are the only ones who have voice and votes; first them, last them, only them. (Baez 1990)

Baez referred to instances wherein the UNO majority sometimes refused to consult with or even acknowledge FSLN legislators during floor debates in the legislative chamber. Her comment helps distinguish between Central American democracy as actual practice and Central American democracy as an aspiration. State-society consensus building, as well as intra-state consensus building, remains a work in progress.

Similarly, Salvadorans Marina Peña from ADEMUSA and Isabel Ramírez of CONAMUS, two women's organizations that focused on ending war and terror through activism and prayer, drew on women's unique experiences as objects of discrimination to highlight how "true democracy"—the elimination of inequalities—has yet to appear. Their statements summarized how participation, group rights, trust and tolerance, and public order are combined in democracy-as-aspiration in Central America:

> I think that we women have a special concept of what democracy is. We conceive of democracy as the equality of rights, obligations, and opportunities for women and men in all fields—political, economic, social, cultural—and recognition and respect for those rights of human beings, men, women, girls, boys, teenagers, old women, old men, indigenous people, or people of different races, all this in its entirety, in recognition of the human quality of those different sectors, and recognition and respect of their rights, of their dignity, of their access to development. So, from that point of view, we consider that no society up to the present has been democratic. (Ramírez 1993)

The notion that all citizens should possess rights and equality stands in stark contrast to the impoverishment, marginalization, and even extermination experienced by various groups in Central America. These activists link development and dignity, believing that citizens cannot engage the state without possessing certain entitlements and

without receiving the opportunity to develop certain capabilities. The creation of this equitable, participatory Central American democracy is part of the future of Central America.

The Central American story reveals the human and holistic components of democratization. Consolidation becomes not an end-state, but a process that takes years. The consolidation of Central American democracy faced several challenges by the mid- to late 1990s. Neoliberalism and structural adjustment failed to counterbalance economic recessions, and the attempted imposition of free-market capitalism (more congruent with liberal democracy) undermined the social-justice orientation of participation, development, and democracy embodied in the peace accords. Newly emerging, debt-ridden democracies faced enormous infrastructural and financial constraints.

The adoption of neoliberal economic policies also threatened women's political participation. An economic crisis can force women into more income-generating activity for the family, resulting in greater opportunities for participation in labor unions and workplace politics, increasing women's involvement in decision-making. However, women's work is often low-paid, irregular, and lacking in benefits (Craske 1999, 2). The double burdens of labor-force participation and household work may leave little time for political participation (Craske 1999, 33). Neoliberalism has resulted in social adjustment as well as structural adjustment (Dagnino and Alvarez 1998, 21–23). The democratizing state in Central America, which was supposed to be more communicative and responsive to citizens' needs, in effect retreated from those demands, leaving lower- and middle-class citizens to devise strategies to cope with financial hardship. These strategies ranged from individual self-help to community organizations, many promoted by the proliferation of NGOs in the region. The addition of neoliberal economic reform to the newly transitioning democracies in the region severely curtailed citizens' abilities to individually sustain their livelihoods or collectively influence social policy.

Democratization raised hopes among Central Americans, yet the uneven extension of procedural and institutional democracy and the persistence of marginality and inequality among social sectors led to disillusionment and discontent. One participant in the *Mujeres '94* campaign believed democracy overreached its own capabilities: "For me, democracy promises [too] many things, and this is bad."[17] The most tantalizing promise of Central American democracy, for redistribution and social and economic rights, remains unfulfilled, accord-

ing to Aíra Rodríguez (1993) of the Guatemalan women's group *Tierra Viva*, who felt that "democracy has not changed the material circumstances of inequality." While democratization proceeds little by little over multiple electoral terms, current fears in Central America are that widespread popular frustration with poverty will re-stimulate revolutionary activity before democracy becomes sufficiently institutionalized within political society and civil society. As President of the Guatemalan Congress José Lobo Dubón (1991) asked, "How are democracies to maintain themselves when they can't meet the needs of their people?"

Women in Central America were largely excluded from the formal institutions of power installed during the transition and consolidation periods. The sphere of civil society, celebrated as the realm of participatory democracy, also contracted. Adoption of ill-fitting concepts of neoliberal economics and political and social individualism have frustrated the development of mechanisms for linking popular organizations to the political sphere. Angela Rosa Acevedo, once a legislator from the FSLN party, summarized women's positions and expectations in Nicaragua in 1993:

I think that women participated in what we call the exercise of representative democracy by exercising the vote. Nevertheless, they are excluded from participation in democracy with respect to the resolution of their practical necessities, not even thinking of the strategic need for participation in the political system, in decision-making, but in the resolution of their basic needs, food, education, preserving the family, and family integrity. We are just entering this stage, where women are reflecting on how they should exercise their individual rights, their [collective] labor rights, their political rights, such as critiquing those in power, demanding of those in power the enforcement of effective policy that includes the real situation of women in Nicaragua. (Acevedo 1993)

As her words reveal, the realization of better opportunities and conditions for women in Central America remains a process of advances and setbacks.

Nonetheless, experiences of democratization as (re)marginalization, whether in political or civil society or in the economy, have led women to perceive new relationships between peace, democracy, development, and gender. Using a gender perspective that links peace and democratization to their human rights and to their social and economic well-being, Central American women have become increasingly critical of politics that discriminate against them. The hope

is that the revitalization of civil society will rehabilitate war-torn communities and allow the articulation of rights-based demands. This new way of doing politics is different from what liberal democratic audiences might expect: Central American women call for unity across race and class, and for group rights and community protections in addition to individual rights and freedoms. Group-based linkages between civil society and political society that draw upon traditions of corporatism, if institutionalized effectively, would help to legitimate women's public voices in Central America. The challenge is achieving group representation while avoiding group cooptation, and balancing individual integrity against the common good. Historically in Latin America, "what was common to all attempts to articulate a notion of civil society was the problematic relation between the private and the public, the individual, and the social, public ethics and individual interests, individual passions and public concerns" (Seligson 1992, 5). If the challenges of criminal violence, political marginalization, and neoliberal economics do not undermine institutions and confidence, then Central American democracy will continue developing a regime type that remains distinct from the liberal system. It will aspire to "be better than the United States' [democracy] with its secular, divisive, fragmented interest group pluralism" (Wiarda 1992, 20).

CHAPTER 6 PUBLIC POLICY

I think that we women parliamentarians can add a great deal to this field, not only because of our competence in women's situation, but also because of our greater [gender] consciousness and greater sense of responsibility. With sixteen women in parliament now, we can generate the conditions so that the next elections will bring more women into the parliament, so that a greater gender consciousness emerges, and so that better options, better opportunities will be generated for the full participation of women in political processes, which will lead to the real deepening of the processes of democratization.

LUISA DEL CARMEN LARIO, legislator, Nicaragua, 1990

INTRODUCTION

Returning to the slogan that introduced the first chapter, it is interesting to note that the Spanish word *política* actually has three meanings. One is the concept of politics, *la política*, as in, "that's just politics." Another, *una política*, refers to a woman who is a political party strategist (*un político* refers to a man). Its third usage is to refer to a policy, and specifically to public policy. Thus the second half of the slogan could also mean that when many women get involved, they change public policy.

Women legislators in Central America have significant influence over public policy, i.e., what government decides to do or not to do, because public policy is decided chiefly by the legislative

branch. Rulings in court cases do not establish general public policy in Central American countries (as they do in the United States). In addition, research has found that women legislators are likely to have specific effects on policy-making. For example, they are more likely than male legislators to sponsor or support policy affecting women, families, and children (Dolan 1997). There are a great many policy issues that have been characterized as "women's issues," or issues affecting women. Some of these issues relate to women in their traditional roles as wives and mothers; others relate to women as individual citizens without regard to particular roles. Still other issues concern identifiable groups of women, often those who have experienced discrimination. Nevertheless, most research concludes that women legislators broaden the policy agenda to include new themes, including those in Latin American legislatures (Rivera-Cira 1993).

The number or proportion of women in a legislature is also important (Saint-Germain 1989). For example, Valerie O'Regan (2000) found that the higher the percentage of women in the legislatures of 22 industrialized nations, the more likely a nation was to have enacted public policies regarding equal wages, equal employment opportunities, maternity leaves, parental leaves, and child care, as well as concerning marriage and divorce, family and child responsibilities, domestic violence, educational equity, and abortion.

With only a limited number of women in the legislatures of Central American countries, and with their presence beginning only a short while ago, public policy toward women could not be expected to change radically overnight. Nevertheless, in the following sections we will explore some of the important changes in public policy that accompanied an increase in the presence of women in the legislatures in the region in the 1980s and 1990s.

PRIOR PUBLIC POLICY

At the time of independence in the 1800s, most Central American countries had very little law or policy pertaining specifically to women. While men's behavior fell into the public sphere regulated by the state, women's behavior fell into the private sphere regulated by men. Central Americans followed Roman law (*patria potestad*), giving the man authority over the children as part of household property. Girls were under the authority of their fathers until marriage, and then under the authority of their husbands. Families with property were also concerned with exercising control over women's repro-

TABLE 6.1. WOMEN'S CITIZENSHIP AND VOTING RIGHTS IN CENTRAL AMERICA

Country	At Independence	Revised to Include Women
COSTA RICA	1848: Citizens are those Costa Rican men who are over 21, and own property in Costa Rica worth 300 pesos, and (after 1853) can read and write . . .	1949
EL SALVADOR	1841: Citizens are those [males] over age 21 who are fathers, or the man of the house, or who can read and write, or who own property . . .	1939
GUATEMALA	1825: Citizens are Guatemalan men, either married or over age 18, who exercise a profession or have economic means . . .	1945
HONDURAS	1824: All men in the Republic are free; Citizens are [male] inhabitants who are married or over 18 years of age as long as they practice a profession or have known means of support . . .	1954
NICARAGUA	1838: Citizens are all Nicaraguan men . . .	1955

Sources:
Costa Rica: Constitution of 1848 and Constitution of 1949.
El Salvador: Constitution of 1841 and Constitution of 1939.
Guatemala: Constitution of 1825 and Constitution of 1945.
Honduras: Constitution of 1824 and Constitution of 1954.
Nicaragua; Constitution of 1838 and Constitution of 1955.

duction in order to control inheritances. As women had no identity apart from the home, marriage, and the family, it was not believed necessary to give women individual rights.

The wars of independence in Central America in the 1820s were generally brief and carried out by the middle and upper classes, not mass uprisings. This era provided some women the opportunity for political participation, but little changed for women as a result. Women were not immediately recognized as citizens of the newly independent Central American republics (Table 6.1). The Constitutions of some nations used masculine pronouns (*ellos*) and masculine forms of nouns (e.g., *los costarricenses*) exclusively, and interpreted this to

TABLE 6.2. EVOLUTION OF WOMEN'S POLITICAL PRESENCE IN CENTRAL AMERICA

Country	Can Vote	Can Be Elected	First Legislator Elected
COSTA RICA	1949	*	1953
EL SALVADOR	1939	1950	1978
GUATEMALA	1945	1945	1954
HONDURAS	1955	1955	1965
NICARAGUA	1955	1955	1958

*As they had never been specifically denied the possibility of being elected, Costa Rican women did not need to be granted this right as they did the right to vote.
Sources: IPU 1988; Díaz de Landa and Lista 1982.

mean that only men could be citizens. Other Constitutions explicitly excluded women, limiting citizenship, for example, to "Costa Rican men over 21, who own property in Costa Rica worth 300 pesos," and, after 1853, "can read and write . . ." (Constitutions of 1848 and 1853). Even where there might have been some ambiguity, women were not allowed the benefit of the doubt in practice.

Central American women slowly began to win more recognition of their individual rights, due to gains in public education, the rise of the popular media, women's incorporation into the labor force during World War I, and international feminist movements (Rivera-Cira 1993). Still, differentiations were made between women and men as citizens. For example, in 1939, married women over 18 could be citizens in El Salvador, but single women had to be over 30. In 1945, all men over age 18 in Guatemala could be citizens, but only women over 18 who could read and write. By 1955, all Central American republics accorded expressed or implied citizenship and voting rights to women (Table 6.2).

MARRIAGE

However, even as the end of the twentieth century approached, women were still discriminated against in many areas of law and public policy, even where basic rights were concerned. For example, the national Constitutions and/or laws of all the Central American countries were revised to implicitly or explicitly recognize the equality of men and women, and to prohibit discrimination based on sex. Notwithstanding, these same Constitutions or laws also often stipulated different family roles based on gender, assuming that the man

is principally responsible for supporting the household and that the woman is primarily responsible for child care and household management. Not only are different roles prescribed, but the man's role is valued above the woman's. For example, as late as 1983 the Salvadoran Constitution required that, upon marriage, the domicile of the man become the legal place of residence of the woman. Even when the equality of the marriage partners is overtly stated, often the man is still the legal head of household or principal representative of the family. In Guatemala, only the husband could represent the married couple, their children, or property unless the wife obtained his specific permission or he abandoned the household (1985 Constitution). As most property is recorded only in the name of the head of the household or its legal representative, women end up with few resources in their own names, either to use for credit or when the marriage dissolves. In Costa Rica, the man prevailed in disputes over how to manage the couple's property, unless it was taken to a judge to decide (1949 Constitution), a process that was too expensive if not too intimidating for most women, and, since most judges were male, not likely to produce a result favorable to the woman.

There was also a difference between the treatment of men and women with regard to marriage. For example, men had to be at least one year—and in some cases two—older than women before they could marry (except in Costa Rica, where both parties could marry at age 15). There were special provisions to protect Guatemalan women who were married to foreign men, but not to protect Guatemalan men married to foreign women (1985 Constitution). The stereotype of women as property of their husbands was also perpetuated by constitutional and family law. For example, Central American women had the right to add their husband's surname to their own, but the husband did not have the same right to add the wife's surname to his. Upon marriage among the wealthy (and, perhaps, the pretentious), one convention was for the woman to add the husband's family surname, e.g., Soto, to her own family surname using the preposition *de* [of], converting "Carmen Navarro" to "Carmen Navarro de Soto," or "Carmen Navarro (property of) Soto." This worked to the advantage of people like Violeta Barrios de Chamorro, who at one point said she was proud to wear the Chamorro "brand" (Cuadra 1990).

DIVORCE
Divorce was another area of difference. Women who divorced had to wait for 300 days before remarrying, while divorced men could re-

marry at once. Most Central American countries required the establishment of a party "at fault" in order to grant a divorce. Adultery could be grounds for divorce, but only women could be guilty of adultery (the same crime for men carried a different name). For example, adultery occurred when a married woman had sex with a man other than her husband (but the reverse was not defined as adultery, i.e., when a married man had sex with a women other than his wife). In Nicaragua, women who were found guilty of adultery were forbidden from marrying their "partner in crime" (although the partner was not punished). No witnesses to the sexual act were needed, and often mere circumstantial evidence, such as being seen dancing with another man, was sufficient for proof of adultery by a woman. If a woman wanted a divorce because her husband was not faithful, however, the crime was called "concubinage," and for a man to be found guilty, witnesses to the act were needed or the husband had to bring the "concubine" into the couple's home or cause a "public scandal." Another justification for divorce for a man was that his wife gave birth to a child conceived with another man either before or during the marriage. However, a woman could not obtain a divorce if another woman gave birth to a child fathered by her husband either before or during the marriage. In El Salvador, a judge could force a woman to leave the home during a separation or divorce and live at any place of residence decided by the court. In Guatemala, a woman was placed under state protection from the moment of separation, essentially treated as a minor child (Ramírez 1987). After the divorce, usually the man was obligated to contribute to the support of the woman, unless she was the "guilty party" in the divorce. His support was owed to her while she did not remarry, but only as long as she exhibited *buena conducta* (good behavior).

CRIMINAL LAW

Criminal laws also treated men and women differently in many situations. In Guatemala, the death penalty could be invoked only for crimes committed by men (1985 Constitution), but if a man murdered his wife while she was having sex with someone else, his penalty was reduced. If a wife murdered her husband while he was having sex with someone else, however, her penalty was increased. In El Salvador, men received a lesser prison sentence if they assaulted their wife than if they assaulted any other person. In Costa Rica, wives received a higher penalty for murdering their husbands than if they murdered any other person. At the same time, women who abandoned their

newborn infants in order to "preserve their reputation" received a lesser sentence than if they committed the crime for any other reason (1983 Constitution).

A whole series of crimes existed where what has been wronged is specified as the woman's honor or decency (*contra el pudor*), whereas no such crimes existed for men. *Rapto* occurred when a woman was carried off for the purposes of having sex with her. In order for the crime to exist, however, the laws often specified that the woman must be of a certain age (e.g., between 12 and 16) and of good character, pure, honest, or a virgin. In some Central American countries, rape as a crime could only occur when the victim was female, but the "honor" of the victim was still taken into account. For example, the penalty was reduced from 3 years to only 2 months in El Salvador if the rape victim was a prostitute (Ramírez 1987).

LABOR LAW

Historically, labor laws in Central America also treated women differently from men. In Honduras, the laws on women in the work force were included in the section on minors (children), reinforcing the notion that women need parental protection. In Guatemala, a woman could not work outside the home without her husband's permission (1985 Constitution), and women might be legally discriminated against in the work force because discrimination was prohibited on the basis of race, religion, political beliefs, and economic status, but not specifically on the basis of sex. Women were also explicitly discriminated against in terms of pay. For example, women and minor children who worked in agriculture could be paid less because it was assumed that their work consisted of helping the chief worker (the man). Women were prohibited from working at night where wages were higher, except in traditionally low-paying jobs (e.g., maids).

CONDITIONS PROMOTING POLICY CHANGE

As the presence of women in national legislatures increased, significant public policy changes began taking place. These changes, in most cases, cannot be traced to individual women legislators. Rather, the changes have been a result of a combination of factors, including:

- The increasing presence of women in politics, government, and legislatures (with a concomitant increase in women working as consultants, policy analysts, and staff on legislative committees);

- The extraordinary efforts of many women during years of war and economic crisis;
- The mobilization of women's pressure groups and non-governmental organizations;
- International events such as the U.N. Decade for Women; and
- The rise of gender consciousness and praxis in Central America.

The first three points were discussed in earlier chapters. In the following section we will address the last two points.

INTERNATIONAL EVENTS

One important source of influence on public policy in Central America was the development of international events focused on women. Central American women have actively participated in inter-American conferences on women's legal status and the protection of human rights, as well as in major international activities during the 1975 United Nations International Women's Year and the 1976–1985 U.N. Decade for Women. The major documents produced during the Decade—the 1975 Declaration of Mexico and World Plan of Action, the 1980 Copenhagen Mid-Decade Program of Action, and the 1985 Nairobi Forward-Looking Strategies—initiated many debates within communities in Central America. Perhaps the most influential document, however, was the United Nations Convention on the Elimination of All Forms of Discrimination Against Women (CEDAW). Proposed by the U.N. Commission on the Status of Women, CEDAW restates the commitment to equality between men and women contained in the original U.N. Charter of 1945 and in many other subsequent international declarations and conventions. It was adopted by the U.N. General Assembly in 1979, and presented for state signatures at the 1980 Copenhagen meeting. This convention has been one of the fastest-moving documents in international history, ratified by over 175 nations (but not the United States) by the end of 2003 (United Nations 2003a). CEDAW has been hailed as "the basic legal document for the international promotion and enforcement of women's rights" (Stumpf 1985, 385), since it defines equality as well as discrimination and the means to overcoming it (Teachnor 1987). Although the enforcement mechanism for this convention is weaker than for other U.N. human-rights treaties (Bayefsky 1986), the language of the convention is actually quite far-reaching. It commits member states to

speedily and assertively end discrimination against women. This includes legislation that will "modify or abolish existing laws, regulations, customs, and practices which constitute discrimination against women," as well as measures to "modify the social and cultural patterns of both men and women with a view toward achieving the elimination of prejudices and all other practices which are based on the idea of the inferiority or superiority of either of the sexes" (Zanotti 1980, 612) or on "stereotyped roles for men and women" (Sheldon 1987, 415). The convention takes a further step by providing that the use of sanctions and "temporary special measures aimed at accelerating *de facto* equality between men and women," such as affirmative action, will not be considered (reverse) discrimination. It calls for equal rights for women in political, economic, social, cultural, and civil areas, specifically in education, finance, health care, and access to jobs. In addition, it acknowledges the equal responsibilities of men with women in the context of family life, and stresses the need for social services, particularly child-care facilities, to enable the combining of family obligations with household work and participation in public life (McKenna 1987). CEDAW has also recently been interpreted as implicitly prohibiting violence against women (Bunch 1990). This convention has been adopted by all the governments in Central America and—at least in theory—takes precedence over any national laws that run contrary to it.

GENDER CONSCIOUSNESS

Another major development that has influenced the policy perspectives of women legislators in Central America is the development of a unique blend of gendered theory and practice in the region. It would be difficult to characterize the perspectives of women legislators as either pro- or anti-feminist. Feminism, like many compelling ideas, seems simple at first but proves much more complex upon further examination. During the second wave of feminism in the mid-twentieth century, the answer to the question "Are you a feminist?" seemed straightforward; at the end of that century, the answer to that question was much more nuanced. Yet the idea of feminism is still intriguing, and many people want to know whether women legislators are, or are not, feminists.

In Central America, I asked women legislators what they thought about feminism. I did not provide a definition of feminism but rather

let the women speak for themselves. Interestingly, not one of the legislators asked me for a definition; many, like Rose Marie Karpinski of Costa Rica in 1989, provided their own:

Let's see what is meant by feminist. If feminist is to confront men to defend only women, then I am not a feminist. It seems to me that the success of women is in working in coordination with men, not to wage a war against men but rather demonstrate to them that together we can do better than either of us separately. So if feminism is what happened in some eras, women's liberation movements, then I am not a feminist. But if feminist is to struggle to get people to have faith in women, struggle so that people can see how well women can do things, that women can give a satisfactory response, then yes, I am a feminist. (Karpinski 1989)

Few responses were clear cut, either "yes" or "no." Those who rejected feminism did so because they saw it as an attempt to elevate women over men, a type of reverse discrimination. Milagro del Rosario Azcúnaga de Meléndez of El Salvador, in 1990, rejected feminism as a type of female egoism.

We have to create consciousness, as much in men as in women, in the entire society, of the role that corresponds to women on an equal footing with men. That we are not attempting, at any time, to displace men. On the contrary, we are not egoists like men have been throughout all the history of humanity, where only they have had power. We say, "Let's share." We don't want it all for ourselves, no, let's share it. In that way, things will turn out much better. (Azcúnaga de Meléndez 1990)

Other women legislators who responded "no," like Hilda González in Costa Rica in 1989, employed a religious or biological justification when asked if she considered herself a feminist.

No, rather as an integrationist of both sexes. Because it seems to me that if both of us are here, God is wise and nature is also. For some reason, we are two sexes. Perhaps it could have been three sexes, or four, or only one. But if both of us have been put here, I think it is for a reason. And we have to share; that is the most beautiful thing that can exist, the equality among all, neither separations nor antagonisms or power struggles of any type between two sexes. The person who has the capacity, be it man or woman, can aspire to rise and occupy better posts within society. (González 1989)

The women legislators who answered simply "yes" also tended not to elaborate much on their response, suggesting perhaps that their

minds were made up and there was nothing to be gained by talking about it further. The majority of legislators, however, were more equivocal, answering either "yes and no," or "no, but" They gave much longer answers, as though they were still debating the question in their own minds and wanted to talk through the issue, like Costa Rican Mireya Guevara in 1989:

> Well, I don't know. But it is clear that, men, with relation to men, it is *machismo* which is dressed up in different form. When they see that women are fighting for their rights, they say, "It's because she is a feminist." At times they consider feminism to be an insult, like, "[women] only want one thing, and they are becoming masculine, and they are doing all these things and what they want is equality." No [I am not a feminist, but] I would say that I have struggled for women and I think that women have the same rights as men. (Guevara 1989)

More recently, the discussion around these issues in Central America has turned away from struggling with the concept of feminism and toward incorporating the concept of gender. Some, like Mario Rolando Cabrera from the NGO FUNDAPAZD in Guatemala in 1991, blamed the lack of a gender perspective for the shabby treatment women received in the negotiations around the peace accords in Nicaragua, El Salvador, and Guatemala. First, few women were included on negotiating teams. Second, some women on those teams did not share a gender perspective on women's issues. And third, even though some women and/or women's groups did adopt a gender perspective, they either had not developed specific policy proposals related to their perspective, or they lacked the resources to air their perspectives and proposals (for example, through publications or through access to decision-makers).

> Perhaps one of the fundamental problems for the participation of women is that not even in organizations for and of women is there clarity about what we could call a gender perspective, nor is it incorporated as a general policy. So, discussions in the state don't even minimally touch on what we could call a gender vision in education, nor in economy, in agriculture, in ranching, etc. There is none. (Cabrera 1991)

A gender perspective incorporates the condition of one's gender, along with other characteristics such as age, class, race, and marital status, into the analysis of the situations of individuals and/or groups in the population. Without a gender perspective, the relatively scarce presence of women in national legislatures would seem to be a natural

result of party electoral competition; the paucity of land parcels distributed to women ex-combatants would seem fair given prevailing cultural norms. With a gender perspective, however, it is possible to ask whether any proposed plan, policy, or program will have a disparate effect on women compared with men, for example structural adjustments (SAPs) or particular democratic arrangements, such as proportional representation. Alda Facio, a well-known lawyer in Costa Rica, observed in 1990 that women in grassroots organizations were creating their own gender perspective:

> There was a lot of antagonism with the word "feminist." We had a magazine that people were afraid to buy. It didn't even have the word "feminist." It was called "an alternative vision for women," but everyone knew it was feminist. And now we are having big discussions with the largest women's organization in Costa Rica, the *Alianza de Mujeres Costarricenses* [Alliance of Costa Rican Women], which is a leftist group that works with women in the popular sectors, and they criticized us a lot for being bourgeois feminists with ideas imported from Europe and the United States and all. And now they, little by little, are becoming feminists, because whatever work you do with women carries you to it. (Facio 1990)

According to María Candelaria Navas, a Salvadoran writer, in 1993 (one year after the signing of the peace accords), from the bitter experience in the peace and democratization process, a gender perspective was being rapidly dispersed and widely adopted:

> [Recent events] have given the discussion of women's problems a particular character because the focus has not remained at the level of intellectual elites or only academic women. Rather, the discussion is passing on; you can find it at every level. It seems to me that this could be an expression of democracy. The discussion of women's problems takes place at every level. And the most interesting thing is that it has reached the masses, the women at the bottom and the men at the bottom, and that could also be an expression of democracy in practice. (Navas 1993)

Women's studies programs in national universities in the region were adopting a gender perspective as the framework for their curricula. The national office on women in each country was publishing materials on gender and devising workshops for government workers. Many NGOs were offering training in gender studies to such groups as union members and handicraft workers. An NGO created to help women register to vote also helped women to employ a gender per-

spective to decide how to vote. Government offices on human rights adopted a gender perspective in their campaigns for legal literacy for women. Autonomous women's groups began interpreting what a gender perspective means through self-reflective discussion and study sessions.

Women in political parties were also revising their stance on party issues, as Nidia Díaz, an FMLN-linked candidate for the legislature in El Salvador in 1993, explained:

> It seems to me that this is an extremely important moment, strategically speaking. We women are the majority in this country, and generally we have never taken up our own cause, that is, from a gender perspective. Even in the revolutionary parties, where we fought for so many years, the facts pertaining to women's situations were never touched upon in all their complexity. Only, well, our part in the struggle, women took up rifles, they fought, but sometimes their conditions with regard to male-female relations remained static. Today the situation is different; we have greater comprehension of the complete phenomenon, including mention of gender. (Díaz 1993)

While some women's groups faulted women legislators as lacking a gender perspective, at least some women legislators were adopting a gender perspective and seeing the lack of gender consciousness as a major problem for Central American women. Social Christian legislator Luisa del Carmen Lario Mora, in the opening quotation in this chapter, cited the need for more policy enacted with a gender perspective in Nicaragua.

WOMEN LEGISLATORS' INFLUENCE

Public policy change was not proceeding exactly the same way throughout the region. First, not every country was identically situated with respect to existing public policy on women. Conditions in each country strongly determined the types of problems that were identified as affecting women, and what—if anything—women legislators proposed to do about it. Second, Central American women legislators were not a homogeneous group. Women legislators had different opinions about existing policy—whether it should be preserved or changed, and if changed, in which direction. Some belonged to right-wing parties, while others were centrists or leftists. Some were feminists, while others were either neutral or anti-feminist. Some worked to preserve women's traditional roles, while others worked to change them. Each of the perspectives described above—as well as

others—influenced what women legislators perceived to be pressing problems in their country and shaped the public policies that women legislators proposed to solve those problems. As a result, women legislators in the five Central American countries expressed quite a variety of policy interests. And even when deputies across Central America used the same words, they often had different meanings in different countries, or even different meanings among political parties in the same country. For example, a right-wing deputy who referred to the "defense of material goods" in El Salvador meant the property rights of wealthy families who had land taken away through agrarian reform, while a left-wing deputy in Nicaragua used the same term to mean the preservation of social guarantees for the working class. Finally, differences in each country with respect to the process of democratization presented unique opportunities and challenges to transforming public policy concerning women.

ECONOMIC PROBLEMS

Nevertheless, Central American women legislators identified similar problems facing women (Table 6.3), which could be considered for public policy proposals. The most commonly mentioned problem was

TABLE 6.3. PERCEIVED PROBLEMS OF WOMEN

	Number	Percent
ECONOMIC PROBLEMS		
Economic crisis, national development, external debt	51	24.6
Lack of services for women heads of household	23	11.1
Lack of health services for women	19	9.2
Lack of education, adult literacy for women	19	9.2
War, violence, and effects on women	16	7.7
Lack of housing, land, and legal titles for women	7	3.4
DISCRIMINATION PROBLEMS		
Discrimination against women	34	16.4
Machismo, culture, values, lack of gender vision	15	7.3
Lack of political power	11	5.3
Government corruption	7	3.4
Other	5	2.4

Source: Interviews with women legislators in Central America.

the economic crisis, including lack of development and the size of the foreign debt. Newer studies on gender and democratization have pointed to the problems caused for women by the adoption of neoliberal economic policies. Scholars such as Nikki Craske (1999), Diane Elson (1995), and Pamela Sparr (1994) have analyzed the complex connections between democratization and economic structural adjustment and their implications for women. This burgeoning literature argues that the implementation of neoliberal economic policies carries social costs for women because when the state cuts back or privatizes social services (e.g., child care), women must either have the means to purchase them in the market or provide them as an additional part of household production. Proponents of neoliberal policies consider many social welfare services, such as care of the elderly or meals for the poor, to be better borne by individuals or privatized. The conclusion is that public spending on these services is inefficient, so the costs are shifted to the household level, making them costless to the state. The traditional division of labor that assigns women responsibility for household work and family care means that women perform a disproportionate number of unpaid hours in household service production. Structural adjustment programs (SAPs) displace the cost of social services from the public realm to the private and rely on the flexibility of women's household labor to absorb these costs.

The problem is that women rely on many of these social services for maintaining family well-being. While the shift may be costless for the state, it is very costly to women who must either work more hours in the labor force to afford to purchase these services in the market, or work more hours in the home to provide these services directly themselves (Craske 1999; Elson 1995; Sparr 1994). There are also consequences for female children. When women decrease their hours in the paid labor force to provide more household services, they are more likely to employ female children in income-generating activities rather than sending them to school. When women increase their hours in the paid labor force, they tend to pull female children out of school to provide household services such as child care, cooking, and cleaning (Chant 1991).

Many other women's practical, everyday problems were seen to be secondary outcomes of the economic crisis, including lack of jobs for women, lack of sufficient income for women who are heads of household, inability to pay for basic household needs such as water and electricity, and so forth. In addition, the economic crisis hampered

the government's ability to provide social services for women, such as health, education, housing, and credit for rural women involved in agriculture. Mireya Guevara, a legislator in Costa Rica, explained how women were affected by economic problems in 1989:

> The three most important problems in this country now are, in first place, the external debt of course, which obliges us to divert our most important funds away from development to pay down our debt. Next is the lack of work; this is very important in the country because even though the rate of unemployment is not too high, nevertheless it is somewhat disguised by underemployment and extremely low wages for working women, and a lack of creation of new jobs. And the other problem which the country could have is production, to diversify the means of production. The lack of jobs affects women the most. Logically, she is the one to be displaced when there is a lack of jobs. (Guevara 1989)

In 1990, just after peace accords were reached, Gladys Baez, a Nicaraguan legislator, echoed the importance of the economic crisis and the extent to which the structural adjustment measures imposed by lending agencies after the peace accords were signed were affecting women, and how women were responding:

> So there is no person from the working class who is not being affected, and among these people, it is we women who are triply affected. [But] I think that this situation, far from squashing us, has resulted, here in León for example, in the decision for civil disobedience. We won't pay [our utility bills], and if they cut off the lights or the water, well, we are just going to hook them back up. (Baez 1990)

DISCRIMINATION PROBLEMS

The second most commonly mentioned problem was discrimination against women. The problem was reported not to be so much the lack of laws against discrimination as the enforcement of those laws, a condition of *de facto* discrimination rather than *de jure*. Subsidiary problems included the permanence of *machismo* in cultural values, the lack of gender consciousness, women's relative lack of power in decision-making positions, and corruption in government. A few other issues of discrimination were mentioned, concerning specific groups of women such as children, adolescents, and seniors. Of course, these two problems (economic and discrimination) could be related. Milagro del Rosario Azcúnaga de Meléndez, a legislator in

El Salvador, explained in 1990 why she believed that discrimination against women is a major problem in her country and has serious economic consequences for women as well.

> Cultural patterns are a fundamental problem for women. If we turn to the moment of crisis in which we are living, the woman is the one who suffers the severest consequences of the economic, political, and social crisis that our country is undergoing. Why? Because if the majority of homes are headed by women, and women are discriminated against in the labor market, then it is difficult for her to obtain an income to support her family. So we have to solve the problem of women with regard to jobs [and provide] opportunity for employment equal with that of men. (Azcúnaga de Meléndez 1990)

Legislator Thelma Iris de Perez in Honduras in 1991 had a similar analysis:

> What are women's problems? In the first place, the fact that she is a victim of discrimination regarding entry, in equality of conditions, into the fields of education, health, and jobs generates a whole series of problems for women, limiting her participation in the rest of life's activities. In politics, where one can hold positions that will open up opportunities for better jobs, women have also been the objects of margination. Perhaps the other *compañeras* have indicated what a large quantity of *diputados* [male legislators] there are here, and how we women barely constitute a minimal percentage of representation. If we review other public offices, there are very few women mayors, very few women governors, very few women judges. That is to say, we have been marginalized, true? (de Perez 1991)

In the following section, we examine what Central American women legislators proposed to do about these identified problems.

A FRAMEWORK FOR PUBLIC POLICY IN CENTRAL AMERICA

In field interviews, women legislators in Costa Rica, El Salvador, Guatemala, Honduras, and Nicaragua discussed many public policy initiatives that they had proposed in the past or would like to propose in the future. When legislators talk about public policy in Central America, they refer chiefly to the national Constitution and to national laws (rather than to specific programs administered by the bureaucracy). This is to be expected, given that their function is to legislate, and that the implementing authorities are under the control of the executive branch. They also refer to the need to conform to international treaties. Generally, the national Constitution takes

TABLE 6.4. A FRAMEWORK FOR ANALYZING POLICY PROPOSALS

	Policy Proposals	
Definition of Women	No Gender Perspective	Gender Perspective
Part of a Family Unit	Type I	Type II
Individual Citizen	Type III	Type IV

Source: Interviews with women legislators.

precedence in establishing public policy within each country, followed by international treaties, and then national laws. When a country signs and ratifies an international treaty in Central America, then national laws that are in conflict with the treaty become invalid and must be changed.

Women legislators in Central America were proposing to change public policy in a variety of ways. The majority of legislators we interviewed listed at least one policy initiative they had worked on that concerned women; many listed several policies. Some wanted recent legislation repealed, while others wanted more new legislation to be enacted. In some countries there were piecemeal efforts, while in other countries whole sections of public policy were challenged, especially those dealing with family and criminal law. In the following section, the various policy proposals are discussed using a typology that categorizes them first on the basis of their view of the woman and second on their perspective of what should be done about it.

Most of these initiatives mentioned by women legislators concerned proposed or adopted legislation, and tended to fall into one of two camps: policies treating women as part of a family; or policies treating women as individuals. Further, policy proposals tended either to enforce a strict equality for men and women, or to adopt palliative or affirmative-action policies for women. The intersection of these two perspectives is shown in Table 6.4 and results in four possible types of public policy: Type I policies reinforce women's traditional family roles; Type II policies attempt to alleviate some of women's role strain from undertaking both traditional family roles and other nontraditional roles (work, education, politics, etc.); Type III policies

enforce a strict definition of legal equality between men and women in all roles, with equal opportunities, equal pay, and equal benefits; and Type IV policies are the most radical because they attempt to change the roles of women—and perhaps of men also—away from the traditional. Some recent policy proposals of all types are summarized in Table 6.5.

TYPE I—TRADITIONAL ROLES

Much of the existing Central American law and policy was originally enacted as a Type I policy, focusing not on women but on the family and reinforcing women's traditional roles within the family structure. A few of the women legislators we interviewed were proposing more Type I policies, which aimed at strengthening women's traditional roles, treating women in their roles as wives, mothers, and homemakers. Type I proposals included establishing pensions for widows and (re-)criminalizing female prostitution. These were Type I policies because through them the state would regulate the lives of women as having no legitimate existence outside the traditional family either economically or sexually. For example, the woman who spends her life discharging traditional household duties is entitled to a widow's pension from the state once her breadwinner husband dies; the exercise of sexual intercourse outside marriage by women should not be legal. These policies are based on the assumption not only that a woman's proper place is subsumed within the family, but also that women fare best there, where they can be both protected and restrained by the state.

A proposal in 1989 in Costa Rica to create the Institute for the Family illustrated the thinking behind Type I policy. This Institute would centralize all existing programs in various government agencies that are directed toward women, and lump them together with policy on children, the elderly, and families. In 1990, Costa Rican legislator Flory Soto explained how the Institute would help women to maintain their traditional role within the family.

I am fighting for the creation of the Institute for the Family because I think that by improving the conditions for the family, the condition of women is also improved. This will be an entity that will lobby for the family, not only for women, but for children and the abandoned elderly. Because realistically, the problem of the family should be looked at holistically. (Soto 1990)

Costa Rican legislator Mireya Guevara, also a proponent, added this policy-making rationale for the Institute for the Family in 1989:

TABLE 6.5. CENTRAL AMERICAN WOMEN LEGISLATORS' POLICY INITIATIVES FOR WOMEN

	Policy Proposals	
Definition of Women	No Gender Perspective	Different Treatment for Women
Part of a Family Unit	TYPE I—TRADITIONAL ROLES * Institute for the family * Pensions for widows * Criminalize prostitution	TYPE II—ALLEVIATE ROLE STRAIN * Paid maternity leave for women * Health care for pregnant women * Earlier retirement for women * Part-time jobs w/benefits for women * Childcare at work for women
Individual	TYPE III—STRICT EQUALITY * Social security & minimum wage for maids * Equal rights for the unmarried * Equal rights for illegitimate children * Equal property rights for women * Equal pay for women * Equal minimum wage for women * Equal title to land/credit/ technical assistance * Equal schooling for girls and boys * Equal textbook roles for men and women	TYPE IV—CHANGE ROLES * Special training for rural women * Quotas for women candidates * Quotas for women's employment * Funding for politics for women * Regulate ads that use women's bodies

Source: Interviews with women legislators.

[Our plan for] the Institute for the Family [means] no longer legislating by patchwork, but instead we would think about the family, which is the fundamental axis of our society. Think not about legislating for the child, but rather legislate for the child as part of that family. Not legislating for the disabled separately, but legislate for that disabled person within a family, for the elderly within that family, for the woman within that family. (Guevara 1989)

Other Type I proposals for public policies and government programs suggested by women legislators include proposals to address economic problems through general campaigns against inflation, diversification in the production of goods and services, increased access to foreign markets and better prices for exports, and aid to small businesses and small farms. These are Type I policies because they do not consider women to be individuals in the context of the policies, and they do not attempt to provide any different treatment for women (either palliative or radical). The sponsors of these proposals, while they may have adopted a gender perspective, do not see a need to address women through public policy as individuals.

TYPE II—ROLE STRAIN

Type II policy proposals also focus on women's traditional roles but attempt to reconcile them with nontraditional activities forced upon women, such as working outside the home due to economic necessity. There were a great many Type II policies proposed by women legislators in Central America. For hundreds of years, despite the adoption of liberal democratic principles in their Constitutions, the group—not the individual—has formed the basis of society in the region, and the family has been one of the most important of the basic groups. Type II policies try to reconcile women's newer nontraditional roles, such as family breadwinner or participation in the formal, paid labor force, with their important traditional roles within the family, for example reproduction and household work. Type II policies tend to be based on the concept of the *Supermadre* (see Chaney 1979), and generally accept the situation of multiple roles, heightened expectations, and longer days for women. Women who work both within and outside the home experience the "double day"; women who add political participation as well experience the "triple day." Some examples of Type II policy include proposals in the 1990s to provide health care for all pregnant working women; to increase the length of maternity leave from work and the amount of the stipend paid; to require the establishment of breast-feeding and child-care centers at workplaces; and

to mandate that part-time jobs for women offer fringe benefits. The opportunity for women to retire earlier than men is also a Type II policy, because it treats women differently than men but still sees women's legitimacy as primarily within the scope of the traditional family. Earlier retirement puts older women back into the home to help alleviate the role strain of their daughters (whereas earlier retirement for men would not have the same social payoff).

TYPE III—STRICT EQUALITY

In accordance with liberal democratic principles, Type III policies treat women as individuals and enforce a strict equality of the sexes; Type III policies are increasingly proposed in Central America. One example requires equal depictions in school textbooks of girls, boys, women, and men in positions of power, leadership, authority, and work outside the home. One study conducted by UNICEF and UNIFEM in 1990 of schoolbooks in El Salvador, Guatemala, and Panama revealed that women were undervalued, there was discrimination against women, and there was unequal treatment of the sexes. Books more often bore the name of a male protagonist than a female one; examples used to teach grammar reinforced stereotypes ("papa reads the newspaper while mama cooks dinner"); and the majority of illustrations featured male characters. Depictions of women in work roles were few and did not mirror the actual level of women's participation in the labor force. Since then, Central Americans have made great strides in the analysis of school textbooks with regard to the depiction of men and women in stereotypical roles. Similarly, other Type III policies promoting equality—such as the need for equal access for women to land, credit, and technical help—have been adopted in several countries.

A proposal to grant to women, irrespective of marital status, the same rights enjoyed uniformly by all men is also a Type III policy. Women in unmarried partnerships—largely from the poorer sectors of society—were often in a legal limbo in Central America, as were their children. Women legislators have pushed to get legal recognition for *de facto* unions, as well as to eliminate the distinction between "legitimate" and "illegitimate" children. A Type III policy proposal to eliminate women's traditional "right" to add their husband's surname to their own upon marriage (using the *de* convention) was hotly debated throughout the region (neither men nor women would do so under the new law). Central American women legislators have also

pushed for laws that allow divorce by mutual consent and for equal distributions of assets upon the dissolution of the marriage. Costa Rica has adopted the most forward-looking strategy for treating the division of assets and custody of children upon divorce. Each spouse maintains rights to his or her own separate property for the duration of the marriage. Upon divorce, authority over the children does not automatically fall to one parent or another, but rather to the parent who would best serve the interests of the child. Both parents must contribute equally to the support of the household where the child resides.

Another Type III policy is a proposal in Guatemala to bring domestic workers (maids) under the labor code, including social security coverage, like any other worker; another proposal would stipulate the same minimum wage for maids as for other workers. This is a Type III proposal because while it does treat women as individuals, it does not offer different treatment for women, either palliative or radical. That is, there is no attempt to change traditional roles for women. With the exception of Costa Ricans, only those Central Americans who work for the government are covered by the social security system, which provides both pensions and health care for enrollees. Some large industries in the private sector may petition to have their employees covered as well, but no more than 10 to 30 percent of the work force has coverage. Legislator Ana Isabel Prera Flores described the situation of most women in Guatemala who, in 1991 (five years before peace accords were concluded), were without social security coverage.

The truth is that the Guatemalan legal system does not discriminate against women. It is relatively egalitarian: it recognizes women; we have had the vote for many years; there is no legal discrimination against women. The problems that we encounter are *de facto*, in a society where there is actual discrimination with respect to job opportunities, with respect to access, with respect especially to responsibilities. The truth is that the majority of women act as father and mother and are the ones who provide for the home. And the great majority, who don't work either for the state or one of the big companies that are affiliated with the social security system, are shut out of social security benefits. (Prera Flores 1991)

Another Type III policy is a reform of the penal code to lessen discrimination against women by treating women as individuals and equally with men. In Guatemala, a comprehensive review in 1990 by the national office for women (UNICEF, UNIFEM, and OPS 1990)

resulted in a proposal for numerous changes. One of the most fundamental was to rename the section of the penal code on "crimes against sexual liberty and security, and against decency" to "crimes against personal integrity." They argued that what was being harmed was the personal integrity (not the decency) of the victim, and that the use of the word "decency" allowed the social reputation of the victim to be called into question in determining whether a crime has been committed, which should not be the issue (Table 6.6).

TYPE IV—NEW ROLES

The last set of policy proposals, Type IV, focuses on women as individuals or as members of important sectors or groups based on gender deserving of state action. These policies attempt to change women's roles—and perhaps men's as well. One of the most impressive examples of a Type IV policy was the Nicaraguan Constitution adopted in 1987. Greatly influenced by the language of CEDAW, this Constitution not only guaranteed equality for women and men, but in addition promised to take positive steps to end discrimination against women (Morgan 1990). An example of a subsequent Type IV policy enacted in Nicaragua was the *Ley Reguladora de la Relación Madre-Padre-Hijos* (Law Regulating the Relationship between Mothers, Fathers, and Children). This policy completely eliminated the concept of *jefe de familia* ([male] head of household). Both parents were to exercise equal rights over children who live with them, and both were to have equal responsibility for contributing to the maintenance of the household, child care, and household tasks; domestic labor was assigned a monetary value.

A Type IV policy introduced in Guatemala in 1990 sought not only to revise the Labor Code to reduce discrimination against women, but also to incorporate some novel ideas—such as comparable worth. Initially, Guatemalan legislators proposed such generally accepted reforms as adding the word "sex" to prohibitions of work discrimination, ending the unequal pay of rural women and children, and ending the prohibition on night work for women. They also wanted to enforce national laws on previously exempt job sites run by multinational companies (*maquiladoras*), and to adopt laws against sexual harassment in the workplace. They also proposed to end job advertising that discriminates on the basis of race, sex, ethnicity, marital status, or age. However, they also went further in other areas. Instead of basing pay on the quality and quantity of work of individuals, they

TABLE 6.6. PROPOSED REFORMS TO THE PENAL CODE IN GUATEMALA

Existing Language	Proposed Reform
The crime of rape is defined only as "lying with a woman" . . .	Define the crime of rape to mean obligating another person to commit sex acts . . .
The crime of sex with underage children is defined as with "an honest woman over age 12 and under age 14, taking advantage of her inexperience or obtaining her confidence" . . .	Define the crime of sex with underage children to mean realizing a sexual act with another person between the ages of 12 and 16, with that person's consent . . .
"Carnal access to an honest woman with a false promise of marriage . . ."	Whoever realizes a sex act with person obtained by false promises . . .
The penalty for the abduction of a women for sex (*rapto*) is less than the penalty for kidnapping in general.	End the distinction between abduction of women (*rapto*) or of men (kidnapping) and apply the same penalty in both cases.
There will be no penalty imposed in the above crimes if the victim marries the offender . . .	There will be no penalty imposed in the above crimes if the victim is over 18, previously consented because of an intention to marry, and still wants to be married . . .
The penalty for incest is less than the penalty for sex crimes with an unrelated person.	Increase the penalty for incest to be greater than for sex crimes with an unrelated person.
Women may not remarry for 300 days after divorce, annulment, or being widowed.	Eliminate
The crime of adultery applies to married women only.	Eliminate
The crime of concubinage applies to married men only.	Eliminate
If a husband forgives his wife, the penalty for adultery can be waived.	Eliminate
None	Ban on advertising showing violence against women
None	No mistreatment of a spouse, whether by word or deed
None	Assault against a family member will be treated like an assault against any other person.

Source: UNICEF, UNIFEM, and OPS 1990.

proposed that pay be based industry-wide on the years of schooling or training required for the job, the level of responsibility exercised, and the type of skill or ability required. For example, grade-school teachers (a female-dominated, low-wage industry) might be paid as much as air-conditioning technicians (a male-dominated, high-wage industry). Instead of paying equal salary for equal work, equal salary would be paid for work of equal value to society. Even more radically, it was proposed that all Guatemalans hire at least 10 percent women to start, and then increase the percentage each year until at the end of 10 years the figure would reach 50 percent. Employers could have no jobs filled by more than 70 percent workers of the same sex, and the combined pay of all the workers of either sex must be in proportion to their presence in the employee ranks (i.e., if women represent 20 percent of employees, their combined pay cannot fall below 20 percent of the total payroll).

Type IV policies have recently been adopted in Latin America to require various forms of quotas for women in politics. At the time of this study (1980–1995), no formal quota systems had been adopted in Central America. An early version of a type of quota system was proposed in Costa Rica in the 1990s, however. The "Law of Real Equality for Women" consisted of five sections dealing with women's social and economic rights, sexual protection, education, the creation of a Women's Prosecutor, and political rights (Saint-Germain and Morgan 1992). The section on social and economic rights included guarantees of equal rights with respect to credit and social insurance and a requirement that all real property granted by the state be in the name of the married couple or, in the case of *de facto* unions, in the name of the woman. This section also contained provisions related to child care for working parents. One section required public employers whose employees together have more than fifteen children under six years of age to maintain child-care centers and to give their employees—men and women—no less than one hour daily for feeding or caring for their children during the child's first year of life. Another section dealt with private employers and authorized (but did not require) them to provide child-care facilities for their employees. As an alternative, private employers could provide benefits inversely proportional to employee salaries to be used exclusively for payments to state-approved child-care centers.

The section on sexual protection set forth several reforms related to the treatment of rape and other sex crimes. The proposals included

amending the Penal Code to restrict pardons for the crimes of rape and trafficking in women and children; to require that, if possible, women be allowed to make denunciations of sex crimes before female judicial authorities and that superior courts hearing such cases contain at least one woman judge; to allow women who are victims of sex crimes to be accompanied by someone of their choosing during forensic examinations; and to provide that the presentation of evidence in cases dealing with sex crimes be in private unless the court determines otherwise.

The next section required educational institutions to remove all stereotypical images of masculine and feminine roles from their educational programs and materials. Promotion of mixed (co-ed) education, the concept of shared rights and responsibilities in the home and the nation, and other types of education that contribute to achieving this objective were stipulated. The following section established a Women's Legal Defender to protect women's rights under international conventions and national laws and to promote equality between the sexes, a practice that was increasingly common in developing countries during this period.

However, the most controversial provision of the proposal was found in the section on political rights. Article One of the bill provided that for the next five national elections, political parties must nominate men and women candidates for the national legislature and city councils in proportion to the number of voters of each sex. Article 2 amended the Electoral Code to stipulate proportional representation according to sex in party assemblies and to require that 25 percent of the public funds received by the parties be devoted exclusively to stimulating the participation, organization, and political affiliation of women. Article 1's requirement of representation proportional to the number of voters of each sex in effect would have required that 50 percent of candidates be women.

The proposal was not well-received by some Costa Rican women legislators, as Maria Eugenia Badilla, from a political party opposing the bill, explained in 1989:

I have decided that I will welcome it if it arrives; I don't think I will oppose it. Nevertheless, it is a project that will add absolutely nothing more for women. What we need is governments that have the political will to help women. What we need is men who will rise to defend wholeheartedly the integrity of these jobs and look for jobs for these people. (Badilla 1989)

Norma Jiménez, another woman legislator from the major opposition party, was even more vocal in her disapproval of the proposal, ostensibly on grounds of unconstitutionality.

The political Constitution of Costa Rica in Article 33 says that there should be equality for all, men and women; the principle of equality exists. So the result is that this proposal, while it certainly is trying to give women protection, is leaving men unprotected, so it is discriminating against men. I feel that this proposal, rather than strengthening the image of women, is leaving us totally debilitated. We have to be considered because we are women? For me this is degrading. I have to achieve my position because I am prepared, because I have the training, the willpower, and the interest to get what I want. But it seems wrong to me that they have to choose me because I am a woman. (Jiménez 1989)

The proposal did eventually pass, in a rather watered-down form. Even so, it has had an effect on the political participation of women in Costa Rica. Hilda González, a legislator in Costa Rica from the political party in power (PLN) that proposed the bill, was in support of the proposed "Law of Real Equality" and its stipulation of political affirmative action for women only because she thought the society was ready and able to accept it.

I agree with the project in the sense that in Latin America it is time to make a break. If we had a different situation, if our history had been different, I would not be in agreement. Above all I agree because of our historical context, that the Spaniard was *machista*, is *machista*, and brought that here to the Latin American countries, the total domination of the man, where the woman was only seen and nothing more; she did not talk. This still persists in the sense that the woman puts herself on an inferior plane because of her education, her mentality, because she is already accustomed to the man always taking the initiative. In order to do away with these barriers, it has become necessary to draft a proposal to give women total participation. (González 1989)

Another Type IV proposal that has been intensively debated but still not adopted is the decriminalization of abortion. Except in a very few, rare circumstances, abortions are illegal, albeit not always prosecuted, in Central America. Even when permitted, however, the conditions discriminate against women. For example, a therapeutic abortion to save the life of the mother is permitted in Nicaragua, but must be approved by three doctors as well as the husband or parent of the woman. Yet the penalty for the woman having the abortion

is reduced if it was done to "save her honor" or preserve her reputation. Still, there is little support among Central American women legislators for weakening sanctions against abortion; in fact, in some countries, sanctions are increasing.[1] For example, a revision to the Penal Code passed in El Salvador in 1997 not only eliminated all circumstances for abortion, including in the case of rape, but also increased the penalties for abortion. María Eugenia Badilla, a legislator in Costa Rica, explained her objections:

I am not in favor of abortion. I am much more in support of sex education to birth control. I have had eight children, and sometimes I think that I could never have slept peacefully if I had had [an abortion]. Because I believe that from the moment in which the fetus begins to form, it is already a person. It is very difficult, due to our education, to believe anything else. But I believe that there should be an active sex education to evade premature or unwanted pregnancies; there should be birth control. Of that, yes, I am in favor. (Badilla 1989)

Hilda González, another Costa Rican legislator from the Liberal party, preferred to place emphasis on the family in explaining her objection to abortion.

When there is respect for the family, problems diminish because there is a more stable situation [and] there are fewer problems related to an unwanted pregnancy. We know that these problems are not going to totally disappear from the world, but they do diminish. There are a whole series of very complicated things resulting from abortion. So to be specific, I would say that the first thing that seems to me to be fundamental is that the family be sacred, that it be respected. Of course, we are never going to arrive at 100 percent of families united and consolidated. (Gonzalez 1989)

Norma Jiménez, a Costa Rican legislator from the conservative opposition party, was adamant that the topic of abortion is anathema to politicians.

Here, the law prohibits abortion. For a woman to abort a child, it has to be only an issue of health, of well-being for her and the child. Christian principles are very deeply rooted, and since the Roman Catholic Apostolic religion is the state religion, it is under those principles that we have been raised. I am Catholic, and abortion is not accepted by the Christian principles of the Costa Rican people either, ever. No politician would ever accept it, no matter how distinguished, no matter how well educated, whether very intelligent or very ignorant, not an illiterate, not a professional, nobody would accept that in Costa Rica. (Jiménez 1989)

Women legislators in Central America are not all of one mind on abortion, however, and some have even changed their minds from one legislative session to another, like Maria Teresa Delgado, a Nicaraguan legislator who was interviewed in two different years. The first time, in 1988, she was asked specifically whether abortion policy was discussed for the new (1987) Constitution and seemed a bit put off by the question.

No, *compañera*, the issue of abortion was not discussed because you must already understand in the short time you have been here that our people have some ideas about what the Divine is. And at this time we consider that we have a lot of very important things to discuss with women, and abortion is not one of them. (Delgado 1988)

But by the next interview, in 1990, she had adopted a different perspective about the issue, even though she was not sure that any legislation on the matter would be successful. In response to a general question about the current problems of women in Nicaragua, she brought up the topic of abortion.

We have many important themes on women, but for us the principal one is sex education. I think that sex education is really important in our society so that women will not have so many children, only those that she can in reality educate and feed.... Also we as women have other issues, for example, trying to help get an abortion when they want one. Because the reality in Nicaragua is that women practice abortion on themselves. So we would like to, perhaps in the long run, establish that women in Nicaragua can practice abortion [legally] and that the doctors can do it without any problems. (Delgado 1990)

In 1990, one legislator from the FSLN party in Nicaragua, Doris Tijerino, was in favor of decriminalizing abortion.

Here abortion is punishable, it is in the penal code, and that means serious problems for Nicaraguan women. In the first place, it converts abortion into an incredibly profitable business for doctors [because there is tremendous demand and it is not regulated like other services, so doctors can charge high prices to perform an illegal operation and pocket all the money]. In the second place, by being a business, which means that an abortion done by a doctor costs a tremendous amount of money, abortion is inaccessible to a poor woman and she has recourse only to terribly savage methods, using knitting needles, using permanganate, or other types of chemicals that can damage her health, sometimes permanently, or cause her death. For these reasons, I think that we have to decriminalize it. (Tijerino 1990)

Type IV policies to eliminate gender stereotypes and ban the use of women's bodies as sex objects in advertising were adopted in Nicaragua and Costa Rica. Other, related areas in which Type IV policy adoption is proceeding slowly are in measures to decrease violence against women and to recognize women's rights as human rights. Many elected women worked to accomplish party goals first, and many unelected women worked to bring about peace first; women's goals were a distant second in order of priority. Similarly, some women worked to bring about an end to military violence in the region without including in that concept the end of violence against women, and other women worked to bring about respect for human rights in the region without including women's rights as human rights. With the introduction of peace and democratization in the region in the 1980s and 1990s, the themes of violence against women and women's rights as human rights began to be seriously discussed. Central American women referenced international declarations of human rights that guarantee the right to physical, psychic, and moral integrity, and that no one should be subject to cruel, inhuman, or degrading treatment, punishment, or torture. Women have interpreted this to cover such forms of violence against women as rape, incest, and sexual harassment, as well as domestic violence (López de Cáceres and Asturias de Castañeda 1992).

Women's concerns about violence were sparked during years of civil war, when governments in El Salvador and Guatemala adopted gender-specific forms of terror against women (Aron et al. 1991). After cessation of battlefield hostilities, however, some forms of violence against women have increased, due largely to structural adjustment policies, poor economic conditions, high unemployment, the return of armed combatants into civil society, the rise of urban gangs with easy access to weapons, and the trauma inflicted by years of war and conflict. Official statistics are incomplete, and it is estimated that only 5 percent of all cases of violence against women are reported. The U.S. Department of State (1993) recorded 564 reports of sexual violence against women in El Salvador in 1992, and hospitals in San Salvador reported an average of 56 rapes per month, while the police received only three reports per month during the same period. Another contributor is the difficulty in raising awareness of this issue and reshaping cultural attitudes about violence toward women.

By 1995, Costa Rica had perhaps the most advanced Type IV policies in this area, with a Women's Rights Prosecutor within the Office

of the Human Rights Prosecutor, and the creation of women's police stations, similar to those in Brazil and Peru (Ministerio de Justicia 1993). The topic of violence against women is of such importance, however, that the multinational, regional Central American Parliament has been trying to create model legislation that could be adopted by each of the national legislatures in the region.

CONCLUSION

Concerning the question posed at the beginning of this book, there is ample evidence that women did change politics as well as policy. With the push toward democratization in most of the countries in Central America, the reopening of the civic sphere, and the cessation of armed conflict, a great deal of activity was directed to public affairs in general and to public policy in particular. The transition from crisis to the early stages of democratic consolidation freed many Central Americans—especially women—to demand attention to needs that had been put aside during years of conflict. The political opening provided by the new practice of widespread consultation with informal political actors in the civic sphere (*concertación*) combined with women's new consciousness of gender theory and practice (*concienciación*) to not only generate many ideas for changes in public policy, but also empower women to make their ideas public. Some legislators in this study felt that there were already plenty of laws—and good ones, too—on the books, and that what the country needed was better enforcement to improve women's condition. But the majority of legislators felt that even if existing laws were better enforced, women's condition still needed to be improved by alternative policies.

The two major problems for women were identified as the economic crisis and discrimination based on gender. The need to borrow from international lenders left Central American economies subject to the imposition of structural adjustment programs (SAPs) that disproportionately affected women. These hardships were compounded by traditional attitudes (*machismo*) that justified discrimination against women due to their different—and lesser—status. But just as Central American women legislators were not a homogeneous group, neither were their policy proposals. While some preferred policies that support the status quo, others were testing the boundaries between private and public spheres, challenging traditional stereotypes with visions of the new woman and incorporating international perspectives into their policy proposals. Four types of policies emerged:

those treating women as submerged within the family; those treating women as individuals in strict equality with men; those attempting to alleviate strains caused by the clash of women's traditional roles with new economic realities; and finally those attempting to change women's traditional roles through recognition of women's claims as a group on the state. A number of the latter were proposed as part of the effort to have women's rights accepted as human rights.

However, the passage of new policy does not guarantee that things will improve. First, the policy needs to be implemented, but in the poor countries of Central America the necessary resources are often scarce. Second, some of these policies address centuries-old attitudes and practices, so change will not occur overnight. Third, with the consolidation of democracy there have been a number of conservative reactions against expanded roles for women. For example, many of the gains for women obtained during the 1984–1990 Sandinista administration in Nicaragua were under attack or rolled back during the subsequent Chamorro (1990–1996) and Alemán (1996–2001) administrations (Kampwirth 1996) (similar to the rollbacks of policies favoring women in Central and Eastern European countries). Women legislators—even from Violeta Chamorro's own political coalition—complained that Chamorro intended to send all working women back into the home to mind children. These developments have helped women legislators to appreciate the need to work across political parties for their shared interests, as well as to work with women in the community, the government, and in the new nonpartisan NGOs that advocate on behalf of women. It can be expected that coalitions of women legislators will work together more often in the future. While political parties may only talk about a gendered perspective, it will be up to women legislators to put that perspective into practice. Women legislators have begun to put women's issues on the agenda of the national legislatures in Central America; it will remain to be seen what their impact will be on women in the twenty-first century.

APPENDIX A: METHODOLOGY

The following pages discuss the methodology used in this study. This book's contribution to the literature on women, politics, democratization, and policy is a comparative, longitudinal study of women elected to the national legislators of five Central American republics. First, it is a descriptive study of women who were elected to the national legislatures of the region from about 1980 to about 1995. Second, it is a comparative study of the election of women in five Central American countries, Costa Rica, El Salvador, Guatemala, Honduras, and Nicaragua. And third, it is an analysis of the contributions of elected women to public policy and to the democratization movements of that era in those countries.

My research was supported, at various times, by the Fulbright program, the Tinker Foundation, the National Endowment for the Humanities, the University of Texas–El Paso, and the University of Arizona as well as its Women's Studies Advisory Council; Cynthia Chavez Metoyer's work was supported by California State University–San Marcos.

The longitudinal and comparative methodology employed several sources of data. One of the most important primary sources consisted of personal interviews in the field with women elected as representatives to the five national legislatures in Central America. I conducted these interviews between 1984 and 1995. The national legislatures of each country were contacted to verify the names, district, and party affiliation of elected women. The goal was to interview 100 percent of women elected during the time period under study (a table displaying the total number of women elected in each country can be found in Chapter 4).[1] The actual percentage of completed interviews ranged from 100 percent in Costa Rica to 83 percent in Guatemala. Several other interviews were

also conducted of women in political parties, women's movements, universities, research institutes, community organizations, self-help groups, and the like. This book, however, presents data only from women elected to national legislatures, unless otherwise noted.

All interviews were conducted in Spanish (with one exception, in English). The interviews, obtained mostly during the months of May through August, were arranged in advance by letter and fax, although they were often rescheduled.[2] Interviews were held mostly in offices in the national legislature, although a few did take place at other locations, such as the woman's home or, once, in a Jeep during a four-hour drive. I used a standard interview schedule (Appendix B) and took notes during the interview. Most interviews were also tape-recorded with the permission of the respondent; only a handful refused to be recorded. For interviews without tapes, I typed up the notes from the interview. Each interview lasted on average about 90 minutes, although some did go on for several hours.

During my periods of field research, I took a small tape recorder, a laptop computer, a transcribing machine, and a small printer (as well as a surge protector) with me to Central America. During evenings or other slack times, I worked on transcribing the tapes so that I could give each person interviewed a copy of the transcript as soon as possible. Once back in the United States, the transcription and review of the interview tapes were completed with assistance from two male and two female research assistants, all native Spanish speakers from Latin America. The interview transcripts or notes were coded for a number of variables of interest. The coding was done separately both by the author and by a research assistant. The two independent codings were compared, and differences were worked out. After paper printouts of the transcripts were coded, the electronic files were entered into The Ethnograph®, a qualitative content analysis software program. The analysis has continued for several years, and perhaps will never completely exhaust the possibilities presented by this extremely rich trove of data.

Research of this kind presents many challenges, both in collecting and analyzing the data, as well as in reporting the results. Opportunities abound during the research process for making decisions that may influence the eventual outcome of the study. Many thoughtful pieces have been written about these challenges, especially with regard to gathering oral testimony from women (Gluck and Patai 1991; Geiger 1986; Nielsen 1990; Oakley and Callaway 1992; Personal Narratives Group 1989; Conway, Bourque, and Scott 1989). In this section, as the primary field researcher I describe the challenges I encountered and how I dealt with them, attempting to minimize or, if that was not possible, at least acknowledge conscious bias on my part.

Prior to undertaking this research, I lived in Nicaragua from 1984 to 1986, when the Sandinista administration was in office. There I worked for the Nicaraguan Institute of Public Administration, a part of the Nicaraguan government, where I helped in developing and delivering an in-service Master of Public Administration program for government employees. My first contacts with elected women were through the Sandinista political party, as all the women elected in Nicaragua in 1984 were either from that party or sympathetic to it. In later electoral rounds, I initially expected to have a difficult time establishing a similar level of rapport and trust with women from other political parties. However,

I had interviewed some of these other women years earlier, when I attempted to interview a woman representative from every Nicaraguan political party that was running candidates for the national legislature. I did not have the same type of difficulty in the other countries where I had not been a resident prior to beginning the interviews. Still, I learned that it could make a difference if my entree to the national legislature was through the political party in power rather than an opposition party, or through a business, university, or government official identified as pro-U.S. rather than one identified as anti-U.S. or neutral, and I attempted to use the most well-respected contacts I could. I strived to present myself as an open and interested researcher who would be sure to tell all sides of the story. Many of these and other challenges to interviewing women members of national legislatures have been frankly described by Puwar (1997).

A related concern is that I did not want to be a "data imperialist," a researcher from a more developed country taking up the time and resources of women in a less developed country and then making off with the data (Geiger 1997). Women in Central America have had this experience many times, where they give of themselves to a foreign researcher but never receive any benefit in return. I did observe a formal protocol for informing women of their rights not to participate, not to answer any question if they wished, and to terminate the interview at any time. I assured them that I would keep the information confidential, not sharing it with any organization or individual in their home country. I asked each if she wanted complete anonymity, but none did. After the interviews I endeavored to give each woman a verbatim copy of the transcript of her interview, and asked if there was anything she wished to add, change, or delete. The only requests I received were to "clean up" the interviews before quoting them. I also took photographs of most of the women I interviewed (unless requested not to), and I asked for permission to use the photographs for publication, which was granted universally.

A second major concern is the accuracy of my transcriptions, translations, and interpretations of the transcripts. Every tape was transcribed by one person, and then printed out and read by a second person while listening to the tape. There is still a possibility that some portion of the recordings may not have been transcribed accurately, but the majority of the transcriptions have been checked and rechecked against the tapes many times over the years by multiple persons. One of the challenges in translating interviews is that the translator can dampen, bias, or distort the original meaning. All the analysis was conducted with the transcripts in their original Spanish. I believe I am qualified to do the analysis in this fashion because I spent nearly a decade growing up in Spain, where I first learned to speak Spanish at the age of 10. During the two years I spent in Nicaragua, I learned to speak Spanish for the second time while working with, living with, and teaching Spanish-speakers. At that time I traveled extensively throughout Costa Rica, Guatemala, and El Salvador. I also spent six weeks living and working in Honduras in a camp for refugees from El Salvador. These latter experiences gave me an appreciation for the differences in Central American Spanish, both its variations from the Spanish spoken in Spain (*castellano*) and its variations from one country to another, as well as between different socio-economic levels and ethnic groups in each country. My co-author, Cynthia Chavez Metoyer, also fluent in Spanish, has checked the accuracy of the translations used in this book.

As anyone who has ever attempted to use a computerized translation program can attest, translation is more of an art than an algorithm. We have made several decisions regarding translations. First, the transcripts are records of spoken interviews and, as such, contain many phrases that people use in speaking that they would not use in writing. The transcripts are also full of pauses, interjections such as "er" or "uh," rhetorical questions such as "you know?" or "right?" and other quirky mannerisms of speech, stutters, repetitions, losing track of one's thoughts, going off on tangents, and so forth. In translating, I have chosen to omit most of these, considering them to be distractions from the main purpose of presenting the ideas of elected women. For other purposes, perhaps for linguistic analysis, it would make sense to present the transcripts exactly as they are, warts and all. Ideally, my preference would be to present the quotations in the original Spanish, along with the tape recording that the reader could listen to while reading the text. Only that experience, I feel, would convey the depth and breadth of meaning contained in the spoken word (to say nothing of what is missed by not having access to the visual dimension as well). Perhaps in the future, with advances in technology, there will be e-books that present both text and audio (and even video) simultaneously.

Another decision concerned which quotations to keep, how much of each interview to include, and how to integrate them into the text. Dr. Cynthia Chavez Metoyer took the lead in this difficult part of constructing the book. I felt that because she was further removed from the interviews, she could more objectively identify the themes, patterns, and connections that emerged in the interview data. Dr. Metoyer also developed and wrote the theoretical framework for this book to contextualize the research. She first traveled with a Latin American Studies Association (LASA) delegation to Nicaragua in 1991, nearly 6 months after the Chamorro administration took office. She subsequently lived in Managua for 6 months while conducting her doctoral research. She has returned regularly, including to observe the 1996, 2001, and 2006 national elections and to volunteer for a humanitarian aid project following the devastation caused by Hurricane Mitch in 1999. She combines research with humanitarian work, and over the years she has interviewed dozens of "marginalized" women and men, as well as public officials and community leaders. While Nicaragua is the primary focus of her research, Dr. Metoyer has also traveled to Costa Rica, El Salvador, and Guatemala.

I have often wished I could include all the original words and stories of all these women, but space and time do not permit. To strike a balance, I have included short, relevant excerpts translated into English and interspersed throughout each chapter to illustrate specific points made by many women. I have tried to present as broad a spectrum of quotations as possible, in terms of dimensions such as political orientation, geographical dispersion, demographic characteristics (age, ethnicity, marital status), and so on.

A NOTE ABOUT LANGUAGE

In Spanish, the male form of the pronoun for the third person singular (*él*) is traditionally used not only to refer specifically to one man, but also to refer to any

person (male or female). This is similar to the way the pronoun "he" was used in English to refer to any person (male or female). Now, writers in English use the pronoun "he" if they are actually referring to a specific man, and the pronoun "she" if they are referring to a specific woman. If the writer is referring to any person in general, the writer may use both pronouns, as in "he or she," or may alternate the use of "he" and "she" throughout the text. At times "s/he," an abbreviated version of "he or she," is used instead.

In the years in which these interviews were conducted, some Spanish speakers were beginning to make the same break with tradition in Spanish. Some people are demanding that both male and female forms of pronouns be included if both men and women are being referred to, either specifically or in general. This is more awkward in Spanish than in English, since every pronoun has a different spelling for referring to men than for referring to women, and any modifier must agree with the gender of the noun. For example, the third-person plural pronoun, or "they" in English, does not refer specifically to men or to women, but the third-person plural pronoun in Spanish takes the form of either *"ellos"* for men or *"ellas"* for women. In the past, *"ellos"* was used to refer to a specific group of men, to specific groups where there was at least one man included, or to any group in general. Now, some Spanish speakers are insisting that both *"ellos"* and *"ellas"* be used if the reference is being made to groups that actually do or could include any women, or the combination of *"ellos/as,"* as in *"Latinos/as."* In the translations I provide in this book, I try to make it evident which pronouns the women are using in their speech, even if this makes for slightly stilted reading in English. In doing so, I am trying to convey how gender is having an influence in many ways in Central America, even on the politics of speech.

SECONDARY SOURCES

This book also draws on supplementary materials gathered from a variety of sources. A key starting point for national-level statistics is Nohlen's (1993) monumental work on Latin American presidential and legislative elections in the twentieth century, published in two editions. *The Chronicle of Parliamentary Elections* is also an excellent source of information on national-level election results. For current information on very recent elections, *Keesing's Record of World Events* provides the number of seats won by each party. Analysis of specific elections can be found in a variety of newsletters and reports. These include the *Central America Report*, *NOTICEN* (an electronic newsletter published by the Latin American Institute at the University of New Mexico), and the excellent election study reports published by the Center for Strategic and International Studies. The Economist Intelligence Unit publishes quarterly country reports on each Central American country that provide useful information on the political situation, including elections.

Information and statistics at the district level can be very difficult to find, depending on the country. Guatemala's electoral tribunal has published for almost twenty years extremely detailed district-level information on each election. The electoral tribunals of other countries have also begun to publish statistics, including some that make them available on their sites on the World Wide Web. Information on these and other electronically available election results can be

located on LANIC by country on its "government" information page (http://lanic.utexas.edu/).

Latin American Election Statistics: A Guide to Sources is an electronic resource (http://dodgson.ucsd.edu/las/index.html) that provides a chronology of elections and an annotated bibliography of works that provide information and statistics on elections in Latin America. It is a work in progress that will eventually include nineteen Spanish- and Portuguese-speaking countries of the Americas and the Caribbean. This site has been created by Karen Lindvall-Larson, Latin American Studies Librarian of the Social Sciences and Humanities Library at the University of California–San Diego in La Jolla.

Over the years, I have presented various aspects of this study at one international women's conference in Costa Rica, one international political science conference in Germany, and one meeting of Latin Americanists in Mexico, as well as several national and regional meetings in the United States. I have submitted several short articles drawn from the research to various English- and Spanish-language publications for consideration. In some cases, the manuscripts have been sent to Central American reviewers (who were not always sympathetic to the article) by the journals for blind review prior to acceptance for publication, and their comments were incorporated. I hope to eventually have this book translated into Spanish and published at a moderate cost so that it will be available not only to the women I interviewed but also to the wider audience of Central American women. It is my hope that this book will interest a new generation of researchers in elected women, politics, democratization, and public policy.

APPENDIX B: INTERVIEW SCHEDULE FOR ELECTED WOMEN LEGISLATORS

Legislator Name: Political Party:
Country: Date:

I. Background
 I.1. Name:
 I.2. Sex:
 I.3. Date of Birth (or current age):
 I.4. Place of Birth:
 I.5. Childhood was spent mainly in:
 I.6. Education:
 I.7. Occupation or area of training:
 I.8. Current employment:
 I.9. Parents' occupations—Father: Mother:
 I.10. Marital status:
 I.11. Number of children and ages:

II. Political Participation
 II.1. At what age did you first become interested in politics?
 II.2. Have other members of your family been active in politics?
 II.3. What did you do during the (latest period of crisis)?
 II.4. In what groups have you been active, e.g., agricultural, business, charitable or voluntary, educational, labor or union, political, professional, religious, social, student or youth, or women's groups?
 II.5. Did involvement in any of these groups lead to your serving in the national legislature?
 II.6. How exactly did you come to be a representative in the national legislature?
 II.7. What other government or public positions have you held, either elected or appointed?
 II.8. How long have you been a member of your party?

 II.9. What party offices do you hold?
 II.10. How long do you expect to continue to be a representative?
 II.11. Are there other political positions which you would like to hold?
 II.12. What would you do if you left the national legislature?
III. Role in the National Legislature
 III.1. What are the ideal qualities of a representative? What should a representative be like?
 III.2. Are there differences for women?
 III.3. What are the activities you engage in as a representative?
 III.4. How much time do you devote to each of these activities?
 III.5. What offices do you hold in the legislature?
 III.6. To what committees are you assigned?
 III.7. How long have you been serving in the legislature?
IV. District Relations
 IV.1. District represented:
 IV.2. Type of district: urban/rural
 IV.3. Time lived in the district
 IV.4. As a representative, who or what do you feel you represent?
 IV.5. As a woman representative, do you feel you have a special obligation to represent the interests of women in the national legislature?
 IV.6. What do you do as a representative in your district?
 IV.7. How much time do you spend on these activities?
 IV.8. Are there any differences between what you think this job is, and how your constituents see it?
 IV.9. What do you like most about the job of representative?
 IV.10. What do you like least about the job of representative?
 IV.11. How do you carry your party's message to the people in your district?
V. Policy Specialization
 V.1. Do you consider yourself an expert in any particular subject of legislation?
 V.2. Have you been active in legislation on women's issues?
VI. Norms
 VI.1. In every national legislature, there are unofficial rules of how members must act or refrain from acting if they want respect and cooperation from other members. What are the "rules of the game"?
 VI.2. Would you say the following are acceptable or not acceptable behavior for a member of the legislature:
 Question another representative's sincerity
 Introduce a bill without party approval
 Put pressure on a government minister
 Give consideration to one's own political career
 Speak on issues you know nothing about
 Improperly disclose private decisions to the media
 Float; never take a position
 Make irrelevant comments
 Be absent to prevent a quorum
 Give priority to special interests

 Speak against your own party's bills
 Vote against your own party's bills
 General absenteeism

VII. Political Perception
- VII.1. What are your chief sources of political information?
- VII.2. What are the three most critical issues facing the country today? Can you put them in rank order?
- VII.3. Which problem is your party concentrating on?
- VII.4. Can the national legislature actually solve this problem? If so, must there be collaboration with other political parties to solve this problem?
- VII.5. What do you feel is the function of the national legislature in (your country)?
- VII.6. Which of the following do you consider to be appropriate functions for the legislature:
 - Manage national-level conflicts
 - Provide a forum for representation of all interests
 - Solve particular problems
 - Serve as a link or channel between government and the people
 - Allow debates among ideological positions
 - Develop/propose legislation
 - Control the bureaucracy

VIII. Other Comments
- VIII.1. Are there any other comments you would like to make?

Thank you for your participation in this interview.

NOTES

CHAPTER 1

The epigraph in this chapter comes from an election pamphlet for the Poder Feminino of the Frente Farabundo Martí para la Liberación Nacional (FMLN) in El Salvador: "Cuando una mujer llega a la política, cambia la mujer. Pero, cuando las mujeres llegan a la política, cambian la política" (quoted in Luciak 1998, 1).

1. Strictly speaking, there were no women in the legislature in 1980 because the legislature had been suspended, but their percentage had increased to 7.4 percent in 1979.

2. Women legislators in three countries have further increased their proportions of legislative seats since 1995, in Costa Rica (35.1 percent in 2002), Nicaragua (20.7 percent in 2001), and El Salvador (16.7 percent in 1997).

3. For a fuller description of this model, see the section on Central American history following Chapter 1.

4. Presumably this is because gender influences an understanding of the importance of these issues, making them "women's issues."

5. It is important to note that while women's alliances have successfully promoted policy changes on some "women's issues," they have not managed to change all women's issues. In fact, the vast majority of Latin American women in public office neither campaign on women's issues nor make these issues the primary focus of their political careers (Htun and Jones 2002, 48).

6. These small Central American states were isolated, as was Spain itself, from advances in democratic governance in Europe and the United States. Nor did they have the wide expanse of territory that could have provided an outlet for men intent on conquest or violence, as did the West in the United States.

7. CEDAW is discussed further in Chapter 6 on public policy.

8. This phenomenon provided many exciting driving experiences in visits to the capital city in the 1990s.

9. In Central America the word *comadre* refers to a woman relative who is a godmother to one's children. *Comadre* is often used symbolically to refer to a close friend or is bestowed as an honorary kinship designation. The word *compadre* serves a similar function for men.

10. Note that estimates of the number of indigenous peoples vary widely, and that there are different political agendas served by either higher or lower estimates of their numbers. This remains a very contentious issue in Central America.

CHAPTER 2

1. There are exceptions such as Rwanda, with 48 percent women in the most recent elections.

2. In all Central American countries except Costa Rica, two sets of representatives are elected at the same time: proprietary deputies and supplementary deputies. That is, for each person elected to serve as a representative in the national legislature, another person is also elected as a substitute or alternate representative, who will serve in case the primary representative cannot. Unless otherwise stated, however, all charts, figures, and statistical analyses in this book refer only to proprietary representatives.

3. A district is generally a geographic area such as a neighborhood, a town, a county, or a province.

4. Social democratic and liberal political cultures are discussed in more detail in Chapter 5 on democratization.

5. In some countries, mostly industrialized democracies, people retain the right to vote directly on some legislation in the form of popular initiatives and referenda.

6. A simple correlation $r = .799$, $n = 16$, was significant at $p < .01$.

7. A simple correlation $r = .916$, $n = 8$, was significant at $p < .01$.

8. A simple correlation $r = .656$, $n = 269$, was significant at $p < .01$.

9. In a simple regression of district magnitude on number of women elected, the beta coefficient equals .12, with a standard error of .008, $t = 14.206$, $p < .01$, $r^2 = .43$. The size of r^2 is small because the relationship is not strictly linear.

10. The correlation coefficient is statistically significant, $r = .658$, $p < .01$, $n = 165$. In a simple regression of district magnitude on number of women elected, the beta coefficient equals .12, with a standard error of .011, $t = 11.168$, $p < .01$, $r^2 = .43$.

11. Much of the reason women were represented among the Sandinista delegates was the adoption of the strategy known as "braiding" (*la trenza*) for the arrangement of women's names on the party's list of candidates.

12. A simple correlation $r = .693$, $n = 147$, is significant at $p < .01$.

13. In a simple regression of seats per party on the number of women elected from that party, the beta coefficient equals .10, with a standard error of .0088, $t = 11.534$, $p < .01$, $r^2 = .48$.

14. A simple regression yields an r^2 of .77 for Nicaragua and .61 for Costa Rica.

15. One problem with discussing regional performance is that different authorities use different definitions of the region. For example, the region may be called the Americas, including North and South America; it may be called Latin America, including the Caribbean, excluding the Caribbean, or including only the Spanish-speaking portions; Cuba may be included or excluded in any of the groupings above; and so forth. Also, the same information on all countries may not be available, or not available for the same years, making the computation of regional averages problematic.

16. Structural adjustment policies (SAPs) are described in the section on the overview of Central American history and also in Chapter 6.

17. Honduras's population was also increased during this period by the presence of enclaves housing large numbers of U.S. military personnel, mostly reserve units being trained for possible war in the Middle East. However, they were not counted toward the ratio of GDP to population.

18. Prostitution is legal in some countries, e.g., Costa Rica, as long as the prostitutes are registered, but brothels and pimps are not legal.

19. Democratic forms of government, such as liberal, social, and radical, are discussed in Chapter 5.

20. It is nearly impossible to find data on the number or proportion of women who are childless. A recent study of Latin American national legislators did not report any findings on the number of children, although it did include other demographic information (Rivera-Cira 1993).

CHAPTER 3

1. No national-level data were found on the number or proportion of childless women in Central America. In many areas childlessness would be seen as a tragedy. Women often are asked not whether they have children but how many. When asked how many children they desire, a common response in the region was "As many as God sends me."

2. United Nations. 2003a. Convention on the Elimination of All Forms of Discrimination against Women, http://www.un.org/womenwatch/daw/cedaw/states.htm.

3. Toward the end of the 1990s, some political parties in Central America began to adopt voluntary strategies to place more women's names on party lists and/or to place women's names in higher places on the lists. However, there were no formal requirements at the national level in any of these countries other than Costa Rica, which adopted quotas in 1996.

CHAPTER 4

1. Costa Rica: Rose Marie Karpinsky Rodero de Morillo in 1986 and Rina María Contreras López in 2000; El Salvador: María Julia Castillo Rodas in 1981 and

Gloria Salguero Gross in 1994; Guatemala: Ana Caterina Soberanis Reyes in 1991, and Arabella Castro Quinoñez de Comparini in 1994, and again in 1997; Nicaragua: Miriam Argüello Morales in 1990 (Waring 2000, 121–122; Worldwide Guide to Women in Leadership, http://www.guide2womenleaders.com/index.html).

2. Many of these interviews predated the widespread use of e-mail or the Internet in Central America.

3. On the concept of role, see J. Wahlke, H. Eulau, W. Buchanan, and L. Ferguson 1962; Jewell 1983 provides a useful synthesis of the original literature on representation.

4. For a discussion of the effects of the proportion of a group that is female, see Rosabeth Moss Kanter, *Men and Women of the Corporation* (New York: Basic Books, 1977); see also Saint-Germain (1989) for the effects in a state legislature.

CHAPTER 5

We are indebted to Jennifer M. Piscopo, doctoral student in the Department of Political Science at the University of California–San Diego in 2005, for her assistance with this chapter. We are also indebted to Dr. Laura Landolt for her assistance with an earlier version of this chapter while she was a graduate student in political science at the University of Texas–El Paso in 1995.

1. Zakaria (1997, 22–23) notes that the constitutional guarantee of liberty—constitutional liberalism—has become intertwined with procedural democracy to create the contemporary definition of liberal democracy in the West. Historically, however, procedural democracy and constitutional liberalism were theoretically distinct. Contemporarily, they are fused.

2. Linz and Stepan (1996) use the term "totalitarianism" to refer to radical democracy.

3. This statement does not imply that colonial and postcolonial Central America lacked voluntary associations; throughout the nineteenth and twentieth centuries, associations—from trade unions to suffrage organizations to health movements—existed in Central America (Miller 1991). Yet, compared with North America and Europe, these associations remained weak, with few ties to and little influence over the oligarchic governments then in power.

4. For descriptions of these incursions in Central America, see Schirmer 1993.

5. Translation by authors.

6. Taylor's description of citizenship is also worth reading at length: "Citizenship (formalized legal rights and responsibilities) . . . comprehends civil rights (relating to freedom of expression and legal matters) and political rights (to elect or to be a candidate); [these are] negative rights setting out mechanisms regulating interactions. Welfare rights seek to provide the necessities of human existence (such as health, education, shelter, sustenance), and as such they require intervention in order to distribute social goods within society. These positive [welfare] rights recognize two important principles; that inequality restricts the ability of citizens to exercise civil and political rights; that inequality is systematic and linked to social/class structures which condition people's lives" (2004, 14).

7. Taylor's description of client-ship is worth reading at length: "Firstly, client-ship is not about equality but inequality; it is about gaining the advantage over one's rival, about professing to be *el patrón*'s most loyal supporter; about selling oneself as deserving of privilege. Secondly, it is not about rights but about favor; it is about making deals, about agreeing to lend support in return for material benefit, and it allows some opportunity to exit if the deal is not filled. Thirdly, it is not about democracy but about negotiated authoritarianism; that is the power relationships between the parties are acknowledged—and even accepted—as being inherently and steeply unequal but each needs the other in order to further their cause and as such even the subaltern dealer can wield a little power. Finally, it is not about formal relationships but personal ties; it does not concern the making of laws but involves dealing with contingent and short term needs, and it is not mediated by procedures or rules but by social custom, expectations, individual personality quirks and lived experience" (2004, 14–15).

8. Upon demobilization in El Salvador, the number of combatants in the FMLN was 13,600; 30 percent were women (Silber 2004, 571). ONUSAL—the U.N. peacekeeping mission charged with registering and processing ex-guerrillas—also reported that women comprised 30 percent of the combatants, but additionally claimed that women comprised 30 percent (not 40 percent) of the total membership. Luciak (1999, 46–47) cautions, however, that not all FSLN members were registered through ONUSAL; many retained their militancy, and many refused to be registered and thus publicize their affiliation with the Frente.

9. Wood (2001) uses the terminology "insurgent counterelite" to explain how the revolutionary leaders' status opposed and destabilized the leadership of the traditional political and military elite. The revolutionary leadership was certainly a "counterelite" in this sense, yet elites in the sense of their ability to engage with the traditional elites during the peace process.

10. Indeed, Nidia Díaz, the FMLN *militante* most supportive of women's rights, deliberately kept a low profile on this issue for fear of destabilizing the peace process (Luciak 2001a, 39).

11. Women in the United States experienced the same re-marginalization at the close of World War II.

12. In the early stages of democratization, women used the slogan "democracy without women is no democracy" (Basu 1995, 9).

13. AMNLAE with the FSLN in Nicaragua and MAM with the *Fuerzas Populares de Liberación* [Popular Liberation Forces, or FPL] in El Salvador.

14. Las Dignas broke away from the *Resistencia Nacional* [National Resistance, or RN].

15. International donor organizations generally seek NGOs with a gender- or women-focused strategy, and NGOs attract funds when they advocate for women's issues and women's rights. National governments often use their state women's agencies or women's bureaucracies as intermediaries: the state women's agency receives the international aid monies and distributes the funds among the NGOs that compete for the agency's attention. In this scenario, access networks matter and NGOs become the clients of the state bureaucracies, themselves clients of the donor agencies (see Franceschet 2003, 22–24, for an explanation of this scenario in Chile).

16. Kampwirth notes that the exact number of organizations that participated in *Mujeres '94* is actually disputed. Interviews with *Mujeres '94* leaders Lorena Peña (a member of the FMLN political party) and Mirna Rodríguez affirmed 40 as the number of constituent groups (1998, note 23).

17. Comment overheard at a press conference given by leaders of *Mujeres '94* in San Salvador in August 1993. Translated from notes taken by author, El Salvador.

CHAPTER 6

1. Note that in Eastern Europe, abortion rights were decreased for women after democratization in some countries; see examples in the edited volume by Jaquette and Wolchik (1998).

APPENDIX A

This section was written by the first author, Michelle Saint-Germain, to whom all uses of the first-person pronoun ("I") refer.

1. In some countries, an alternate is elected at the same time as the primary representative. In this study, women who were alternates were not included unless they had permanently taken the place of the primary representative.

2. It must be remembered that during the time period when interviews were being conducted, wars were going on in Nicaragua, El Salvador, and Guatemala, which drove the response rate downward, as did natural disasters, unexpected national holidays proclaimed for both mourning and celebration, frequent interruptions in electrical supply, strikes, one sudden dissolution of the national legislature, and other unanticipated events.

GLOSSARY

ADEMUSA. *Asociación de Mujeres Salvadoreñas* (Association of Salvadoran Women); NGO for women.
AMNLAE. *Asociación de Mujeres Nicaragüenses Luisa Amanda Espinosa* (Luisa Amanda Espinosa Association of Nicaraguan Women); FSLN's organization for women after July 1979.
Amparo. Traditional right of Central Americans to claim redress from the government for violation of basic legal rights.
AMPRONAC. *Asociación de Mujeres Ante la Problemática Nacional* (Association of Women Facing the National Problem); FSLN women's organization before July 1979.
ARENA. *Alianza Republicana Nacionalista* (Nationalist Republican Alliance); right-wing political party in El Salvador.
Asamblea Legislativa. Name of the national legislature in Costa Rica and El Salvador.
Asamblea Nacional. Nicaraguan national legislature.
ASC. *Asamblea de la Sociedad Civil* (Assembly of Civil Society); umbrella group for informal political groups negotiating the peace accords in Guatemala.
ASIES. *Asociación de Investigación y Estudios Sociales* (Association for Research and Social Studies); NGO research organization in Guatemala.
CACIF. *Comité Coordinador de Asociaciones Agrícolas, Comerciales, Industriales y Financieras* (Coordinating Committee of Agricultural, Commercial, Industrial, and Financial Associations); pro-business umbrella group that supported government policies in Guatemala.
Campesino/a. Migrant agricultural laborer.
Cantón. A politico-administrative unit consisting of a village or group of villages.
Cacique. Local strongman or political leader.
Caudillo. Authoritarian ruler or political strongman.
CEB. *Comunidad Eclesiástica de Base* (Christian Base Community); grassroots religious organization.

CEDAW.	Convention on the Elimination of All Forms of Discrimination Against Women; United Nations treaty signed by 180 nations but not the United States.
CEDEM.	*Centro de Estudios Democráticos* (Center for Democratic Studies); NGO in El Salvador.
CEMUJER.	*Instituto de Estudios de la Mujer Norma Virginia Guirola de Herrera* (Norma Virginia Guirola de Herrera Center for the Study of Women); first nonpartisan NGO for women in El Salvador.
CENIDH.	*Centro Nicaragüense de Derechos Humanos* (Nicaraguan Center for Human Rights).
CENZONTLE.	NGO in Nicaragua; the word *Cenzontle* means "a thousand voices" in the indigenous Nahuatl language.
COMADRES.	Support group for mothers of political prisoners and missing persons in El Salvador; literally, *comadre* means godmother or a close woman friend.
Compañero/a.	Form of address adopted in Nicaragua by the FSLN, meaning companion, colleague, or comrade.
CONAMUS.	*Coordinadora Nacional de la Mujer Salvadoreña* (National Coordinating Committee of Women in El Salvador); NGO for women.
CONAVIGUA.	*Coordinadora Nacional de Viudas de Guatemala* (National Coordinating Committee of Guatemalan Widows); NGO.
Concertación.	A process of reaching agreements in civic space among formal and informal political participants.
Concienciación.	Development of a gender perspective or gender consciousness.
Congreso de la República.	Guatemalan national legislature.
Congreso Nacional.	Honduran national legislature.
Conquistadores.	Conquerors; Spanish armed forces that invaded the Americas in the 1500s.
Consejo de Estado.	A consultative body that advised the Sandinista government from 1979 to 1984.
Contras.	Abbreviation of *contrarrevolucionarios*; the counterrevolutionary armed forces based in Honduras and backed by the Reagan administration to overthrow the Sandinista government of Nicaragua.
COPAZ.	*Comisión Nacional para la Consolidación de la Paz* (National Commission for the Consolidation of Peace); a body to implement political agreements and to monitor civilian participation in the peace process in El Salvador.
Corporatism.	A form of government that organizes society into hierarchical interest groups.
Criollos.	Central American elites born in the New World who descended from *conquistadores*.

Diputado/a.	Literally, "deputy"; traditional word for referring to an elected legislator.
Democradura.	A nominal of democracy that resembles a *dictadura* (dictatorship).
Denuncia.	Traditional practice of Central Americans to denounce crimes to government authorities for prosecution.
Encomienda.	Large tract of land (and its indigenous inhabitants) awarded by Spain to *conquistadores.*
Esquipulas.	A site in Guatemala where agreements were reached on a framework to end the civil wars in Nicaragua, El Salvador, and Guatemala in the 1990s; the process for reaching peace in Central America.
FMLN.	*Frente Farabundo Martí para la Liberación Nacional* (Farabundo Martí Front for National Liberation); left-wing political party in El Salvador.
FSLN.	*Frente Sandinista de Liberación Nacional* (Sandinista National Liberation Front); left-wing political party in Nicaragua.
FUNDAPAZD.	*Fundación Para la Paz, la Democracia, y el Desarrollo* (Foundation for Peace, Democracy, and Development); NGO in Guatemala.
GAM.	*Grupo de Apoyo Mutuo* (Mutual Support Group); NGO for families of missing persons in Guatemala.
GDP.	Gross Domestic Product; the value of a country's total economic production.
Golpe de Estado.	A takeover of government by force; also known as a *coup d'etat.*
Guerrilla.	An armed combatant seeking to overthrow a government using unconventional means.
IDB.	Inter-American Development Bank; promotes economic and social development in Latin America through loans.
IDEAS.	*Instituto Para el Desarrollo, Evaluación, Asesoría, y Soluciones* (Institute for Development, Evaluation, Assessment, and Solutions); NGO in Guatemala.
IMF.	International Monetary Fund; provides temporary financial assistance to countries that agree to its policies.
ISI.	Import substitution industrialization; a failed plan to promote manufacturing in Central America.
Ladino/a.	An indigenous person who adopts Spanish language, dress, and customs.
Las Dignas.	*Asociación de Mujeres por la Paz, la Dignidad y la Vida* (Association of Women for Peace, Dignity and Life); NGO for women in El Salvador.
Machismo.	A set of cultural beliefs that exaggerate stereotypical masculine qualities.
MAM.	Movimiento de Mujeres Mélinda Anaya Montes [Mélinda

	Anaya Montes Women's Movement]; women's group in El Salvador that broke away from the FMLN.
Maquiladora.	Assembly plant; a type of light manufacturing that employs mostly women to assemble imported parts and ships the finished product back to the suppliers.
Marianismo.	A set of cultural beliefs that focus on women's spirituality.
Matanza.	A massacre; refers to the killing of thousands of mainly indigenous *campesinos* in El Salvador in the 1930s.
Maya.	Indigenous people of Guatemala.
Mestizo.	A person of mixed Spanish and indigenous heritage.
Militante.	A dedicated political party activist.
Minifundio.	A small grant of land, a family-size farm.
Mujer Ciudadana.	Woman Citizen; NGO in El Salvador.
Mujeres '94.	Women '94; a platform of policies supporting women proposed to but not adopted by any political parties in the elections in El Salvador in 1994.
Multi-member district.	Electoral district from which more than one candidate is elected to a legislative body.
NGO.	Non-governmental organization; an organization that is not affiliated with the government or with a political party.
OAS.	Organization of American States; a regional association of governments of North and South America known in Spanish as OEA (*Organización de Estados Americanos*).
OMS.	*Organización de Mujeres Salvadoreñas* (Organization of Salvadoran Women); NGO.
ONG.	*Organización No Gubernamental* (Non-Governmental Organization); see NGO.
ONUSAL.	United Nations Observer Mission in El Salvador; UN peacekeeping mission in El Salvador, 1991–1995.
ORDEN.	*Organización Democrática Nacionalista* (Democratic Nationalist Organization); government-sponsored paramilitary groups trained by the Salvadoran army to ferret out guerrillas.
ORMUSA.	*Organización de Mujeres Salvadoreñas por La Paz* (Organization of Salvadoran Women for Peace); NGO.
PAC.	*Patrulla de Auto-defensa Civil* (Civilian Self-Defense Patrol); government-sponsored paramilitary group trained by the Guatemalan army to ferret out guerrillas.
Pacto.	Pact; agreement among national elites that often formed the basis for changes in government.
Paramilitary.	Armed group that carries out military-style activities but is not part of the official armed forces.
PL.	Party List; a form of election where voters select a political party's list of nominees rather than individual candidates.

PLN.	*Partido Liberación Nacional* (National Liberation Party); centrist political party in Costa Rica.
Política.	1) a woman political party activist; 2) the activity of politics; 3) a policy.
PR.	Proportional representation; a form of election where political parties are awarded seats in the legislature according to their proportion of the popular vote.
Puntos de Encuentro.	Points of Encounter; NGO in Nicaragua.
Sandinistas.	See FSLN.
SAP.	Structural Adjustment Policy (or Program); economic austerity measures imposed by international lenders.
Somoza.	Family that ruled Nicaragua for nearly 40 years; overthrown by a coalition led by the FSLN in 1979.
Supermadre.	A woman who justifies her political activity based on her traditional role of mother.
Suplente.	An alternate elected at the same time as the primary legislator in El Salvador, Guatemala, Honduras, and Nicaragua (but not Costa Rica).
Tierra Viva.	*Agrupación de Mujeres Tierra Viva* (Living Earth Women's Group); NGO in Guatemala.
UN.	United Nations.
UNESCO.	United Nations Educational, Scientific, and Cultural Organization.
UNICEF.	United Nations International Children's Emergency Fund; the lead UN organization working for the long-term survival, protection, and development of children.
UNIFEM.	United Nations Development Fund for Women; provides financial and technical assistance to promote women's human rights, political participation, and economic security.
UNO.	*Unidad Nacional Opositora* (United National Opposition); a center-right collection of political parties opposed to the FSLN in the 1990 Nicaraguan elections led by Violeta Chamorro.
URNG.	*Unidad Revolucionaria Nacional Guatemalteca* (Guatemalan National Revolutionary Unity); umbrella group for guerrilla movements fighting the Guatemalan government.
USAID.	United States Agency for International Development; primary U.S. government organization responsible for non-military aid to foreign countries.

REFERENCES

INTERVIEWS

Acevedo, Angela Rosa. 1988 and 1993. Nicaragua.
Aguilar, Matilda. 1988. Nicaragua.
Antezana, Paula. 1989. Costa Rica.
Argüello Morales, Miriam. 1990. Nicaragua.
Arostegui, César. 1993. Nicaragua.
Azcúnaga de Meléndez, Milagro del Rosario. 1990. El Salvador.
Azpuru de Cuestas, Dinorah. 1993. Guatemala.
Badilla, Ana Elena. 1989 and 1990. Costa Rica.
Badilla Rojas, María Eugenia. 1989. Costa Rica.
Báez Alvarez, Gladys. 1988 and 1990. Nicaragua.
Batres, Angélica. 1993. El Salvador.
Bendaña, Julieta. 1993. Nicaragua.
Bermudez Corea, Blanca. 1988. Nicaragua.
Bonilla, Jamilette. 1988. Nicaragua.
Buitrago Salazar, Santos. 1988. Nicaragua.
Cabrera, Mario Rolando. 1993. Guatemala.
Calderón de Escalón, Carmen Elena. 1990. El Salvador.
Cansino, Sonia. 1992. El Salvador.
Carcedo, Ana. 1989. Costa Rica.
Castillo Fernández, María Eugenia. 1991. Guatemala.
Castro de Comparini, Arabella. 1991. Guatemala.
Centeno González, Yadira. 1988. Nicaragua.
Chaka, María. 1993. Guatemala.
Chamorro, Xiomara. 1988. Nicaragua.
Chávez Petit, Ana. 1991. Honduras.
Criquillón, Ana. 1993. Nicaragua.
Cruz de Chavarría, Morena Disnarda. 1990. El Salvador.
Cuningham, Mirna. 1990. Nicaragua.
de Pineda, Vera Sofia Rubí. 1991. Honduras.

Delgado Martínez, María Teresa. 1988 and 1990. Nicaragua.
Díaz, Nidia. 1993. El Salvador.
Díaz Sol, Lilian. 1993. El Salvador.
Esquivel, Rosa Julia. 1988. Nicaragua.
Facio, Alda. 1989. Costa Rica.
Ferrey Echaverry, María Azucena. 1990 and 1993. Nicaragua.
Figueres, Muni. 1989. Costa Rica.
Flores, Berta Rosa. 1988. Nicaragua.
Fuentes de Fajardo, Berta Lyria. 1991. Honduras.
Funis Donaire de Ramirez, Soledad. 1991. Honduras.
Garrón, Victoria. 1989. Costa Rica.
Gómez, Marta. 1993. El Salvador.
González Ramírez, Hilda. 1989 and 1990. Costa Rica.
Greñas, Rosa. 1989. Costa Rica.
Guevara Fallas, Mireya. 1989. Costa Rica.
Guirola, Alba América. 1993. El Salvador.
Guzmán, Ulices de Dios. 1993. El Salvador.
Guzmán Gutiérrez, Vilma. 1989. Costa Rica.
Guzmán Zanetti, Dora. 1989. Costa Rica.
Henríques, Dolores Eduviges. 1990. El Salvador.
Hernández, Silvia. 1993. El Salvador.
Hernández Bolaños, Ana. 1989. Costa Rica.
Herrera, Leticia. 1988. Nicaragua.
Herrera Andrade, Marta Delia. 1991. Honduras.
Herrera de Nasar, Eda Eulalia. 1991. Honduras.
Irías García, Juana Antonia. 1991. Honduras.
Janser de Aguilar, María Teresa. 1991. Honduras.
Jiménez, Norma. 1989. Costa Rica.
Karpinski Dodero, Rose Marie. 1989. Costa Rica.
Lario Mora, Luisa del Carmen. 1988 and 1990. Nicaragua.
Law Blanco, Hazel. 1988. Nicaragua.
Lobo de García, Carmen Elisa. 1991. Honduras.
Lobo Dubón, José. 1993. Guatemala.
López, Ofelia. 1993. El Salvador.
López de Pérez, Thelma Iris. 1991. Honduras.
MacGuire, Henrietta. 1989. Costa Rica.
Martínez, Auxiliadora. 1988. Nicaragua.
Mata Baca, Erlinda. 1991. Honduras.
Mejía de Jalil, Gloria Paula. 1991. Honduras.
Mena Rivera, Julia. 1988. Nicaragua.
Mendiola, Benigna. 1988 and 1990. Nicaragua.
Mendoza Saravia, Yadira. 1988. Nicaragua.
Mishaan Rosell, Sara Ivonne. 1991. Guatemala.
Mixco Reyna, Miriam Eleana. 1990. El Salvador.
Munguía, Martha. 1988. Nicaragua.
Naranjo, Carmen. 1989. Costa Rica.

Navarro Duarte, Eda Orbelina. 1991. Honduras.
Navas de Melgar, María Candelaria. 1993. El Salvador.
Núñez de Escorcia, Vilma. 1993. Nicaragua.
Olsen de Figueres, Karen. 1989. Costa Rica.
Pagán Rodríguez, Leda Lizeth. 1991. Honduras.
Peña, Marina. 1993. El Salvador.
Prado, Mimi. 1989 and 1990. Costa Rica.
Prera Flores, Ana Ísabel. 1991. Guatemala.
Quezada Abarca, Marcia. 1990. Nicaragua.
Ramírez, Ísabel. 1993. El Salvador.
Ramírez, María. 1990. Nicaragua.
Rivas, Hortensia. 1998. Nicaragua.
Rodríguez, Aira. 1993. Guatemala.
Rodríguez, Alicia. 1993. Guatemala.
Rodríguez Quesada, Sonia. 1990. Costa Rica.
Rojas Prado, Gladys. 1990. Costa Rica.
Romero de Torres, Macla Judith. 1990. El Salvador.
Salamón de Facussé, Soad. 1991. Honduras.
Salguero Gross, Mercedes Gloria. 1990 and 1993. El Salvador.
Sancho Barquero, María de los Angeles. 1990. Costa Rica.
Santos Roque, Juana. 1988. Nicaragua.
Serrano Vargas, Daysi. 1990. Costa Rica.
Soberanis Reyes, Ana Catalina. 1991. Guatemala.
Soto Valerio, Flory. 1990. Costa Rica.
Taylor Brown, Marcel. 1989. Costa Rica.
Tijerino Haslam, Doris. 1990. Nicaragua.
Urquilla Guzmán, Jeannette. 1993. El Salvador.
Vargas Aguilar, Blanca Nury. 1990. Costa Rica.
Villatoro, Amanda. 1993. El Salvador.
Wilson Thatum, Dorotea. 1988. Nicaragua.
Zamora Fonseca, Olga. 1989. Costa Rica.
Zeledón, Dora. 1993. Nicaragua.
Zúñiga, Lola. 1988. Nicaragua.

OTHER SOURCES

Acuerdo de Esquipulas. http://www.acnur.org.
Alatorre, Anna-Lizbeth. 1999. Parties, Gender, and Democratization: The Causes and Consequences of Women's Participation in the Mexican Congress. BA thesis, Harvard University. Cited in Htun and Jones, 2002.
Almond, Gabriel, and Sidney Verba. 1963. *The Civic Culture: Political Attitudes and Democracy in Five Nations.* Princeton: Princeton University Press.
Alvarez, Sonia E. 1997. Contradictions of a "Women's Space" in a Male-Dominant State: The Political Role of the Commissions on the Status of Women in Post-

Authoritarian Brazil. In *Women, International Development, and Politics: The Bureaucratic Mire*, 2nd ed., ed. Kathleen Staudt. Philadelphia: Temple University Press, pp. 59–100.

———. 1998a. Advocating Feminism: The Latin American Feminist NGO "Boom." Paper presented at the University of Santa Cruz.

———. 1998b. Latin American Feminisms Go Global: Trends of the 1990s and Challenges for the New Millennium. In *Cultures of Politics, Politics of Cultures: Re-Visioning Latin American Social Movements*, ed. Evelyn Dagnino, Sonia E. Alvarez, and Arturo Escobar. Boulder: Westview Press, pp. 293–324.

Ameringer, Charles D., ed. 1992. *Political Parties of the Americas, 1980s to 1990s: Canada, Latin America, and the West Indies*. Westport, CT: Greenwood Press.

Amnesty International. 2002. Amnesty International Report 2002: Guatemala. Also available at http://web.amnesty.org/web/ar2002.nsf/amr/guatemala!open.

———. 2005. Guatemala: Human Rights Concerns. Also available at http://www.amnestyusa.org/countries/guatemala/index.do.

Anderson, Thomas P. 1982. *Politics in Central America: Guatemala, El Salvador, Honduras, and Nicaragua*. New York: Praeger.

Aron, Adrianne, Shawn Corne, Anthea Fursland, and Barbara Zelwer. 1991. The Gender-Specific Terror of El Salvador and Guatemala: Post-Traumatic Stress Disorder in Central American Refugee Women. *Women's Studies International Forum* 14(1/2): 37–47.

Asamblea Nacional de Nicaragua. 2004. Diputados ANN 2002–2007. http://www.asamblea.gob.ni/.

Barker, Robert S. 1986. Constitutional Adjudication in Costa Rica: A Latin American Model. *Inter-American Law Review* 17(2), Winter: 249–274.

Barnes, William A. 1998. Incomplete Democracy in Central America: Polarization and Voter Turnout in Nicaragua and El Salvador. *Journal of Interamerican Studies and World Affairs* 40(3): 63–101.

Baró, M. I. 1988. Acción e Ideología. *Pscología Social de Centroamérica*. University of Central America (UCA), San Salvador, El Salvador. Quoted in Sternberg, 2000.

Basu, Amrita, ed. 1995. *The Challenge of Local Feminisms: Women's Movements in Global Perspective*. Boulder: Westview Press.

Bayefsky, Anne F. 1986. Human Rights: The Covenants Twenty Years Later. *American Society of International Law Proceedings* 80: 408–427.

Beckwith, Karen. 1984. Structural Barriers to Women's Access to Office: The Cases of France, Italy, and the United States. Paper presented at the annual meeting of the American Political Science Association in Washington, D.C.

———. 1989. Sneaking Women into Office: Alternative Access to Parliament in France and Italy. *Women & Politics* 9(3): 1–15.

———. 1992. Comparative Research and Electoral Systems: Lessons from France and Italy. *Women & Politics* 12(1): 1–33.

Beilstein, Janet C., and Stephen F. Burgess. 1995. Women in Political Decision-Making: Liberalism Versus Social Democracy. Paper presented at the American Political Science Association in Chicago.

Bell, Charles G., and Charles M. Price, eds. 1975. *The First Term: A Study of Legislative Socialization*. Beverly Hills, CA: Sage.

Best, Marigold, and Pamela Hussey. 1996. *Life Out of Death: The Feminine Spirit in El Salvador*. London: Catholic Institute for International Relations.

Biesanz, Mavis Hiltunen, Richard Biesanz, and Karen Zubris Biesanz. 1998. *The Ticos: Culture and Social Change in Costa Rica*. Boulder: Lynne Reinner.

Bird, Shawn L., and Philip J. Williams. 2000. El Salvador: Revolt and Negotiated Transitions. In *Repression, Resistance, and Democratic Transition in Central America*, ed. Thomas W. Walker and Ariel C. Armony. Wilmington: Scholarly Resources, pp. 25–46.

Bogdanor, Vernon, ed. 1984. *What is Proportional Representation?* Oxford: Martin Robertson.

———, ed. 1985. *Representatives of the People? Parliamentarians and Constituents in Western Democracies*. Brookfield, VT: Gower.

Booth, John A. 1998. *Costa Rica: Quest for Democracy*. Boulder: Westview Press.

Booth, John A., and Mitchell A. Seligson. 1993. Political Culture and Regime Type: Evidence from Nicaragua and Costa Rica. *Journal of Politics* 55 (August): 777–792.

Booth, John A., and Thomas W. Walker. 1999. *Understanding Central America*, 3rd ed. Boulder: Westview Press.

Bourque, Susan, and Jean Grossholtz. 1998. Politics as an Unnatural Practice: Political Science Looks at Female Participation. In *Feminism and Politics*, ed. Ann Phillips. Oxford: Oxford University Press, pp. 23–43.

Boynton, G. R., and Chong Lim Kim, eds. 1975. *Legislative Systems in Developing Countries*. Durham, NC: Duke University Press.

Brennan, T., and Carole Pateman. 1979. "Mere Auxiliaries to the Commonwealth": Women and the Origins of Liberalism. *Political Studies* 27: 183–200.

Las Bujias. 1996. *Los derechos de las mujeres en Nicaragua*. Managua: Asociación de Mujeres Profesionales por la Democracia en el Desarrollo (Las Bujias).

Bunch, Charlotte. 1990. Women's Rights as Human Rights: Toward a Re-Vision of Human Rights. *Human Rights Quarterly* 12: 486–498.

Caldeira, Teresa P. R., and James Holston. 1999. Democracy and Violence in Brazil. *Comparative Studies in Society and History* 41(4): 697–729.

Camp, Roderic Ai, ed. 2001. *Citizen Views of Democracy in Latin America*. Pittsburgh: University of Pittsburgh Press.

Carroll, Susan. 1985. *Women as Candidates in American Politics*. Bloomington: Indiana University Press.

Catalán Arevena, Oscar. 2000. A Decade of Structural Adjustment in Nicaragua. *International Journal of Political Economy* 30(1): 55–71.

Caul, Miki. 1997. Women's Representation in National Legislatures: Explaining Differences across Advanced Industrial Democracies. Paper presented at the Western Political Science Association in Tucson, AZ.

Center for Strategic and International Studies. CSIS, 1800 K St. NW, Washington, D.C. 20006. http://www.csis.org/index.php.

Central America Report. Published by Inforpress Centroamericana, Calle Mariscal, Diagonal 21 6-58 Zona 11, Guatemala City, Guatemala. http://www.inforpressca.com/CAR/about.php.

Chaney, Elsa M. 1979. *Supermadre: Women in Politics in Latin America*. Austin: University of Texas Press.

Chant, Sylvia. 1991. *Women and Survival in Mexican Cities: Perspectives on Gender, Labour Markets, and Low-Income Households.* Manchester University Press.

Chant, Sylvia, and Nikki Craske. 2003. *Gender in Latin America.* London: Latin American Bureau.

Child, J. 1992. *The Central American Peace Process, 1983–1991: Sheathing Swords, Building Confidence.* Boulder: Lynne Rienner.

Chinchilla, Norma Stoltz. 1993. Gender and National Politics: Issues and Trends in Women's Participation in Latin American Movements. In *Researching Women in Latin America and the Caribbean,* ed. Edna Acosta-Belén and Christine E. Bose. Boulder: Westview Press, pp. 37–54.

Chodorow, Nancy. 1997. The Psychodynamics of the Family. In *The Second Wave: A Reader in Feminist Theory,* ed. Linda Nicholson. New York: Routledge, pp. 181–197.

Christy, Carol. 1987. *Sex Differences in Political Participation: Processes of Fourteen Nations.* New York: Praeger.

Chronicle of Parliamentary Elections. Published by Inter-Parliamentary Union, 5 Chemin du Pommier, Case postale 330, CH-1218 Le Grand-Saconnex, Geneva, Switzerland. http://www.ipu.org/english/home.htm.

Close, David. 1988. *Nicaragua: Politics, Economics, and Society.* London: Pinter.

Coleman, Kenneth, and George Herring, eds. 1991. *Understanding the Central American Crisis: Sources of Conflict, U.S. Policy, and Options for Peace.* Wilmington: Scholarly Resources.

Colombia International Affairs Online (CIAO). 1988. El Salvador: Country History. Available at http://www.ciaonet.org/.

———. 1993a. Honduras: Country History. Available at http://www.ciaonet.org/.

———. 1993b. Nicaragua: Country History. Available at http://www.ciaonet.org/.

Comisión para el Esclarecimiento Histórico (CEH). 1999. *Guatemala: Memoria del Silencio.* Guatemala: CEH.

Commission on the Truth for El Salvador. 1993. From Madness to Hope: The 12-Year War in El Salvador. NY: United Nations.

Commisso, Ellen. 1997. Is the Glass Half Full or Half Empty: Reflections on Five Years of Competitive Politics in Eastern Europe. *Communist and Post-Communist Studies* 30(1): 1–21.

Conway, Jill, Susan C. Bourque, and Joan W. Scott, eds. 1989. *Learning about Women.* Ann Arbor: University of Michigan Press.

Córdova Macías, Ricardo. 1996. El Salvador: Transition from Civil War. In *Constructing Democratic Governance: Latin America and the Caribbean in the 1990s,* ed. Jorge I. Domínguez and Abraham F. Lowenthal. Baltimore: Johns Hopkins University Press, pp. 26–49.

Córdova Macías, Ricardo, Günther Maihold, and Sabina Kurtenbach, eds. 2001. *Pasos hacia una nueva convivencia: Democracia y participación en Centroamérica.* San Salvador: FUNDAUNGO, Instituto de Estudios Iberoamericanos de Hamburgo and Instituto Iberoamericano de Berlin.

Costa Rica. Constitution of 1848.

———. Constitution of 1853.

———. Constitution of 1949.

———. Constitution of 1983.
Craske, Nikki. 1998. Remasculinisation and the Liberal State in Latin America. In *Gender, Politics, and the State*, ed. Vicky Randall and Georgina Waylen. New York: Routledge, 100–120.
———. 1999. *Women and Politics in Latin America*. Brunswick, NJ: Rutgers University Press.
Craske, Nikki, and Maxine Molyneux, eds. 2002. *Gender and the Politics of Rights and Democracy in Latin America*. New York: Palgrave.
Crisp, Brian F., et al. 2004. Vote-Seeking Incentives and Legislative Representation in Six Presidential Democracies. *Journal of Politics* 66(3): 823–846.
Cuadra, S. 1990. A Vote for Equality. *Barricada International*. 20 January 1990.
Dagnino, Evelyn, Sonia E. Alvarez, and Arturo Escobar, eds. 1998. *Cultures of Politics, Politics of Cultures: Re-Visioning Latin American Social Movements*. Boulder: Westview Press.
Dahl, Robert A. 1971. *Polyarchy: Participation and Opposition*. New Haven: Yale University Press.
———. 1989. *Democracy and Its Critics*. New Haven: Yale University Press.
Darcy, R., and Karen Beckwith. 1991. Political Disaster, Political Triumph: The Election of Women to National Parliaments. Paper presented at the annual meeting of the American Political Science Association in Washington, D.C.
Darcy, R., Susan Welch, and Janet Clark. 1987. *Women, Elections, and Representation*. New York: Longman.
Debayle, Luis Manuel. 1933. The Status of Women in Nicaragua. *Mid-Pacific Magazine* 45(3), March: 237–239.
Deere, Carmen Diana. 1995. What Difference Does Gender Make? Rethinking Peasant Studies. *Feminist Economics* 1(1): 53–72.
de Oyuela, Leticia. 1989. *Notas sobre la evolución histórica de la mujer en Honduras*. Tegucigalpa, Honduras: Guaymuras.
Díaz de Landa, Martha Ines, and Carlos Alberto Lista. 1982. *Estudio Comparativo de la Legislación de los Países Americanos Respecto a la Mujer*. Washington, D.C.: Comisión Interamericana de Mujeres, Organización de los Estados Americanos. Serie Estudios (7).
Disney, Jennifer Leigh. 2003. Democratization, Civil Society, and Women's Organizing in Post-Revolutionary Mozambique and Nicaragua. *New Political Science* 25(4): 533–560.
Dolan, Julie. 1997. Support for Women's Interests in the 103rd Congress: The Distinct Impact of Congressional Women. *Women & Politics* 18(4): 81–94.
Dolan, Kathleen, and Lynne E. Ford. 1998. Are All Women State Legislators Alike? In *Women and Elective Office: Past, Present, and Future*, ed. Sue Thomas and Chris Wilcox. New York: Oxford University Press, pp. 73–86.
Domínguez, Jorge I., and Marc Lindenberg, eds. 1997. *Democratic Transitions in Central America*. Gainesville: University Press of Florida.
Dunkerly, James. 1988. *Power in the Isthmus: A Political History of Modern Central America*. London: Verso.
Duverger, Maurice. 1955. *The Political Role of Women*. Paris: UNESCO.
Economist Intelligence Unit. EIU, 26 Red Lion Square, London WC1R 4HQ United Kingdom. http://portal.eiu.com/.

Edelman, Marc. 1999. *Peasants against Globalization: Rural Social Movements in Costa Rica.* Stanford: Stanford University Press.

Elias, Anilu. 1988. Los hombres que creen amar a las mujeres. *Fem* 12(60), September: 38–40.

El Salvador. Constitution of 1841.

———. Constitution of 1939.

———. Constitution of 1983.

Elshtain, Jean Bethke. 1981. *Public Man, Private Woman: Women in Social and Political Thought.* Princeton: Princeton University Press.

Elson, Diane. 1995. Gender Awareness in Modeling Structural Adjustment. *World Development* 23(11): 1851–1868.

Enloe, Cynthia. 1993. *The Morning After: Sexual Politics at the End of the Cold War.* Berkeley: University of California Press.

Envío Collective. 1990. Two Faces of UNO. *Envío* 9 (July): 24–37.

Facultad Latinoamericana de Ciencias Sociales (FLACSO). 1992. *Perfil Estadístico Centroamericano.* San José, Costa Rica: FLACSO.

Fernández Poncela, Ana María. 1997. Nicaraguan Women: Legal, Political, and Social Spaces, transl. Grail Dorling. In *Gender Politics in Latin America: Debates in Theory and Practice,* ed. Elizabeth Dore. New York: Monthly Review Press, pp. 36–51.

Flores-Alatorre, Sergio Tamayo, ed. 1999. *Sistemas urbanos: Actores sociales y ciudadanías.* Mexico City: Universidad Autónoma Metropolitana Press.

Franceschet, Susan. 2003. State Feminism and Women's Movements: The Impact of Chile's Servicio Nacional de la Mujer on Women's Activism. *Latin American Research Review* 38(1): 9–41.

Frente Sandinista de Liberación Nacional (FSLN). 1987. *El FSLN y la mujer en la revolución popular Sandinista.* Managua: Editorial Vanguardia.

Friedman, Elisabeth J. 1998. Paradoxes of Gendered Political Opportunity in the Venezuelan Transition to Democracy. *Latin American Research Review* 33(3): 87–135.

———. 2000. *Unfinished Transitions: Women and the Gendered Development of Democracy in Venezuela, 1936–1996.* University Park: Penn State Press.

Fundación Arias para la Paz y el Progreso Humano. 1992. *El Acceso de la Mujer a la Tierra en El Salvador.* San José, Costa Rica: Fundación Arias.

Furlong, Marlea, and Kimberly Riggs. 1996. Women's Participation in National-Level Politics and Government: The Case of Costa Rica. *Women's Studies International Forum* 19(6): 633–643.

García, Ana Isabel, and Enrique Gomáriz. 1989. *Mujeres Centroamericanas: Tendencias estructurales.* San José, Costa Rica: FLACSO.

Geiger, Susan. 1986. Women's Life Histories: Method and Content. *Signs* 11(2): 334–351.

———. 1997. *Tanu Women: Gender and Culture in the Making of Tanganyikan Nationalism, 1955–1965.* Portsmouth, NH: Heinemann.

Genovese, Michael A., ed. 1993. *Women as National Leaders.* Newbury Park, CA: Sage Publications.

Gerth, H. H., and C. Wright Mills, eds. and trans. 1958. *From Max Weber.* New York: Galaxy.

Gideon, Jasmine. 2002. Economic and Social Rights: Exploring Gender Differences in a Central American Context. In *Gender and the Politics of Rights and Democracy in Latin America*, ed. Nikki Craske and Maxine Molyneux. London: Macmillan, pp. 173–198.

Gilligan, Carol. 1997. Woman's Place in Man's Life Cycle. In *The Second Wave: A Reader in Feminist Theory*, ed. Linda Nicholson. New York: Routledge, pp. 198–215.

Glebbeek, Marie-Louise. 2001. Police Reform and the Peace Process in Guatemala: The Fifth Promotion of the National Civilian Police. *Bulletin of Latin American Research* 20(4): 431–453.

Gluck, Sherna Berger, and Daphne Patai, eds. 1991. *Women's Words: The Feminist Practice of Oral History*. London: Routledge.

Godoy, Angelina Snodgrass. 2002. Lynchings and the Democratization of Terror in Postwar Guatemala: Implications for Human Rights. *Human Rights Quarterly* 24: 640–661.

González, Victoria, and Karen Kampwirth, eds. 2001. *Radical Women in Latin America: Left and Right*. University Park: Pennsylvania State University Press.

Green, Linda. 1999. *Fear as a Way of Life: Mayan Widows in Rural Guatemala*. New York: Colombia University Press.

Guatemala. Constitution of 1825.

——. Constitution of 1945.

——. Constitution of 1985.

Gutman, Amy. 1993. Democracy. In *A Companion to Contemporary Political Philosophy*, ed. Robert Goodin and Philip Pettit. Oxford: Blackwell.

Haavio-Mannila, Elina, et al., eds. 1985. *Unfinished Democracy: Women in Nordic Politics*. Transl. Christine Badcock. London and New York: Pergamon Press.

Hansen, Susan B. 1995. Was Susan B. Anthony Wrong? State Public Policy and the Representation of Women's Interests. Paper presented at the annual meeting of the American Political Science Association in Chicago.

Hellman, Judith Adler. 1995. The Riddle of New Social Movements: Who They Are and What They Do. In *Capital, Power, and Inequality in Latin America*, ed. Sandor Halebsky and Richard L. Harris. Boulder: Westview Press.

Heywood, Andrew. 2002. *Politics*, 2nd ed. London: Palgrave Macmillan.

Holden, Robert. 2004. *Armies without Nations: Public Violence and State Formation in Central America, 1821–1960*. New York: Oxford University Press.

Honduras. Constitution of 1824.

——. Constitution of 1954.

Htun, Mala. 2000. Women's Leadership in Latin America: Trends and Challenges. http://www.iadb.org/sds/doc/MalaEnglish.pdf.

Htun, Mala, and Mark P. Jones. 2002. Engendering the Right to Participate in Decision-Making: Electoral Quotas and Women's Leadership in Latin America. In *Gender and the Politics of Rights and Democracy in Latin America*, ed. Nikki Craske and Maxine Molyneux. New York: Palgrave, 32–56.

Inter-Parliamentary Union. 1986. *Parliaments of the World: A Comparative Reference Compendium*. International Centre for Parliamentary Documentation of the IPU. New York: Facts on File Publications.

———. 1988. *Participation of Women in Political Life and in the Decision-Making Process: A World Survey as of 1 April 1988.* Geneva: International Centre for Parliamentary Documentation (CIDP).

———. 1995. *Women in Parliaments, 1945–1995: A World Statistical Survey.* Geneva: IPU. Series Reports and Documents, No. 23.

———. 1997. *Men and Women in Politics: Democracy Still in the Making— A World Comparative Study.* Geneva: IPU.

———. 2005. *Women in National Parliaments: 50 Years of History at a Glance.* http://www.ipu.org/english/home.htm.

IRIPAZ. 1991. *Cronologías de los proceso de paz: Guatemala y El Salvador.* Guatemala City: Instituto de Relaciones Internacionales y de Investigaciones para la Paz.

Jaquette, Jane. 1976. Female Political Participation in Latin America. In *Sex and Class in Latin America*, ed. June Nash and Helen Icken Safa. New York: Praeger, 221–244.

———. 2000. Women and Democracy: Past, Present, Future. Paper prepared for Democracy Seminar at Stanford University.

Jaquette, Jane S., and Saron L. Wolchik, eds. 1998. *Women and Democracy: Latin America and Central and Eastern Europe.* Baltimore: Johns Hopkins University Press.

Jelin, Elizabeth, ed. 1990. *Women and Social Change in Latin America.* London: Zed Books.

———. 1998. Toward a Culture of Participation and Citizenship: Challenges for a More Equitable World. In *Cultures of Politics, Politics of Cultures: Re-Visioning Latin American Social Movements*, ed. Evelyn Dagnino, Sonia E. Alvarez, and Arturo Escobar. Boulder: Westview Press, pp. 405–414.

Jewell, Malcolm E. 1970. Attitudinal Determinants of Legislative Behavior: The Utility of Role Analysis. In *Legislatures in Developmental Perspective*, ed. Allan Kornberg and Lloyd D. Musdolf. Durham, NC: Duke University Press, pp. 228–272.

———. 1983. Legislator-Constituency Relations and the Representative Process. *Legislative Studies Quarterly* 8(3): 303–337.

Jonas, Susanne. 1999. The Mined Road to Peace in Guatemala. The North-South Center, University of Miami, agenda paper no. 38. Also available at www.ciaonet.org/wps/jos01/.

———. 2000. Democratization through Peace: The Difficult Case of Guatemala. *Journal of Interamerican Studies and World Affairs* 42(2): 9–38.

Jonas, Susanne, and Thomas W. Walker. 2000. Guatemala: Intervention, Repression, Revolt, and Negotiated Transition. In *Repression, Resistance, and Democratic Transition in Central America*, ed. Thomas W. Walker and Ariel C. Armony. Wilmington: Scholarly Resources, pp. 3–24.

Jones, Mark P. 1997. Legislator Gender and Legislator Policy Priorities in the Argentine Chamber of Deputies and the United States House of Representatives. *Policy Studies Journal* 25(4): 613–629.

———. 2004. Quota Legislation and the Election of Women: Learning from the Costa Rican Experience. *Journal of Politics* 66(4): 1203–1233.

Kampwirth, Karen. 1996. The Mother of Nicaraguans: Doña Violeta and the UNO's Gender Agenda. *Latin American Perspectives* 23(1): 67–86.

———. 1998. Feminism, Antifeminism, and Electoral Politics in Postwar Nicaragua and El Salvador. *Political Science Quarterly* 112(3): 259–279.

Kampwirth, Karen, and Victoria González, eds. 2001. *Radical Women in Latin America: Left and Right.* University Park: Penn State University Press.

Kanter, Rosabeth M. 1977. *Men and Women of the Corporation.* New York: Basic Books.

Kantor, Harry. 1969. *Patterns of Politics and Political Systems in Latin America.* New York: Rand McNally.

Karl, Terry Lynn. 1992. El Salvador's Negotiated Revolution. *Foreign Affairs* 71(2): 147–164.

———. 1995. The Hybrid Regimes of Central America. *Journal of Democracy* 6(3): 72–86.

Keesing's Record of World Events. Published by Keesing's Worldwide, 4905 Del Ray Avenue, Suite 402, Bethesda, Maryland 20814. http://www.keesings.com/print_products/world_events/default.asp.

Kim, Chong Lim, and Samuel C. Patterson. 1988. Parliamentary Elite Integration in Six Nations. *Comparative Politics* 20(4): 379–399.

Kim, C. L., J. Barkan, I. Turan, and M. Jewell. 1984. *The Legislative Connection: The Politics of Representation in Kenya, Korea, and Turkey.* Durham, NC: Duke University Press.

Kohn, Walter S. G. 1980. *Women in National Legislatures: A Comparative Study of Six Countries.* New York: Praeger.

Koonings, Kees, and Dirk Krujit, eds. 1999. *Societies of Fear: The Legacy of Civil War, Violence, and Terror in Latin America.* London: Zed Books.

Kovel, J. 1988. *In Nicaragua.* London: Free Association Press.

Krennerich, Michael. 1993. El Salvador. In *Enciclopedia electoral latinoamericana y del caribe*, ed. Dieter Nohlen. San Jose: Instituto Interamericano de Derechos Humanos (IIDH), pp. 307–330.

Krujit, Dirk. 2000. Guatemala's Political Transitions: 1960s–1990s. *International Journal of Political Economy* 30(1): 9–35.

Kurian, George T., ed. 1998. *World Encyclopedia of Parliaments and Legislatures.* Sponsored by Research Committee of Legislative Specialists, International Political Science Association [and] Commonwealth Parliamentary Association. Washington, D.C.: Congressional Quarterly.

Lagos, Marta. 2003. Public Opinion. In *Constructing Democratic Governance in Latin America*, 2nd ed., ed. Jorge I. Domínguez and Michael Shifter. Baltimore: Johns Hopkins University Press, pp. 137–164.

Landau, Saul. 1993. *The Guerrilla Wars of Central America: Nicaragua, El Salvador, and Guatemala.* London: Weinfeld and Nicolson.

Landolt, Laura K. 1996. Women and Democratization in Egypt: 1919–1981. Masters thesis, University of Texas–El Paso.

LANIC. Latin American Network Information Center. University of Texas–Austin. http://lanic.utexas.edu/.

Latin American Election Statistics. Assembled by Karen Lindvall-Larson, Latin

American Studies Librarian, University of California–San Diego. http://sshl.ucsd.edu/collections/las/.

Leiken, Robert S., ed. 1984. *Central America, Anatomy of a Conflict*. New York: Pergamon.

Levy, Marion Fennelly. 1988. *Each in Her Own Way: Five Women Leaders of the Developing World*. Boulder: Lynne Rienner.

Lievesley, Geraldine. 1999. *Democracy in Latin America: Mobilization, Power, and the Search for a New Politics*. Manchester, UK: Manchester University Press.

Linkimer Bedoya, Llihanny. 1999. Presencia de las mujeres en las estructuras de poder politico. *Revista Parlamentaria de la Asamblea Legislativa de Costa Rica* 7(1): 137–160.

Linz, Juan J., and Alfred Stepan. 1996. *Problems of Democratic Transition and Consolidation: Southern Europe, South America, and Post-Communist Europe*. Baltimore: Johns Hopkins University Press.

López de Cáceres, Carmen, and Mercedes Asturias de Castañeda. 1992. *Situacion global de la legislacion nacional en los paises de la region Centroamericana en relacion a la convencion sobre la eliminacion de todas formas de discriminacion contra la mujer*. Guatemala City, Guatemala: Parlamento Centroamericano (PARLACEN).

Lovenduski, Joni, and Jill Hills. 1981. *The Politics of the Second Electorate: Women and Public Participation*. London: Routledge.

Lowenberg, Gerhard, and Samuel C. Patterson. 1979. *Comparing Legislatures*. Boston: Little, Brown.

Luciak, Ilja. 1998. Gender Equality and Electoral Politics on the Left: A Comparison of El Salvador and Nicaragua. *Journal of Interamerican Studies and World Affairs* 40(1): 39–64.

———. 1999. Gender Equality in the Salvadoran Transition. *Latin American Perspectives* 26(2): 43–67.

———. 2001a. *After the Revolution: Gender and Democracy in El Salvador, Nicaragua, and Guatemala*. Baltimore: Johns Hopkins University Press.

———. 2001b. Women's Networking and Alliance Building in Postwar Central America. *Development* 45(1): 67–73.

Mainwaring, Scott, Guillermo O'Donnell, and J. Samuel Valenzuela, eds. 1992. *Issues in Democratic Consolidation: The New South American Democracies in Comparative Perspective*. Notre Dame: University of Notre Dame Press.

Maitland, Richard E. 1991. Institutional Variables Affecting Female Representation in National Legislatures: The Case of Norway. Paper presented at the annual meeting of the American Political Science Association in Washington, D.C.

May, Rachel A. 1999. "Surviving All Changes Is Your Destiny": Violence and Popular Movements in Guatemala. *Latin American Perspectives* 26(2): 68–91.

McCleary, Rachel. 1997. Guatemala's Postwar Prospects. *Journal of Democracy* 8(2): 129–143.

McKenna, J. 1987. Address given at the 4th annual International Law Symposium. *Whittier Law Review* 9: 407–411.

Menchú, Rigoberta. 1984. *I, Rigoberta Menchú: An Indian Woman in Guatemala*. Ed. and introduced by Elisabeth Burgos-Debray. New York and London: Verso.

Metoyer, Cynthia Chavez. 1997. Nicaragua's Transition of State Power: Through Feminist Lenses. In *The Undermining of the Sandinista Revolution*, ed. Gary Prevost and Harry Vanden. London: Macmillan, pp. 114–140.

———. 2000. *Women and the State in Post-Sandinista Nicaragua*. Boulder: Lynne Rienner.

Mezey, Michael L. 1983. The Functions of Legislatures in the Third World. *Legislative Studies Quarterly* 8(4): 511–550.

Miles, Sara. The Real War: Low-Intensity Conflict in Central America. 1986. *NACLA* 20(2), April/May: 17–48.

Miller, Francesca. 1991. *Latin American Women and the Search for Social Justice*. Hanover and London: University Press of New England.

Ministerio de Justicia. 1993. Mujer y derechos humanos en America Latina y el Caribe. Conferencia Mundial de Derechos Humanos. Reunión Regional de America Latina y el Caribe. San José, Costa Rica: Ministerio de Justicia.

Molyneux, Maxine. 1995. Gendered Transitions: A Review Essay. *Gender and Development* 3(3): 49–54.

———. 1998. Analyzing Women's Movements. *Development and Change* 29(2): 219–245.

Molyneux, Maxine, and Shahra Razavi. 2003. Gender Justice, Development, and Rights. *Democracy, Governance, and Human Rights, Programme Paper 10*. United Nations Research Institute for Social Development.

Montecinos, Verónica. 2001. Feminists and Technocrats in the Democratization of Latin America: A Prolegomenon. *International Journal of Politics, Culture, and Society* 15(1): 175–199.

Montero Araya, Carolina, and Quesada Saravio, Lili. 1997. Costa Rica. In *Centroamérica: Las mujeres en el espacio local*, ed. Ivonne Siu. Managua: Centro Editorial de la Mujer, Programa Regional la Corriente, pp. 147–178.

Morelli, Donald R., and Michael M. Ferguson. Low-Intensity Conflict: An Operational Perspective. *Military Review* 64, No. 11, November 1984, 2–16.

Moreno, Elsa. 1995. *Mujeres y política en Costa Rica*. San José, Costa Rica: FLACSO.

———. 1997. *Mujeres y política en El Salvador*. San José, Costa Rica: FLACSO.

Morgan, Martha I. 1990. Founding Mothers: Women's Voices and Stories in the 1987 Nicaraguan Constitution. *Boston University Law Review* 70(1), pp. 1–104.

Moser, Caroline, and Cathy McIlwaine. 1999. Participatory Urban Appraisal and Its Application for Research on Violence. *Environment and Urbanization* 11(2): 203–226.

Nash, Kate. 1998. Beyond Liberalism? Feminist Theories of Democracy. In *Gender, Politics and the State*, ed. Vicky Randall and Georgina Waylen. London: Routledge, pp. 45–57.

Navas, María Candelaria. 1990. Conceptualización de Género. San Salvador, El Salvador: CSUCA. Cuadernos de Investigacion No. 58. Available online at http://ns.ccp.ucr.ac.cr/~cmarin/hostigamiento/lec.htm.

Nechemias, Carol. 1994. Democratization and Women's Access to Legislative Seats: The Soviet Case, 1989–1991. *Women & Politics* 14(3): 1–18.

Nelson, Harold D. 1983. *Costa Rica: A Country Study*, 2nd ed. Washington, D.C.: U.S. Government Printing Office.

Nicaragua. Constitution of 1838.
———. Constitution of 1955.
———. Constitution of 1987.
Nielsen, Joyce McCarl, ed. 1990. *Feminist Research Methods: Exemplary Readings in the Social Sciences.* Boulder: Westview Press.
Nohlen, Dieter. 1993. *Enciclopedia electoral latinoamericana y del caribe.* San José: Instituto Interamericano de Derechos Humanos (IIDH).
Norris, Pippa. 1985. Women's Legislative Participation in Western Europe. In *Women and Politics in Western Europe,* ed. Sylvia Bashevkin. London: Frank Cass, pp. 90–101.
———. 2004. *Electoral Engineering: Voting Rules and Political Behavior.* New York: Cambridge University Press.
Norris, Pippa, and Joni Lovenduski. 1995. *Political Recruitment: Gender, Race, and Class in the British Parliament.* Cambridge: Cambridge University Press.
NOTICEN. Newsletter on Central American and Caribbean Political and Economic Affairs, including Cuba (formerly titled EcoCentral). Published by the Latin American Data Base, Latin American and Iberian Institute, MSC-02-1690, University of New Mexico, Albuquerque, NM 87131-0001. http://ladb.unm.edu/.
Nuñez de Escorcia, Vilma. 1996. *La política es aún un campo dominado por los hombres.* Managua: Centro Nicaraguense de Derechos Humanos (CENIDH).
Nuss, Shirley. 1985. Women in Political Life: Variations at the Global Level. *Women & Politics* 5(2/3): 65–78.
Nussbaum, Martha C. 2000. *Women and Human Development.* Cambridge: Cambridge University Press.
Oakley, Judith, and Helen Callaway, eds. 1992. *Anthropology and Autobiography.* London: Routledge.
O'Donnell, Guillermo. 1992. Transitions, Continuities, and Paradoxes. In *Issues in Democratic Consolidation: The New South American Democracies in Comparative Perspective,* ed. Scott Mainwaring, Guillermo O'Donnell, and J. Samuel Valenzuela. Notre Dame: University of Notre Dame Press, pp. 17–56.
———. 1994. Delegative Democracy. *Journal of Democracy* 5(1): 55–69.
———. 1999. Polyarchies and the (Un)rule of Law in Latin America. In *The (Un)rule of Law and the Underprivileged in Latin America,* ed. Juan E. Méndez, Guillermo O'Donnell, and Paul S. Pinheiro. Notre Dame: University of Notre Dame Press, pp. 303–338.
Okin, Susan Moller. 1998. Gender, the Public, and the Private. In *Feminism and Politics,* ed. Anne Phillips. Oxford: Oxford University Press, pp. 116–141.
O'Regan, Valerie. 2000. *Gender Matters: Female Policymakers' Influence in Industrialized Nations.* Westport: Praeger.
Ost, David. 2000. Illusory Corporatism in Eastern Europe: Neoliberal Tripartism and Postcommunist Class Identities. *Politics and Society* 28(4): 503–530.
Pateman, Carole. 1988. *The Sexual Contract.* Stanford: Stanford University Press.
Pearce, Jenny. 1998. From Civil War to "Civil Society": Has the End of the Cold War Brought Peace to Central America? *International Affairs* 74(3): 587–615.
Peeler, John. 1987. Costa Rican Democracy: Pluralism and Class Rule. *Commonwealth Journal of Political Science* 1: 26–56.

Personal Narratives Group. 1989. *Interpreting Women's Lives: Feminist Theory and Personal Narratives.* Bloomington: Indiana University Press.

Phillips, Anne, ed. 1998. *Feminism and Politics.* Oxford: Oxford University Press.

Piscopo, Jennifer M. 2002. Gender, Democracy, and Politics: A Costa Rican Case Study. BA Thesis, Wellesley College, Wellesley, MA.

Pitkin, H. F. 1967. *The Concept of Representation.* Berkeley: University of California Press.

Power, Timothy, and Mary Clark. 2001. Does Trust Matter? Interpersonal Trust and Democratic Values in Chile, Costa Rica, and Mexico. In *Citizen Views of Democracy in Latin America,* ed. Roderic Ai Camp. Pittsburgh: University of Pittsburgh Press, 51–70.

Prindeville, Diane-Michele, and Teresa Braley Gomez. 1999. American Indian Women Leaders, Public Policy, and the Importance of Gender and Ethnic Identity. *Women & Politics* 20(2): 17–32.

Przeworski, Adam. 1992. The Games of Transition. In *Issues in Democratic Consolidation: The New South American Democracies in Comparative Perspective,* ed. Scott Mainwaring et al. Notre Dame: University of Notre Dame Press, pp. 105–152.

Putnam, Robert, with R. Leonardi and R. Y. Nanetti. 1993. *Making Democracy Work: Civic Traditions in Modern Italy.* Princeton, N.J.: Princeton University Press.

Puwar, Nirmal. 1997. Reflections on Interviewing Women MPs. *Sociological Research Online* 2(1). http://www.socresonline.org.-uk/socresonline/2/1/4.html.

Radell, David R. 1969. Historical Geography of Western Nicaragua: The Spheres of Influence of Leon, Granada, and Managua, 1519–1965. PhD diss., University of California–Berkeley.

Rai, Shirin, Hilary Pilkington, and Annie Phizacklea, eds. 1992. *Women in the Face of Change: The Soviet Union, Eastern Europe, and China.* London: Routledge.

Ramírez, Carmen O. 1987. *La Mujer: Su situación jurídica en veintiseis paises Americanos.* Buenos Aires, Argentina: Marcos Lerner, Editorial Cordoba.

Randall, Margaret. 2000. Rethinking Power from a Feminist Vision. *Envio* 222. http://www.envio.org.ni/articulo/1398.

Randall, Vicky. 1987. *Women and Politics: An International Perspective,* 2nd ed. London: Macmillan.

Randall, Vicky, and Georgina Waylen, eds. 1998. *Gender, Politics, and the State.* London: Routledge.

Regulska, Joanna. 1992. Women and Power in Poland: Hopes or Reality? In *Women Transforming Politics: Worldwide Strategies for Empowerment,* ed. J. Bystydzienski. Bloomington: Indiana University Press, pp. 175–191.

Reingold, Beth. 2000. *Representing Women: Sex, Gender, and Legislative Behavior in Arizona and California.* Chapel Hill: University of North Carolina.

Rhode, Deborah L. 1998. The Politics of Paradigms: Gender Difference and Gender Disadvantage. In *Feminism and Politics,* ed. Anne Phillips. Oxford: Oxford University Press, pp. 344–362.

Richter, Linda K. 1990–1991. Exploring Theories of Female Leadership in South and South East Asia. *Pacific Affairs* 63(4): 524–541.

Rivera Bustamante, Tirza Emilia. 1981. *Evolución de los derechos políticos de la mujer en Costa Rica.* Thesis, University of Costa Rica Law School, San José, Costa Rica.

Rivera-Cira, Teresa. 1993. *Las mujeres en los parlamentos Latinoamericanos.* Valparaiso: Universidad Católica.

Rodríguez, Victoria. 1998. The Emerging Role of Women in Mexican Political Life. In *Women's Participation in Mexican Political Life,* ed. Victoria Rodríguez. Boulder: Westview Press, pp. 1–22.

———. 2002. *Women in Contemporary Mexican Politics.* Austin: University of Texas Press.

Rojas Bolaños, Manuel. 1990. La democracia costarricense: mitos y realidades. In *Mitos y realidades de la democracia en Costa Rica,* ed. Yadiro Calvo. San José: Departamento Ecuménico de Investigaciones, pp. 25–44.

Rosales, Sara Elisa. 1980. *Consideraciones preliminares sobre la situación de la mujer en Honduras.* Tegucigalpa: Universidad Nacional Autonoma de Honduras.

———. 1997. Honduras. In *Centroamérica: las mujeres en el espacio local,* ed. Ivonne Siu. Managua: Centro Editorial de la Mujer, Programa Regional la Corriente, pp. 111–123.

Rosenberg, M. B. 1981. Social Reform in Costa Rica: Social Security and the Presidency of Rafael Ángel Calderón. *Hispanic American Historical Review* 61(2): 278–296. Reprinted in Marc Edelman and Joanne Kenen, eds., *The Costa Rica Reader,* 1989. New York: Grove Weidenfeld.

Rosenblum, Nancy. 1998. *Membership and Morals: The Personal Uses of Pluralism in America.* Princeton: Princeton University Press.

Rueschemeyer, Marilyn, ed. 1998. *Women in Postcommunist Eastern Europe,* 2nd ed. Armonk: M. E. Sharpe.

Ruhl, J. Mark. 2000. Honduras: Militarism and Democratization in Troubled Waters. In *Repression, Resistance, and Democratic Transition in Central America,* ed. Thomas W. Walker and Ariel C. Armony. Wilmington: Scholarly Resources, pp. 47–66.

Rule, Wilma. 1984. How to Increase Feminist Representation in Parliament. Paper presented at the Second International Congress on Women in Groningen, Netherlands.

———. 1987. Electoral Systems, Contextual Factors, and Women's Opportunity for Election to Parliament in Twenty-Three Democracies. *Western Political Quarterly* 40(3): 477–498.

———. 1992. The Preference Vote: Key to Women's Parliamentary Success? Paper presented at the American Political Science Association in Chicago.

———. 1993. Electing Women to Parliament: Policy Alternatives for Greater Opportunity. Paper presented at the Fifth International Interdisciplinary Congress on Women in San José, Costa Rica.

———. 1994a. Women's Election to Parliament, Campaign and Party Finance: Implications for Democratizing Countries, an Exploratory Study. Paper presented at the XVI World Congress of the International Political Science Association in Berlin.

———. 1994b. Parliaments of, by, and for the People: Except for Women? Paper presented at the Western Political Science Association in Albuquerque, NM.

———. 1998. Women's Legislative Recruitment in 46 Developing Democracies: A Comparative Contextual Analysis. Paper presented at the Western Political Science Association in Los Angeles.

Safa, Helen I. 1995. Women's Social Movements in Latin America. In *Women in the Latin American Development Process*, ed. Christine E. Bose and Edna Acosta-Bélen. Philadelphia: Temple University Press, pp. 227–241.

Sagot, Montserrat. 1994. Women, Political Activism, and the Struggle for Housing: The Case of Costa Rica. In *Women, the Family, and Policy: A Global Perspective*, ed. Esther Ngan-Ling Chow and Catherine White Berheide. Albany: State University of New York, pp. 189–208.

Saint-Germain, Michelle A. 1989. Does Their Difference Make a Difference? The Impact of Women on Public Policy in the Arizona Legislature. *Social Science Quarterly* 70(4): 946–958.

———. 1993a. Women in Power in Nicaragua: Myth and Reality. In *Women Heads of State*, ed. M. Genovese Newbury Park: Sage, 70–102.

———. 1993b. Paths to Power of Women Legislators in Costa Rica and Nicaragua. *Women's Studies International Forum* 16(2): 119–138.

———. 1994. The Representation of Women and Minorities in the National Legislatures of Costa Rica and Nicaragua. In *Electoral Systems, Minorities, and Women in Comparative Perspective*, ed. Wilma Rule and Joseph Zimmerman. Westport, CT: Greenwood Publishing, pp. 211–222.

———. 1997. "Mujeres '94": Democratic Transition and the Women's Movement in El Salvador. *Women & Politics* 18(2): 75–99.

Saint-Germain, Michelle A., and Martha Morgan. 1992. Equality: Costa Rican Women Demand "the Real Thing." *Women & Politics* 11(3): 23–74.

Sarkesian, Sam C. 1985. Low-Intensity Conflict: Concepts, Principles, and Policy Guidelines. *Air University Review* 36(2): 4–23.

Saxonberg, Steven. 2000. Women in East European Parliaments. *Journal of Democracy* 11(2): 145–158.

Schild, Verónica. 2000. Gender Equity without Social Justice: Women's Rights in the Neoliberal Age. *NACLA Report on the Americas* 34(1): 25–28.

Schirmer, Jennifer. 1993. The Seeking of Truth and the Gendering of Consciousness: The COMADRES of El Salvador and the CONAVIGUA Widows of Guatemala. In *Viva: Women and Popular Protest in Latin America*, ed. Sarah Radcliffe and Sallie Westwood. London: Routledge, 30–64.

———. 1999. The Guatemala Politico-Military Project: Legacies for a Violent Peace? *Latin American Perspectives* 26(2): 92–107.

Schmitter, Philippe C. 1998. Contemporary Democratization: The Prospects for Women. In *Women and Democracy: Latin America and Central and Eastern Europe*, ed. Jane Jaquette and Sharon Wolchik. Baltimore: Johns Hopkins University Press, pp. 222–238.

Schmitter, Philippe C., and Terry Lynn Karl. 1996. What Democracy Is . . . and Is Not. In *The Global Resurgence of Democracy*, 2nd ed., ed. Larry Diamond and Marc F. Plattner. Baltimore: Johns Hopkins University Press, pp. 49–62.

Schooley, Helen. 1991. History. In *South America, Central America, and the Caribbean*. London: Europa Publications, 312–313.
Schumpeter, Joseph A. 1976. *Capitalism, Socialism, and Democracy*. New York: Harper & Row.
Seligson, Amber. 1992. *The Idea of Civil Society*. New York: The Free Press.
Sheldon, Dinah. 1987. Improving the Status of Women Through International Law. *Whittier Law Review* 9: 413–418.
Sieder, Rachel. 1995. Honduras: The Politics of Exception and Military Reformism (1972–1978). *Journal of Latin American Studies* 27: 99–127.
———. 2002. War, Peace, and the Politics of Memory in Guatemala. In *Burying the Past: Making Peace and Doing Justice after Civil Conflict*, ed. Nigel Biggar. Washington, D.C.: Georgetown University Press, pp. 209–234.
Silber, Irina Carlota. 2004. Mothers/Fighters/Citizens: Violence and Disillusionment in Post-War El Salvador. *Gender & History* 16(3): 561–587.
Siu, Ivonne, ed. 1997. *Centroamérica: Las mujeres en el espacio local*. Managua: Centro Editorial de la Mujer, Programa Regional la Corriente.
Skard, Torild, and Elina Haavio-Mannila. 1985. Women in Parliament. In *Unfinished Democracy: Women in Nordic Politics*, ed. Elina Haavio-Mannila et al., trans. Christine Badcock. Oxford: Pergamon Press, pp. 51–80.
Smith, Peter H. 2005. *Democracy in Latin America: Political Change in Comparative Perspective*. New York: Oxford University Press.
Sparr, Pamela, ed. 1994. *Mortgaging Women's Lives: Feminist Critiques of Structural Adjustment*. New Jersey: Zed Books.
Spencer, Denise. 1997. Demobilization and Reintegration in Central America. Bonn International Center for Conversion (BICC), Paper #8.
Stahler-Sholk, Richard. 1994. El Salvador's Negotiated Transition: From Low-Intensity Conflict to Low-Intensity Democracy. *Journal of Interamerican Studies and World Affairs* 36(4): 1–59.
Stanley, W. 1996. *The Protection Racket State*. Philadelphia: Temple University Press.
Stepan, Alfred. 1988. *Rethinking Military Politics: Brazil and the Southern Cone*. Princeton: Princeton University Press.
Stephen, Lynn. 1997. *Women and Social Movements in Latin America: Power from Below*. Austin: University of Texas Press.
Sternbach, Nancy Saporta, Marysa Navarro-Aranguren, Patricia Chuchryk, and Sonia E. Alvarez. 1992. Feminisms in Latin America: From Bogotá to San Bernando. In *The Making of Social Movements in Latin America: Identity, Strategy, and Democracy*, ed. Arturo Escobar and Sonia E Alvarez. Boulder: Westview Press, pp. 207–239.
Sternberg, P. 2000. Challenging Machismo: Promoting Sexual and Reproductive Health with Nicaraguan Men. *Gender and Development* 8(1): 89–99.
Stevens, Evelyn P. 1973. The Prospects for a Women's Liberation Movement in Latin America. *Journal of Marriage and the Family* 35(2): 313–321.
Stumpf, A. E. 1985. Re-Examining the UN Convention on the Elimination of All Forms of Discrimination Against Women: The UN Decade for Women Conference in Nairobi. *Yale Journal of International Law* 10: 384–405.
Tayacan. 1985. *Psychological Operations in Guerrilla Warfare*. New York: Vintage Books. 1985

Taylor, Lucy. 2004. Client-ship and Citizenship in Latin America. *Bulletin of Latin American Research* 23(2): 213–227.

Taylor-Robinson, Michelle. 2001. Candidate Selection in Costa Rica. Paper presented at the XXIII International Congress of the Latin American Studies Association in Washington, D.C.

Taylor-Robinson, Michelle, and David J. Sky. 2002. Who Participates and Who Is Seen But Not Heard? Evidence from the Honduran Congress. *Journal of Legislative Studies* 8(1): 11–36.

Teachnor, S. 1987. The UN Convention on the Elimination of All Forms of Discrimination Against Women: An Effective Tool to Combat Discrimination in the 20th Century. *Whittier Law Review* 9: 419–422.

Tedesco, Laura. 2003. NGOs and the State: The Latin American Case. Lecture presented at the University of Cambridge, UK.

Thomas, Sue. 1994. *How Women Legislate.* New York and Oxford: Oxford University Press.

Thomas, Sue, and Clyde Wilcox, eds. 1998. *Women and Elective Office: Past, Present, and Future.* New York: Oxford University Press.

Torres-Rivas, Edelberto. 1996. Guatemala: Democratic Governability. In *Constructing Democratic Governance: Latin America and the Caribbean in the 1990s,* ed. Jorge I. Domínguez and Abraham F. Lowenthal. Baltimore: Johns Hopkins University Press, pp. 50–63.

———. 1999. Notes on Terror, Violence, Fear, and Democracy. In *Societies of Fear: The Legacy of Civil War, Violence, and Terror in Latin America,* ed. Kees Koonings and Dirk Krujit. London: Zed Books, pp. 295–300.

Transparency International. 1998. The Corruption Perceptions Index. http://www.transparency.org/cpi/1998/cpi1998.html.

Tuana, Nancy, and Rosemarie Tong, eds. 1995. *Feminism and Philosophy.* Boulder: Westview Press.

UNICEF and UNIFEM. 1990. *Estudio comparativo de la revisión de textos escolares de mayor use en planteles públicos y Porivados de Guatemala, Panamá, y El Salvador.* Guatemala City, Guatemala: UNICEF.

UNICEF, UNIFEM, and OPS. 1990. Propuestas de Ley en relacion a la Condicion Juridica de la Mujer Guatemalteca III. Guatemala City, Guatemala: UNICEF.

United Nations. 1998. Population by Sex, Sex Ratio, and Percentage of Population under Age 15, 1997. http://www/un.org/Depts/-unsd/gender/1-Ilat.htm.

———. 1999. Table 5.4, Maternity Leave Benefits, Early 1900s. http://www.un.org.

———. 2003a. Convention on the Elimination of All Forms of Discrimination against Women. http://www.un.org/womenwatch/daw/cedaw (accessed December 2003).

———. 2003b. Life Expectancy and Infant Mortality Rate, 1995–2000 (Table 3-1). http://www.un.org.

———. 2005. World and Regional Trends. http://unstats.un.org/unsd/mi/mi_links.asp.

U.S. Department of State. 1993. El Salvador Human Rights Practices. http://dosfan.lib.uic.edu/ERC/democracy/1993_hrp_report/93hrp_report_ara/ElSalvador.html.

———. 1999. Background Notes: El Salvador, March 1999. Washington, D.C.: U.S. Department of State.

Valdés, Teresa, and Enrique Gomáriz, eds. 1995. *Mujeres Latinoamericanas en cifras: Tomo comparativo.* Santiago, Chile: Facultad Latinoamerica de Ciencias Sociales (FLACSO) and Instituto de la Mujer, Ministerio de Asuntos Sociales de España.

Valenzuela, Arturo. 1999. Chile: Origins and Consolidation of a Latin American Democracy. In *Democracy in Developing Countries: Latin America,* 2nd ed., ed. Larry Diamond, Jonathan Hartlyn, Juan J. Linz, Seymour Martin Lipset. Boulder: Lynne Rienner, pp. 191–248.

Vargas, Gina. 1999. Latin American Feminism in the 90s. *International Feminist Journal of Politics* 1(2): 300–310.

Vargas, Oscar-René. 1989. *Elecciones en Nicaragua, 1912–1982: Análisis sociopolítico.* Managua: Dilesa.

Velázquez, José Luis P. 1986. *Nicaragua: Sociedad civil y dictadura.* San José: Libro Libre.

Vilas, Carlos Maria. 1996. Prospects for Democratization in a Post-Revolutionary Setting: Central America. *Journal of Latin American Studies* 28(2): 461–503.

———. 2000. Neoliberalism in Central America. In *Repression, Resistance, and Democratic transition in Central America,* ed. Thomas W. Walker and Ariel C. Armony. Wilmington: Scholarly Resources, pp. 211–232.

Wahlke, John C., et al. 1962. *The Legislative System: Explorations in Legislative Behavior.* New York: John Wiley.

Waisman, Carlos H. 1999. Argentina: Capitalism and Democracy. In *Democracy in Developing Countries: Latin America,* 2nd ed., ed. Larry Diamond, Jonathan Hartlyn, Juan J. Linz, Seymour Martin Lipset. Boulder: Lynne Rienner, pp. 71–130.

Walker, Thomas W. 2000. Nicaragua: Transition through Revolution. In *Repression, Resistance, and Democratic Transition in Central America,* ed. Thomas W. Walker and Ariel C. Armony. Wilmington: Scholarly Resources, pp. 67–88.

Walker, Thomas W., and Ariel C. Armony, eds. 2000. *Repression, Resistance, and Democratic Transitions in Central America.* Wilmington: Scholarly Resources.

Walter, Knut, and Philip J. Williams. 1993. The Military and Democratization in El Salvador. *Journal of Interamerican Studies and World Affairs* 35(1): 39–91.

Walzer, Michael. 1991. The Idea of Civil Society. *Dissent* 39: 293–304.

Waring, Marilyn. 2000. *Politics: Women's Insight.* New York: Inter-Parliamentary Union. http://www.ipu.org/PDF/publications/-womeninsight_en.pdf.

Waylen, Georgina. 1992. Rethinking Women's Political Participation and Protest: Chile 1970–1990. *Political Studies* 40(2): 299–315.

———. 1994. Women and Democratization: Conceptualizing Gender Relations in Transition Politics. *World Politics* 46(3): 327–354.

———. 1996. *Gender in Third-World Politics.* Boulder: Lynne Rienner.

Weaver, Frederick Stirton. 1994. *Inside the Volcano: The History and Political Economy of Central America.* Boulder: Westview Press.

West, Guida, and Rhoda Lois Blumberg, eds. 1990. *Women and Social Protest.* New York: Oxford University Press.

Wiarda, Howard. 1981. *Corporatism and National Development in Latin America.* Boulder: Westview Press.

———. 1992. *From Reagan to Bush: U.S. Foreign Policy in Latin America in the 1980s and 1990s.* New York: New York University Press.

Wide, Jessika. 2002. Women's Political Representation around the Globe. Paper presented at the Commonwealth Conference on Educational Administration and Management in Umeå, Sweden.

Williams, Phillip J. 1994. Dual Transitions from Authoritarian Rule: Popular and Electoral Democracy in Nicaragua. *Comparative Politics* 26(2): 169–185.

Wilson, Bruce M. 1989. *Costa Rica: Politics, Economics, and Democracy.* Boulder: Lynne Reinner.

Wolchick, Sharon L., and Alfred G. Meyer, eds. 1985. *Women, State, and Party in Eastern Europe.* Durham, NC: Duke University Press.

Wood, Elisabeth Jean. 2001. An Insurgent Path to Democracy: Popular Mobilization, Economic Interests, and Regime Transition in South Africa and El Salvador. *Comparative Political Studies* 34(8): 862–888.

World Bank. 1999. World Development Indicators 1999. http://www.worldbank.org/data/archive/wdi99/home.html.

Yashar, Deborah J. 1997. *Demanding Democracy: Reform and Reaction in Costa Rica and Guatemala, 1870s–1950s.* Stanford: Stanford University Press.

Zakaria, Fareed. 1997. The Rise of Illiberal Democracy. *Foreign Affairs* 76(6): 212–243.

Zanotti, Isadora. 1980. Convention on the Elimination of All Forms of Discrimination Against Women. *Lawyer of the Americas* 12: 610–614.

INDEX

abortion, 252, 278–280
active representation. *See under* representation
activism, 9, 10, 11, 18, 33, 35, 52, 56, 111, 117, 141, 147, 188, 189, 198, 204, 207–208, 210–212, 225, 226, 228, 229, 230–232, 237–238, 241, 247
affirmative action, 75, 78, 87, 150, 207, 259, 268, 278
African slaves, 19, 32
agrarian reform, 34, 42, 43, 44, 45, 51, 52, 59, 61, 70, 100, 136, 156, 235, 264
agriculture, 57, 96–101, 257, 261, 266. *See also under specific countries*
alternates. See *suplentes*
appointments, 48, 92. *See also under specific countries*

birth rates, 99, 101, 112, 113, 114
bureaucracy, 22, 23, 35, 40, 42, 68, 220, 239, 267

caciques, 58
camino centroamericano, 202
campaigns, 164, 177, 222
campesinos, 115, 116, 121, 138–139, 212–213
Catholic Church, 54, 116, 209, 246. *See also* religion
caudillos, 24, 39, 64
CEDAW. *See* Convention on the Elimination of All Forms of Discrimination Against Women (CEDAW)

Central America
 children in, 129–130
 conquest of, 18–20
 corporatism in, 82
 democratization of, 11–12, 25–27
 economics of, 20–21, 264
 education in, 102–104, 122
 electoral system in, 77–81, 82, 83–86, 87–88, 89–90, 91–94, 100, 116, 117
 and gender, 259, 261
 gross domestic product (GDP) of, 94–95
 history of, 18–36, 252–253
 international influence of, 258–259
 labor force in, 104–108, 130–131
 legislatures in, 151–153, 154–155, 156–159, 106–161
 and *machismo*, 114–117
 marital status in, 126–127, 256
 military in, 98–102
 non-governmental organizations (NGOs) in, 13
 and peace, 27–31
 politics of, 21–25
 poverty in, 95–96
 and policy in, 13–15, 267–282
 quality of life in, 112–114
 and socialization, 133–134
 and socio-economic status, 120–121
 structural adjustment programs (SAPs) in, 97–98

Central America (continued)
 women legislators in, 1–3, 4,
 8, 72–73, 135–140, 141–149,
 166–168, 179
 women's suffrage in, 86–87
 See also under specific countries
Central American Common Market, 21
Central American Parliament, 29, 145,
 282
Central Intelligence Agency (CIA),
 25, 51
centrist parties, 53, 88, 90, 146
Chamorro, Violeta, 63, 65, 67, 68, 89,
 141, 226, 255, 283
children, 36, 47, 55, 103, 105, 106, 112–
 114, 116, 119, 121, 128–131, 132, 134,
 137–140, 143, 144, 164, 185, 206,
 223, 240, 252, 255, 256, 257, 259, 265,
 266, 269, 271, 272, 273, 274, 276, 277,
 279, 280, 283
childbearing, 112, 128
childcare, 15, 36, 69–70, 97, 252, 255,
 259, 265, 274, 276
child labor, 13
 See also under specific countries
CIA. See Central Intelligence Agency
 (CIA)
citizenship, 27, 203, 217–218, 234, 254.
 See also women and under specific
 countries
civil sphere, 12, 23, 27, 35, 36, 45–47,
 53–54, 59, 65, 67–68, 71, 86, 111,
 114, 198, 202–203, 206–207, 209,
 213–219, 223–229, 233, 237–239,
 240–243, 249–250, 281, 282
civil war, 28, 30, 32, 38, 39, 43, 44, 45,
 48, 50, 52, 54, 56, 60, 89, 90, 99, 100,
 104, 110, 111, 112, 140, 144, 150,
 162, 170, 171, 215, 281
Cold War, 4, 11, 25, 27, 28, 29, 30, 59,
 208, 243
concertación, 12, 13, 216–217, 219,
 224–225, 227, 242, 282
conservatives, 44
constitutional democracy. *See*
 democracy

Contadora, 29
contraception, 112, 113
Contras, 28, 29, 58, 59, 62, 66, 67, 98,
 101, 148, 164, 172, 184
Convention on the Elimination of All
 Forms of Discrimination Against
 Women (CEDAW), 35, 41, 132,
 258–259, 274
corporatism, 5, 22, 23, 24, 34, 45, 65,
 66, 82, 206, 218, 220, 227, 250
Costa Rica, 36–42, 212, 216, 221,
 236–237, 239, 245
 agriculture in, 98
 appointments in, 92–93
 and the Catholic Church, 116
 children in, 128–130
 citizens of, 254
 debt of, 98
 economics of, 37–38
 education in, 103–104
 and feminism, 110–111
 and gender, 33, 41–42
 gross domestic product (GDP)
 of, 95
 history of, 21–22, 27–28, 36–42, 44,
 62, 71
 labor force in, 104–105, 107–108,
 121, 131
 laws of, 255–256
 legislature of, 156–158
 and national defense, 99
 and policy, 269, 273, 281
 politics of, 38–41
 quality of life in, 112–114
 quotas in, 276–278
 women legislators in, 73, 83–84,
 121–123, 125–127, 130–131, 133–
 135, 137, 166–167, 168, 173–176,
 178–179, 181, 183, 184, 187, 189,
 191–192
 women's sections in, 146–147
 women's suffrage in, 86
counter-insurgency, 25, 45, 51, 52,
 53, 60
criminal law, 256, 268, 273, 277,
 279–280. *See also* law

death squads, 53, 60
debt, 15, 38, 58, 63, 65, 97, 99, 100, 101, 192, 248, 265–266. *See also under specific countries*
defense, 24, 40, 100, 101, 153, 162, 164, 185, 192, 264
democracy, 6, 11, 12–13, 17, 29–30, 35, 36, 39, 41, 47, 51, 54, 55, 67, 74, 78, 81, 154, 180, 206, 212, 213, 233, 262, 271, 272, 283
 constitutional, 53
 ideology of, 204, 206, 212, 221
 liberal, 66, 67, 202, 203, 204, 205, 206, 207, 213, 224, 230, 233, 240, 243, 248
 participatory, 45, 66, 67, 201, 216, 217, 219, 229, 231, 233, 241, 249
 procedural, 27, 45, 46, 67, 202, 229, 233
 radical, 197, 201, 202, 207–209, 213, 230
 social, 39, 75, 76, 107, 109, 111, 117, 201, 202, 205, 206, 207, 213, 217, 219, 230
 transition to, 25, 46, 54, 60, 68, 221, 224, 244–246
 See also democratization
democraduras, 27, 55, 60
democratization, 1, 3, 4, 5, 11, 12, 14, 15, 16, 17, 18, 25, 26, 28, 34, 35, 54, 66, 67, 68, 110, 149, 196, 197, 229, 249, 251, 262, 264, 265, 281, 282. *See also* democracy *and under* women
dictatorships, 38, 41, 49, 59, 110, 111, 161, 204, 208–209, 240
discrimination, 178, 193, 205, 211, 225, 227, 232, 239–240, 247, 252, 254, 257–260, 266–267, 272–274, 282. *See also under specific countries*
district magnitude, 77, 87, 88. *See also under specific countries*
divorce, 125, 127, 252, 255–256, 273
domestic violence, 14, 17, 49, 115, 205, 225, 237, 239–240, 252, 281. *See also* violence

Eastern Europe, 12, 109, 198, 207, 243–246, 283
economics, 20–21, 28, 30–31, 35–36, 39–41, 44, 46–47, 50–53, 59–60, 63–69, 74, 76, 77, 94, 96, 97, 98, 100, 109, 114, 117. *See also under* women *and under specific countries*
 crisis in, 15, 44, 53, 60, 68, 100, 109, 248, 258, 264–267, 271, 281–283
 and development, 7, 47, 59, 74, 75, 76, 77, 95, 102, 117, 118, 197, 199, 201, 244, 265–266
 liberalization of, 65, 216
 neoliberal policy concerning, 211–212, 240, 248–250, 265
 and rights, 234, 245–246, 248
education, 7, 8, 20, 38, 39, 40, 41, 47, 56, 61, 69, 75, 76, 77, 92, 97, 102, 103, 104, 112, 114, 115, 117, 121–124, 129, 131, 132, 136, 137, 150, 153, 159, 172, 174, 180, 187, 193, 206, 209, 211, 223, 229, 234, 236, 240, 242, 249, 254, 259, 261, 266, 267, 268, 276, 277, 278, 279, 280. *See also under specific countries*
egalitarianism. *See* equality
elections, 25, 26, 27, 30, 33, 35, 38, 39, 45, 46, 51, 53, 60, 64, 66, 67, 68, 70, 75, 81, 82, 83, 86, 87, 88, 89, 90, 91, 109, 201–204, 206, 217, 224, 227, 233, 235, 242–243, 245
 candidates in, 75, 80–81, 90–91, 121, 139, 140, 142, 144, 146, 148, 149, 161, 176, 196, 198, 217, 234–235, 242, 277
 districts for, 74, 78, 80, 87, 88, 91, 117
 and the electoral system, 73, 74, 75, 76, 77, 78, 80, 81, 82, 87, 94, 117, 119
 incumbents, 6, 77, 83, 87, 117, 145
 and politics, 73, 74, 75, 76, 77, 78, 80, 81, 82, 87, 88, 89, 90, 91, 92, 94, 110, 117, 135, 136, 139, 140, 143, 146, 148, 149
 See also voting *and under* women

elites, 21, 23, 26, 28, 32, 38, 39, 40, 42, 43, 47, 50, 52, 53, 54, 57, 65, 209, 216, 218, 223–225, 236, 239, 243
El Salvador, 42–49
 agriculture in, 99–101
 children in, 114, 129
 citizens of, 254
 discrimination in, 267
 economics of, 42–44
 education in, 103–104, 123
 and feminism, 260
 history of, 21, 22, 24, 25, 42–49
 and gender, 33, 34, 47–49
 gross domestic product (GDP) of, 95–96, 104
 and health, 279–280
 and inflation, 97
 labor force in, 105, 108, 130
 laws of, 256–257
 leftist parties in, 90
 legislature of, 78, 157–158, 160
 and *machismo*, 115, 176–178
 marital status in, 125, 127
 military in, 98–99, 148
 and party strength, 90
 and peace, 28–30, 261, 263
 and policy, 272, 279
 politics of, 47, 145, 147
 population of, 99
 and representation, 162–163, 181–182, 185–187, 189, 191–192
 state terror in, 281
 structural adjustment programs (SAPs) in, 97
 violence in, 281
 and war, 101, 136
 women in, 267
 women legislators in, 73, 82, 83, 84, 155, 167, 170–171, 173–175, 179
 women's suffrage in, 86, 110
employment, 103, 107, 112, 234, 240, 252, 265, 276. *See also* unemployment
encomienda, 20
equality, 7, 15, 17, 37, 41, 69, 75, 156, 179, 191, 198, 204, 205, 206, 217, 219, 226, 231, 235, 245, 247, 254–255, 258–261, 267–269, 272, 274, 277–278, 283. *See also under* women
Esquipulas, 5, 29, 30, 66, 67, 225–226
ethnicity, 19, 20, 55, 81, 205, 274

family, 20, 22, 32, 34, 35, 36, 37, 49, 62, 63, 64, 103, 105, 106, 121, 132, 133, 134, 136, 138, 139, 141, 142, 143, 149, 150, 166–168, 175, 179, 184, 191, 194–195, 212, 218, 223, 226, 231–232, 237, 248–249, 252, 253, 254, 255, 259, 265, 267, 268, 269, 271, 272, 279, 283
fathers, 121, 124, 127, 133, 134, 139, 140, 141
feminism, 41, 178, 190, 191, 196, 204–207, 226, 230, 232, 240, 254, 259, 260, 261, 262, 263. *See also* equality *and under* women
FMLN. *See Frente Farabundo Martí para la Liberación Nacional* (FMLN)
Frente Farabundo Martí para la Liberación Nacional (FMLN), 45, 46, 47, 48, 98, 99, 148, 162, 221–226, 228, 237–238, 263
Frente Sandinista de Liberación Nacional (FSLN), 65, 66, 67, 68, 69, 70, 71, 88, 89, 98, 102, 115, 136, 137, 138, 145, 146, 147, 148, 159, 164–165, 172, 182–183, 188, 217, 221, 225, 237, 238, 243, 247, 249, 280
 and women, 136, 148
FSLN. *See Frente Sandinista de Liberación Nacional* (FSLN)

GDP. *See* gross domestic product (GDP)
gender, 31–36, 41–42, 47–49, 55–56, 61–62, 68–71, 111, 132, 173, 178, 190, 212, 214, 225–228, 231–235, 237–239, 242, 245, 249, 251, 254, 258, 261–263, 265–266, 271, 274, 281–282
 consciousness of, 9, 16, 18, 49, 71, 251, 258, 263, 266
 relations among, 18, 55, 232–233, 239
 and roles, 231–232

stereotypes of, 259, 281
and terror, 140
See also under specific countries
gross domestic product (GDP), 74, 94, 95, 96, 98, 99, 100, 101, 102, 103, 104, 105, 109, 117, 120. *See also under specific countries*
Guatemala, 49–56, 137, 144, 145, 148, 149, 150, 199, 200, 201, 208, 210, 211, 212, 216, 220–221, 223, 225–227, 229, 239, 249
 agriculture in, 100
 children in, 114, 128
 citizens of, 254
 discrimination in, 272
 economics of, 50–51
 education in, 103–104, 123–125
 and gender, 55–56, 261–262, 276
 gross domestic product (GDP) of, 100
 history of, 49–56
 labor force in, 105, 107, 108
 legislature of, 78, 83
 marital status in, 125, 127
 military in, 98
 and policy, 255–257, 267, 273–274
 population of, 100
 quality of life, 112–113
 and representation, 181–182, 186, 188, 193
 and state terror, 281
 women legislators in, 73, 82, 83, 84, 155, 157–158, 171–174, 179
 women's suffrage in, 86, 110
guerrilla warfare, 30, 47, 48, 52, 55, 60, 64, 210, 215, 221, 224, 225, 226, 230, 236, 238

health care, 259, 271, 273
Honduras, 56–62, 128, 135, 201, 212, 238
 agriculture in, 100–101
 appointments in, 92–93
 children in, 114, 128
 district magnitude in, 87
 economics of, 57–58
 education in, 103–104, 123

 and gender, 61–62
 gross domestic product (GDP) of, 95–96
 history of, 56–62
 labor force in, 105–106, 107, 108
 leftist parties in, 90
 legislature of, 78, 157–158
 marital status in, 125, 127
 military in, 98–99
 and party strength, 90
 and policy, 257
 politics of, 58–60
 population of, 101
 quality of life, 111–112
 representation, 82, 181–182, 186–187, 189–193
 structural adjustment programs (SAPs) in, 97
 and war, 101
 women legislators in, 73, 82, 83, 85, 155, 156–158
 women's suffrage in, 86, 110
human rights. *See* rights

illiteracy. *See* literacy
import substitution industrialization (ISI), 21
income inequality. *See under* inequality
independent women's groups, 147
indigenous peoples, 19–20, 32–33, 37, 42–43, 49–50, 51, 52, 54, 56, 57, 103, 104, 147, 152, 153, 189, 205, 215, 247
inequality, 40, 52, 95, 115, 204, 207–208, 210, 217, 219, 229–230, 233–234, 239, 244, 247–248, 249
 in income, 95
inflation, 60, 63, 67, 68, 96, 99, 100, 101, 271. *See also under specific countries*
interest groups, 141, 206, 220, 250
international aid, 35, 50, 70, 101
Inter-Parliamentary Union (IPU), 72
IPU. *See* Inter-Parliamentary Union (IPU)
ISI. *See* import substitution industrialization (ISI)

labor, 205, 209, 215, 232, 248, 249, 254, 257, 265, 267, 271, 272, 273, 274
 and the labor force, 7, 13, 75, 98, 100, 101, 102, 104, 105, 107, 111, 121, 205–206
 laws concerning, 50, 105, 208, 257
 migrant labor, 21, 37, 55
 unions for, 111
 See also under specific countries
land reform. *See* agrarian reform
Latin America, 94, 95, 102, 103, 105, 107, 112, 155, 193, 198, 199, 210, 211, 216, 232, 242, 243, 244, 250
 laws of, 256–257, 279–289
 legislatures of, 14, 252
 and policy, 276, 278
 violence in, 282
 women in, 132, 282, 259, 266, 276–278
 See also specific countries
law, 14, 18, 19, 27, 33, 40, 41, 47, 59, 94, 105, 110, 111, 199, 201–202, 204, 208, 210–211, 214, 236–237, 239, 252, 254–255, 257, 267–269, 272–274, 279. *See also under* women *and under specific countries*
leftist parties, 6, 75, 88, 90, 94. *See also under specific countries*
legislators, 61, 72, 73, 74, 75, 76, 77, 78, 80, 83, 86, 87, 90, 92, 98, 106, 109, 114, 115, 116, 117, 143, 144, 146, 147, 148, 225, 245, 236, 239
 ideal qualities of, 155, 168–180, 186, 195–196
 See also representatives; women legislators
legislature, 72, 73, 74, 75, 76, 77, 78, 80, 81, 82, 83, 86, 87, 88, 89, 90, 91, 92, 93, 94, 98–99, 100, 101, 102, 104, 106, 107, 109, 111, 112, 114, 116, 117, 152–154, 203, 236, 201, 203, 233, 236, 245, 257, 261, 268, 277, 282, 283
 and committees, 156, 157, 159, 195, 257
 functions of, 151, 152, 153, 154, 155, 160, 161
 See also representation *and under specific countries*

liberal democracy. *See* liberalism *and under* democracy
liberalism, 11, 13, 27, 38, 66, 67, 75, 76, 107, 109, 178, 196, 197, 201, 202, 203, 204, 205, 206, 207, 209, 213, 216, 219, 224, 227, 230, 233, 240, 243, 248, 250, 271–272
liberation theology, 20, 116
LIC. *See* low-intensity conflict (LIC)
life expectancy, 75, 112, 113, 114
literacy, 70, 119, 263
low-intensity conflict (LIC), 25, 28, 45, 48, 66

machismo, 7, 11, 15, 31, 32, 34, 41, 107, 114, 115, 117, 119, 140, 166, 178–180, 193, 196, 214, 261, 266, 278, 282
 overcoming, 178–180, 194, 196
 See also under specific countries
marianismo, 31, 214
marital status, 112, 125–128, 131, 261, 272, 274.
maternal mortality, 75, 112, 113, 114
maternity leave, 15, 69, 105, 252, 271
Maya, 50, 51, 55, 104
mestizo, 20, 33, 51
migrant labor. *See under* labor
military, 96, 98, 99, 100, 101, 102, 110, 111, 156, 184, 209, 210, 215, 220, 223, 244, 246. *See also under specific countries*
mothers, 16, 32, 48, 61, 69, 103, 111, 114, 115, 121, 130, 132, 134, 135, 137, 138, 139, 140, 142, 149, 175, 187, 191–193, 252, 269, 273–274
Mujeres '94, 241–242, 248

national defense. *See* defense
National Guard, 59, 63, 64, 65, 70, 138
NGOs. *See* non-governmental organizations (NGOs)
Nicaragua, 62–71, 139, 141, 142, 148, 149, 200, 208, 212, 216, 221, 223, 225, 226, 228, 233, 236, 237, 239, 241, 249
 agriculture in, 101–102
 appointments in, 92–93

and the Catholic Church, 116
children in, 128
and their Council of State, 89, 110
debt of, 98
district magnitude in, 87
economics of, 63
education in, 103, 104, 123–124
electoral system of, 78–79
and family, 132–133
and feminism, 110–111
and gender, 65–71
gross domestic product (GDP), 95–96
and health, 278–280
history of, 62–71
and inflation, 97
labor force in, 105–108
leftist parties in, 88–90
legislature of, 82, 157–159, 160–161, 163–165
machismo, 115, 178–180
marital status in, 125–127
military in, 98–99
and party strength, 90
and peace, 261
and policy, 256, 263, 267, 274, 281, 283
politics of, 64–68
population of, 101
poverty in, 95
quality of life in, 112–113
and representation, 181–186, 188, 190, 194
structural adjustment programs (SAPs) in, 97, 266
women legislators, 73, 83, 85, 155–156, 171–172
women's section, 91
women's suffrage, 86
non-governmental organizations (NGOs), 13, 17, 42, 70, 147, 149, 208, 216, 236–241, 243, 248, 258, 262, 283
non-violence, 223, 242–243

OAS. *See* Organization of American States (OAS)
Office of Women, 207

Organization of American States (OAS), 143, 145

pact/*pacto*, 25, 38, 39, 216, 224, 227, 239, 243–244
paramilitary, 210, 215, 223, 281
participatory democracy. *See under* democracy
parties. *See* political parties
party lists (PLs), 6, 77, 78, 80, 81, 87, 88, 90, 91, 94, 117, 119, 147, 150, 181, 182, 235
patria potestad, 252
patronage, 161, 164, 229, 249
peace, 27–32, 41, 45–47, 50, 53, 55–56, 64–68, 90, 116, 162, 165, 197, 199, 210, 211, 212, 223, 225, 226, 227, 229, 234, 238, 248, 249, 261, 262, 266, 273, 281. *See also under specific countries*
peasant. See *campesinos*
penal codes, 273, 274, 280
PLs. *See* party lists
pluralism, 204, 217, 241, 243, 250
police, 9, 24, 46, 51, 64, 70, 145, 148, 149, 162, 210, 238, 218–282
political parties, 80, 83, 90, 102, 117, 133, 136, 141, 142, 143, 144, 145, 146, 147, 149, 150, 199, 206, 226, 229, 234, 235, 251, 263–264, 277, 278, 283. *See also specific parties*
political sphere, 202, 203, 204, 205, 215, 223, 224, 227, 228, 232–233, 238, 249
politics, 21–25, 38–41, 44–47, 51–55, 58–60, 64–68, 77, 94, 102, 109, 111, 198, 199, 205, 207, 209, 210, 213, 216, 219, 225, 226, 228, 229, 232, 233, 236, 237, 238, 246, 248, 249, 250, 251, 257, 267, 268, 276, 282
activism in, 115, 134, 142, 150, 181, 228
and appointments, 92–94
awareness of, 16, 133, 140
and campaigns, 135, 137, 139, 144, 149
careers in, 9, 97, 141, 142, 143, 144, 146, 150

politics (continued)
 culture of, 4, 7, 12, 55, 65, 75, 76, 107
 interest in, 120, 134, 135, 139, 140, 141
 participation in, 132, 133, 134, 135, 139, 140, 253, 271, 278
 power in, 244, 246
 rights in, 219, 249, 259, 276–277
 society of, 35, 36, 47, 203, 213, 218, 236, 241, 242, 249, 250
 students and, 136–137, 149
 See also under specific countries
population, 74, 77, 82, 94, 95, 96, 99, 100, 101, 102, 105, 112, 120, 122, 123, 124, 125, 127, 165–166, 187, 194, 207, 223, 231, 234. See also under specific countries
poverty, 48, 57, 58, 59, 95, 96, 99, 100, 101, 117, 119, 120, 124, 125, 137, 138, 140, 153, 198, 210, 212, 215, 229, 234, 240, 244, 249, 265, 280, 281, 283
PR (proportional representation). See under representation
private sphere, 132, 150, 202, 203, 204, 205, 207, 211, 213, 214, 215, 216, 217, 220, 223, 224, 225, 231, 232, 237, 240, 250, 252, 265, 273, 282
privatization, 68, 212
procedural democracy. See under democracy
proportional representation (PR). See under representation

quotas, 147, 150, 207, 212, 245, 276. See also under specific countries

race, 247, 250, 257, 261, 271
radical democracy. See under democracy
rape, 56, 62, 56, 215, 223, 257, 276, 277, 279, 281
religion, 20, 75, 107, 114, 116, 257, 260, 279. See also Catholic Church
representation, 151, 154, 159, 162, 164, 165, 180–183, 185–191, 194, 196, 198, 204, 208, 209, 218, 220, 224, 227, 229, 236, 250, 267, 277
 active representation, 190, 196
 of interest groups, 160, 183, 185, 187, 190–194
 of political parties, 162–163, 182–183, 186–188
 of the poor, 153, 183–185
 of the population, 183–185
 proportional representation (PR), 6, 73, 74, 75, 76, 77, 80, 81, 82, 94, 117, 119, 182, 262, 277
 style of, 185–187, 189, 196
 of women, 4, 6, 23, 75, 77, 78, 81, 82, 86, 104, 109, 111, 154, 159, 187
 See also legislature and under specific countries
representatives, 1, 8, 23, 54, 66, 74, 78, 80, 91, 92, 120, 122, 146, 151, 154, 157, 165, 173, 175, 180, 182, 187, 189, 195–196, 204, 246, 249
 ideal qualities of, 168, 171–172, 178, 231. See also legislators
reproductive health, 14, 17, 237
revolutions, 5, 9, 30, 34, 37, 48, 59, 65, 70, 86, 88, 89, 98, 101, 111, 115, 124, 136, 137, 140, 144, 148, 172, 189, 194, 208, 222, 225, 227, 228, 238, 239, 240, 241, 249, 263
rights, 12, 17, 18, 26–27, 33, 34, 35, 36, 72, 105, 110, 138, 151, 161, 171–172, 176, 184, 187, 191, 192, 194, 202, 203, 204, 205, 206, 207, 208, 210, 211, 213, 215, 218, 219, 220, 225, 226, 227, 228, 229, 231, 234, 235, 240, 242, 243, 245, 246, 247, 248, 249, 250, 259, 264, 276–277
 human rights, 24, 28, 30, 36, 40, 42, 46, 48, 51, 52, 54, 60, 65, 66, 67, 199, 200, 210–213, 223, 238, 247, 249, 258, 263, 281, 282, 283
 of individuals, 22, 33, 202, 207, 209, 219, 230, 249, 250, 253–254
 concerning voting, 36, 51, 61, 72, 86, 110, 134, 137, 254. See also under women

right-wing groups, 34, 44, 52, 59, 88, 90, 115, 136, 139, 140, 145, 204, 228, 235, 263–264

Sandinistas, 28, 34, 59, 65, 66, 67, 68, 70, 88, 89, 90, 98, 109, 115, 136, 137, 165–166, 189, 191, 208, 226, 237, 238, 243, 246, 283
SAPs. *See* structural adjustment programs (SAPs)
social democracy. *See under* democracy
socialization, 8, 16, 131–132, 134, 135, 149, 231, 233
social justice, 11, 13, 30, 47, 197, 199, 201, 209, 210, 211, 213, 216, 221, 224, 229, 233, 246
Somoza, 59, 62, 63, 64, 65, 67, 69, 70, 101, 110, 115, 138, 150, 160–161, 164, 172, 191
state terror, 56, 140. *See also under specific countries*
structural adjustment programs (SAPs), 15, 21, 63, 68, 73, 74, 76, 77, 94, 97, 98, 100, 102, 104, 107, 117, 118, 119, 205, 212, 238, 248, 262, 265, 266, 281, 282. *See also under specific countries*
student politics. *See* politics
suplentes, 78, 91–92

UN. *See* United Nations (UN)
unemployment, 75, 100, 105, 240, 266, 281
United Fruit, 50, 51, 58
United Nations (UN), 29, 54, 132, 145, 234, 245, 258
United Nations Decade for Women, 92
United States (U.S.), 80, 153, 162, 201–202, 243, 250, 252, 258, 262, 281
 corporations in, 38, 50, 51, 58, 62
 government of, 24, 25, 28, 45, 46, 64, 65, 66
 military of, 21, 24, 25, 59, 64, 69
 in Nicaragua, 139
 women legislators in, 75
U.S. *See* United States (U.S.)

violence, 12, 13, 19, 28, 31, 36, 39, 42, 43, 46, 47, 49, 52, 55, 56, 64, 138, 162, 203, 205, 210, 211, 217, 234, 237, 241, 242, 250
 against women, 13, 36, 259, 281, 282
 See also domestic violence *and under specific countries*
voting, 61, 78, 80, 81, 82, 86, 87, 88, 90, 109, 110, 111, 115, 134, 137, 143, 155, 183, 188, 193, 198, 213, 217, 235, 240, 244, 249, 254, 262–263, 273, 277

war, 86, 98, 99, 101, 110, 161–162, 164, 166, 170, 172, 184, 221, 228, 237, 240, 244–245, 247, 250, 253–254, 258, 260. *See also under specific countries*
women
 appointed to office, 92–94
 as candidates, 80–81, 90, 91, 111, 117
 and citizenship, 252–254
 as delegates, 143, 145
 and democratization, 197
 as deputies, 164, 173–174, 190
 and divorce, 255–256
 and economics, 269
 elected to office, 2, 4, 6, 119, 120, 122, 123, 125, 128, 129, 130, 131, 134, 135, 141, 150, 281
 and elections, 72, 74, 75, 94
 equality for, 272–274
 and interest in politics, 120, 133, 135, 136, 137, 141, 150
 in the labor force, 105, 106–107
 and law, 256–257
 as legislators. *See* women legislators
 and marriage, 254–255
 rights of, 18, 33, 34, 35, 36, 78, 86, 110, 225–227, 234, 238, 240, 242, 253, 255, 258, 259, 261, 272, 273, 274, 276, 281, 283
 roles of, 176, 209, 227, 252, 255, 263, 269–271, 273–283
 role change for, 273–274

women (continued)
 role strain for, 268, 271–272
 in rural areas, 48, 106–107, 266, 274
 and suffrage, 72, 87–109, 110, 111
 See also under specific countries
women legislators, 72, 73, 74, 75, 76, 77, 83, 87, 90, 92, 109, 117, 119, 120, 121, 122–124, 151, 155–157, 160–161, 163–166, 168, 174–176, 178–180, 182, 186, 188, 190, 192, 195–196, 251–252, 257, 259, 260, 263–267, 268, 269, 271, 272, 277, 279, 280, 282, 283
 and children, 128–129
 education of, 122–124
 election of, 72, 74, 75, 147
 and their fathers' occupations, 121
 marital status of, 125–127
 and their mothers' occupations, 130–131
 percent elected, 72, 73, 74, 75
 profiles of, 140–142, 143, 144, 145, 148, 149, 150
 and socialization, 132–136
 See also under specific countries
women's movement. *See* feminism
women's organizations, 238, 242–243
women's sections. *See under specific countries*
women's suffrage. *See under* women *and under specific countries*